D0765031

100 THINGS
STAR WARS®™
FANS
SHOULD KNOW & DO
BEFORE THEY DIE

DAN CASEY

TRIUMPH
BOOKS

Library of Congress Cataloging-in-Publication Data

Casey, Dan, 1988–
 100 things Star wars fans should know & do before they die / Daniel Casey.
 pages cm
 One hundred things Star wars fans should know & do before they die
 Includes bibliographical references.
 ISBN 978-1-62937-164-1
 1. Star Wars films—Miscellanea. I. Title. II. Title: One hundred things Star wars fans should know & do before they die.
 PN1995.9.S695C38 2015
 791.43'75—dc23
 2015029720

This book is available in quantity at special discounts for your group or organization. For further information, contact:
 Triumph Books LLC
 814 North Franklin Street
 Chicago, Illinois 60610
 (312) 337-0747
 www.triumphbooks.com

Printed in U.S.A.
ISBN: 978-1-62937-164-1
Design by Patricia Frey
Photos courtesy of AP Images unless otherwise indicated

To my mother, Ellie.
Like the Force, she is with me. Always.

Contents

Introduction

The year was 1997 and I was sitting on the floor of a rented cottage on Cape Cod. My father was out playing golf with my uncles, and my mother had gone to a nearby craft fair with my aunt. Being the avid indoorsman I was and a preternaturally shy nine-year-old with no siblings of which to speak, I elected to plop down on the shag carpet in the living room rather than journey into the harmful UV rays of the Massachusetts sun. Don't get me wrong; I loved the beach and playing outdoors with my friends, but sometimes you just want to be alone, sitting in the dark in the middle of the day—so that's exactly what I did. Little did I know that afternoon would change my geeky little life forever, as I uncovered a whole new realm of pop culture heretofore unknown to me.

My father had come home with a surprise recently, a black-and-gold box of three VHS tapes emblazoned with the bisected face of a mysterious man in black, samurai-style armor. Without thinking much of it, I popped the first tape into the VCR, and then I proceeded to sit there transfixed by the sprawling space opera that unfolded before my eyes. Robed men battled with swords made of pure light, spaceships zoomed back in forth in epic dogfights, and the samurai from the cover terrified me to my core as he choked the life out of those who stood in his way. This was my earliest recollection of seeing *Star Wars*.

The box in question was the now-infamous "Special Edition" release of the original *Star Wars* trilogy. Of course, I had no idea at the time that what I was watching had been meticulously tinkered with by a fastidious director-producer obsessed with refining his vision into its most perfect form. The only thing that I knew was that this was unlike any other movie that I had seen. Even now, it is hard to recall specific moments from that

afternoon. Over the years, it has congealed into a sort of general sense of wonderment, a warm, fuzzy feeling that I can think back to when I need a pick-me-up.

It seems impossible to me that I had not seen *Star Wars* until the age of nine. Granted, it wasn't necessarily in its heyday during the early '90s when I was growing up; at the time, the Expanded Universe was in the process of reviving and relaunching itself thanks to novels like Timothy Zahn's Admiral Thrawn trilogy. Behind the scenes, George Lucas was hard at work on a brand-new trilogy of *Star Wars* films for a new generation of viewers, but that was still two years away. When you're nine years old, two years is an eternity, and time seems to dilate as summer days stretch out forever and ever, with no end in sight. In fact, I am positive that I had a Darth Vader action figure that I made fight in epic imaginary battles against Spider-Man, G.I. Joes, and my coveted Arctic Batman. Since 1977, *Star Wars* has been a cultural signifier, a monolithic force of nature that conquered the hearts, minds, and action figure collections of an entire generation. While I had never seen *Star Wars* until that moment, I would be shocked if I hadn't at least had a working knowledge of it. But like *Rashomon*, that's how I recall the events that happened, and I'm sticking to it.

From that point forward though, *Star Wars* was not something I would ever forget. I was never one for the Expanded Universe novels and comics—I was something of a Marvel and DC snob where those were concerned (and yes, I understand the irony because Marvel made the first *Star Wars* comics). With my friends, I would watch those VHS tapes again and again until they were battered and the labels began to fade away. Taking me deeper into the fandom of the galaxy far, far away was the rich catalogue of *Star Wars* video games. Some of my fondest memories involve sneaking down into the basement after my parents had gone to bed in order to play "just one more level" of

Dark Forces or *Jedi Knight.* In high school, I continued leading my rich inner life by losing myself in the sprawling prehistoric Jedi versus Sith saga of *Knights of the Old Republic,* an immersive role-playing game that let you chart your character's fate based on the decisions you made. It was one of the first times that I felt like I was a part of the *Star Wars* universe, and even though it was a single-player game, it was something which I could discuss at length with my friends at school.

That is the beauty of *Star Wars* fandom. It has its own secret language. One doesn't necessarily need to understand every aspect of it; there is a certain vocabulary and rhythm to it that makes you feel like you're part of something larger, a hidden club that has somehow spread all across the world. And you can go as deep into the galaxy far, far away as you want. No matter what your point of access is, there is someone else out there who can understand and appreciate it. Do you obsessively catalog the genealogy of the Skywalker-Solo family tree? Someone else does too. Do you tinker with scrap metal and solder circuit boards to make your own working R2-D2 unit? Someone else does too. Did your jetpack misfire, sending you careening into the esophagus of an eldritch beast on a faraway desert planet? Then, you might be Boba Fett, in which case I could have *sworn* you were dead.

My point is that *Star Wars* has always been a welcoming, comforting presence. It is the great equalizer in a sense. Whether or not one would admit it to you is one thing, but unless they were a feral child, there is a 99.9 percent chance that every man, woman, and child alive today has made a lightsaber noise with their mouth and pretended to swing around the most iconic weapon in cinema history. This is largely due to the elemental, quintessential narrative qualities George Lucas imbued into his swashbuckling saga of fathers, sons, princesses, knights, and evil empires. Now, with Lucasfilm's recent acquisition by Disney,

the impossible is happening once more: new *Star Wars* films are being made. The galaxy far, far away looks poised to take over the universe as we know it all over again. This time, though, I won't just be ready for it; I'll be welcoming it with open arms. And after reading this book, I hope you will too.

A Galaxy Far, Far Away

Everything changed on May 25, 1977. To the untrained eye, it was just another endless day in what seemed like a year that threatened to drag on forever. In the Netherlands, two days prior, a group of Moluccan terrorists seized control of a train and a school in the Netherlands, holding more than 100 children hostage.[1] Two months prior, KLM Flight 4805 and Pan Am Flight 1736 collided mid-air, killing 583 people in a horrific accident at the Tenerife airport in the Canary Islands; at the time, it was the deadliest accident in aviation history.[2] In Dover, Massachusetts, residents reported seeing sights of an eerie monster dubbed the Dover Demon. On television, viewers were made to wrestle with their own demons as British journalist David Frost reopened old wounds with former President Richard Nixon in a four-night interview series. In short, the country—and even the world—felt as though it could use a new hope. On that Memorial Day weekend, that was exactly what they got, as a little-known sci-fi film called *Star Wars* opened in theaters and changed the course of cultural history.

The lights in the theaters faded to black as the reel-to-reel roared to life. After the classic Chuck Jones cartoon short *Duck Dodgers in the 24½th Century* played—something on which George Lucas insisted—the Fox fanfare filled the theater with its indelible drum roll and bright, piercing horns, heralding the arrival of something new.[3] (In fact, this fanfare, originally created in 1933 by Alfred Newman, had fallen out of use by the time of *Star Wars'* premiere; it was another relic that Lucas insisted on reviving and appending to his baby.)[4] Yet the fanfare was merely a preamble, a

triumphant crescendo paving the way for 10 simple words in an icy blue font that would burn their way into the wrinkles of our brains: "A long time ago, in a galaxy far, far away…"

This was the first indication that audience members weren't in for another run-of-the-mill sci-fi affair; these words had a fairy tale quality to them. That's because this wasn't "sci-fi" per se—it was space fantasy, a clever amalgamation of multiple genres to make an elemental tale of good and evil, light and dark, all set against a backdrop of the infinite. Of course, this thought barely had time to register for most viewers because suddenly the massive, yellow *Star Wars* logo filled the frame, accompanied by the thunderous arrival of John Williams' opening theme. Then, came the opening crawl, the sprawling wall of slowly scrolling text that crept up from the bottom of the screen, flying off into oblivion. (Note: the title *Episode IV: A New Hope* would not appear in the opening credits until the film's re-release in 1981.)[5]

On its first day, the film opened in just 32 theaters across the country, and was set to open in 11 more over the coming days. There had only been one trailer for the film that had come out the previous Christmas, which promptly disappeared until, like Jesus, it returned for Easter. In spite of what seemed like a relative non-presence, the film had record-breaking ticket sales, grossing $255,000 on opening day. By the end of the weekend, it had grossed $2.5 million in ticket sales, technically placing it behind *Smokey and the Bandit*, which grossed $2.7 million across 386 screens.[6] The numbers don't lie, though. A new king had been crowned.

The film became an instant cultural phenomenon. It spread like wildfire, all in an era before texting, Twitter, and Internet message boards. "On opening day I was on the East Coast and I did the morning-show circuit—*Good Morning America*," producer Gary Kurtz recalled in an interview. "In the afternoon I did a radio call-in show in Washington and this guy, this caller,

was really enthusiastic and talking about the movie in really deep detail. I said, 'You know a lot abut the film.' He said, 'Yeah, yeah, I've seen it four times already.' And that was opening day. I knew something was happening."[7] In fact, it is largely due to the popularity of *Star Wars* that theaters instated a policy of clearing out audiences in between shows; previously crowds could remain seated and watch the film again if they waited long enough.[8]

Seeing the film immediately inducted the viewer into a sort of secret cabal with its own signifiers and vocabulary. "May the Force Be With You" buttons and homemade t-shirts emblazoned with *Star Wars* sayings became common sights, immediate indicators that you were in the know. Fans began trading theories and speculating about the film's vibrant backstory and the rich world Lucas had created. They were particularly curious about the nature of the Force. The film would go on to earn seven Academy Awards, $461 million in domestic box office receipts, and nearly $800 million in ticket sales worldwide.[9] But more importantly, it had created a movement, a legion of diehard fans who weren't just obsessed with the intricacies of the galaxy far, far away.

This was, of course, just the beginning. Over the next 38 years, there would be five more *Star Wars* films, an ill-fated holiday special, two critically acclaimed animated series, countless video games, and a veritable merchandising empire. Honestly, if you can think of an item, there is a *Star Wars*-ified version of it (and it's likely housed at Rancho Obi-Wan for posterity). In total, the franchise has grossed more than $2.2 billion at the domestic box office, and more than $4.5 billion worldwide.[10] Those box office receipts were just a fraction of the income generated by *Star Wars*; an April 2015 estimate stated that the franchise had generated $27 billion when toy sales, book sales, home video, and other assorted licensing fees were factored into the equation.[11]

With statistics like that, it should come as no surprise that on October 30, 2012, the Walt Disney Corporation paid $4.05

billion to acquire Lucasfilm and all of its holdings, including the *Star Wars* brand. After giving his sweat, blood, and tears to this mythic story of good versus evil—two trilogies spanning the course of three decades—George Lucas was ready to pass the torch, the proverbial lightsaber, as it were. "For the past 35 years, one of my greatest pleasures has been to see Star Wars passed from one generation to the next," said Lucas in an official press release at the time. "It's now time for me to pass *Star Wars* on to a new generation of filmmakers. I've always believed that Star Wars could live beyond me, and I thought it was important to set up the transition during my lifetime."[12]

Leading that new generation of filmmakers into the bold, new future are J.J. Abrams and Kathleen Kennedy, the respective Luke Skywalker and Obi-Wan Kenobi of this new era of *Star Wars* stories. After co-founding Amblin Entertainment with Steven Spielberg and Frank Marshall, Kennedy had a long, fruitful career in film that prepared her well to become president of Lucasfilm. Making a name for himself first as a maverick writer and director, J.J. Abrams proved that he was more than up to the task of tackling a revered franchise in a sci-fi setting when he rebooted *Star Trek* for Paramount. Now, the duo are preparing the first new *Star Wars* film in a decade, *Star Wars Episode VII: The Force Awakens*, combatting feverish fan expectation and ravenous paparazzi while they craft the film that will effectively kick off the next era of *Star Wars* films.

Considering that we already have release dates for *Episode VIII* and *IX*, as well as planned *Star Wars Anthology* standalone films in between, it doesn't look like the saga will be slowing down anytime soon. Some might see it as potential oversaturation, but to the *Star Wars* faithful, it seems like manna from heaven. Calling *Star Wars* a multi-generational franchise is underselling it because this is truly a family affair. Parents took their children to see it in the 1970s and '80s, and those children grew up endlessly

watching it. Now, those children have children of their own, a new era of freshly minted Padawan learners who are growing up with their own unique encounters with the *Star Wars* series. It's all quite fitting for a saga of fathers and sons, really; after all, family has always been at the core of the *Star Wars* story. Where this sprawling space opera will take us next, nobody knows. Come December 18, 2015, we'll find out when we finally return to the galaxy far, far away—together.

2 George Lucas

George Lucas is so much more than *Star* Wars. Not only did he create *Star Wars*, but he is also the creative force behind the *Indiana Jones* franchise. Over the course of his career, he has earned four Academy Award nominations. His companies, Industrial Light & Magic and Skywalker Sound, not only brought those films to life, but they redefined industry standards of excellence for a generation of filmmakers with advancements in special effects technology and filming techniques. He is largely responsible for the rise of the modern effects-driven blockbuster. He has a net worth of more than $5 billion, which is no small feat by anyone's measure. Yet without him—and moreover, without *Star Wars*—much of that would not exist.

Star Wars is the reason why we are here, after all. It is a uniting force, a pop cultural superpower that transcends cultures, languages, and generations. Epic in its scale, elemental in its narrative, it is a cultural product that borders on the universal—and it all sprang from the mind of one man, at least at first it did. Before we dive headfirst into the twisting, winding history of *Star*

Wars, one must understand the origins of the galaxy far, far away. Though *Star Wars'* influences can be traced back to a number of sources, it was born from the confluence of passions and interests of George Lucas. With a quiet demeanor, a keen analytical eye, and a perpetual beard, Lucas seems at times like a man unstuck from time. A lifelong passionate film fan whose tastes appeared at odds with the mainstream, Lucas remained undeterred in his mission to transform the distinct pleasures of his youth into a sprawling saga of space fantasy.

Born on May 14, 1944, in Modesto, California, George Lucas grew up in relative comfort on an isolated ranch just outside the town itself. It was, by all means, the quintessential experience of growing up in small-town America. Like Luke Skywalker, Lucas had a need for speed in his younger days, spending endless hours at the racetracks of Modesto. Securing a fake ID, the young Lucas entered into autocross races of his own, and his world seemed to revolve around tinkering under the hood of his souped-up Autobianchi Bianchina, an Italian supermini that he tricked out to eke out every extra ounce of speed that he could. However, all of that changed on June 12, 1962, when Lucas was involved in a nearly fatal car wreck that cut short his teenage aspirations of being a professional racecar driver. It was a watershed moment that gave Lucas a new attitude on life, one that would stay with him for many, many years.

Speaking with Oprah Winfrey in 2012, Lucas said, "It gave me this perspective on life that I'm operating on extra credit. I'm never afraid of dying. What I'm getting is bonus material."[13] It was the fearlessness Lucas now experienced which allowed him to channel that familiar sense of adrenaline into his filmic work. In fact, when *Star Wars* first came out in 1977, it felt faster-paced than any of its rivals at the time. It may sound silly when compared to the frenetic, apoplectic editing style heralded by Jason Bourne and his ilk, but it was the truth.

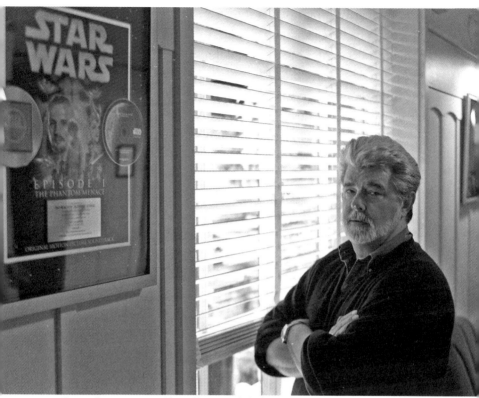

George Lucas poses at Skywalker Ranch before a poster for The Phantom Menace. (Eric Risberg)

Lucas' fondness for filmmaking also blossomed from his passion for automobile racing. While working as a pit mechanic for the AWOL Sports Car Competition Club, Lucas would often bring his 8mm camera with him. One day, it happened to catch the eye of a famous cinematographer named Haskell Wexler, who took an interest in the young man, noting his keen cinematic eye. With some pushing and prodding—and a phone call by Wexler to a USC instructor—Lucas applied to the film school at the University of Southern California. Whether it was due to Wexler's influence or his own aptitude, Lucas was accepted, and officially enrolled as a film student at USC.[14]

Though he would come into his own at USC, the origins of Lucas' lifelong fascination came from his time at Modesto Junior College. Alongside his childhood friend John Plummer, Lucas would venture into Berkley and San Francisco to seek out the burgeoning independent film scene on the North Coast. In particular, a series called Canyon Cinema, curated by filmmakers Stan Brakhage and Bruce Conner, called out to the boys like a siren song. At these screenings, George Lucas turned from casual consumer to cineaste. Of all the films he saw, a short film called *21-87* had the greatest influence on Lucas. Created by a young Montreal filmmaker named Arthur Lipsett, *21-87* was a pastiche of seemingly random audio clips and video footage culled from the National Film Board of Canada's archives. One audio clip spoke of a "kind of force" that pervaded man and nature. It was a sentiment that would evolve into the Force of the *Star Wars* films and a film that would echo across the galaxy far, far away.[15]

At USC, however, George Lucas went from gawky Modesto teen to one of the brightest young cinematic lights the school had ever known. Alongside classmates like Walter Murch, John Milius, Howard Kazanjian, and Robert Zemeckis, Lucas became part of a clique known as the Dirty Dozen, a group of emerging filmmakers who would go on to become major players within the film industry. In particular, they had a passion for cinema outside the cultural norm, especially world cinema. To wit, John Milius, who would go on to co-write *Apocalypse Now* and direct *Conan the Barbarian*, introduced him to the works of Akira Kurosawa, which would have a powerful effect on the development of *Star Wars*.[16]

In 1966, Lucas graduated from USC and received a draft letter for the U.S. Army. However, when Lucas reported for medical inspection, he learned that he would not be heading to Officer Candidate School or to Vietnam at all; he received a 4-F rating and a diagnosis of diabetes, the result of surviving on a

steady diet of Coca-Cola and Hershey's bars in the editing room at USC. Embarking on a lifestyle that bordered on ascetic, Lucas cleaned up his act and his diet in order to improve his bill of health. Though he intended to apply to USC graduate school, his brief detour into potential military service caused him to miss the application deadline. Rather than rest on his laurels, Lucas started a job cutting films together for the U.S. Information Agency, working out of editor Verna Fields' living room. This was a formative experience for Lucas, not only because he learned that he wanted to be a director and producer, not an editor, but also because he met a young woman named Marcia Griffin, whom Fields had hired as a second editor. She was clever, willful, and able to match Lucas creatively, pound for pound. It's no wonder that in a few short years, she would be his first wife.[17]

"Neither one of us would take any shit from the other," Lucas said of his future wife. She was his intellectual equal, but more importantly, she challenged him in new and exciting ways. It's fitting that she was one of the first people that he told about the space fantasy story swirling around in his head, the result of years of consuming sci-fi adventure serials like *Flash Gordon*. "That damn movie was whirring through the editing machine in George's head on the day we met," Marcia would reveal nearly 20 years later, in the wake of their divorce. "He never doubted it would get made…. He spent a lot of time thinking of ways to get those spaceships and creatures on the screen."[18]

Before he made *Star Wars* though, Lucas made a splash at USC graduate school with a futuristic sci-fi short called *Electronic Labyrinth: THX-1138 4EB*. It was a dense, Orwellian tale of man on the run from an oppressive government. The film would serve as a calling card of sorts for Lucas, attracting the attention of another student filmmaker, a young man named Steven Spielberg (although it would be more than a decade before the two would collaborate). After graduating, the strength of *THX* helped Lucas

land a scholarship for an internship at Warner Bros. While on the studio backlot, his former classmate and Dirty Dozen cohort Howard Kazanjian introduced Lucas to another hotshot director whose star was on the rise, Francis Ford Coppola. Slightly older than Lucas, Coppola saw potential in the young USC grad, and took him under his wing.

Together, they co-founded the studio American Zoetrope with the intention of creating a free-flowing environment for aspiring creatives to get films made outside the restrictive studio system. Their first production was a feature-film version of *THX-1138*, which Lucas and his old classmate Walter Murch infused with the sort of oddball sensibility of the films Lucas saw in San Francisco coffeeshops in his youth. However, Warner Bros. balked when they saw the final cut, taking control away from Lucas, recutting it, and giving it a limited release. To make matters worse, the studio backed out of its distribution deal with American Zoetrope, nearly bankrupting Coppola and the company in the process. For Lucas' next film, 1973's *American Graffiti*, he once again found himself at odds with the studio— this time Universal—who threatened not to release the film. When it turned out to be one of the highest-grossing films ever made, Lucas realized he had to take matters into his own hands, and began building Lucasfilm as an independent company he could run as he saw fit.[19]

The success of *American Graffiti* attracted the attention of other executives eager to hear about Lucas' next project. Finally, Lucas decided it was time to bring his "little space thing" to life. In the early 1960s, Lucas looked around him and realized that there was "no longer a lot of mythology in our society," which was exactly what he sought to change with *Star Wars*. Though his name carried a lot of buzz, Lucas found himself facing serious difficulties getting *Star Wars* made, as both United Artists and Universal passed on the project. It was thanks to the confidence

Spielberg's Big Gamble

Over the years, *Star Wars* has made a lot of people very, very rich. But one of them had literally nothing to do with the movie: Steven Spielberg. Sure, he was a friend of George Lucas' and a creative sounding board at times, but why does he make money off of *Star Wars*? Because of a silly little bet. Here's what happened in Spielberg's own words:

"George came back from *Star Wars* a nervous wreck. He didn't feel *Star Wars* came up to the vision he initially had. He felt he had just made this little kids' movie. He came to Mobile, Alabama, where I was shooting *Close Encounters* on this humongous set and hung out with me for a couple of days. He said, 'Oh my God, your movie is going to be so much more successful than *Star Wars*. This is gonna be the biggest hit of all time.'

"He said, 'You want to trade some points? I'll give you two and a half percent of *Star Wars* if you give me two and a half percent of *Close Encounters*.' I said, 'Sure, I'll gamble with that, great.'"

Just how much did Spielberg make? By the end of 1978, *Star Wars*' box office receipts totaled more than $500 million, which earned Spielberg approximately $12.5 million. When adjusted for inflation, of course, that is roughly $46.675 million! And in case you were wondering, yes, he is still making money on that deal to this day.

Warner, Brian. "How Steven Spielberg Won A Lucrative Percentage Of Star Wars Off A Bet With George Lucas." Celebrity Net Worth. N.p., 07 May 2014. Web. 19 May 2015.

of Alan Ladd Jr., an executive at 20th Century Fox, and Ralph McQuarrie, a young artist who he commissioned to create concept art based on his script, that the film got made at all.

Even after getting the greenlight, *Star Wars* required Lucas' sweat, blood, and tears to go from concept to completion. After a grueling pre-production process and an even more taxing shoot, *Star Wars* opened in theaters on May 25, 1977, to critical acclaim and massive success. Made on a budget of $11 million, *Star Wars* went on to gross more than $450 million at the domestic box office, becoming the highest-grossing film of all time until it

was dethroned by *E.T. the Extra-Terrestrial*.[20] Financially, it was a success, particularly for Lucas, who negotiated ownership and licensing rights over the material and the production of sequels in exchange for taking a reduced writer's and director's fee. Culturally, it was unstoppable. *Star Wars* fever swept the land as ravenous fans watched the film repeatedly in theaters. Lucas managed to bottle lightning again with 1980's *The Empire Strikes Back* and 1983's *Return of the Jedi*, using the profits to build a filmmaking empire of his own on his ranch in Marin County, California.

Setting up Industrial Light & Magic (ILM) and Skywalker Sound, Lucasfilm was fast becoming a state-of-the-art, self-sustaining studio situated far, far away from Hollywood, which Lucas saw as a nest of snakes. Overlapping with the success of *Star Wars*, Lucas teamed up with his longtime friend and fellow filmmaker Steven Spielberg to develop an adventure series about a tough, sardonic archaeologist named Indiana Jones. Casting *Star Wars* antiheroic bad boy Harrison Ford in the title role, *Raiders of the Lost Ark* hit theaters in 1981, becoming an instant box-office hit and effectively launching another mammoth franchise. In the wake of *Star Wars'* and *Indiana Jones'* immediate and overwhelming success, Lucas stepped back from his directorial role, preferring to help develop the stories and serve as a hands-on producer on the sequels that followed both films.

Over the next decade, Lucas operated primarily as a producer and an executive producer on a plethora of projects. Among the most notable non-*Indiana Jones*/*Star Wars* projects in which Lucas produced were Akira Kurosawa's *Kagemusha* (1980), Lawrence Kasdan's *Body Heat* (1981), and Jim Henson's *Labyrinth* (1986). However, not everything went Lucas' way; *More American Graffiti* (1979) drastically underperformed and *Howard the Duck* (1986) was the biggest disaster of his career. In the mid-1990s, Lucas began plotting his return to the galaxy far,

far away by working on a screenplay for *Star Wars Episode I: The Phantom Menace.* When it was released in 1999, it was not only the first *Star Wars* story in 16 years, but the first film that Lucas had directed in nearly two decades. Though the prequels were generally less well received than the original saga, Lucas wrote and directed all three films, including 2002's *Attack of the Clones* and 2005's *Revenge of the Sith.* In spite of whatever protestations fans and critics lobbied, they still made obscene amounts of money at the box office, further lining Lucas' Scrooge McDuckian coffers.

"I like *Star Wars,* but I certainly never expected it would take over my life," Lucas reflected in a 2005 interview with *WIRED.* By that point, Lucas was done with *Revenge of the Sith,* and looking toward the future. Weary of the vast pop culture kingdom he created and looking to pass the torch to a new generation of filmmakers, Lucas embarked on a surreptitious quest to find a suitable successor. "I'm retiring," Lucas said at the premiere of 2012's *Red Tails.* "I'm moving away from the business, from the company, from all this kind of stuff."[21] After much searching, Lucas settled on Kathleen Kennedy, Spielberg's long-time producing partner and a sometimes creative collaborator. With Kennedy recruited to his side, Lucas secretly negotiated the sale of his vast movie-making empire to another entertainment juggernaut—Disney. On October 30, 2012, George Lucas made it official, signing the papers to sell Lucasfilm and its associated holdings to The Walt Disney Corporation for $4.05 billion, naming Kathleen Kennedy the new president of the company, and handing over the keys to the kingdom.[22]

From a technical standpoint, Lucas is equally laudable for his commitment to improving the technology and mechanisms of filmmaking. From Lucasfilm's computer graphics department emerged Pixar, who worked on films like *Star Trek II: The Wrath of Khan* before being purchased by Steve Jobs in 1986. In 1983, in order to help ensure *Return of the Jedi'*s sound quality would be

consistent across venues, Lucasfilm's Tomlinson Holman developed the THX audio/visual sound system that is widely used in movie theaters today. Even 1977's *Star Wars* yielded impressive technical achievements in the form of John Dykstra's Dykstraflex camera set-up, which enabled complex effects shots to be shot more fluidly than ever before. Honestly, the next time you go to see a special effects-driven movie, sit through the credits and there's a disproportionately large chance that you'll see an ILM logo or a Skywalker Sound seal.

Looking back at his legacy, Lucas has no difficulty processing why his films resonate across such a spectrum of viewers. "My films operate like silent movies," he explained in an interview. "The music and the visuals are where the story's being told. It's one of the reasons the films can be understood by such a wide range of age groups and cultural groups. I started out doing visual films—tone poems—and I move very much in that direction. I still have the actors doing their bit, and there's still dialog giving you key information. But if you don't have that information, it still works."[23] With his adherence to the archetypal qualities laid out by writers like Joseph Campbell and the fairytale quality to his work, particularly with *Star Wars*, cultural context becomes irrelevant; rather Lucas has crafted timeless tales of a galaxy far, far away that feel both futuristic and nostalgic all at once.

Famously hands-on and known for being a bit of a control freak, Lucas is now, for the first time, watching the production of *Star Wars Episode VII: The Force* Awakens and the subsequent sequels from the sidelines. And for once, that's okay, because now it's time for Lucas step aside, but his works—as this book will demonstrate—will continue to endure and thrive for many, many years to come.

Star Wars: A New Hope

A farm boy leaves his home to go on a grand adventure in the big city. That is the plot of the original 1977 *Star Wars* in a nutshell. Visually compelling though they may be, the lightsabers, X-wing fighters, and armor-clad villains are just window dressing for a classic story, a fairy tale writ large against a backdrop of intergalactic warfare. Growing up on a steady diet of sci-fi novels and serials like *Flash Gordon* and *Buck Rogers*, George Lucas combined his boyhood loves with his adult interests, like Akira Kurosawa's *The Hidden Fortress* and the independent cinema of the North Coast of California. Add in a dash of political commentary—Lucas, a self-confessed news junkie, wrote *Star Wars* as a damning indictment of the Nixon presidency and America's role in the Vietnam War—and you have the recipe for a nearly perfect viewing experience.

Yet though it was a project about which he was deeply passionate, writing the script was like pulling teeth for Lucas. He worked furiously on it for several years, working late into the night even while working on other projects. According to one story, Lucas would get so frustrated while writing the script that he would cut off his hair with a pair of scissors. "I came in one day and his wastebasket had tons of hair in it!" his secretary Lucy Wilson recalled. "It was driving him crazy."[24] Lucas kept second guessing himself and reimagining what the project should be about. At one point, he even considered making it a film with a cast consisting entirely of little people.[25] That isn't to say a cast full of vertically challenged actors couldn't make a compelling sci-fi story, but it would have been a different movie, to be sure.

There is a famous quote that is often attributed to Ernest Hemingway: "It is easy to write. Just sit in front of your typewriter and bleed." With *Star Wars*, Lucas didn't just bleed; he hemorrhaged like he was a member of the Russian royal family circa 1915. Lucas finished his first draft in May 1974. It would change remarkably in the days and months to come. After countless drafts and rewrites, additions and subtractions of characters, and changing naming conventions (e.g., Annikin Starkiller became Justin Valor who in turn became Luke Skywalker), filming commenced on March 22, 1976 in the desert of Tunisia, a stand-in for the planet Tatooine. George Lucas' swashbuckling story of swordfighters, princesses, and evil empires had proved to be far more complex than anyone could have anticipated. Though the story is simple in its premise, its execution was a fair sight more complicated. The shoot was fraught with difficulties, budgetary issues, and often-inhospitable conditions. Yet, Lucas and his crew persevered, blowing past their original Christmas 1976 release date to get the film into theaters for the summer of 1977.

Nineteen years after the formation of the Galactic Empire, the Death Star nears completion. Spies for the Rebel Alliance have scored their first major victory by stealing plans for the Death Star, a massive Imperial battle station capable of obliterating an entire planet with a single blast. With the plans in her possession, Princess Leia Organa attempts to elude capture aboard the *Tantive IV*. However, the evil Lord Darth Vader outpaces the Rebel craft, boarding the vessel with a detachment of Imperial stormtroopers. Although she is captured and interrogated by Vader, Leia manages to hide the plans within the astromech droid R2-D2's memory banks along with a holographic distress call: "Help me Obi-Wan Kenobi; you're my only hope." Together, R2-D2 and a golden protocol droid named C-3PO escape with their precious cargo on an escape pod, which makes a beeline for the desert planet of Tatooine.[26]

On the planet's surface, the droids are immediately captured by a tribe of scavenging aliens called Jawas. Taken back to the Jawas' mobile fortress (the Sandcrawler, for you completionists), the droids are sold to a pair of moisture farmers, Owen and Beru Lars, and their nephew, Luke Skywalker. Back at the Lars moisture farm, Luke uncovers a garbled, partial version of Leia's message while cleaning R2-D2. He wonders if the "Obi-Wan Kenobi" of the message could, in fact, be a man named Ben Kenobi, who lives nearby. Like most teenagers, Luke doesn't think about it too long, opting instead to go to bed. In the morning, Artoo manages to escape, initiating a subroutine to look for Obi-Wan Kenobi. Setting out into the desert to look for the astromech droid, Luke and C-3PO soon find themselves set upon by Tusken Raiders, a tribe of predatory bandits that live in the canyons of Tatooine. Before they can kill the poor boy, an elderly man appears and handily dispatches the assailants—it is the hermit "Old Ben" Kenobi, who then takes the boy to his home.

At Ben's house, the old hermit gives Luke a lightsaber that once belonged to the boy's father, reminiscing about how he used to be friends with him. He also tells Luke that his father was betrayed and murdered by a Jedi named Darth Vader. While cleaning the droids, they discover Leia's distress call, and Obi-Wan tries to convince Luke to accompany him to Alderaan to deliver the Death Star plans to the Rebels. Though reluctant at first, Luke discovers his aunt and uncle have been brutally slaughtered and burned alive by Imperial stormtroopers who were searching for the missing droids, compelling him to action. So, with Obi-Wan he heads to the spaceport of Mos Eisley, a dangerous place by anyone's measure, and one crawling with Imperial soldiers. "You will never find a more wretched hive of scum and villainy," Obi Wan warns the young Skywalker. "We must be cautious." We also get our first glimpse of Obi-Wan's Jedi powers as he seemingly hypnotizes an inquisitive stormtrooper

who recognizes the two droids traveling with him. "These aren't the droids you're looking for," Obi-Wan tells the soldier sternly with a wave of his hand. "These aren't the droids I'm looking for," the stormtrooper repeats in a dreamy haze.

In need of passage off the planet, Luke and Obi-Wan entreat with the smuggler Han Solo and his first mate, a massive Wookiee named Chewbacca. For a 17,000 credit fee, Han agrees to take them to Alderaan on his ship, the *Millennium Falcon*. Though it looks like a hunk of junk, it is the fastest ship in the galaxy. "She may not look like much," Solo cautions, "but she's got it where it counts, kid." Thankfully, Han is a man of his word, and the motley crew busts through the Imperial blockade surrounding the planet, charting a course for Alderaan. However, when they get to Alderaan, all they find is an asteroid field. In fact, the planet had been destroyed on the orders of a high-ranking Imperial officer, the Grand Moff Tarkin, to set an example for those who would rise up against the Empire. Making Princess Leia watch, Tarkin charges up the Death Star's superlaser and murders millions of innocent people on the planet's surface. To make matters worse for our heroes, the *Millennium Falcon* gets caught in the Death Star's tractor beam and pulled aboard the space station before it can escape.

With their ship trapped on the Death Star, the team decides to divide and conquer—Obi-Wan attempts to free the *Millennium Falcon* from the tractor beam, as Luke, Han, and Chewbacca venture into the space station to rescue Princess Leia, who is being held hostage on board. Disguised as stormtroopers, Han and Luke escort Chewbacca to Detention Block AA-23, claiming that he is a prisoner being transferred. Although the plan goes off without a hitch and they rescue Leia, there's just one problem: no one thought of an escape plan. Without thinking, Leia grabs a blaster and blows a hole in a nearby grate, into which they all dive. However, the grate leads to a garbage

The Kurosawa Connection

Lucas was deeply inspired by the works of Akira Kurosawa, particularly the 1958 film *The Hidden Fortress*, which is told from the point of view of two peasants, Tahei and Matashichi. The duo serves as comic relief while they travel across Japan in the company of a great general and a princess, bearing witness to the inner workings of high-level international diplomacy in spite of their low social standing. Lucas made R2-D2 and C-3PO serve as similar stand-ins for these characters. Even the editing style influenced Lucas' space fantasy. You know how *Star Wars* tends to wipe the screen to switch from one scene to another? Kurosawa did it first in *The Hidden Fortress*. As a more direct connection, Toshiro Mifune, who played the samurai general in *The Hidden Fortress*, was offered the part of Obi-Wan Kenobi. Hey, considering how well it worked for Sergio Leone in *A Fistful of Dollars*, running with Kurosawa characters is a pretty smart way to go.

Rinzler, J. W. *The Making of Star Wars: The Definitive Story behind the Original Film.* New York: Ballantine, 2007. p. 74. Print.

compactor that isn't just full of trash; it's also home to a dianoga, a tentacled beast that nearly kills our heroes. As if things weren't bad enough, the walls of the garbage compactor begin closing in on our heroes, threatening to squeeze them tighter than William Shatner in a girdle.

Thankfully, R2-D2 manages to disable the trash compactor before our characters are reduced to two dimensions. Hurrying back to the ship, they evade stormtroopers and prepare to make good their escape. Obi-Wan has successfully disabled the tractor beam, but one obstacle remains in their way: the nefarious Darth Vader. It was a battle that had been a long time coming as viewers would come to learn in later years. Luke, Han, Leia, and company were helpless to watch as Obi-Wan and Vader crossed lightsabers. Realizing what he had to do, Obi-Wan sacrificed his life, allowing Vader to kill him so the others could escape. Luke screams in agony as Obi-Wan is cut down before his eyes.

However, what Luke doesn't realize is that by sacrificing his life, Obi-Wan has become one with the Force. Grieving for his dead friend, Luke and the others escape on the *Millennium Falcon*, retreating to the Rebels' hidden base on Yavin 4.

A glimmer of hope awaits them at the Rebel Alliance's base of operations: their analysis of the Death Star's blueprints reveals a vulnerability—an exposed thermal exhaust port that leads to the station's main reactor. If they can attack it, they could potentially disable or destroy the station. With those impossible mission parameters in mind, they launch an all-out assault on the battlestation. Luke enlists in the Rebel army as an X-wing pilot for Red Squadron, but Han tells Luke that he's going to leave because the terms of their contract are up. "May the Force be with you," the Rebel General Dodonna tells the pilots before they head off to battle. During the attack, the Rebels incur heavy losses, with much of Luke's squadron dying in fiery, laser-fueled explosions. Still, Luke and the surviving pilots press on, flying into the Death Star trench for a suicide run.

Flying low past the autoturrets, Luke and the remaining members of Red Squadron find themselves tailed by a squadron of Imperial TIE Fighters led by Darth Vader himself. Though pilots are falling left and right, Luke screams up the Death Star's trench, making a run toward the exhaust port. Maneuvering behind Luke in his TIE Advanced Fighter, Darth Vader is about to open fire on him when suddenly the *Millennium Falcon* appears. Under an intense barrage of fire from the *Millennium Falcon*, Vader is forced to peel off out of the trench. As Luke speeds through the trench, he hears Obi-Wan Kenobi's voice telling him to use the Force, a request that he happily obliges. Trusting his feelings and letting the Force guide his aim, Luke makes a seemingly impossible shot, firing a proton torpedo into the exposed exhaust port, causing the Death Star to explode in a nova of steel and fire.

Back on Yavin 4, the survivors celebrate their victory over the Empire. With much fanfare, Princess Leia awards Han Solo and Luke Skywalker medals for their bravery and their service to the Rebel Alliance. Though Chewbacca isn't actually awarded a medal in the original film, he does get the distinct privilege of having the last line with his signature guttural yawp. (To be fair, in the novelization of the film, Chewbacca gets a medal too.) The day was won, but the war—as future audiences would learn—was just beginning.[27]

In spite of the film's small-scale release on May 25, 1977, it did gangbusters at the box office leading into Memorial Day weekend. The final product was unlike anything audiences had seen up to that point, an effects-driven slice of space fantasy with characters that were primordial in their archetypes, but hyper-specific in their portrayals. The "used universe" aesthetic of Ralph McQuarrie's entrancing concept art came to life on the big screen, invigorated by groundbreaking special effects from John Dykstra and the newly minted team at Industrial Light & Magic. What Lucas and company made on a relative shoestring budget of $11 million made $1.5 million in its opening weekend, and $775.3 million worldwide over the course of its theatrical run.[28]

Of all the things to come out of *Star Wars*, the most fascinating and the most frequently debated was the Force, this cosmic energy that binds all living things together. Fans argued endlessly about its true meaning and projected their own ideas and theories onto the film in the wake of its release. But that's part of the beauty of it. "I asked him about the origin of the idea, and he said it's in about 450 old science fiction novels," Mark Hamill said in a 1983 interview. "He's the first to admit it's not an original concept. It's nice how George presented the idea so everyone can get as much or as little out of it as they want. Some see it as a very religious thing."[29]

Moreover, *Star Wars* wasn't just a launching point for theological and philosophical debate amongst superfans. Rather, it was the beginning of a pop cultural phenomenon the likes of which have only been rivaled a scant few times in modern history. From the childhood fantasies of George Lucas had sprung a sprawling universe, one that would stand the test of time even some 35-odd years later. After all, it's *Star Wars*, not *Star War*— making only one would be just plain cruel.

4 The Empire Strikes Back

Quick. Stop what you're doing, go outside, and grab the first person you see. Ask them, "What is the greatest cinematic sequel of all time?" There's a preternaturally high chance that they will say, "*The Empire Strikes Back.*" (Note: you may also hear answers like "*Aliens,*" "*The Godfather Part II,*" and "Oh god, who are you, please don't hurt me.") Riding high on the success of 1977's *Star Wars*, George Lucas and his Lucasfilm cohorts were faced with the unenviable task of following up a film that had conquered hearts, minds, and box offices the world over. They had a backup plan in the form of Alan Dean Foster's *Splinter of the Mind's Eye*, a *Star Wars* novel he had penned under the auspices of writing a story that could serve as a low-budget sequel for *Star Wars* if the original had tanked. But, *Star Wars* didn't tank, and no one was more surprised by that fact than the people who made it.

For George Lucas, it didn't quite hit home until he went to go see the film at a movie theater in San Francisco with his friend and mentor Francis Ford Coppola. Even then, it was more of a quiet bemusement than anything else. "That was probably

the first time I saw it with a real audience," Lucas reflected. "It was enjoyable, but the thing of it is, by the time you get that far down on a movie, you're so numb and tired and so emotionally involved that it's very hard to get excited. You feel good, but it's a very quiet kind of thing."[30]

It was a slightly more raucous affair for Mark Hamill, who freely admitted to enjoying the perks that came with success. "*Star Wars* tumbled out in the summer of 1977 and just went cuckoo," said Hamill, who portrayed Luke Skywalker. "It was like the hula-hoop or Beatles rages. After the film came out, I broke up with my girlfriend for a while. I was like a kid in a candy store. *Gee! All these groupies.* I don't feel I dealt with that very successfully."[31]

Alec Guinness, who played Obi-Wan Kenobi, was a little less crass about the runaway freight train that was *Star Wars*. "Failure has a thousand explanations," he said matter-of-factly. "Success doesn't need one."[32]

While that's all well and good to say, the executives at 20th Century Fox wanted an explanation for that success if for no other reason than so they could recreate it in a sequel film. The nature of George Lucas' initial contract meant that they were going to do a sequel anyway, but doing a sequel to one of the most successful films of all time was another matter entirely.

The Empire Strikes Back fast-forwards the action to three years after the destruction of the Death Star. The Rebel Alliance has been pushed back from their base on Yavin IV, forced to seek refuge on the frozen planet of Hoth, where Princess Leia leads a seemingly bolstered division of the Rebel Alliance, with Han Solo and Luke Skywalker by her side. When Luke goes to investigate a mysterious crash site, he discovers an Imperial probe droid sent by Darth Vader, but before he can report it, a Yeti-like creature called the wampa attacks him. As Han Solo searches for his missing friend, Luke manages to free himself by

using his lightsaber, but succumbs to hypothermia. While in his cold weather-induced fugue state, Luke experiences a vision of his deceased mentor Obi-Wan Kenobi, who impels him to seek out the Jedi Master Yoda on the planet Dagobah. Before Luke freezes to death, Han Solo finds him, using Luke's lightsaber to cut open his recently deceased mount, a tauntaun, to use as shelter. "I thought they smelled bad on the outside," Han snarls in disgust as he pries open the animal's entrails to provide his friend with life-giving warmth.[33]

Much like Luke's core body temperature, things are heating up for the Rebel Alliance too as the Imperial fleet launches a massive assault on the Rebels at Echo Base. With towering AT-AT Walkers stomping across the snowy plains and a detachment of cold-weather warriors called snowtroopers, the Battle of Hoth rages on. Though the Rebels put up a good fight, they are overwhelmed by the Imperial army and forced to abandon the base. Clambering aboard the *Millennium Falcon*, Leia, Han, Chewbacca, and C-3PO make good their escape, and all seems to be going well until the hyperspace drive malfunctions and leaves them stranded in an asteroid field. Of course, while they're stranded, the sparks aren't just flying off of the hyperspace drive that is being repaired; they're also flying between Han and Leia, who are growing closer together.

Meanwhile, Luke follows Obi-Wan's advice from beyond the pale, charting a course for Dagobah in his X-wing with R2-D2 in tow. After crash-landing his X-wing in a swamp on the foggy, marsh-filled world, Luke encounters a mysterious diminutive green creature who taunts him and offers to take him to see Yoda. "Not far, Yoda is, not far," the precocious little creature assures him. Of course, as it turns out, the little green man was Yoda all along, teasing the young Skywalker all the while. After much deliberation, Yoda relents and agrees to train Luke in the ways of

the Jedi. Dagobah is a planet with an immense connection to the Force, which makes it ideal for such training.

During one exercise, Yoda sends Luke into a dark, mysterious cave where he encounters Darth Vader waiting inside. The two cross lightsabers, but Luke manages to overpower the Sith Lord, decapitating him. When he removes Vader's mask, however, Luke sees his own face underneath. Shocked and appalled, Luke realizes he had been experiencing an intense vision, and none of it was real. Moreover, it is a sign that if he cannot learn to control his emotions, he is destined—or doomed—to succumb to the dark side, following in Vader's footsteps. Though he makes progress, Luke still suffers from the impetuousness and recklessness of youth, which makes him impatient. Unable to lift his X-wing from the swamp in which it is submerged, Luke gets frustrated and loses hope, declaring that he'll never get the ship out. When Yoda tells him it is, in fact, possible, Luke says he'll try. "No!" Yoda admonishes his student. "Do or do not, there is no try."[34]

After training extensively with Yoda, Luke experiences another vision, this one more vivid and more disturbing than before; he foresees his friends in grave danger and immense pain, and wants to leave Dagobah to save them. Both Yoda and the astral projection of Obi-Wan Kenobi tell him leaving will be disastrous and could undo everything he has worked for, but the headstrong young Jedi ignores his Masters, taking off to track down his friends. Disappointed, Yoda admonishes Luke for being reckless. Obi-Wan tells his old friend to have faith because Luke is the Jedi's last hope for survival. However, Yoda cryptically retorts, "There is another…." Of course, series fans know exactly who that "another" is, but at the time it was one hell of a teaser.

Back on the *Millennium Falcon*, Han's crew arrives at the floating mining colony of Cloud City, where they're welcomed by his old friend, the smooth-talking, blue-caped slickster Lando Calrissian. Unbeknownst to Han and Leia, Darth Vader has

sicced a squadron of deadly bounty hunters on them, and one among their number, the jet pack-clad Mandalorian mercenary Boba Fett, has been tracking them all along. Let this be a lesson to you: always check your rearview mirrors because you never know what crazies could be hot on your tail.

Shortly after arriving at Cloud City, though, Lando hands our heroes over to Darth Vader and Boba Fett, who coerced him into betraying his friends under pain of death. In spite of Lando's protestations, Vader insists on using his new captives as bait to lay a trap for Luke Skywalker, and proceeds to torture Han Solo. Originally, Vader was supposed to let Han go, but now he tells Lando that he is altering their deal and will hand over the smuggler to Boba Fett, who is looking to redeem the massive bounty on the Corellian captain's head. Vader intends to capture the young Jedi warrior by freezing him in carbonite, placing him in suspended animation. As part of the Empire's rigorous quality assurance program, Vader decides to test it out beforehand using Han Solo as his guinea pig, ignoring Boba Fett's protestations over how it might damage his merchandise. Before Han is put into the chamber, Leia and he share a tender moment. "I love you," she finally tells the scoundrel. "I know," he shoots back, without missing a beat. With that, Han is frozen solid in a block of carbonite, his face and hands gnarled in fear and anguish like a morbid statue.

As Boba Fett hauls Han Solo away, intending to take him to Jabba the Hutt back on Tatooine, Darth Vader betrays Lando one more time, ordering Leia and Chewbacca to be taken into custody. Unable to live with what he's done, Lando springs Leia and Chewbacca free. Though they make a last-ditch effort to save Han Solo, Boba Fett is one step ahead of them, blasting off with the smuggler on his ship, *Slave I*. Meanwhile, Luke finally arrives at Cloud City, walking right into Vader's trap. The two square off in a tense lightsaber duel, battling back and forth across the

city's central air shaft. As the battle rages on down below, R2-D2 reunites with his companion C-3PO, and together they pile into the *Millennium Falcon* with the rest of the group, escaping Cloud City sans Solo, and plotting their next move. Back down below Cloud City, Darth Vader manages to disarm Luke Skywalker quite literally, cutting off his right hand, which falls into a nearby air shaft along with the lightsaber it was holding. What follows is perhaps one of the single most iconic moments in modern cinema:

> **VADER:** The Force runs strong in the Skywalker line, you must use the dark side. Together we would be the most powerful. Stronger with the Force than even the Emperor.
> **LUKE:** Never will I join with you.
> **VADER:** We will rule the galaxy as father and son.
> **LUKE:** What?
> **VADER:** Old Kenobi never told you what happened to your father, did he?
> **LUKE:** Enough! He said you killed him.
> **VADER:** I am your father.
> **LUKE:** That's impossible. It's not true.
> **VADER:** Search your feelings; you already know it to be true. Join me.[35]

Talk about a megaton bomb of a plot twist! Luke Skywalker's face twists into an ugly gnarl as he lets loose a horrified, doleful scream. His father was not, in fact, murdered by Darth Vader; he *is* Darth Vader, which is worse by a factor of at least 10. Refusing Vader's offer, Luke chooses death over descending into the dark side with his diabolical dad. Throwing himself into the air shaft, Luke plummets to what he presumes will be his death, only to catch himself on an antenna on the bottom of the city. Hopeless, hapless, and all alone, Luke calls out through the

Force, desperately trying to reach Obi-Wan Kenobi. In abject despair, he calls out to the only other person he can think of who might be able to help: Princess Leia.[36]

It's a good thing he did, too. Somehow, Leia telepathically senses that Luke is in trouble, and turns the *Millennium Falcon* around. As TIE Fighters scramble, hurtling toward the *Falcon*, Leia and company manage to catch Luke in an escape hatch. Proving his miniature mettle once again, R2-D2 repairs the ship's hyperdrive system, allowing the *Falcon* to blast off into hyperspace before the Imperial forces can stop them. Later, aboard a Rebel medical ship, Luke undergoes surgery to have a robotic prosthetic hand installed on his cauterized stump. Lando and Chewie take off in the *Millennium Falcon* to find a way to rescue Han Solo, while the rest of our heroes sadly watch them depart. It is their darkest chapter yet, a bitter defeat for our heroes, and grim reversal of the joyous closing moments of *A New Hope*.

The future was uncertain for our heroes in the galaxy far, far away, but the film was a runaway success. Although it received mixed reviews at the time of initial release, *The Empire Strikes Back* has widely come to be regarded as the best film in the franchise. With an $18 million budget (a 50 percent increase over the first movie), the film went on to make $538.3 million globally, certifying it as a smash hit. Even so, this was by no means a relaxed production for Lucas. In order to ensure creative control, he poured a great deal of his personal fortune into the film, but even the financial windfall he'd received from *Star Wars* wasn't enough. Forced to take out a bank loan, Lucas' personal finances were intimately tied up in the production, which was over-budget, behind schedule, and being filmed in London, thousands of miles away from his home.[37] If the film was anything less than a success, the prince of pop culture would be reduced to a pauper.

Perhaps the film's success was due to an influx of new creative blood behind the scenes; last time, Lucas had labored for

four long years on the script for *A New Hope*, then directed the film himself. Though he had creative input, it was largely Lucas executing his creative vision on a grand scale. However, Lucas has always been quick to admit that he has no knack for the minutiae of storytelling. This time around, Lucas knew that he needed to ensure that the story hit all the appropriate emotional beats that the sequel demanded. He neither directed nor wrote the screenplay this time around; rather he opted to serve as producer (a very hands-on producer, at that). To direct the film, he courted Irvin Kershner, a man who had no real experience with science fiction, but immediately resonated with the film's Buddhist undertones. Although Kershner's directorial style, which allowed for actors to improvise and alter lines, was at odds with Lucas' style of moving as quickly as possible and rubbed Lucas the wrong way, its results were undeniable. According to stories, Han Solo's most famous two-word response, "I know," was improvised after doing many, many takes of the scene on a swelteringly hot set.[38]

To handle writing duties, Lucas tapped Leigh Brackett to pen the screenplay, an experienced science fiction author and screenwriter who had penned films for Robert Altman and Alfred Hitchcock, as well as Howard Hawks' films like *The Big Sleep*, *Rio Bravo*, and *El Dorado*. As per his tradition, Lucas wrote the first draft himself, holding a series of story conferences with Brackett, and producing a finished, handwritten version in November 1977. Bracket then took that as a jumping-off point and wrote a draft of her own, based on those early story conference notes. The draft wasn't quite what they were looking for, but Brackett had become terminally ill and passed away during pre-production. To replace her, Lucas brought in Lawrence Kasdan, a hotshot young screenwriter who was set to write *Indiana Jones and the Raiders of the Lost Ark* for Steven Spielberg and him.

"Leigh had written something that was of a different era," Kasdan said in an interview. "She hadn't quite gotten what it

is about George, all the ways in which *Star Wars* revolutionized these kinds of movies."[39] Kasdan, however, was able to speak Lucas' language, figuring out exactly what the fickle forefather wanted. Which was what, exactly? Well, in his own words:

"[With *The Empire Strikes Back*] I wanted to do something that was a little bit more grown-up in terms of the entertainment value, which meant more realistic and more of a fear factor," Lucas said. "But the genre has a range that you're allowed to work in. I try to work in that range while pushing the parameters a little bit to see what I can actually get away with. Still, I was very adamant that it be one movie, that both films have the same sensibility."[40]

With Han Solo frozen in carbonite and possibly dead, Luke Skywalker losing a hand and gaining a frightful father, and C-3PO literally being torn asunder, there was definitely "more of a fear factor," for what it's worth. Finishing 1980 as the undisputed champion of the box office, and earning more than double the number two film of the year, *Kramer vs. Kramer*, it would seem that Lucas' mission to showcase a darker side of the galaxy far, far away was an undisputed success. Moreover, the film's triumph helped ensure not only the success of *Star Wars*, but the continued success and expansion of Lucasfilm and ILM. Of course, the fact remained that *The Empire Strikes Back* was the second chapter in what was so clearly a story that warranted three chapters. Audiences knew it too, and eagerly waited for three long years for *Return of the Jedi* to be released.

Return of the Jedi

If the pressure was on between *Star Wars* and *The Empire Strikes Back*, it must have been approaching Defcon 1 for Lucas and company as they geared up for 1983's *Return of the Jedi*. In the wake of the exceedingly successful *The Empire Strikes Back*, all eyes were on Lucas to see how his swashbuckling space fantasy would conclude. With a relatively new director in Richard Marquand, the departure of longtime series producer Gary Kurtz, and the unenviable duty of wrapping up the biggest storyline in modern popular culture, Lucasfilm had its work cut out. As J.W. Rinzler wrote in his comprehensive history *The Making of Star Wars: Return of the Jedi*, "With *Return of the Jedi*, the end, victory, was in sight; yet the bittersweet taste of finality was tangible, and those who had endured nearly a decade of frenzied activity had to weigh the psychic cost against their laurels."[41] Indeed, this film couldn't just be a victory lap for Lucas. There were too many loose ends to wrap up and too many eyes on him. He absolutely needed to stick the landing.

After *Empire* went over-budget and behind schedule, Lucas wanted to exercise tighter creative control over the finale to his little space fantasy. To begin, he replaced producer Gary Kurtz, who departed partway through *Empire Strikes Back,* with one of his old USC colleagues, Howard Kazanjian. Having felt like *Empire* was more Irvin Kershner's movie than his own, he brought in a young director that he could keep under heel— Richard Marquand. Per usual, Lucas wrote the first draft of the script himself, but to polish the product into something work-able, he called upon Lawrence Kasdan once more. At the time, Kasdan seemed reluctant to return. After the success of *Empire*

Strikes Back and *Raiders of the Lost Ark*, he had moved on to writing and directing his own projects. He had already written and directed *Body Heat*—which Lucas produced—and was about to direct *The Big Chill* when he got the call from Lucas. As a favor to the man who had kickstarted his career time and time again, he obliged.

In a series of story conferences, Lucas, Kasdan, Marquand, and producer Howard Kazanjian met for hours and hours each day, beating out the story, refining plot points, and turning their script from a lump of coal into an intergalactic diamond. From January 11, 1982, until May 20, 1982, the production filmed at a variety of locations in California's Redwood National Park, Arizona's Yuma Desert, and the United Kingdom's Elstree Studios. It was a production schedule six weeks shorter than *The Empire Strikes Back*, pushing through filming at a breakneck speed to maximize the amount of time ILM would have to work on the special effects. In a testament to Lucas' pioneer sensibilities, Kazanjian estimated that using an outside company to handle the film's production would cost $50 million. By using ILM, they were able to save nearly $18 million as the film only cost a cool $32.5 million. However their coffers weren't the only thing that needed saving; so, too, did the universe.

After ending on a bit of a down note, with Han Solo frozen in carbonite and carted off to Jabba the Hutt's Tatooine palace, *Return of the Jedi* opened on something of a hopeful one. Disguised as a bounty hunter named Boushh, Leia infiltrates Jabba's palace, marching Chewbacca in there as her prisoner. To his credit, Lando Calrissian is already inside, undercover as a guard, to boot. Though Leia is able to seize a moment of opportunity to free Han from the carbonite, she's captured shortly thereafter and made to wear the now-infamous gold-metal bikini. Luke Skywalker, now a Jedi knight, arrives and attempts to barter with Jabba for his friends' lives, but Jabba will have none of it.

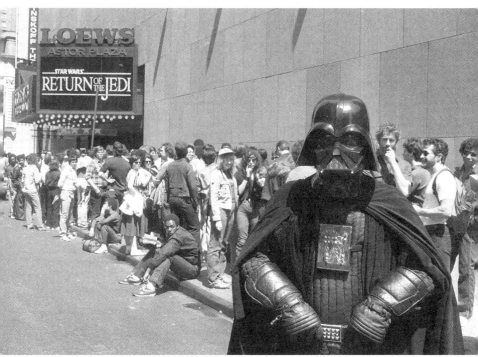

Fan Danny Fitzgerald of Staten Island, in Darth Vader costume, poses in front of Loews Astor Plaza in Times Square on May 25, 1983, where fans lined up for the premiere of Return of the Jedi. (Dave Pickoff)

Jabba is upset after Luke defeats his monstrous Rancor, and so takes his new guests out to the desert wastes of Tatooine on his pleasure barge. There he sentences Han, Luke, and Chewbacca to death by slow, thousand-year digestion in the Sarlacc pit. However, before any "justice" can be served, the true escape plan commences, with R2-D2 shooting Luke's lightsaber across to him, where he uses it to fight off Jabba's men and free his friends.

In the ensuing melee, Han Solo—still blind as a bat, a side effect of the unfreezing process—accidentally hits Boba Fett on his jetpack with a long pole, sending the badass bounty hunter careening into the Sarlacc pit too. Leia, however, knows

exactly what she's doing when she uses the chain tying her to Jabba the Hutt to strangle the miserable bastard. With the gang back together again, they leave the desert planet with Han and Leia heading to meet the Rebel Alliance on their flagship, and Luke making a trip to Dagobah to resume training with Yoda. Unfortunately, when Luke arrives, he learns that Yoda is dying, his body ready to return to the Force. In his dying breaths, Yoda confirms to Luke that Darth Vader used to be Luke's father and that there is, in fact, another Skywalker out there: his twin sister Leia! That's right, suddenly any sexual tensions between the two in *A New Hope* and *Empire Strikes Back* feels really uncomfortable.

History, as they say, is cyclical and nowhere is that more evident than in *Return of the Jedi*. Once again, the Empire is constructing a version of the Death Star, a supermassive, moon-size space station capable of obliterating planets in a single shot. In a bid to destroy the new machine, which is protected by an impenetrable force field, Han Solo leads a strike team to destroy the Death Star's shield generators on the surface of the forest moon of Endor. On the planet's surface, Luke, Han, Leia, and the others discover a primitive tribe of teddy bear-esque creatures called Ewoks. Cute, cuddly, and more than a little deadly, the Ewoks' decision to fight alongside the Rebel Alliance against the Imperial forces on the planet's surface probably tipped the scales in the favor of our heroes in a major way. Don't let their relative adorableness fool you; Ewoks are ruthless killers. In one scene, they're actually using stormtrooper heads/helmets for drums.

With the shields taken offline, it is up to Luke to venture aboard the Death Star and settle things once and for all with his father, and the evil Emperor Palpatine. Before departing, Luke lets Leia know about their special sibling relationship, telling her that he is heading off to fight their father—which is a pretty crazy sentence now that I am reading this back. Aboard the Death Star, Darth Vader entreats his son to join the dark side.

Emperor Palpatine implores Luke to give in to his base emotions and desires, to let his anger fuel him and to lash out against his father. A frantic fight follows with the Sith Lord and the Jedi Knight coming to blows, crossing lightsabers, and dodging a flurry of attacks. Finally, Luke overpowers Vader, cutting off his sword hand and disarming the Sith. Palpatine gleefully cackles for Luke to deal the killing blow, but Luke refuses, throwing away his lightsaber.

Infuriated by Luke's unwillingness to murder his own father and give himself over to the dark side, Palpatine flies into a rage, unleashing a barrage of Force lightning on Luke. Slowly dealing more and more damage to the boy, Palpatine shows no signs of stopping this torture. Calling out to his father, Luke asks for help, and just as Palpatine is about to kill the young Jedi, Darth Vader rises up, having made his choice. This time, Vader chooses compassion, opting to save one of the last vestiges of his humanity rather than the man who brought out the worst parts of him. The seditious Sith lifts Palpatine over his head, hurling the decrepit degenerate into a chasm, presumably leading to the reactor core. We didn't *see* the body, but let's just say that it did *not* look good for old Sheev Palpatine. Of course, there's a whole Expanded Universe storyline involving Palpatine returning in the form of a bunch of evil clones, so maybe there's still more story to be mined there.

Though he redeemed himself in his final moments, Vader is mortally wounded and not long for this world. Taking off his helmet, Vader—played here by Sebastian Shaw—looks at his son with his own eyes—not Lord Vader's—before passing away. As Darth Vader, he did many, many reprehensible things. As Anakin Skywalker, though, he earned a modicum of redemption, fulfilling the prophecy of the Chosen One who would bring balance to the Force, and giving his own life to save his son's. With that, Darth Vader dies, fading away to become one with the

Blue Harvest

When it came time to make *Return of the Jedi*, secrecy was of paramount concern. In order to keep curious fans and scoop-hungry journalists off their scent, the movie filmed under the production name of *Blue Harvest*, a fake horror movie with the tagline "Horror Beyond Imagination." The ruse didn't stop there either, according to director Richard Marquand. "We devised a complete movie, which was in fact *Blue Harvest*," Marquand said. "It would start with Carrie Fisher in her slave girl costume lying asleep in her trailer. We said, 'Why not put a ghost in it?' George was going to write a five-page screenplay, I'd shoot it in a couple of days, and it would be 'Horror Beyond Imagination.' The story would have had dune buggies coming over the hills and invading the trailers, with nothing around them but graves and werewolves. We were seriously going to do it." Hey, if Roger Corman can shoot a feature film in two days, why not *Blue Harvest* too?

Anders, Charlie Jane. "10 Things You Probably Didn't Know About Star Wars: Return of the Jedi." Io9. Gawker Media, 25 Sept. 2013. Web. 18 May 2015.

Force. While this has been going on, of course, a heated dogfight has been raging outside the supermassive space station.

Led by Lando Calrissian in the *Millennium Falcon*, the full might of the Rebel Alliance armada was unleashed upon the orbital battlestation, which Palpatine revealed to be fully operational in spite of its half-finished appearance. Screaming into the Death Star's main reactor, an array of well-timed concussion missiles and proton torpedoes from the *Millennium Falcon* cause the reactor to collapse, initiating a chain reaction that causes the station to self-destruct. Luke manages to escape the station on an Imperial shuttle mere moments before the Death Star II explodes in a massive, fiery wreckage. Back on Endor, the Rebels celebrate with their new Ewok friends. The Empire has well and truly been defeated, and the day, it would seem, has been saved for now. As the celebration roars on into the night, Luke sees the ghosts of

Obi-Wan, Yoda, and the vindicated Anakin Skywalker watching over them and smiling. At long last, balance has been restored to the Force, and the galaxy—much like George Lucas—can breathe a much-needed sigh of relief.

Return of the Jedi premiered to mostly positive reviews, with many critics at the time rating it higher in their estimation than *Empire Strikes Back.* As time has gone on, though, many fans and critics consider it to be the weakest of the original trilogy, with many complaining about the Ewoks, deriding them as being too childish. The teddy bear-like aliens were one of the first instances of a rift appearing between older fans, who had grown up with the films, and younger fans, who were catching up with them. Oh, if they only knew what was coming for them in 1999's *The Phantom Menace.* Soon they would long for the halcyon days of Wicket and friends hurling rocks at unsuspecting stormtroopers.

An article in *Variety*, a major Hollywood entertainment industry paper, summed up the situation rather nicely. "There is good news, bad news, and no news about *Return of the Jedi*," wrote *Variety.* "The good news is that George Lucas and company have perfected the technical magic to a point where almost anything and everything—no matter how bizarre—is believable. The bad news is the human dramatic dimensions have been sorely sacrificed. The no news is the picture will take in millions regardless of the pluses and minuses."

And take in millions it most certainly did. In spite of its $32.5 million budget, *Return of the Jedi* raked in $23 million on its opening weekend, grossing $252.5 million during its initial domestic run, and $475.1 million globally over the course of its lifetime. With its plethora of action set pieces, like the speeder bike chase on Endor and the Sarlacc pit battle scene, the *Star Wars* faithful found plenty of reasons to watch the film again and again and again.

On Lucas' personal calendar, his executive assistant Jane Bay had labeled August 1, 1983, as the day George Lucas would retire. Of course, that was far from what would actually happen, but Lucas was finally seeing the light at the end of the tunnel, now that *Return of the Jedi* was in his rearview mirror.

"I feel as if this huge weight has been lifted off my shoulders," he said. "It's going to take a while for me to come down from where I've been. I'm taking two years off, definitely, and will not do anything except raise my daughter. I will get my personal life straightened out, get my mind and body in a better place, and then see what I want to do. I want to go back to driving race-cars—whatever. Suddenly, my life is going to be mine. It's not going to be owned by Luke Skywalker and his friends."[42]

Of course, beginning in 1994, a different Skywalker would take over Lucas' life for the next decade, one by the name of Anakin....

6 The Phantom Menace

The year was 1999 and excitement was at a fever pitch. Eager fans skipped out on school, called in sick to work, and waited in lines that stretched down the block and around the corner. Only one thing could have elicited such a fanatical response: *Star Wars*. This was the premiere of *Star Wars Episode I: The Phantom Menace*, the first official feature film entry in the *Star Wars* canon in 16 years. Taking place 32 years before the events of *Star Wars Episode IV: A New Hope*, the film launched Lucas' prequel trilogy and grossed more than $924 million worldwide, in spite of mixed critical reaction. And yes, it also unleashed Jar Jar Binks upon an

unsuspecting public, but every good story needs a villain, after all. (What? He's not the bad guy?)

For a long time, it seemed like George Lucas would never make the prequels; the filmmaker spent so much time waffling back and forth that fans had no idea what to expect. However, in the early '90s he changed his mind, partly out of a desire to write and direct films again, partly out of a desire to revisit the world of *Star Wars* with greatly improved filmmaking technology, and partly due to a need to recoup financial losses following a bitter divorce from Marcia Lucas. Of the three prequel films, *The Phantom Menace* proved most strenuous for Lucas to write, given the constantly changing and evolving plot line.

"In writing *Episode I*, I spent a lot of time doing research," Lucas said. "I had to develop an entire world. I had to make a lot of decisions about things that would affect the next two movies, as well as this movie. Everything had to be laid out in this script so that the next two scripts would follow as they should. I also had to play this script against three movies that had already been made, making sure that everything was consistent and that I hadn't forgotten anything. There was a tremendous amount of minutiae in these movies that I had to consider."[43]

That feeling of being burdened by the weight of canon is one that would remain with Lucas for the duration of his time working on *Star Wars*, but such is the price one pays for creating a vibrant, living, breathing world. Dusting off some binders and old notes scrawled twenty years earlier, Lucas wrote the script working from a seven-to-twelve page outline (the account varies) with character descriptions and loose plot points. For a long time, Lucas considered making the prequel trilogy about the "young days of Ben Kenobi," but as he ruminated on the narrative, he realized that Anakin Skywalker's story—that of a promising, talented young Jedi manipulated by an evil force into succumbing to the dark side—was far more tragic and narratively

compelling.[44] With that thought in mind, Lucas now had a throughline that would not only sustain him through the prequel trilogy, but connect these new films to the original saga as well.

The basic plot of the film is as follows: Tensions are running high between the Galactic Republic and the Trade Federation. Two Jedi, Qui-Gon Jinn (Liam Neeson) and Obi-Wan Kenobi (Ewan McGregor) are dispatched to negotiate a peace with the Trade Federation, who are secretly taking orders from Darth Sidious and invade Naboo at the behest of the Sith Lord. The Jedi find that there were no negotiations at all; rather, it was all a pretext for an invasion of Naboo. They barely escape with their lives, making it off the ship and crashing down to Naboo's surface. On the planet's surface, Qui-Gon Jinn saves the Gungan outcast Jar Jar Binks from certain death, and along with the bumbling Gungan, they rescue the ruler of the Naboo people, Queen Padmé Amidala (Natalie Portman), and escape the planet, hurtling past the Federation blockade.[45]

Forced to land for repairs on Tatooine, the group makes their way to the spaceport of Mos Espa in search of replacement parts to fix the ship's hyperdrive. In a junk shop, they encounter a nine-year-old slave boy named Anakin Skywalker, who just so happens to be a skilled engineer—to wit, he created his own protocol droid named C-3PO—and a talented podracer pilot. Moreover, he is highly sensitive to the Force, leading Qui-Gon to believe that he may be the "Chosen One" from an ancient Jedi prophecy predicting the rise of a Jedi who will bring balance to the Force. Hedging his bet, Qui-Gon wagers Anakin's freedom in a podrace. Anakin drives as fast and as furiously as possible, and manages to win, intending to leave Tatooine—and his mother Shmi—to train as a Jedi. However, before they can escape, a mysterious shrouded figure appears, attacking the group with a lightsaber. Qui-Gon beats him back, and they manage to escape, but the Jedi is deeply troubled, believing that this could mean

that the Sith, the ancient religious order of followers of the dark side of the Force, have returned.

Returning to the planet Coruscant, home to the Galactic Senate and the Jedi Council, Qui-Gon informs the Council of his concerns over the Sith's return, and that he wants Anakin to train as a Jedi. However, his concerns are largely dismissed and they outright refuse to train Anakin, citing that his emotions cloud his judgment and he is susceptible to being ruled by fear. While this is happening, Queen Amidala meets with her close confidante, fellow Naboo Senator Sheev Palpatine, who advises her to call for a Vote of No Confidence in Supreme Chancellor Valorum in order to stamp out corruption in the Senate. Though she pushes for the vote, she grows frustrated with the Senate's perceived inaction, and opts to return to Naboo with the Jedi.

Back on Naboo, Queen Amidala entreats the water-dwelling Gungan people to enter into an alliance against the Trade Federation, in spite of the fact that Jar Jar Binks has been on screen literally the entire time. What follows is an epic battle as the Naboo and Gungan people—led by Jar Jar—fight back against the droid army. While this is happening, Amidala hunts down the Trade Federation leader, Nute Gunray, and eventually captures him. While skulking about in a starship hangar, Anakin and the astromech droid R2-D2 accidentally activate the autopilot function in a nearby starfighter and inadvertently join the battle against the Federation control ship, destroying it and, in turn, deactivating the droid army doing battle on the planet's surface.[46]

Meanwhile, back on Naboo, Obi-Wan and Qui-Gon realize that the mysterious shrouded figure is waiting for them with the intent of killing them and capturing Queen Amidala. To make matters worse, the figure is none other than the Sith warrior Darth Maul, the apprentice of Darth Sidious. Wielding a double-bladed red lightsaber, Maul enters into a savage duel with the two Jedi.

Qui-Gon is mortally wounded and Obi-Wan seems like he is about to fall to his death when suddenly the Jedi flips through the air over Darth Maul's head, cuts the Sith warrior in half with Qui-Gon's lightsaber, and sends the villain hurtling down a chasm to the planet's core. With his dying breath, Qui-Gon asks Obi-Wan to train Anakin as a Jedi. Though the battle is won, everything has changed: Qui-Gon is dead, Nute Gunray is arrested for his crimes, and Palpatine is named the new Supreme Chancellor. The Jedi Council too has a change of heart, reluctantly deciding to honor Qui-Gon's dying wish by anointing Obi-Wan as a full-fledged Jedi Knight and making Anakin his Padawan.[47]

It's a simple enough plot, right? A failed invasion reveals the return of a potentially larger galactic threat. Yet, the way in which Lucas deployed it came across as convoluted to some viewers (which, to be fair, is often the charm of the *Star Wars* universe). Largely, it didn't matter, as NPR film critic Elvis Mitchell acknowledged. He was not a fan of the film, but he understood the unique space the film occupied in the cultural zeitgeist. "It's entirely critic-proof," Mitchell said. "It doesn't matter if this movie is basically like an intergalactic version of C-SPAN. They're talking about treaties for two hours. No. People will go. They want to see it because they want to be part of the phenomenon."[48] Mitchell wasn't wrong; as Lucas would later admit, he struggled with the first film because he had to spread the plot thin in order to stretch it out to cover the extended running time.

"I did run into the reality of the first film," Lucas said. "Basically, [Anakin] is a slave kid. He gets found by the Jedi and becomes part of the Jedi Order and that he loves his mother. You know, that's maybe a half hour movie. And so I did a kind of jazz riff on the rest of it and I said, 'Well, I'm just going to enjoy myself. I have this giant world to play in and I'm going to just move around and have fun with this because, you know, I have to get to the second part.'"[49]

Lucas also saw this as an opportunity to tell the kind of family-friendly children's adventure fantasy that he had always dreamed about making. Still, there were elements with which many fans took umbrage, namely the introduction of midichlorians as a biological explanation for people's connection to the Force. Others complained about perceived overacting by Natalie Portman as Padme Amidala and Jake Lloyd as young Anakin Skywalker. The majority of fans' venom, however, was reserved for Jar Jar Binks, the bouncing, babbling jester who seemed to many to be shoehorned in for the sake of providing forced comic relief. Lucas never much cared what critics had to say. "Dialogue isn't the point," he offered in his defense. "These movies are about new things to look at."[50]

Another source of ire for some was the heavy reliance on CGI in order to create the epic space battles and special effects, but that should come as no surprise to students of Lucas' work; ever since the release of the "Special Edition" versions of the original trilogy, Lucas has demonstrated a continued commitment to using the latest technologies available to refine his films. Whether or not that's something *Star Wars* fans *want* is another matter entirely, but the point is that Lucas sees his works as constantly evolving and has no qualms about tinkering with them after the fact. Regardless, it was nominated for three Academy Awards—Best Sound Editing, Best Visual Effects, and Best Sound Mixing—but lost all three categories to another sci-fi film, *The Matrix*.

Whatever issues fans had, they clearly could not resist the allure of returning to the galaxy far, far away. Scalpers, too, seized on this fact, charging desperate fans as much as $100 for advance tickets to secure themselves a seat.[51] The hype was at such a fever pitch, with promotional tie-ins like McDonald's Happy Meal toys, Pepsi and Mountain Dew cans emblazoned with characters' faces, and a truly terrifying confection that allowed you to jam Jar

Jar's tongue down your throat in the form of a disgusting cherry lollipop. There was no way *anything* was going to live up to the lofty expectations. Even so, *The Phantom Menace* went on to become the second-highest-grossing film worldwide at the time, coming in just behind *Titanic.* Whether or not you personally liked it, *The Phantom Menace* holds a unique and important place in *Star Wars'* history. It heralded a new era of *Star Wars* films and was, for many younger audiences, a portal to the incredible world of the galaxy far, far away—and that is precisely what George Lucas wanted. (Of course, the fact that it made oodles and oodles of cash probably helped too.)

7 Attack of the Clones

In August of 1999, some three months after the premiere of *The Phantom Menace,* George Lucas set to work on the second of his prequel trilogy. Set ten years after the events of *The Phantom Menace,* the galaxy teeters on the verge of a civil war. The Trade Federation's rebellion inspired other systems to begin breaking away from the Republic, forming a new Separatist movement spearheaded by the rogue former Jedi Count Dooku. This time around, though, it was a decidedly more dour affair with the cherubic Anakin of *The Phantom Menace* replaced by the brooding angst of Hayden Christiansen and the galaxy on a runaway train leading to war. Such were the stakes of *Episode II: Attack of the Clones,* the fifth *Star Wars* film in the series and one of the first films to be shot entirely on a high-definition digital 24-frame camera system—something of which Lucas would be particularly proud.

Whereas he labored for three years on the script for *The Phantom Menace*, this time around Lucas only had nine months to pen the screenplay. Lucas was not without a sense of humor, though; the film was sarcastically given the working title of *Jar Jar's Big Adventure* as a sneering nod to the bilious reaction the character received in the wake of *The Phantom Menace*'s release.[52] Writing was like pulling teeth for Lucas, who did not finish his first draft of the film until two days before filming began. Producer Rick McCallum made light of the fact in an interview with *Star Wars Insider*, saying, "Right now we don't need a script. It's better for [Lucas] to concentrate on the dialog and themes as he goes along." He went on to compare the situation to Orson Welles finishing the script for *Citizen Kane* a mere two days before filming began.[53] However, *Attack of the Clones* was nowhere close to being Lucas' *Citizen Kane*.

If *The Phantom Menace* saw Lucas doing a "jazz riff," then *Attack of the Clones* was a fully improvised saxophone solo in which he kicked over the music stand and hip-checked the bass player off the stage. Case in point, during the entire preproduction process, none of the creative crews or design teams ever saw a script. It is difficult to say how much material Lucas had in advance; the production process of *Attack of the Clones* was even more secretive than *The Phantom Menace*, which could explain why pre-production crews were kept in the dark. However, certain elements were undeniably teed up well in advance. Case in point, the revelation of the clone troopers, who would one day evolve into the stormtroopers that marched into the hearts and minds of audiences across the world in the original trilogy. As early as 1980, Lucas had mentioned that the Jedi had been betrayed by a trap of some sort that the Emperor had laid for them. In 1977, too, Lucas stated that "the [Jedi] tried to regroup, but they were eventually massacred by one of the special elite

forces led by Darth Vader."[54] Clearly, this idea had been gestating in Lucas' mind for quite some time.

"This was much more like a movie from the 1930s than any of the others had been," Lucas said of the film, "with a slightly over-the-top, poetic style."[55] With the inclusion of a film noir-esque storyline for Obi-Wan Kenobi, a sweeping love story for Padmé and Anakin, and a title that seemed ripped straight from a 1930s serial like *Flash Gordon* or *Buck Rogers*, the case can be made that Lucas accomplished his mission. "This is about serendipity, alchemy—it comes together when it does," McCallum assured an interviewer.[56] Not everyone agreed with that sentiment. When told the title at the film's premiere on the red carpet, Ewan McGregor seemed taken aback. "Is that it?" he asked. "That's a terrible, terrible title."[57] Indeed, for the final draft, Lucas tapped *Young Indiana Jones* writer Jonathan Hales to come in and help clean up the dialogue to the best of his ability. His influence was likely minuscule, however, based on how late in the game he joined the production.

So what eventually wound up in the film? Let's take a walk down memory lane, shall we? A decade after the Trade Federation's invasion of Naboo, the Galactic Republic faces a new threat in the form of the Separatist movement, a secession-ist bloc organized by former Jedi Master Count Dooku that is convincing thousands of systems to secede from the Republic. On Coruscant, Senator Padmé Amidala faces challenges of her own in the form of an assassination attempt. Placed under the protective aegis of Obi-Wan Kenobi and his Padawan Anakin Skywalker, Padmé finds herself the target of yet another attempt on her life. This time, though, the Jedi manage to not only prevent the attack, but subdue the assassin, the shapeshifting bounty hunter Zeb Wesell. However, before she can reveal the identity of her client, she is murdered, hit in the neck by a toxic dart. Tasked by the Jedi Council with unraveling the conspiracy

to assassinate Amidala, Obi-Wan Kenobi sets out on a galaxy-spanning investigation. Anakin, on the other hand, is assigned to escort Padmé back to Naboo where the two begin falling in love.[58] Sometimes it pays to be a Padawan learner…

Over the course of Obi-Wan's investigation, he discovers something disturbing—not only is the remote aquatic planet of Kamino expunged from the Jedi Archives, but it is home to an army of clones being produce as an army for the Republic. Serving as the genetic template for the army of clone troopers is the Mandalorian bounty hunter Jango Fett, who Obi-Wan identifies as the man who assassinated Zeb Wesell back on Coruscant. Placing a tracking device on Fett's ship, he tails the bounty hunter and his son, Boba, to the desert world of Geonosis. Back on Naboo, though, Anakin is having issues of his own. Troubled by increasingly vivid visions of his mother, Shmi, in mortal danger, Padmé and he travel to his homeworld of Tatooine to save her. When Anakin arrives, he learns that his mother has been taken captive by the Tusken Raiders and has been missing for several weeks. Venturing into the wastes, Anakin discovers the Tusken camp only to find his mother bruised, beaten, and tortured. She dies in his arms, sending him into a blinding rage in which he slaughters each and every Tusken in the camp—including men, women, and children. In fact, Anakin's rage is so powerful that it causes Yoda to sense a dark disturbance in the Force. (Kind of like how you would close the door to your room super dramatically back in high school, but with way more homicide involved.)

Back on Geonosis, things go from bad to worse for Obi-Wan Kenobi as he discovers that Count Dooku is behind the Separatist movement, they have a new droid army, and Nute Gunray was the one who ordered Amidala's assassination. However, before Obi-Wan can relay this information completely, he is captured. Count Dooku tries to get Obi-Wan to join him, revealing that Darth Sidious is in control of the Senate, but it is to no avail.

With news of Dooku's army spreading across Coruscant, an emergency session of the Galactic Senate is called to order. Remember that snarky reference to Jar Jar Binks in the film's working title? As it turns out, in this film, Jar Jar would quite literally ruin the galaxy far, far away by proposing a measure to give Chancellor Palpatine emergency wartime powers. The Senator played the gullible Gungan like an annoying fiddle, manipulating the rube into essentially giving him totalitarian control over the Galactic Republic and its army of clone troopers.

Anakin and Padmé arrive to rescue their friend only to be immediately captured as well. Together, our three heroes are put into the Geonosis arena and sentenced to death by battling three monstrous creatures—a reek, a nexu, and an acklay. It would seem that our heroes are doomed when suddenly Mace Windu arrives with the cavalry—a strike force of nearly 200 Jedi—and begins battling with Dooku's droid army. During the fray, Jango Fett challenges Windu to a battle, *mano a mano*, and winds up decapitated for his trouble. This is why you don't bring a jetpack to a lightsaber fight, guys. Outside the arena, too, battle also raged as Yoda arrived with a battalion of clone troopers. Chasing down Count Dooku, Anakin and Obi-Wan engage the fallen Jedi in lightsaber combat, but are quickly overpowered as Dooku reveals that he has full command over the powers of the dark side. He gravely injures both Jedi, going so far as frying Anakin with Force lightning and cutting off his right arm. When our heroes seem well and truly defeated, Yoda arrives, engaging Dooku in a lightsaber duel, forcing him to retreat. The Battle of Geonosis is won, but the Clone Wars are just beginning.

Back on Coruscant, Obi-Wan, Mace Windu, and Yoda confer about Count Dooku's warning that Darth Sidious is controlling the Senate. However, Yoda is reluctant to believe what the Sith said due to the dark side's propensity to mislead. They all agree that the Senate should be closely watched from this point

forward. Meanwhile, the newly appointed Supreme Chancellor Palpatine begins overseeing the deployment of massive detachments of clone troopers. Back on Naboo, Anakin, who has a slick new robotic arm, and Padmé finally admit their feelings for one another, having a secret wedding with only R2-D2 and C-3PO as witnesses. They might not seem like the best wedding guests, but considering that marriage is strictly against the Jedi Order's code of ethics, it's probably for the best.

When all was said and done, the film was still a massive financial success, earning over $310 million domestically and $338 million internationally. That being said, *Attack of the Clones* holds the unique distinction of being the only *Star Wars* movie not to be the highest-grossing film in the year of its release; it was out-earned by *Spider-Man, Harry Potter and the Chamber of Secrets*, and *The Lord of The Rings: The Two Towers*. (Damn, looking back at it, 2002 was a great year for fans of geeky genre cinema, huh?) Critical reaction was mixed, although it was generally better received than *The Phantom Menace*. Some praised the unexpected nature of the fight sequence between Dooku and Yoda, as well as the reveal that the clone troopers were essentially prototypical stormtroopers who once fought on the side of the angels. Other reviews derided the film, comparing it to the old *Flash Gordon* serials Lucas had loved so much—and this time unfavorably so.[59]

Of course, none of that mattered much to Lucas, for whom bad reviews seemed akin to white noise. "We discovered that we have two fan bases," he said. "One is over 25 and one is under 25. The over 25 fan base is loyal to the first three films and they are actually in their 30's and 40's now, so that they're in control of the media, they're in control of the web, they're in control of everything basically. The films, which those people don't like, which are the [prequels] actually are fanatically bored by the other two. And if you get on the web and you listen to these

conversations, they are always at each other's throats and the devotion for each group is pretty equal."[60]

After all, what did the virtual vitriol of cranky fans matter to George Lucas? He had the box office receipts to vindicate him. Moreover, he had a company to run, one that was constantly expanding. In the wake of the film's success, Lucasfilm opened a massive new headquarters for ILM on the Presidio in San Francisco, and the company spun off its theater sound division into THX, in which Lucas held a minority stake. On September 25, 2002, the terms "Jedi," "The Force," and "Dark Side" were officially entered into the *Oxford English Dictionary*.[61] Whether or not critics cared for the movie was a moot point; *Star Wars* was in the very DNA of our culture, and it showed no signs of going away.

8 Revenge of the Sith

"Act III is when everything comes together. That's going to be the most fun to do."

—George Lucas[62]

George Lucas first uttered those words shortly after the release of *Episode II*, partly in response to critics who complained about the first two installments of the prequel trilogy, and partly to show in his own Cheshire Cat sort of way that he did, in fact, have a plan. For many viewers, *Revenge of the Sith* was the strongest entry in the original trilogy, effectively tying together many of the plot threads the first two films dangled like carrots. As it turns out, it was something about which the filmmakers were acutely aware.

"There's no question we knew way back in 1990 that *Episode I* and *II* were going to be very tough, especially with anyone over probably 18 years old or anyone who had any relationship to the original trilogy," said producer Rick McCallum. "But we also knew that [*Episode III*] was the film that everybody who was older wanted *Episode I* to be."[63]

Revenge of the Sith begins in the throes of war, as the Battle of Coruscant rages between the Galactic Republic and the Separatists above the planet's surface. Supreme Chancellor Palpatine has been kidnapped by General Grievous, the Separatist cyborg commander, leaving the Jedi Knights Obi-Wan Kenobi and Anakin Skywalker to rescue him. Sneaking aboard Grievous' flagship, the Jedi Knights find that they've wandered into a trap laid by Count Dooku, the Separatist leader and Sith Lord, who launches a vicious assault on our heroes. The battle rages on with both sides pressing their advantage, until Dooku manages to trap Obi-Wan beneath a massive steel platform that the Force pushes onto the Jedi. Squaring off against Anakin, Dooku is shocked to find the young Jedi fighting with reckless abandon and a strength he had not expected. Disarming the Sith Lord, Anakin holds his lightsaber at Dooku's neck. Suddenly, Palpatine hisses, "Kill him!" Using Dooku's lightsaber and his own like a pair of hedge trimmers, Anakin decapitates the Separatist leader in one of the more grisly moments of the entire trilogy.[64]

After heading back to Coruscant, Anakin reunites with his secret wife, Padmé Amidala, who reveals that she is pregnant! Although given the illicit nature of their marriage, they can't exactly share the good news with anyone. To make matters worse, Anakin's Force visions have returned and this time he foresees Padmé dying in childbirth. Anakin suffers another crisis of faith when Palpatine appoints him to the Jedi Council. The Council begrudgingly gives Anakin a seat on the Council, but refuses to

name him a Jedi Master; instead they ask him to spy on Palpatine for them, which makes him distrust the Council further.

In a moment alone with Anakin, Palpatine reveals himself as the Sith Lord Darth Sidious (cue dramatic music). Preying on Anakin's fears over Padmé's impending death, Darth Sidious tells the troubled Jedi the tragedy of Darth Plagueis the Wise, a Sith Lord who harnessed the Force to save those he cared about from dying, a statement which greatly appeals to Anakin. However, as Palpatine notes, Plagueis became so obsessed with trying to save other people from dying, he did not anticipate that his apprentice—who we can assume to be Palpatine—would kill him. When Anakin asks how he can learn to access that power to defy death, Palpatine's answer is simple: "Not from a Jedi."[65]

With Obi-Wan off-world on a mission to chase down General Grievous on Utapau, Anakin cannot consult his Master over what to do. Burdened with the knowledge of Palpatine's treachery, Anakin reports his discovery to Mace Windu, who brings a small squad of Jedi Masters with him to arrest Palpatine on charges of treason. In the fight that follows, Palpatine handily slays Kit Fisto, Agen Kolar, and Saesee Tiin—the Jedi Masters accompanying Mace Windu—but finds himself disarmed and the amethyst-colored lightsaber of Mace Windu pointed in his face. However, just as Mace is about to deliver the killing blow, Anakin makes the fateful choice to intervene. Drawing his lightsaber, Anakin cuts off Mace's hand, leaving the Jedi Master stunned and staggered. In a flash of blinding light, Force lightning erupts from Palpatine's hands, blasting Mace Windu through a window, sending the Jedi Master hurtling to his death hundreds of stories below. Giving himself over fully to the dark side, Anakin pledges his loyalty to Palpatine, who in turn christens him Darth Vader. With that, a future Sith Lord is born.

With his newly minted apprentice by his side, Palpatine executes Order 66, a latent command programmed into the clone

troopers via a dermatologically-embedded bio-chip that causes the soldiers to target all Jedi for extermination, labeling them enemies of the state. Palpatine also gives Anakin a very special mission, sending him and a detachment of clone troopers to the Jedi Temple in order to eliminate all remaining survivors. Anakin obliges, murdering even the younglings in cold blood. Whatever shred of goodness remained in the fallen Jedi is nowhere to be seen. Almost overnight, the entirety of the Jedi Order is decimated, although Obi-Wan and Yoda manage to escape with their lives. Meanwhile, Palpatine addresses the Galactic Senate, letting them know that the Republic as they know it is no more; now, they are all subjects in the Galactic Empire and he is their ruler. "So this is how liberty dies," Padmé remarks bitterly, "with thunderous applause."

Traveling to the volcanic planet Mustafar, Anakin kills the rest of the Separatist leaders who are hiding there. With these killings, the dark side begins to affect Anakin physically, as his irises turn a sallow hue of yellow and the rest of his eyes take on a vibrant crimson hue. After learning of Anakin's treachery, Padmé journeys to Mustafar, although unbeknownst to her, Obi-Wan has stowed away on her ship because Padmé would not reveal where her estranged husband had gone. (Classic Obi-Wan.) On Mustafar, Padmé confronts Anakin about his deeds, and he does not deny any of his awful actions. Rather, he tells Padmé of his intention to betray Palpatine and overthrow him so that the two of them can rule the galaxy together. Disgusted by how the man with whom she fell in love has changed, she recoils in horror, begging him to stop.

Suddenly, Obi-Wan reveals himself to Anakin, which enrages the Sith apprentice. Believing that Padmé brought his former Master here to kill him, Anakin Force chokes his wife, rendering her unconscious. After a brief, but failed heart-to-heart, the student and master prepare to fight. At nearly the same time,

A stormtrooper holds up a Revenge of the Sith *t-shirt shortly after Lucasfilm announced the new title of the final prequel at Comic-Con on July 24, 2004.* (Denis Poroy)

Darth Sidious and Yoda engage in a frantic duel at the Senate Building on Coruscant, fighting through the halls and the Grand Convocation Chamber. The two masters of the Force trade devastating blows, but prove unequal to best the other; finally, with the help of Bail Organa, Yoda escapes, intending to go into exile off-world. Meanwhile, back on Mustafar, Anakin and Obi-Wan's fight has escalated, with the two trading savage blows along the banks of the molten lava river. Staying on the defensive throughout the fight, Obi-Wan leaps to the safety of a nearby sand bank,

giving him the high ground. Though he warns Anakin that his position is unassailable, Anakin refuses to believe his former friend, snarling, "You underestimate my power!" However, what Anakin underestimated was Obi-Wan's reflexes and physics; with a lightning-fast maneuver, Obi-Wan severs both of Anakin's legs, as well as his left arm, sending him tumbling down the bank to the lava river's edge. Believing his former ward to be doomed, Obi-Wan leaves Anakin for dead, taking Padmé away from the desolate, death-filled world.

Retreating to the asteroid Polis Massa, Padmé gives birth to twins, who she names Luke and Leia. However, Anakin's fall from grace drained Padmé of her will to live, and she dies shortly after childbirth. Ironically, Anakin wound up being the cause of the very thing she sought to prevent. Back on Coruscant, Anakin's mangled body has been retrieved by Palpatine and is outfitted with a number of cybernetic enhancements to keep him alive, including a jet-black respiratory suit. Palpatine informs his apprentice of Padmé's death, which leads to the single greatest delivery of the line "Noooooooooooooo!" in cinematic history. With both parents presumed dead, Yoda and Obi-Wan determine what to do with the Skywalker twins. In order to hide them from the Empire, Senator Bail Organa adopts Leia, taking her to Alderaan, and Obi-Wan brings Luke to the surviving members of his stepfamily, Owen and Beru Lars, on the planet Tatooine. Yoda goes into exile on the swamp world of Dagobah to study the Force, and Obi-Wan goes undercover on Tatooine, living in secret and keeping an eye on Luke to protect him, biding his time until he is ready to rise up and challenge the Empire.

Whew—that was an awful lot, huh? Well, that's because there was an awful lot of plot to get through in the course of this one movie. With epic fight scenes, brutal murders, and the *Star Wars* equivalent of emotional carpet-bombing, *Revenge of the Sith* is a full-on tragedy, forcing the viewer to watch as hope is

extinguished in the galaxy far, far away. Perhaps this is a reflection of the times, to a degree, as the film was written in the wake of the United States' invasion of Iraq following the events of September 11, 2001. Much like the original *Star Wars* was an indictment of the Nixon presidency and the Vietnam War, *Episode III* can be seen as a commentary on the post-9/11 Bush administration.[66]

With its portrayal of a once-enlightened Republic, wracked by attacks on their home soil, trading in their freedom for security, and empowering a dictatorial leader with emergency wartime powers, it's hard not to draw parallels between *Star Wars* and the Bush administration. "If you're not with me, you're my enemy," Darth Vader tells Obi-Wan during their final confrontation, a direct reference to George W. Bush's impassioned speech to Congress on September 20, 2001. "Only a Sith deals in absolutes," Obi-Wan responds, echoing the sentiments of millions of Americans as they watched hawkish politicos steer the country toward military conflict. Lucas would even make things more explicit on the film's press tour. "I didn't think it would get this close," Lucas told journalists at Cannes. "The endless circle of politics, as Darth Vader might say, was now complete."[67]

From a narrative perspective, many of the ideas, themes, and scenes had been roiling around Lucas' head for a long, long time. In particular, the set piece between Obi-Wan and Anakin at the end was something which Lucas had planned for years. "I knew that's where this movie was going to end up," he said. "It's all volcanic land, with lava shooting up, so it's almost monochromatic in its red and blackness. I've had that image with me for a long time."[68] Say what you will about Lucas' sometimes messy style of storytelling, but his keen eye for creating visually striking tableaus and sequences is undeniable. Creating both visual and narrative parallels between *Revenge of the Sith* and *Return of the Jedi*, Lucas creates tangible connective tissue between the prequel trilogy and

the original trilogy, giving the viewer a sense of recurrence and that this is in the service of telling a larger story.

Earning $868 million worldwide, *Revenge of the Sith* wasn't only the highest-grossing film of 2005, it was the second-highest grossing film in the entire *Star Wars* franchise. It premiered to mostly positive reviews, a marked change from the decidedly mixed reactions to the previous two films. The film was not without its problem, though. Anakin's descent to the dark side seemed far too sudden for many viewers. What was presumed to take place over the course of three films happened in a shocking ten-minute sequence that took Anakin from moody young man to stone-faced killer.

Lucas also acknowledges that certain storylines were left by the wayside in favor of focusing on Anakin. Thankfully, many of them would be explored in the excellent *Star Wars: The Clone Wars* animated series, which filled in many of the gaps between *Attack of the Clones* and *Revenge of the Sith* over the course of its six seasons, and added layers of complexity to the characters of Anakin Skywalker and Obi-Wan Kenobi. However that, dear reader, is a story for another chapter. (Don't worry, though—it's a chapter in this book.)

Ultimately, this film is significant in that it marks the last time Lucas would work on a *Star Wars* live-action feature film. Clearly, the Creator had made his peace with this fact, and now he wanted fans to stop raking him over the coals as well:

"*Star Wars* is something to enjoy, and take away what you can from it that maybe helps you in your lives," he said to an assembled audience at *Star Wars* Celebration III in Anaheim, California. "But don't let it take over your lives. You know that's what they say about Trekkies. *Star Wars* fans don't do that. The point of the movies is to get on with your lives. Take that challenge, leave your uncle's moisture farm, go out into the world and save the universe."

Of course, the fans were far from done with *Star Wars*, even if Lucas' saga was coming to an end. Just as *Star Wars* is a story of generations, the end of *Revenge of the Sith* meant that it was time for Lucas to pass on the mantle of Creator to a new generation of *Star Wars* creators. With the completion of *Revenge of the Sith*, Lucas had achieved his goals of making the kind of movies he wanted to make outside the bounds of the studio system. Now, like so many of the Jedi Masters who appear at the end of *Return of the Jedi*, he could give himself over to the Force, allowing it to subsume him at long last.

Luke Skywalker

With his shock of shaggy blond hair, cleft chin, and wide-eyed earnestness, Luke Skywalker was a conduit for adventure, the access point for a generation of *Star Wars* fans into the unfolding mystery of the galaxy far, far away. All of us have dreamed at one point or another of finding out we were destined for something greater, which is precisely what happens to Luke when Old Ben Kenobi reveals that there are greater forces at work in the universe and he has an important part to play. Originally named Luke Starkiller, the character's name was changed after shooting had already commenced in order to avoid any connection to Charles Manson.[69] With his new name in tow, over the course of the original trilogy, Luke evolves from callow youth, a backwater farm boy to the savior of the galaxy and one of the greatest Jedi Knights who ever lived. Brought to life by Mark Hamill, with his youthful exuberance and impetuous performance, Luke

Skywalker didn't just resonate with audiences; he grew up before their very eyes.

When we first meet Luke Skywalker, we know nothing of his parentage. We know neither that he is the son of Darth Vader/Anakin Skywalker and Padme Amidala nor that he has a twin sister, who just so happens to be a princess *and* the leader of the Rebel Alliance. What we see is a young man who labors away on his uncle's moisture farm, forced to do chores instead of going into Tosche Station to pick up some power converters for his souped-up landspeeder. The image of Luke gazing out on Tatooine's desert landscape as the planet's twin suns set isn't just a great piece of cinematography; it immediately gives us a sense of this young man who has his head in the stars. Well, Luke longed for a more exciting life and little did he know that his wish would be granted. When his uncle Owen purchased a pair of droids—R2-D2 and C-3PO—a chain of events was set in motion that would alter the fate of Luke and the galaxy as we knew it forever.

Unbeknownst to Luke, the Galactic Empire is currently scouring the wastes of Tatooine looking for these droids. When R2-D2's subroutine telling him to search for the Jedi Knight Obi-Wan Kenobi kicks in, Luke and C-3PO follow suit, narrowly escaping death at the hands of the Tusken Raiders. Once they're safe and sound in "Old Ben" Kenobi's hermit hut, R2-D2 reveals a hidden message, a tiny hologram of Princess Leia issuing a distress signal to Obi-Wan Kenobi. With the cat out of the bag, Kenobi reveals his Jedi heritage to Luke and gives the boy his father's old lightsaber. Together—with the help of some newly recruited friends, Han Solo and Chewbacca—they set off to deliver the stolen Death Star plans hidden inside R2-D2 to the Rebel Alliance on Alderaan.[70]

Unfortunately, not even our heroes' ship, the *Millennium Falcon*, can outrun the Death Star's tractor beam. Although they manage to free Princess Leia from the Death Star, Obi-Wan

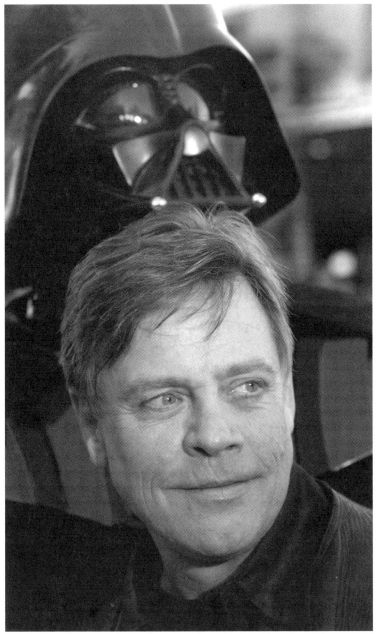

Mark Hamill poses in front of an actor dressed as Darth Vader at the Los Angeles premiere of Revenge of the Sith *on May 12, 2005. (Chris Pizzello)*

sacrifices his life in a lightsaber duel against Darth Vader to buy Luke and company time to escape. With Obi-Wan's sacrifice weighing heavy on him, Luke puts his mechanical aptitude to good use, joining the Rebel fleet as an X-wing pilot in a frenzied all-out assault on the Death Star. In what would come to be known as the Battle of Yavin, Luke makes a daring run through the trenches of the Death Star, narrowly avoiding hot, laser-filled death at the hands of Darth Vader and his squadron of TIE Fighters. By tapping into the Force, Luke makes a seemingly impossible shot, launching a proton torpedo into the Death Star's exposed thermal exhaust port, destroying the battlestation and saving the day.

Newly anointed and be-medalled as a hero of the Rebel Alliance, Luke Skywalker doesn't rest on his laurels. After some quick thinking and high flying during the Battle of Hoth, Luke journeys to the swampy planet of Dagobah to seek out the Jedi Master Yoda at the behest of Obi-Wan Kenobi, who appears to Luke in spirit form. (Normally, I would be calling the Ghostbusters or at least figuring out ways to start a Force ghost reality show, but I guess they do things differently in the galaxy far, far away.) After crashing his X-wing in a swamp (*not* a parking spot, young Skywalker) and getting trolled by a tiny, green man, Luke is ready to give up hope…until he realizes that his tormentor is none other than Master Yoda. Though reluctant to take on a new apprentice, particularly one as emotional and headstrong as Luke, Yoda eventually relents and imparts his centuries of wisdom into the young Jedi. In what will become grand *Star Wars* tradition, though, Luke sees a vision of the future that shows his friends in grave danger, prompting him to abandon his training before it is complete.

Though he arrives at Cloud City before his friends can be executed, Luke suffers grievous injuries to both his body and his psyche when he crosses lightsabers with Darth Vader for the

The Elm Street Connection

Though Hamill has proven himself to be an accomplished actor over the years, he has Freddy Krueger to thank for helping him become Luke Skywalker. Actor Robert Englund, best known as Freddy Krueger in the *Nightmare on Elm Street* series, auditioned for a role in *Apocalypse Now*, but he proved to be too old. Instead, they suggested he might be right for a role in a film across the hall, which happened to be *Star Wars*. Englund read for Han Solo, and was deemed too young, but he realized that a young actor crashing on the couch in his Hollywood Hills apartment would be ideal for the part of Luke Skywalker: Mark Hamill.

"I think he had spoken to his agent about the role, but I may have even mentioned to him there was a great project and remember sharing details of that audition with him too," Englund said in an interview. Clearly, the inside tips paid off, because Hamill landed the role and effectively changed the trajectory of his career. More importantly, though, who knew that Luke Skywalker and Freddy Krueger were such good pals?

MacDonald, Neil. "Robert Englund Exclusive Interview Part One—Star Wars, Willie and V, a Role in New V and Listening to Monty Python with Mark Hamill." SCIFILOVE. N.p., 27 Nov. 2009. Web. 10 May 2015.

first time. Easily overpowering the young Jedi, Vader reveals that he is Luke's father (after cutting off his hand, of course, because everyone has their own unique style of parenting) and implores his son to join the dark side so that they can rule the galaxy side by side. Fortunately for truth, justice, and the Alderaanean way, homie don't play that, and Luke hurls himself into a chasm, barely escaping with his life. Humbled by his encounter, Luke redoubles his efforts to be a better Jedi, and prepares for his eventual showdown with Vader. After rescuing Han and his friends from Jabba's palace and showing off his sweet new cyborg hand, Luke returned to Dagobah to continue his training with Yoda. However, Yoda was on his last legs and had nothing more to teach Skywalker; the final part of Luke's Jedi training would be to confront his father, the fallen Jedi, once and for all.

Aboard the second Death Star, he duels his father once more, nearly killing the Sith at Emperor Palpatine's evil urging. Though the power of the dark side is tempting, Luke rejects its false promises. "I am a Jedi, like my father before me," Luke declared, throwing his lightsaber away. Furious that his ploy to convert Luke to the dark side failed, the Emperor unleashed a barrage of Force lightning on him, causing Luke to writhe on the ground in intense agony, the life draining from his body. However, Luke's selflessness and his love for his father—in spite of everything Vader had done—awoke the humanity inside of Darth Vader, leading the Sith Lord to rise up against his Master and throw him to his death. Fatally wounded, Darth Vader removed his helmet, sharing one final face-to-face moment with his son before passing on. Having saved the day, Luke escaped the space station before it exploded, and his journey came to an end. No longer was he an impetuous, reckless farmhand; now, Luke was truly a Jedi Knight, one whose bravery and compassion saved the galaxy from utter destruction.[71]

Now, with *The Force Awakens* on the horizon, we will see Luke Skywalker 30 years after the events of *Return of the Jedi*. Though Luke defeated the Empire, fragments remain in the form of the First Order. The emergence of the seeming Sith Lord Kylo Ren means that evil is returning to the galaxy, and it is now up to Luke Skywalker to serve as an Obi-Wan Kenobi/ Yoda-like figure for the next generation of Jedi. "The Force is strong in my family," Luke says in the film's trailer, echoing his words at the end of *Return of the Jedi*. Who exactly will benefit from Luke Skywalker's wisdom remains to be seen, but it will be a long-awaited treat to see the former farmboy in his twilight years. Who knows, maybe we'll even get some sweet, sweet, newly canonized Expanded Universe action? (Probably not, but a fan can dream….)

10 Princess Leia Organa

Princess. Senator. Surprise twin sister. From her cinnamon bun hairdo to the infamous chainmail bikini, Princess Leia Organa is one of the most striking and important figures in the *Star Wars* mythos. Yet, she is more than just a sex symbol or a damsel in distress; quite the opposite, in fact. While Luke Skywalker was off learning how to wield a lightsaber, Leia was leading an underground rebellion against a fascist dictatorship that threatened to exterminate all who opposed them. Leia is a shrewd political operator, a fearless military commander, and an undercover operative who is equally adept with a blaster pistol in her hand as she is issuing orders to a squadron of Rebel soldiers. Played by Carrie Fisher, Princess Leia is just as comfortable staring down Grand Moff Tarkin with a disdainful curl of the lip as she is leading an elite squad of ground forces to disable a shield generator on the forest moon of Endor.

The daughter of Queen Padme Amidala and Anakin Skywalker, and the twin sister of Luke Skywalker, Princess Leia Organa, a.k.a. Leia Skywalker, is the driving force behind much of what happens in the original *Star Wars* trilogy. From the very first scenes in *A New Hope*, Leia is setting the wheels of change in motion as she squirrels away stolen Death Star plans aboard the *Tantive IV* and sends a distress call to Obi-Wan Kenobi. With her true parentage a secret, Leia was raised by Senator Bail Organa on the planet Alderaan, which was subsequently destroyed by the Death Star in a ghastly display of its terrible power. This heinous act would only serve to stoke the fires of rebellion further, giving Leia and her followers a cause around which to rally. By the end of *A New Hope*, Leia has a new group

of friends—brash and prone to irksome displays of bravado, but friends nonetheless. And these friends would prove to be valuable assets for the Rebel Alliance that Leia was building.

Though Han Solo's arrogant behavior drove her crazy, Leia could not deny her feelings for the "stuck-up, half-witted, scruffy-looking nerf herder," as she once called him in a burst of anger. After the smooth-talking, slightly sleazy Lando Calrissian betrayed Leia, Han, and their friends on Cloud City to the Empire, Han was frozen in carbonite and shipped off to Jabba the Hutt's palace. Rather than leave her friend to die, Leia mounted an elaborate rescue mission in which she posed as a bounty hunter named Boushh. She succeeded in unfreezing Han, but the jig was up—Jabba was on to them, and took them prisoner too. For a time, Leia was forced to wear a metal bikini and serve as Jabba's slave girl, a position that was decidedly demeaning, but one that didn't break her spirit.

When Luke Skywalker showed up to help rescue his friends, Leia finally took her sweet, sweet vengeance by choking Jabba to death with the very chains that bound her. It's one of the more badass kills in all of the *Star Wars* canon and was better than the pitiful, misogynist Mafioso deserved. Reunited with her friends and her wardrobe once more, Leia and the team rendezvoused with the Rebel fleet in order to determine a plan of attack to dismantle the Empire's second attempt at building a Death Star. Rather than remain behind with the Rebel fleet, Leia chose to put herself in harm's way once more, using a stolen Imperial shuttle to lead a strike force on the forest moon of Endor. Their mission: to destroy the shield generator protecting the gigantic superweapon. What followed was a massive melee between Imperial forces and the Rebel soldiers, who were aided by their newfound furry friends, the Ewoks. If there was any doubt as to what a crack shot Leia is, look no further than the Battle of Endor where she snipes stormtroopers left, right, and center.

While she is, by all accounts, a strong, determined character, there are some who view Princess Leia Organa, in Fisher's own words, as "some kind of space bitch." Here's the thing though—if you were in Leia's shoes, you might be a "space bitch" too. "She has no friends, no family; her planet was blown up in seconds—along with her hairdresser—so all she has is a cause," Fisher explained in a 1983 interview with *Rolling Stone*. "From the first film, she was just a soldier, front line and center. The only way they knew to make the character strong was to make her angry."[72] Angry though she may be, Leia still manages to kick ass, take names, and save the universe alongside her friends. So maybe we should amend Fisher's original words to read "HSBIC," or "head space bitch in charge."

When *Star Wars: The Force Awakens* was first announced, many wondered whether or not we'd see Princess Leia grace the silver screen once more. Thankfully, the answer to that is yes, and something tells me that it will be more than a mere cameo. In the meantime, go ahead and pick up a copy of Marvel Comics' *Princess Leia* to get your fix of the Alderaanean ass-kicker. Written by Mark Waid and illustrated by Terry Dodson, *Princess Leia* is one of the comics publisher's top-selling series, and for good reason. "Who could forget that she's the one constantly showing the boys how to use their weapons?" Waid mused in an interview. "She's not rude, she's direct. She's not bitchy, she's easily exasperated by nitwits. She's not bossy, she's—okay, well, she's a little bossy, but she *is* a princess."[73] And that, dear reader, is precisely why you should love her. (That, and her hair will make you hungry for delicious pastries.)

11 Darth Vader (a.k.a. Anakin Skywalker)

Usually, heavy breathing is a sign you might need to see a cardiologist, but in the world of *Star Wars*, it heralds the approach of the ruthless cyborg Sith Lord, Darth Vader. Arguably the greatest villain in cinema history—he came in third after Hannibal Lecter and Norman Bates according to the American Film Institute—Darth Vader, with his flowing cape, jet-black armor, and signature red lightsaber is an icon all over the world.[74] Not only has the *Star Wars* villain been parodied time and time again, but entomologists also named a slime-mold beetle in his honor (*A. vaderi*, characterized by its "broad, shiny, helmetlike head").[75] There is even a grotesque carved in his likeness on the façade of the Washington National Cathedral. Not too shabby for an asthmatic burn victim with a couple estranged children.

Like R2-D2 and C-3PO, Darth Vader is one of the few characters to appear in all six existing *Star Wars* films, albeit in a slightly different form. "I had to make Darth Vader scary without the audience ever seeing his face," George Lucas explained in an interview.[76] With a name translating to "Dark Father," and a costume inspired by Japanese samurai films and the black military uniforms of the *Schutzstaffel* (SS), Hitler's secret police during World War II, Vader is decidedly intimidating. The iconic black suit came into play when artist Ralph McQuarrie painted concept art of the opening scene in which Vader is boarding the *Tantive IV*. Initially, it was supposed that Darth Vader would need a suit and breathing apparatus so that he could travel through space outside of a ship. Thankfully, the suit was made a permanent fixture of the story, and evolved into the signature aesthetic we know and love today.

In the original trilogy, Vader was played by four different actors: British bodybuilder David Prowse actually wore the signature suit and performed the role on set; stuntman Bob Anderson handled particularly intense fight scenes; Sebastian Shaw played the horrifically scarred, unmasked version in *Return of the Jedi*; and, after a lengthy search that included candidates like legendary actor Orson Welles, Lucas enlisted James Earl Jones to lend his booming *basso profondo* voice to the series in post-production. (He didn't provide the iconic breathing effect though; that was the result of sound designer Ben Burtt placing a microphone inside an underwater breathing apparatus and recording the results.) In the prequel trilogy, actor Jake Lloyd portrayed young Anakin Skywalker in *The Phantom Menace*, later replaced by Hayden Christensen in *Attack of the Clones* and *Revenge of the Sith*. Later, for the Special Edition reshoots, Industrial Light & Magic VFX supervisor C. Andrew Nelson filled in to play the Dark Lord. All in all, that's seven actors who have portrayed Vader on the big screen, which is a lucky number for an awfully unlucky character.

Before he was the deadliest, most intimidating enforcer in the Galactic Empire, Darth Vader was Anakin Skywalker, an impoverished young boy with a knack for mechanics and engineering who would go on to become both a Jedi and one of the greatest heroes of the Clone Wars. Born to a slave named Shmi, Anakin has no known father. "There was no father," Shmi explains in *The Phantom* Menace. "I carried him, I gave birth, I raised him. I can't explain what happened." Is he a miracle baby? Some sort of Christ figure? Probably, but most importantly, he is the throughline for the entire *Star Wars* saga thus far.

Though he was among the most skilled Jedi in the universe, Anakin was always something of a rulebreaker, and his secret marriage to Padme Amidala—which broke the Jedi code of conduct—lead to a rift between the young warrior and his order.

As Anakin drew further and further away from his onetime allies, he began experiencing visions of his wife dying during childbirth. Desperate for a way to save her life, Anakin turned to one of his mentors, the Supreme Chancellor Palpatine, who revealed that not only was he secretly a Sith Lord known as Darth Sidious, but that the dark side's powers could be used to prolong her life indefinitely. Wracked with guilt and struggling with his decision, Anakin ultimately gave in to the seductive power of the dark side, descending into evil.

In his new life, Anakin was reborn as Darth Vader, serving as Darth Sidious' personal agent of destruction, hunting down and killing members of the Jedi Order. Backed by a legion of clone troopers, Anakin personally led an assault on the Jedi Temple where he viciously exterminated both fully trained Jedi and younglings alike. Later, an assassination mission on the volcanic planet of Mustafar led Vader to a fateful encounter with his former Master and longtime friend Obi-Wan Kenobi. A brutal battle followed as the two clashed lightsabers on the increasingly dangerous lava fields, trading blows and fighting with savage ferocity. Having given himself over to the dark side, however, Vader let his emotions get the best of him and ultimately lost. Gravely injured, severely burnt, and filled with hatred, it seemed as though Vader would be left to die on the side of that lava river. Yet, Palpatine discovered his ward and rescued his injured apprentice, placing him into a suit of horrific black armor, a menacing obsidian prison that Vader would have to wear for the rest of his life in order to keep himself alive. Truly, there was no more Anakin Skywalker; now there was only Darth Vader.[77]

Though the Empire would have likely expanded at a rapid pace nonetheless, Darth Vader became its symbol, the looming spectre of doom that heralded Emperor Palpatine's wrath. In the wake of the Clone Wars, Vader hunted down Jedi who managed to elude the culling of Order 66, which declared any

and all Jedi to be enemies of the state. Vader didn't do it all by himself, however. Though Vader and the cold, calculating Moff Tarkin were often at odds with one another over the best ways in which to execute the Emperor's will, the duo came to respect one another when treachery was discovered within their ranks. Much like Liam Neeson in *Taken*, each one of these men has a particular set of skills, which they set to work on ferreting out and fileting the traitors in their midst. It was only fitting that the two would wind up working together to execute the Empire's most ambitious plan, the construction of their ultimate weapon, the Death Star.

Nearly nineteen years after his fateful showdown with Obi-Wan Kenobi, Darth Vader was stronger than ever. With the Death Star nearing completion, disaster struck as the growing Rebel Alliance managed to steal schematics for the planet-sized orbital super-weapon. Although Vader tracked down the stolen tape to the starship *Tantive IV*, Princess Leia Organa had already smuggled the stolen plans and a distress call inside the droid R2-D2, and sent him and his protocol droid companion, C-3PO, to Tatooine in search of Obi-Wan. Killing everyone aboard the ship except for Leia, Vader took the Alderaanean princess to the Death Star for further interrogation. Soon afterward, though, the cavalry arrived on the space station in the form of Luke Skywalker, Han Solo, Chewbacca, and C-3PO, along with Obi-Wan Kenobi and R2-D2. Though the heroes managed to escape with the Princess in tow, not everyone made it out with them—Vader and Obi-Wan faced off for one final time in a duel to the death. This time, however, Vader struck the killing blow, slaying his former Master and devastating the spirits of young Luke Skywalker.

Though the Rebels had seemingly escaped with the Princess and their lives, it was only because Vader and the Empire willed it. The sinister Sith had placed a tracking beacon on their ship, which lead the Empire directly to the Rebels' secret base of

operations at Yavin 4. What followed is the now-legendary Battle of Yavin 4, an all-out dogfight between Imperial and Rebel ships as the hopelessly outnumbered Rebels mounted a last-ditch attack on the supermassive space station. Darth Vader himself took flight in his TIE Advanced x1 Fighter and, flanked by a brigade of pilots, began shooting down the Rebel pilots. All seemed lost as Luke Skywalker screamed through the trenches of the Death Star's well-defended exterior, and Vader had a bead on the Rebel upstart when suddenly the *Millennium Falcon* appeared, attacking him from behind. The momentary distraction threw Vader off of Luke's tail long enough for the young Skywalker to launch a well-timed proton torpedo into the Death Star's thermal exhaust port, which blew the space station to smithereens.[78]

Narrowly dodging death again, Darth Vader returned stronger than before and with a singular purpose: to track down the Rebel who bested him, Luke Skywalker. Using an armada of probe droids, Vader followed the Rebel Alliances' trail to Hoth, where the Empire launched an attack on the ice planet only to find their quarries had escaped. Hellbent on finding his man, Vader commissioned a team of bounty hunters to track down the *Millennium Falcon*. It was the Mandalorian mercenary Boba Fett who ultimately intercepted the heroes on Cloud City, having bribed the city administrator Lando Calrissian to betray his former friends. With Han, Leia, and company captured, Vader used them as bait to lure Luke out of hiding. Ever the hero, the young Skywalker took the bait and curtailed his Jedi training in order to save his friends. Drawing their lightsabers, Vader and Luke began dueling in a savage battle. Ultimately, the Sith Lord proved too powerful for Luke, and Vader drove that point home by slicing off Luke's hand. To make matters worse, Vader took that opportunity to reveal to Luke that he was, in fact, his father. To give you an idea of how bad of a father Darth Vader is, his son literally chose to throw himself into a seemingly bottomless

abyss rather than hang out with him. So, the next time you have an argument with your dad, remember that it could always be worse. (Sorry, maybe I should have given you a spoiler alert in case you *just* decided to read this chapter devoid of any other context. Anyway, Bruce Willis was dead the whole time.)

Intent on crushing the "Rebel scum" once and for all, Darth Vader and the Empire set to work building—you guessed it—another Death Star. Like the old saying goes, if at first you don't succeed, build a bigger, badder, deadlier planet-sized superweapon until you do. For Vader, however, he decided to try a different tack with fatherhood: luring his son to the dark side of the Force. After all, the family that lets their hatred and anger course through them together, stays together. The Emperor and Vader waited for Luke to come to them, which he did in short order. Another duel between father and son ensued, but this time Luke managed to overpower his father, slicing off his hand in the process. (This is, I imagine, the *Star Wars* universe equivalent of when a son finally posts up a killer layup on his dad while playing basketball in the driveway.) Yet, true love conquers all in the world of *Star Wars;* Luke refused to give in to the Emperor's commands to slay his father, and inspired by his son's compassion, Vader lifted the Emperor above his head and threw the miserable old bastard off a ledge to his death. Though the Emperor's force lightning dealt Vader fatal injuries, he had one last moment of redemption and a chance to reconcile with his estranged son before shuffling off this mortal coil.

Given his untimely but sentimental passing in *Episode VI*, it's unlikely that we'll see Darth Vader return in *The Force Awakens* unless it's as part of a flashback sequence or as a Force ghost. Still, Vader's shadow looms large over the series as an indelible and essential part of the overall story, so it will be fascinating to see who fills the power vacuum left behind by the dearly departed Darth.

12 Han Solo

Of George Lucas' many mentors and inspirations, the one who probably influenced him most was Joseph Conrad and his seminal book *The Hero with a Thousand Faces*. One of these faces is that of the accidental or reluctant hero, an archetype in which a character is, against their better judgment and/or inclination, pulled into events bigger than himself, and is forced to rise to the occasion. In the world of *Star Wars*, no one embodies this ideal more than Han Solo, the self-interested smuggler who, alongside his co-pilot Chewbacca, gets drawn into an intergalactic conflict and ultimately joins the Rebel Alliance to prevent the Galactic Empire from destroying the universe as we know it.

Lucas described the scruffy-looking nerf herder (as Leia not-so-affectionately calls him) as "a loner who realizes the importance of being part of a group and helping for the common good."[79] Han wasn't always intended to be the swashbuckling smuggler that we know and love. In earlier drafts of the script, Lucas envisioned Han in a much smaller role as an undercover operative rather than a roguish smuggler-type. What's more, he wasn't even human in the original drafts; rather, he was a green-skinned extraterrestrial. "[Han Solo] did start out as a monster or a strange alien character, but I finally settled on him being human so that there'd be more relationship between [Luke, Leia and Han]," Lucas said. "That's where Chewbacca came in as the kind of alien sidekick."[80]

In later drafts, Solo evolved into a "burly, bearded Corellian pirate who dressed flamboyantly." It wasn't until the third draft that Han Solo became the "tough James Dean style starpilot" that we know and love.[81]

Played by arguably the dreamiest man of the 1970s and '80s, Harrison Ford, Han Solo is one of the most beloved characters in both *Star Wars* and pop culture as a whole. Our first introduction to the Corellian smuggler is in that wretched hive of scum and villainy, the Mos Eisley Cantina. Deeply in debt to local crime lord Jabba the Hutt, Han has a bounty on his head that local sleazebags are all too ready to collect. One bounty hunter in particular—the grimy green alien Greedo—sits down across from Solo in a tense standoff, only to receive a brand new orifice courtesy of Han's blaster pistol. (The matter of who shot first—Han or Greedo—would go on to prompt one of the most heated debates in *Star Wars* history.)

Opportunistic assassins weren't the only ones seeking out Solo, though; Obi-Wan Kenobi and Luke Skywalker convinced him to help them break past the Imperial blockade on his rusted hunk of junk, the *Millennium Falcon.* Of course, looks can be deceiving ("She may not look like much, but she's got it where it counts, kid"), and Han agreed to help—for a fee of course. Han and Chewie are nothing if not shrewd businessmen, and not even a galaxy-threatening evil could prevent them from turning into glorified Uber drivers. (Hey, at least, it wasn't surge pricing.) However, what started as a simple contract mission soon turned into a life-or-death quest to rescue Princess Leia, destroy the Death Star, and save the universe. Faced with seemingly impossible odds, Han rose to the occasion, becoming one of the most important and renowned heroes of the Rebel Alliance. Funny how that can happen….

Through thick and thin, going up against an elite squadron of Imperial TIE Fighters and getting frozen in carbonite, treacherous bounty hunters and romancing Alderaanean princesses, Han Solo has seen it all. Beyond the scope of the original trilogy, Han Solo played a major role in the Expanded Universe stories, most of which are now considered apocryphal or fall under

the "Legends" banner—a side effect of Disney's purchase of Lucasfilm. In particular, Solo played a starring role in Marvel's 107-issue comic book run, and was a primary character in many of the novels and comics published throughout the 1990s and early 2000s.

During these stories, we met Han and Leia's three children, bring the Galactic Civil War to an end, and see Han rise to the rank of Commodore in the New Republic. With *The New Jedi Order* book series, Han Solo's adventures extended a full 43.5 years after the events of the original 1977 *Star Wars* film, with Han dealing with the death of his friend Chewbacca, becoming an alcoholic, and overcoming his condition to help defeat a race of intergalactic religious zealots known as the Yuuzhan Vong. Whether or not we'll ever see these stories work their way onto the big screen is another matter entirely.

Speaking of which, when will we see the smug smuggler on the big screen again? Why, in December 2015, of course. Harrison Ford is confirmed to reprise his role as Han Solo in *Star Wars: The Force Awakens*—and not just in a cameo role. Plus, Han Solo is getting a standalone, spin-off film of his very own on May 25, 2018! The anthology film will be directed by *21 Jump Street* and *The Lego Movie* directors Phil Lord and Chris Miller, and will be written by Lawrence Kasdan and his son Jon. According to Lucasfilm president Kathleen Kennedy, the film will likely follow Han Solo during his late teens/early twenties. Maybe we'll see Han meet his recently revealed wife, Sana Solo! Or maybe we'll see him make the infamous Kessel Run! Can you say "road trip"?

Considering how much people love Han Solo, I could probably fill up another book with 100 chapters on possible successors to the role. What're the chances that it'll be any good and won't upset longtime fans? As Han himself once said, "Never tell me the odds!"

13 Chewbacca

Towering, ferocious, fiercely loyal, and exceedingly hairy, Chewbacca is easily one of the most memorable and popular characters in the entire Star Wars universe. Chewbacca—Chewie if you're nasty—is a legendary Wookiee warrior, which is fitting because he is named for another great Wookiee warrior: Bacca, the first of the great chieftains of Kashyyyk, the Wookiee home-world. With a lustrous coat of brown fur, a white bandolier slung across his powerful shoulder, and his trusty bowcaster by his side, Chewbacca is Han Solo's steadfast companion and the co-pilot of the *Millennium Falcon*, the fastest ship in the galaxy.

Although Chewbacca has been famously portrayed by British actor Peter Mayhew, it very nearly wasn't the case. Lucas originally eyed the 6'6" bodybuilder David Prowse as Chewbacca, but opted to put the imposing strongman in the role of Darth Vader instead. George Lucas went searching for actors, and as Mayhew put it during a 2013 panel at Salt Lake Comic Con, in order to get cast, "all [he] had to do was stand up." Considering he is more than seven feet tall, it's easy to see how his stature immediately attracted Lucas' attention.

With his massive height and lustrous fur, Chewbacca may seem more like a giant dog than a man. There's a good reason for that: George Lucas' massive Alaskan malamute Indiana (as in "We named the dog Indiana"). Apparently, the dog would always sit in the passenger seat of Lucas' car like a co-pilot, and many would confuse the dog for a person.[83] Half dog, half man? Suddenly it's all adding up. As for the name Chewbacca, it is derived from the Russian word "Sobaka," which translates to "dog." As for the term Wookiee, it was the invention of voice

actor Terry McGovern, who improvised the phrase during a recording session for Lucas' directorial debut *THX 1138*.[84]

In order to bring Chewbacca to life, Lucas needed the best in the business, so he hired makeup supervisor Stuart Freeborn, who had garnered acclaim for his work on the apes in the legendary "Dawn of Man" sequence in Stanley Kubrick's *2001: A Space Odyssey*. Lucas originally designed the character as a combination of a monkey, a dog, and a cat, according to makeup and creature designer Stuart Freeborn. The costume itself was a combination of rabbit hair and yak hair, knitted into a base of mohair. However, the costume proved quite warm, so when Mayhew reprised the role in *Episode III*, a modified version was made with built-in cooling systems that allowed the actor to wear the costume comfortably for longer periods of time.[85]

Creating Chewbacca's iconic voice proved challenging for sound designer Ben Burtt. "He didn't have articulated lips," Burtt remarked in an interview. "He could basically open and close his mouth. So you also needed to create a sound which would be believable coming from a mouth that was operated like his."[86] To achieve the desired effect, Ben Burtt mixed together field recordings of wild animals, including several bears (including a four-month-old Cinnamon bear), a badger, a seal, a lion, and a walrus. From these raw materials, Burtt created a wide array of emotional sounds and responses that would take Chewbacca from a man in a suit to a living, breathing character.

But enough about the men behind the costume; let's talk about the character we know and love. During the Clone Wars, Chewbacca was captured by Trandoshan hunters, whereupon he was transported to a jungle moon, released, and hunted for sport, *Most Dangerous Game*-style. However, Chewie isn't one to take threats against his life lightly; alongside his fellow captive, the Jedi apprentice Ahsoka Tano, he staged a revolt, jury-rigged a transmitter, and secured their escape to their respective homeworlds.

Back on Kashyyyk, the Wookiees welcomed Jedi Master Yoda and a battalion of clone troopers to their homeworld, where they waged some of the final battles of the Clone Wars. Chewie battled alongside the clonetroopers until Chancellor Palpatine issued Order 66, an emergency protocol that branded the Jedi Order traitors to the Republic, and called for their immediate execution. Ever the quick thinker, Chewbacca and another Wookiee named Tarfful led Yoda to a secret escape pod and spirited him away from the war-torn planet.

Before the Galactic Civil War (a.k.a. the events of *Star Wars Episode IV-VI*), Chewbacca managed to get himself kidnapped once more by Trandoshan slavers. (Seriously, dude, maybe just stay away from Trandoshans already.) Though the other Wookiee slaves distrusted one another thanks to ancient blood rivalries and vendettas, Chewie managed to unite them, escape, and brutally murder his captors. He did leave one Trandoshan alive though (if you can call having your arms and legs being ripped out of their sockets living).[87]

After escaping his captors, Chewbacca began a campaign of freeing other enslaved Wookiees who had been kidnapped by Trandoshans and the Galactic Empire. During a slave transfer between a Trandoshan unit and Imperial commander Pter Nyklas, Chewbacca helped most of the slaves, who were mostly Wookiee children, escape. During the raid, Chewie's ship came under fire by Imperial TIE Fighters, commanded by none other than Lieutenant Han Solo. Captured by the Empire, Chewbacca was sentenced to death by whipping by Nyklas. However, before the gruesome deed could be done, Han Solo stunned the commander, and escaped with his new Wookiee friend in tow. Realizing that Solo had saved his life, Chewbacca pledged a life debt to the Corellian smuggler, and together the two set out on what would become one of the most epic bromances of all time. Seriously, these two are straight up adorable.

What *Is* a Wookiee Anyway?

We know that voice actor Terry McGovern improvised the phrase "Wookiee" in George Lucas' directorial debut, *THX-1138*. It seems less than likely that McGovern envisioned a race of massive, furry alien warriors though. So, what the hell was McGovern talking about?

According to *THX-1138* sound designer Walter Murch, he asked McGovern what the phrase meant. "Oh, that's a friend of mine who lives in Texas, Ralph Wookie," McGovern replied. "I just threw his name in there as I always want to stick it to him and thought he'd get a kick out of hearing his name in a film." Little did McGovern or his Texas-bound friend know that his name would become one of the most well-known words in the English language. But that, dear reader, is simply the power of *Star Wars*.

Lucas, George and Murch, Walter. Audio commentary. *THX-1138: The George Lucas Director's Cut.* Dir. Lucas. Warner Bros. 1971.

While knocking back a few cold ones in a seedy cantina on Mos Eisley, Chewbacca met Obi-Wan Kenobi, who was looking to secure passage to Alderaan. Together with Han, Chewie arranged a transportation fee to smuggle the Jedi and Luke Skywalker off the planet, through the Imperial blockade. Once they realized that all that remained of Alderaan were smoldering hunks of rock floating through space, Chewie posed as a prisoner of Luke and Han, who were disguised as stormtroopers, in order to infiltrate an Imperial space station and rescue Princess Leia.

After the Battle of Yavin, in which Chewie and Han helped Luke to destroy the Death Star, the duo remained with the Rebel Alliance. An Imperial assault on their headquarters on Hoth meant that Chewie and Han had to make a hasty escape with Leia and C-3PO. Navigating through a treacherous asteroid field, the crew eventually made their way to Cloud City, which they discovered was being run by their old pal, the smooth-talking, cape-wearing Lando Calrissian. Unbeknownst to our heroes,

Boba Fett and Imperial forces were one step ahead of them, and had already paid off Lando. Han was captured, frozen in carbonite, and Chewie and company barely made their escape after Lando had a change of heart. Naturally, Chewie thanked him by wrapping his powerful claws around Lando's throat before they escaped on the *Millennium Falcon.*

In order to save Han from Jabba the Hutt's clutches, Chewie once more posed as a prisoner, this time a captive of the bounty hunter Boushh (who was secretly Leia in disguise). Lightning, however, didn't strike twice; Jabba saw through their gambit and imprisoned them, sentencing them all to death by Sarlacc (nature's garbage disposal). Thankfully, a newly robot-handed Luke Skywalker rescued his friends before they could become appetizers for the Sarlacc.

When the Rebel Alliance discovered that the Empire was building another Death Star, Chewie helped lead a mission to destroy the orbital space station's shield generator on the forest moon of Endor. Alongside his newfound furry friends, the Ewoks, Chewbacca helped commandeer an AT-ST (better known as "the chicken walker") with which they decimated the Imperial ground forces. Without that important piece of grand theft auto (is it still "auto" if you're stealing a bipedal mech?), the Rebels would never have been able to penetrate the Imperial defenses and destroy the shield generator. Once again, Chewie had saved the day.

Though the Disney acquisition rendered much of the Expanded Universe inert, Chewbacca is notable for being the only main character from the film series to die outside the films. During the Yuuzhan Vong War, Chewie ran a mission with Han Solo and his youngest son Anakin to retrieve a shipment from Sernpidal. However, when they arrived, they learned that the planet was on a collision course with one of its moons, Dobido. Although they helped to evacuate many citizens, Chewie

ultimately sacrificed himself to save Anakin, who had been knocked away by powerful winds. With Anakin safely aboard the *Millennium Falcon* in its pilot seat, Han stood at the cargo bay doors, but it was too late for the Wookiee warrior. Anakin was forced to punch it into overdrive, leaving their friend behind to perish alongside thousands of Sempidalians who couldn't escape.[88] Although it was exceedingly sad that Chewie shuffled off this mortal coil, it's fitting that the only thing that could kill him was being crushed by a freakin' moon.

Fortunately for us, this is no longer considered canon, which means that once again, someone let the Wookiee win. The next time we'll see the lovable fuzzball grace our screens is in *Star Wars Episode VII: The Force Awakens*. Until then, well, you can always rewatch the *Star Wars Holiday Special*....

14 R2-D2

Shaped like a trashcan on wheels, R2-D2 (shorthand for "Second Generation Robotic Droid Series-2") is an astromech droid designed to assist pilots with navigation, and a core member of the *Star Wars* supporting cast. Although we first met R2-D2 in 1977's *Star Wars*, the little astromech droid that could is one of the OGs of the *Star Wars* universe, appearing in every film to date. From projecting the holographic message of Princess Leia's distress call to Obi-Wan Kenobi to repairing the *Millennium Falcon*'s hyperdrive systems after a betrayal on Cloud City, Artoo has been there through thick and thin, and could even be considered a face of the franchise. After all, when it came time to celebrate *Star Wars*' 30th anniversary, the United States

Postal Service didn't make Darth Vader–themed mailboxes; they modeled them after Artoo instead.

Using concept art from artist Ralph McQuarrie, mechanical effects supervisor John Stears created the first working version of R2-D2. Sound designer Ben Burtt then gave Artoo his "voice," using an ARP 2600 analog synthesizer to create his trademark electronic bleeps and bloops. However, the animatronics technology of the day meant that it would be impossible to achieve the desired range of motion without a human actor. When it came time to cast the diminutive droid, Lucas needed an actor who could feasibly fit into the 80-pound costume. Its weight ruled out children, but meant that British comedian Kenny Baker, who stood 3'5", was perfect for the role. After a meeting with George Lucas, Baker was immediately cast and it was off to the races for the sassiest little astromech droid in the galaxy.

During the Trade Federation's occupation of Naboo during the events of *The Phantom Menace*, Queen Amidala attempted to make an escape by piloting her ship through the orbital blockade of warships. Her Royal Starship suffered heavy damage, and so several astromech droids were dispatched to make emergency repairs. All of them were destroyed by enemy fire save for one audacious little blue-and-white droid: R2-D2. He managed to restore the ship's shields, buying the craft enough time to make the jump into hyperspace and escape their attackers.

Once they reached Tatooine, R2-D2 accompanied the Queen's handmaiden, Padmé, and their new traveling companions, Jar Jar Binks and the Jedi master Qui-Gon Jinn. It was on that dusty desert planet that R2-D2 met the Han Solo to his Chewbacca, a work-in-progress protocol droid named C-3PO. (Okay, maybe C-3PO isn't quite as dashing or charismatic as Han Solo, but you catch my drift.) The two droids became fast friends—which may seem like a foreign concept considering they are machines, but their connection is undeniable. R2-D2

developed a strong connection to Threepio's maker too, the Force-sensitive child Anakin Skywalker. During the Battle of Naboo, Artoo assisted young Anakin in piloting a Naboo N-1 starfighter, which they used to gain access to the Federation droid control ship and deactivate the rampaging robot army.[89]

After *The Phantom Menace*, R2-D2 remained in the service of Padmé/the *real* Queen Amidala, when she became a senator, and accompanied Anakin and her on a visit to Naboo. Later, Artoo found himself back on Tatooine once more, reunited with his friend C-3PO. With the protocol droid in tow, the foursome left for the planet Geonosis, a Separatist world with a massive droid factory that was preparing an army with which to attack the Republic. Inside the factory, Artoo once again saved Padmé's life by deactivating the factory's assembly line in the nick of time, saving the Senator from taking a bath in molten metal. (Although I hear it does *wonders* for the skin.)

When the Clone Wars broke out in earnest, R2-D2 served as Anakin's pilot assistant, and even an undercover agent for the Republic. Alongside four other droids, Artoo became a member of the D-Squad, an elite unit whose mission it was to recover an encryption module from a Separatist ship. Although the D-Squad went on many adventures, their greatest moment came when they located the *Venator*-class Star Destroyer, the *Renown*, and boarded it. Once onboard, however, they quickly realized they had fallen into a trap; the ship was essentially a giant missile aimed squarely at a Republic strategy conference on the space station *Valor*. In order to prevent massive damage to the Republic fleet and catastrophic loss of life, Artoo made the ultimate sacrifice by remaining behind on the ship while his squadmates escaped. He reprogrammed the ship's detonator to explode prematurely, obliterating the Star Destroyer and Artoo along with it. The day had been saved, and thankfully due to

Anakin's resourcefulness, Artoo was too; salvage teams recovered his remains, and were luckily able to repair the brave little droid.[90]

R2-D2 continued to serve as Anakin's co-pilot and sidekick during the Clone Wars, helping his master and Obi-Wan rescue Chancellor Palpatine from Count Dooku's ship, the *Invisible Hand*. Proving his tactical mettle once more, Artoo managed to take down two massive super battle droids by outmaneuvering them. Later, when the Galactic Empire is formed and Anakin has fully transformed into Darth Vader, C-3PO's memory banks are wiped in order to keep the location of Luke Skywalker and Leia Organa safe from their father. R2-D2's memory banks, however, remain untouched, making him one of the few witnesses to the tragedies that led to the fall of the Republic and the rise of the Empire.

Paired once more with C-3PO, Artoo was placed under the charge of Captain Raymus Antilles, whom he served faithfully for 19 years aboard the Corellian ship *Tantive IV*. As Matthew McConaughey reminds us in *True Detective*, "time is a flat circle," and history has a way of catching up with everyone, even astromech droids. After years of despotic rule by the Empire, the nascent Rebellion managed to steal plans for the Death Star. Onboard the *Tantive IV*, Princess Leia Organa, herself a secret Rebel leader, hides the data tapes within R2-D2's memory banks along with a distress signal, then puts Artoo and C-3PO aboard an escape pod, which crash-lands on Tatooine.

Abducted by Jawas, Artoo and Threepio are sold to Luke Skywalker's step-uncle Owen Lars. While cleaning R2-D2, Luke stumbles upon Leia's message (which Artoo claims to have no knowledge of), and sets out to find Obi-Wan Kenobi. Little did they know, but the Empire had launched a manhunt (or droid-hunt) for the missing droids, which leads to Lars and his wife Beru's murder at Imperial hands. Alongside Luke, Obi-Wan, C-3PO, and their newly acquired companions Han Solo and

Chewbacca, they set out to rescue Princess Leia from Imperial clutches. Later, after Leia is saved and the Death Star's blueprints have been delivered to the Rebels, Artoo rides shotgun with Luke in his X-wing during the assault on the orbital space station. Although R2-D2 sustained substantial damage during the attack, Luke was able to repair his trusty droid companion. Like father, like son, eh?

In the wake of the destruction of the Death Star, the Empire launched an attack on the Rebel Alliance's Hoth base. Barely surviving the Imperial assault, Luke and Artoo set off for Dagobah in order to seek out the Jedi master Yoda. Later, on Cloud City, Artoo manages to rescue and repair a critically damaged C-3PO, as well as override the city's security systems. Betrayed by the city's administrator and with Han Solo frozen in carbonite, Artoo and company are forced to make good their escape; R2-D2 manages to repair the *Millennium Falcon*'s hyperdrive system, allowing them to elude Imperial clutches once more.

In order to rescue Han, R2-D2 and C-3PO are tasked with infiltrating Jabba the Hutt's palace. Once inside, they provide cover for Leia, Chewbacca, and an unarmed Luke Skywalker to join them—as Jabba's prisoners. Just when all hope seems lost and our heroes are about to be fed to a Sarlacc, Artoo reveals that he had been smuggling Luke's lightsaber all along, rocketing it into the waiting hand of the Jedi, who uses it to defeat their captors and save their freshly unfrozen friend.

When the Rebels discover the Empire intends to make a second Death Star, Artoo joins an assault mission to disable the space station's shield generators on the forest moon of Endor. In the ensuing melee, known as the Battle of Endor, R2-D2 and C-3PO attempt to open the blast doors guarding the shield generator's main controls. However, the security system overloads R2-D2's circuits. Fortunately, the durable droid is repaired once

more, and joins his now-victorious friends and their new Ewok allies in celebrating the Empire's defeat.[91]

As for what we can expect from R2-D2 in the future, he was the first cast member confirmed to appear in the *Star Wars: The Force Awakens*. What sets this R2-D2 apart though is the fact that he is fan-made, constructed by R2-D2 Builders Club members Lee Towersey and Oliver Steeples, who are officially a part of the *Episode VII* creature effects team. "It all started when Kathleen Kennedy toured the R2-D2 Builders area at Celebration Europe this past summer in Germany," said Steeples.[92] He jokingly mentioned that the R2-D2 Builders in the UK were available if needed, but then as production geared up, executive producer Jason McGatlin recruited them on Kennedy's recommendation. Want to make an R2-D2 of *your* very own? Repair the hyperdrive, then make the Kessel run to chapter 98 to find out you can make like a Skywalker and become a certified droidbuilder.

C-3PO

"We're doomed!" Those two words perfectly encapsulate the philosophy of C-3PO, the walking, talking, cyborg version of Emily Post. Though he spends most of his time constantly fretting whether or not he and his friends will survive, C-3PO is much more than comic relief. Rather, he is a tremendously capable protocol droid who is fluent in over 6 million forms of communication (as he is more than ready to tell you) and designed to facilitate intergalactic diplomacy. Alongside his trusty compatriot R2-D2, the Rosencrantz to his Guildenstern, C-3PO is one of only two characters to appear in all seven *Star Wars* films, making

him a series stalwart and a welcome symbol of the galaxy far, far away.

In his original concept art, Ralph McQuarrie drew inspiration from the automaton from Fritz Lang's 1927 classic *Metropolis*. (In fact, it was the strength of this concept art that led Anthony Daniels to accept the role.)[93] His original version featured a much more human-like face and a different torso. However, McQuarrie still found himself disappointed with the design. It wasn't until production designer John Barry suggested making the eyes round—which gave Threepio his signature surprised look—that McQuarrie felt truly satisfied with the character.[94]

As a young slave on Tatooine, Anakin Skywalker used his budding engineering talents to build a droid in order to assist his mother, Shmi: C-3PO. Lacking for materials, the original Threepio model did not yet have his iconic golden casing; rather, he appeared "naked" thanks to his servos and motors showing (a fact that R2-D2 was all too willing to point out). Though Anakin left his faithful droid behind when he left to become a Jedi, the two would be reunited 10 years later. Unfortunately, it wasn't necessarily a happy reunion as Anakin's mother Shmi had been kidnapped by Tusken Raiders, and would later die from the wounds she sustained during the ordeal.

Departing with Anakin and R2-D2, the group heads to Geonosis in order to rescue an imprisoned Obi-Wan Kenobi. Naturally, things go a little haywire when Threepio's head winds up on a battle droid's body. Fortunately, R2-D2 was able to set things right before Threepio had a chance to commit any wartime atrocities. Unfortunately, however, the same cannot be said for Chancellor Palpatine, who issued the dastardly Order 66, which branded the Jedi and those who helped them enemies of the state. Threepio was all but helpless as he witnessed the Jedi hunted down and killed like dogs, as well as his master's descent into the dark side. It wasn't all doom and gloom for our favorite robotic

worrywart though; he witnessed the birth of the Skywalker twins, Luke and Leia. When all was said and done, R2-D2 and he were reassigned to Captain Antilles aboard the *Tantive IV*. In spite of his valuable service, Threepio had seen too much; Senator Bail Organa ordered C-3PO's mind to be wiped.[95]

Flash forward 19 years, C-3PO and R2-D2 were still in Captain Antilles' service onboard the *Tantive IV*, on a top-secret mission to spirit away the Alderaanean Princess Leia along with plans for the Death Star. The Empire tracked them down, but Threepio and Artoo managed to make their way to an escape pod, which then crash-landed on the desert planet Tatooine. After being beset by Jawa scavengers, C-3PO and R2-D2 found themselves in the custody of Owen Lars, a moisture farmer, who put his nephew Luke Skywalker in charge of them. While cleaning the droids, however, Luke discovered that R2-D2 had the Death Star plans—and a distress signal from Princess

The Droids You're Looking For

Although C-3PO and R2-D2 are some of the most important characters to the *Star Wars* mythos, they did not appear in the original 1973 14-page story synopsis of "The Star Wars." They first appear in a 132-page rough draft of "The Star Wars," from 1974 as ARTWO DETWO and See Threepio. In the draft, ARTWO is an antiquated, battered, old tripod whose face is an array of computerized lights surrounding a radar eye, and Threepio is a tall, thin, equally battered humanoid robot. They are described as construction robots in an Imperial Space Fortress, which is subsequently attacked by Aquilaean starships. In spite of ARTWO's protestations, Threepio convinces the two to abandon their post, whereupon they meet Anakin Starkiller in the dune sea of Utapau. By 1975, however, Lucas' script titled *Adventures of the Starkiller, Episode I: The Star Wars* began with the droid duo already onboard a Rebel starship, and their subsequent evacuation and landing on a desert planet—a detail that would remain relatively unaltered through the production of the 1977 film.

Leia—stored within his databanks. Alongside new companions Obi-Wan Kenobi, Han Solo, and Chewbacca, the group set off to recue Princess Leia and put a stop to the Empire's evil plot.

With Leia held captive aboard the Death Star, the group had no choice but to make a daring rescue by infiltrating the space station. C-3PO and R2-D2 had their chance to shine when they managed to prevent their friends from being crushed in a trash compactor—not bad for a droid that moves as stiffly as Threepio. Although he did not participate in the Battle of Yavin 4, C-3PO volunteered to donate his parts to restore his dear friend R2-D2, who had been gravely damaged during the assault on the Death Star. Fortunately, they weren't needed as the astromech droid was repaired, and both were rewarded for their bravery in the Alliance's medal ceremony to celebrate their crucial victory over the Empire.[96]

In the wake of the Death Star's destruction, Threepio was relocated to Echo Base, the Rebel Alliance's forward operating base on the ice planet of Hoth. Although he was there primarily to work as an interpreter, C-3PO managed to detect and identify a rogue droid as an Imperial probe, buying the Rebel Alliance valuable time to scramble their fighters and make good their escape. Before he knew it, C-3PO found himself on Cloud City, alongside Han, Leia, and Chewbacca. What seemed like a safe port in a storm turned out to be an Imperial trap; Threepio was first to discover the Empire's presence, but his sleuthing was rewarded with blaster fire at point-blank range. Although Chewbacca and R2-D2 eventually managed to repair the mangled protocol droid and the group escaped on the *Millennium Falcon*, nothing could be done to save their friend Han Solo, who had been frozen in carbonite and handed over to the bounty hunter Boba Fett.

As it turns out, Han Solo's frozen body was brought to the palace of Jabba the Hutt, a crime lord on Tatooine. Threepio proved essential in the plan to rescue Solo—Luke Skywalker, now

a Jedi Knight, offered them up as tribute to the corpulent crime lord in a bid to save Han. Of course, unbeknownst to C-3PO, he and Artoo were just pawns to lull the gangster into a false sense of security. When the moment was ripe, Artoo revealed that he had smuggled Luke's lightsaber inside his body. When the dust settled, Jabba the Hutt was dead, Han was rescued, and Boba Fett was a Sarlacc snack, leaving our heroes to resume their fight against the Empire on the forest moon of Endor.

While attempting to destroy the Death Star II's shield generator on Endor, the group found themselves tangled up in more than just Sith plots; Chewbacca accidentally triggered a net trap, hoisting the group high above the ground. A tribe of small furry creatures called Ewoks surrounded them, and seemed like they were going to attack until they saw C-3PO. Immediately, the Ewoks went from hostile to reverent, dropping to their knees and chanting. They had mistaken C-3PO for a god. His divinity was short-lived, however, after Luke Skywalker used his Force powers to scare the Ewoks into cooperation. After C-3PO explained the severity of the situation, the Ewoks lent their aid to the Rebels in the ensuing Battle of Endor, an alliance that ultimately won them the battle and effectively saved the galaxy. Praise be to Threepio indeed.

As for what to expect from C-3PO in *The Force Awakens*, don't worry about seeing your beloved protocol droid replaced by a CGI monstrosity; Anthony Daniels has confirmed that not only will he reprise his iconic role, but he will be back in the suit performing it live. While Daniels has been coy about giving away details of the upcoming film—rightly so—he did muse about how he'd like to see Threepio's ultimate storyline progress:

"I think probably he would realize that his programming was failing, that it was too old fashioned, and Microsoft had stopped supporting that particular brand," Daniels said. "He would see upcoming new robots and realize his power source was running

out. He'd say to R2, 'Can you go down and get me a new power spectrum?' or whatever.... I think he would go on. Getting spare parts, getting surgery. And I think the people around him, humans and droids alike, would help because he had become part of their daily lives, part of their environment. They wouldn't want to let him go," he continued.[97]

"Threepio is nice to have around. I think he would go on and on and on," said Daniels. Based on the incredible popularity of the *Star Wars* saga, it's a safe bet to say that this particular protocol droid will keep on going for many years to come.[98]

16 *Star Wars: The Clone Wars*

Though the prequel trilogy takes a lot of flak from older fans, the Clone Wars are a genuinely compelling piece of *Star Wars* history. After nearly a thousand years of dormancy, the Sith reemerge to engineer a sprawling and bloody conflict, exterminating most of the Jedi, and bringing most of the galaxy under heel. It's a plan that is stunning in scope, beautiful in its sheer evilness, and terrifying in its execution. While the prequel trilogy did not exactly do that story justice—in my opinion, at least—the two Clone Wars–centric animated series and the animated movie provided the connective tissue and further world-building that was so desperately needed. Beginning with Genndy Tartakovsky's *Star Wars: Clone Wars* microseries in 2003, then with the 2008's *Star Wars: The Clone Wars* film, and the subsequent *Star Wars: The Clone Wars* TV series that ran for six seasons, the period in between *Episode II: Attack of the Clones* and *Episode III: Revenge of the Sith* expanded in some seriously radical ways.

Set during the three-year period between *Episode II* and *III* 2003's, *Star Wars: Clone Wars* offered a wide-ranging, probing look at the escalating conflict between the Republic and the Confederacy of Independent Systems. Created by animation phenom Genndy Tartakovsky (*Samurai Jack*, *Dexter's Laboratory*), *Star Wars: Clone Wars* was, according to its creator, "a Clone Wars–style story with a *Band of Brothers*-feel to it— where its episodes of different battles and strategies during the Clone Wars." This style of storytelling lent itself well to Tartakovsky's episode structure, which consisted of three-minute shorts during the first season, and 12–15 minute shorts during the second season.

The Emmy-winning program followed Obi-Wan Kenobi leading an assault on the planet Muunilinst, where the Intergalactic Banking Clan is bankrolling the CIS. Meanwhile, Anakin Skywalker is tasked with leading the space forces and providing aerial support. Interwoven with this storyline are the interplanetary exploits of other Jedi: Mace Windu battles an entire droid army unarmed by himself on the planet Dantooine; Anakin defeats Count Dooku's Dark Jedi apprentice Asajj Ventress on Yavin 4, but only by tapping into his inner anger (which as we all know leads to the dark side); and Kit Fisto leads a team of marine clone troopers to the squidtacular aquatic planet of Mon Calamari. *Star Wars: Clone Wars* capped off its run by charting Anakin's growth as a Jedi Knight and a war hero of the Republic, only to show how General Grievous launches an assault on Coruscant in order to kidnap Chancellor Palpatine for Count Dooku. With his spirit in more turmoil than ever, Anakin sets out with Obi-Wan Kenobi to rescue the Chancellor, events that lead directly into *Revenge of the Sith*.

With *Clone Wars*' finale in March 2005, *Star Wars* fans would have to wait three long years until an animated feature film, titled *Star Wars: The Clone Wars,* would hit theaters.

Intended to serve as an introduction to the animated series of the same name, *The Clone Wars* was widely panned by critics, with one reviewer saying, "*The Clone Wars* is to *Star Wars* what karaoke is to pop music."[99] If that weren't scathing enough, several other critics referred to it as the worst thing since the notoriously ill-fated *Star Wars Holiday Special*. The film itself followed the Jedi Knights Obi-Wan Kenobi and Anakin Skywalker, and Ahsoka Tano, Anakin's newly appointed Padawan, as they try to rescue the kidnapped son of Jabba the Hutt. Though Jabba is a generally reviled sleazy scumbag of a crimelord, his son is being used as a pawn in an attempt to frame the Jedi for the heinous crime. In truth, it is a Separatist plot hatched by Count Dooku in order to position the Hutts against the Republic, further weakening their position in the Clone Wars. Of course, our heroes prevail, foiling Dooku and his apprentice Asajj Ventress, as well as bringing the Hutts into the war on behalf of the Republic.

Over the course of *The Clone Wars*' six seasons, we cover an incredible amount of ground for what is supposed to be a three-year period. Created by a creative braintrust of George Lucas and Dave Filoni, *The Clone Wars* Season 1 took the baton passed by the movie, pitting our Jedi heroes against two primary antagonists, Count Dooku and General Grievous, and showed how both the Republic and the CIS were scrambling to get different planets and systems on their side.[100] Marketed as "Rise of the Bounty Hunters," Season 2 saw the Sith outsourcing their evil schemes to an array of bounty hunters and killers-for-hire, leading to subterfuge, skullduggery, and Boba Fett's quest to kill Mace Windu to avenge his father's death.[101] With Season 3, dubbed "Secrets Revealed," new character designs were implemented to reflect the passage of time, as well as the introduction of the Nightsisters of Dathomir, an ancient order of witches that

produced warriors like Asajj Ventress, Darth Maul, and, as we see in this season, Maul's brother, the deadly Savage Opress.[102]

Picking up the breadcrumbs laid in the previous season, Season 4, subtitled "Battle Lines," sees Count Dooku decimate the Nightsisters in revenge for their attempts to assassinate him, Palpatine's first attempts to turn Anakin to the dark side, and the long-teased return of Darth Maul.[103] (Gasp, you should!). After seasons of positioning and vying for dominance, everyone is ready to enact their endgames, it would seem. In Season 5, everything comes to a head as Darth Maul assembles an unholy alliance of space pirates and terrorists in a bid to conquer Mandalore, only to see his brother murdered and himself tortured at Darth Sidious' hand; R2-D2 joins an elite task force of covert ops droids called D-Squad; and last but not least, Ahsoka Tano is accused of engineering a terrorist plot, forced to go on the lam, and ultimately leaves the Jedi Order.[104] Unfortunately, this was the last official season of the show on Cartoon Network, leaving a number of episodes in limbo that became known as *The Lost Missions*.

Thankfully, the Force was strong with *The Clone Wars*, and Netflix transformed *The Lost Missions* into a 13-episode Season 6. The first arc played out like a Hitchcockian thriller, unraveling a potboiler of a story about the near-discovery of Order 66 before it was to come to pass. Later, the season explored the story of Sifo-Dyas, the exiled Jedi who commissioned the creation of the clone troopers in the first place, and his subsequent assassination by the Sith. In a fitting fashion, the series ended with Yoda venturing to the heart of the galaxy, at the behest of his long-dead friend Qui-Gon Jinn, to learn the secrets of the Force. Once reaching the planet where the Force first appeared, Yoda undergoes a series of spiritual trials, experiencing bleak visions of the future, and ultimately mastering the secret of Force immortality (the ability to project one's consciousness as a Force ghost after death). In the

course of his visions, Yoda comes to understand that though the future and the outcome of the Clone Wars are uncertain, one day a new hope will appear—a nice touch connecting the prequels to the original saga.[105]

Where *The Clone Wars* in all of its iterations triumphs is in creating tangible connections between the prequel trilogy and deepening the audience's relationship to these characters in palpable ways. The introduction of characters like Ahsoka Tano not only gave audiences new heroes to root for, but it gave Anakin Skywalker a context for the rapid change he seems to undergo between *Episode II* and *III*. Likewise, the series managed to make Count Dooku one of the most frightening, effective villains in the *Star Wars* universe, as well as giving a swan song to Darth Maul, a fan favorite who many thought was unfairly killed off before his time. In an interview, supervising director Dave Filoni spoke of the series' legacy, saying, "People have a hard time relating to each generation of *Star Wars* fans. Now there's a whole generation of *Clone Wars* fans that are very fond of those characters and what they meant to them."[106] Though *The Clone Wars* have come to a close, there is a new hope for fans of the original series, too, in the form of a little show called *Star Wars: Rebels*.

17 Star Wars: Rebels

Just as *The Clone Wars* provided much-needed connective tissue between the events of *Attack of the Clones* and *Revenge of the Sith*, *Star Wars: Rebels* gives us a greater understanding of the years leading up to the events of *A New Hope* and the Galactic Civil War. The CG-animated series serves as something of a spiritual

successor to *The Clone Wars*, expanding the official canon of the *Star Wars* saga in bold new ways since its launch in October 2014. Since we know what comes before and after, the challenge then becomes making the story of the interim and the journey from point A to point B an interesting one. As producer Simon Kinberg put it, "You don't want to be too close to *New Hope* so that it feels like it's repetitive, you want to feel like you're watching the earliest seeds of what will sprout into a full-blown rebellion."[107] Fortunately, *Star Wars: Rebels* not only meets that goal; it obliterates it.

Set five years before *Star Wars Episode IV: A New Hope* and 14 years after the fall of the Republic and the Jedi Council (as seen in *Revenge of the Sith*), *Star Wars: Rebels* follows a motley crew of, well, rebels who come together from across the galaxy in order to fight back against the Empire. Yet, this is not the Rebel Alliance we know and love from the original saga; rather, our heroes are a small, ragtag cell of freedom fighters who seek to destabilize Imperial operations on and around the planet Lothal, a relative hinterlands compared to more cosmopolitan worlds like Coruscant. Though its scope may seem limited at first blush, the series slowly peels back the curtains to reveal an ever-larger universe, and one in which our titular rebels are a small, but integral part. You know, kind of like the marshmallows in your hot chocolate; sure you could enjoy it without them, but it just wouldn't be the same. Now go ahead and take a quick five-minute break to get yourself some hot chocolate. I'll wait...are you back? Good!

Created by Carrie Beck, Dave Filoni, and Simon Kinberg, *Star Wars: Rebels* was born out of an idea by Beck to create a series focusing on an A-Team–style group of characters that went around righting wrongs. Except instead of a weird van, they gallivant around the galaxy in a sweet starship. According to Filoni, it was a pitch that reminded him of his initial concept for *The Clone Wars*. "My rough idea was to deal with a small number of

characters," said Filoni. "[A Jedi Master and Padawan, a smuggler and his girlfriend, and a Gungan 'strongman' called Lunker], have them based on a *Millennium Falcon*–style smuggling ship, and involve them in black market trade, war espionage, and other stories that existed outside the giant galactic conflict going on in the background."[108] Considering it comes from much of the same creative team behind *The Clone Wars*, it makes sense that it has such shared DNA. To date, the series is comprised of four shorts, a film (*Star Wars: Spark of Rebellion*), and a 13-episode first season, with a second season on the way.

The series centers on a disparate group of characters who come together for the common purpose of striking back against the increasingly oppressive Galactic Empire. Aboard their trusty freighter, the *Ghost*, our heroes are rebels *with* a cause (albeit without an Alliance): Hera Syndulla, the ace Twi'lek pilot and the glue that keeps the group together; Ezra Bridger, the troubled young thief with Padawan potential; Kanan Jarrus, a rough-and-tumble Jedi Knight who survived Order 66, and serves as both the de facto leader and Ezra's mentor; Sabine Wren, the Mandalorian explosives expert with a passion for street art; Garazeb "Zeb" Orrelios, the extremely loyal musclebound bruiser and one of the last remaining Lasat people in the galaxy; and, of course, Chopper, a finicky astromech droid that could out-sass R2-D2 any day of the week—which is really saying something. (In fact, Chopper's design is based heavily on Ralph McQuarrie's original R2-D2 sketches.)[109]

In the early days of the battle against the Galactic Empire, the crew of the *Ghost* does what little they can to impede the Empire's progress. However, this attracts the attention of Agent Kallus, an officer in the Imperial Security Bureau, who wants these troublemakers eliminated before they can pose a greater threat than they already do, or worse—inspire others to do the same. Over the course of the season, we see Kanan's struggles

to help train Ezra, especially after Ezra winds up using the dark side of the Force in a fit of rage; Hera uncovers an Imperial spy in their midst and maintains contact with the shadowy, but helpful informant known as "Fulcrum"; Chopper continues to be unreasonably petulant; and what starts as small-scale sabotage and stealing cargo from Imperial freighters turns into a dangerous game of cat and mouse. With the gang fully in Kallus' crosshairs, a deadly enforcer known as The Inquisitor is dispatched to track them down. Considering his name is "The Inquisitor," it shouldn't come as too much of a surprise that he is a cold-blooded bastard whose mission statement is to hunt down and murder all Jedi who survived Darth Sidious' nefarious Order 66.

Though the odds are stacked against them, good manages to prevail as the team defeats The Inquisitor, who chooses to fall to his death rather than face the punishment awaiting him for failing. Fulcrum is revealed to be none other than—spoiler alert—Ahsoka Tano, the former Padawan of Anakin Skywalker-turned-Rebel leader, who tells the crew of the *Ghost* that they are but one cell working for a larger rebellion. The fires of change are on the horizon and the heroes of *Rebels* are providing the sparks needed to ignite. Yet another threat looms large on the horizon. With The Inquisitor out of the picture, there is a new agent tasked with rooting out and destroying the rebels: Darth Vader. What was a microcosm of the *Star Wars* universe and the larger conflict that has wracked the galaxy is opening up and widening its scope with every episode. One can bet their bottom dollar—or their Imperial credit—that this world will only get more expansive in season two. Considering how little we know about the intervening period between the end of the Clone Wars and the start of the Galactic Civil War, *Rebels* is a must-watch for any *Star Wars* fan. Plus, how can you say no to a droid like Chopper? He's so dang cute (even if he is a little rude).

18 J.J. Abrams: A Franchise's New Hope

When Disney announced in October 2012 that it was spending a cool $4 billion to purchase Lucasfilm Ltd. (including the *Star Wars* IP) and that *Star Wars Episode VII* (later to be subtitled *The Force Awakens*) was coming in 2015, fans around the world, myself included, damn near lost their minds. Once the dust settled and we, as a society, collectively regained consciousness, the question then became "Who will direct the movie?" Names like Edgar Wright, Brad Bird, and Steven Spielberg were tossed around the blogosphere as potential candidates to fill the shoes of men like George Lucas, Irvin Kershner, and Richard Marquand. However, a few months later all rumors were put to rest when Disney announced that J.J. Abrams would be helming the project. What followed was roughly 60 solid days of non-stop lens-flare jokes. Seriously. I wish I was kidding.

Born in New York and raised in Los Angeles, Abrams is the son of television producer George W. Abrams and producer Carol Ann Abrams. In other words, the entertainment industry is in his genes. His very first job in show business came at the tender age of 16, when he penned the music for cult horror director Don Dohler's 1982 film *Nightbeast*. From these auspicious beginnings, Abrams would make his first real splash in the entertainment industry in 1990 by teaming with Jill Mazursky during his senior year at Sarah Lawrence College to write a treatment for a film that would be purchased by Touchstone Pictures and turned into *Taking Care of Business*, a comedy starring Jim Belushi and Charles Grodin.

From there, Abrams went on to write a number of films, including *Regarding Henry* (1991), *Forever Young* (1992), *Gone*

Fishin' (1997), and *Armageddon* (1998). The same year he worked on *Armageddon*, Abrams made his first leap into television with *Felicity*, which he co-created alongside future *Dawn of the Planet of the Apes* director Matt Reeves. Though *Felicity* was a critical success, Abrams wanted to make something more action-packed. In 2001, Abrams founded his production company Bad Robot alongside producer Bryan Burk, and launched the spy drama *Alias,* starring Jennifer Garner as the superspy Sydney Bristow. Over the course of *Alias*, Abrams developed a reputation for layered, intricate, twisting storytelling, but nowhere would that be more evident than in his 2005 megahit *Lost*.

In case you had any doubts about Abrams' pedigree, look no further than *Lost*. The show centered around the survivors of a plane that crashed on a mysterious island. Running for six increasingly labyrinthine seasons, *Lost* was a dynamic, polarizing, and wildly popular piece of serialized television storytelling. It also had an inexplicable smoke monster, polar bears, and electromagnetic phenomena held at bay by little more than an innocuous red button. While the program grew increasingly divisive and complicated as the years went on, it remains one of the quintessential examples of "must-watch TV." It also effectively created the phenomenon of binge-watching once it came out on DVD, prompting weekly viewing parties and heated discussion in forums and around office water coolers across the land. I have watched its pilot episode more than any other piece of television to date as part of my high school and college crusade to induct other people into its maddening mysteries.

While Abrams continued producing television series like *What About Brian, Six Degrees,* and *Fringe*, and films like *Cloverfield*, his biggest break to date would come in the form of 2009's *Star Trek*, a high-profile film reboot of the long-running sci-fi franchise. Little did Abrams know, but managing the incredibly dense mythology he and his crew cultivated on *Lost*

was a toolset that would serve him well on projects like *Star Trek* and, eventually, *Star Wars: The Force Awakens*. Grossing $385 million worldwide, *Star Trek* was a feather in Abrams' cap and proof that not only could he helm a massively popular franchise film, but he could revitalize it too.

Having just reinvigorated (and retconned) Paramount's ailing *Star Trek* franchise, Abrams seemed like a natural choice to help launch the next chapter of *Star Wars*. After all, this is

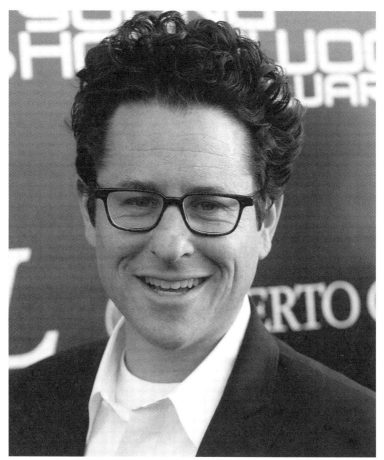

An image of The Force Awakens *writer/director J.J. Abrams, depicted without his signature lens flares.* (Dan Steinberg)

the man who snuck an errant R2-D2 into the background of *Star Trek Into Darkness*. No stranger to genre cinema, Abrams has carved out a niche as one of Hollywood's go-to creatives for tackling massive franchises with complex, arcane universes, as evidenced by his work on *Star Trek, Lost,* and *Mission Impossible IV: Ghost Protocol.* Yet when it came to tackling *Star Wars*, Abrams was understandably hesitant, so much so that he turned down the project when it was initially offered to him. However, in classic Abrams twist-ending fashion, he made an about-face and accepted the most coveted director's chair in the world.

"My knee-jerk reaction was that I'm in the middle of working on the *Star Trek* movie and I can't even consider it," he said in an interview with *Empire* magazine. "But then time went by and I got further along working on the movie and getting to a place where I had done most of the heavy lifting. So when I met with Kathy Kennedy we just started discussing it and I was able to actually engage in the conversation. I went down to tell Katie, my wife, and I said 'I just had a very interesting conversation with Kathy.' That was the beginning."[110] From those auspicious beginnings, *The Force Awakens* has emerged like a phoenix from the ashes of what many thought was a finished franchise.

What's next for Abrams after he returns from the galaxy far, far away? Well, most fascinating among Bad Robot's production slate is a partnership with the Valve Corporation in order to make film adaptations of uber-popular video games *Half-Life* and *Portal*. (For the record, fellow gamers, we're way likelier to see a *Half-Life* movie before we'll ever see a *Half-Life 3*.) One thing is for certain, though, so long as Abrams is around, no matter the project, you can rest assured that it will have ambition, heart, and a sense of adventure. And yes, there will probably be lens flares too. (Ugh, fine, I did it. Are you happy now?)

Irvin Kershner

While George Lucas is often pointed to as the creative force behind the *Star Wars* universe—and given the ominous proper noun nickname The Creator by some—it was director Irvin Kershner who helped give an unprecedented level of emotional depth to *The Empire Strikes Back*, which is widely regarded as the best film in the series. Affectionately dubbed "Kersh" on set, the Philadelphia-born director first made a name for himself working on documentaries in Iran, Greece, and Turkey for the United States Information Service, as well as a series of feature films, including *The Flim-Flam Man* with George C. Scott and *Eyes of Laura Mars* with Faye Dunaway and Tommy Lee Jones. Most famously, though, Kershner was given the unenviable task of helming the follow-up to the biggest film in the world—and the weight of all the fan expectation that came along with it.

To many, the USC graduate may have seemed like an unlikely candidate to take on the mantle of directing the *Star Wars* sequel. When he asked George Lucas why he had been selected over a number of other young, hot-shot directors, Lucas countered in his classic outsider fashion: "Well, because you know everything a Hollywood director is supposed to know, but you're not Hollywood."[111]

"I think the critics felt that they were going to see an extension of *Star Wars*," Kershner reflected in a 2010 interview with *Vanity Fair*. "In other words, they wanted another *Star Wars*. I decided that the potential was much greater than a rerun of *Star Wars*. When I finally accepted the assignment, I knew that it was going to be a dark film, with more depth to the characters than in the first film."[112]

By far, the most difficult scene they shot was the scene in which Han Solo is frozen in carbonite after Lando Calrissian betrays his former friend to the Empire. "That was a hell of a day," Kershner recounted in an interview. "We were all about 30 feet off the stage floor and it was a black set. Black. We were shooting reflections off the black lacquer, can you imagine that? It was a perfectly round set, but we couldn't fit the round set on the stage so we built half a set, and I reversed. I'd shoot one direction and then I would change everybody around and put the people the opposite side in the same place and shoot them for the reaction, you see? But I only had to build half a set. And I had to keep it in mind, what the hell was happening on the side that you didn't see, because I had to keep going back and forth."[113]

The room itself was infamously hot and the scene called for a lot of steam to shoot out of the floor. "Some of the little people fainted because they were closer to the steam," Kershner recalled. "The actors were about 30 feet off the ground and we had to be careful that they didn't fall."[114]

Shooting the scene wasn't the only difficulty Kershner faced that day; that was also the day that the infamous "Frozen Han" mold was to be made. "I had sent Harrison down to the special effects shop to make the mold for the slab that he was gonna be encased in," Kershner said. "They finished it and he came back to me and it was ridiculous. He was lying there like a corpse, absolutely dead. And I said, 'No, it's out of character.' I was trying to train them all that everything has to be true to character, including when Harrison is in the slab. So I told him, 'Try to fight your way out of the slab.' And so he went back and they made a new one where he's pushing out with his hands, and that was the right one. You see, character again. He would never give up."[115]

One more major behind-the-scenes moment happened while Kershner and company were shooting the Carbon Freeze scene. In the original script, when Princess Leia tells Han Solo,

"I love you," his response in the script was, "I love you, too." According to Kershner, they shot the scene, but something didn't seem right; the line wasn't in keeping with his character. They kept trying and trying, but no matter what, they couldn't get it right. Finally, on the last take before the designated lunch break, Harrison Ford improvised the line, "I know." After that take, Kershner turned to his assistant director David Tomblin and said, "It's a wrap." Tomblin looked back at Kershner in mild horror, asking Kershner if he was *sure* that was the line he wanted. "I said, 'Yes, it's the perfect Han Solo remark,' Kershner explained, "and so we went to lunch."[116]

When Lucas finally saw the first cut of the film, he was more than a little perturbed. However, after the altered line brought the house down at a preview screening in San Francisco, Lucas realized it was, indeed, better and more in keeping with Solo's character. Though *Empire* proved to be a strenuous shoot, Kershner never let hardship get him down; rather, he kept plugging away. "It was so difficult," Kershner remarked. "Every shot was like pulling a donkey out of a hat. Because things didn't work, you had to make them work and improvise every time."[117]

It's a testament to the quality of Kershner's work that *The Empire Strikes Back* was largely unchanged in the infamous 1997 Special Edition releases. To the disappointment of many fans, Kershner turned down a chance to direct *Return of the Jedi*. "After working for two years and nine months doing *Empire*, and having it take so much out of my life and having given me so much, I felt that it was a complete experience and it was time to move on," he said.[118]

On November 27, 2010, Irvin Kershner passed away at age 87 after a lengthy battle with lung cancer. In addition to his indelible contributions to the *Star Wars* universe, Kershner directed a number of other feature films, including *Never Say Never Again* and *RoboCop 2*. Though his light may be gone from the world,

the mark he left on a generation of filmgoers is undeniable, and his creative legacy remains untarnished. Perhaps it was Kershner himself who said it best in the May 1980 issue of *Starlog,* when asked about the value of films like *Empire Strikes Back*:

"Entertainment. Not thoughtless sensory stimulation, though. Entertainment at its best stimulates the senses, the emotions, the intellect; and it reveals something of the world that has heretofore been closed to you. Doors are opened to new esthetic forms. Every illusion in a film is an organization of space and objects. If the result has form, that tends to educate the audience, to give them that sense of form. And that is illuminating."[119]

20 Richard Marquand

He may not have been the first choice to direct *Return of the Jedi.* Nor was he the second or possibly the third choice. Those honors belong to David Lynch, David Cronenberg, and, rumor has it, Steven Spielberg, respectively. But the fact of the matter is that none of those men directed the capstone of the original *Star Wars* trilogy; that honor belongs squarely to Richard Marquand, the Cardiff, Wales–born director who made a name for himself directing the 1981 thriller *Eye of the Needle.* "I was very impressed with [Marquand's] directing," said George Lucas. "It's very tight, very clean, [a] strong movie with narrative, character and just getting the most emotional value out of a concept."[120]

The only non-American to have directed a *Star Wars* film, Marquand was already a fan of George Lucas' work, and especially the *Star Wars* saga, when he accepted the job. "I am a tremendous *Star Wars* fan; I know the story means an enormous

love to me," he revealed in a 1984 interview. "I love the characters. In a way, I felt like a young man who knows the music of Beethoven extremely well, and who is finally asked to play it with the London Symphonic Orchestra."[121]

Marquand faced a unique challenge with making *Return of the Jedi*. Not only did he have to appeal to children, but viewers who were children when they saw the original *Star Wars* film had grown up alongside the film. As the tone grew more mature in *Empire Strikes Back*, so did they. Thus, Marquand needed to craft a film that could appeal to both younger viewers and adults alike. With a budget of slightly over $32 million and George Lucas determined not to go over budget, Marquand had his work cut out for him. Whereas Kershner had relative creative autonomy on *Empire Strikes Back*, Lucas was more heavily involved since Marquand lacked experience directing a film so reliant on special effects. "It is rather like trying to direct *King Lear*," Marquand once joked, "with Shakespeare in the next room!"[122]

Still, Marquand was able to make an impact on the film's creative development. When it came time to write an official shooting script, Lucas, screenwriter Lawrence Kasdan, and producer Howard Kazanjian spent two weeks taking part in story conferences where they discussed ideas and hammered out final details.[123] It was during these meetings that Marquand was able to affect the most change. For instance, Marquand suggested that Lando disguise himself within Jabba's palace and that Leia disguise herself as the bounty hunter Boushh, only to get discovered and turned into a "dancing girl." Likewise, Marquand is responsible for casting Ian McDiarmid as Emperor Palpatine, and acting as a go-between for Lucas and screenwriter Lawrence Kasdan, who often found themselves at odds with one another. Marquand's level-headedness and thoughtful nature often prevailed, leading the two to compromise.

Most importantly, when George Lucas asked Marquand who should play Admiral Ackbar, the director replied that it should be a creature. When prompted to pick one out, the Welshman selected a "wonderfully big calamari man."[124] Though his choice was considered highly objectionable, he prevailed and the franchise gained one of its greatest characters.

A firm believer in pre-planning, Marquand proved more than up to the task of directing, doing his best to run a tight ship under Lucas' watchful eye. "As the director you're the focus of everybody's attention," Marquand said in an interview. "It's important that they feel that you know where the scene is going. The moment it's over and you're happy and you say 'Print,' if the very next thing you say is, 'Now we're over here on the 35 and I want to be on a low angle,' if you immediately know where the next scene is going, everybody can feel this horse racing under him and they know it's carrying them to the finish line. It's a nice feeling, but it can easily be broken by an actor having a temperament or by a first assistant who thinks that everything should be done through a bullhorn."[125]

The most challenging actor for Marquand actually wasn't an actor at all; it was the R2-D2 unit *without* Kenny Baker inside. "When R2-D2 is running just on his electronics, he's a beast," Marquand said. "He's the most rude and ill-behaved actor you've ever worked with in your whole life. He would just turn around and walk out of the door. I love him, though, because he's so good in the end." Though Marquand may have loved the little astromech droid, problems with his operation lead to delays on the production. Likewise, issues with the set for the Ewok village and with the special effects device that Boba Fett used to ensnare Luke Skywalker led to additional delays.[126] Still, Marquand overcame adversity and managed to wrap the production on schedule—no small feat, especially in the galaxy far, far away.

Tragically, Marquand died of a stroke on September 4, 1987, at age 49, just 18 days shy of his 50th birthday. Though he

had expressed interest in eventually directing a prequel film, he would, unfortunately, never be able to. Marquand's part of the *Star Wars* legacy is an important one as he brought the sprawling original saga to a close, a daunting task by anyone's measure. Some people love *Return of the Jedi*, while others consider it the weakest of the original trilogy. For years and years, when I was younger, it was my favorite of the three, perhaps because the forest moon of Endor reminded me of the wooded thicket near my childhood home.

By his own estimation, Marquand remarked that with *Return of the Jedi*, he was "able to entertain the little kids with the Ewoks and all the stuff that made them feel safe." He continued, saying, "But I was able, at the same time, to give young adults the kind of things they're looking for, which is a lot of excitement, a lot of showmanship. But they are also looking for true relationships and genuine emotions. I think that's what has always been in the Star Wars saga, but I was really able to bring that out and make it work. I think that's what *Return of the Jedi* had that the others didn't have. I'm not criticising the others: they simply weren't ready for it."[127] Maybe the world wasn't ready for Marquand and his Ewok-filled finale, but he certainly was—and that's all that really counts.

21 The Jedi Order, Champions of the Light Side

Luke Skywalker, Obi-Wan Kenobi, Master Yoda, Mace Windu, Qui-Gon Jinn, Ahsoka Tano—these lightsaber-wielding, Force-using warriors have one thing in common: they look great in beige robes. Okay, that might be a side effect of the *real* thing

they have in common—they are all members of the Jedi Order, the guardians of peace and justice in the galaxy far, far away that George Lucas created as the heroes of his epic space opera. Typically wielding blue or green lightsabers, Jedi are members of a monastic order who lead an ascetic lifestyle, eschewing earthly desires and emotional attachment in favor of attuning themselves with the Force and the natural world.

As for the word "Jedi," it is said to be derived from the Japanese word "*jidaigeki*," a term referring to historical dramas like Akira Kurosawa's *The Hidden Fortress*, which directly inspired the creation of *Star Wars*.[128] Those who sought to become Jedi must follow The Three Pillars—The Force, Knowledge, and Self-Discipline—a system of overarching philosophical guidelines to guide their everyday lives. Just as they follow a strict code of conduct, the Jedi Order follows a rigid hierarchical structure, with its members progressing through four different stages of development.

Jedi Initiate: The first part of a Jedi's training and educational development, during which candidates are taught rudimentary self-defense techniques and basic control over the Force. Most Initiates are recruited from a very young age—some as young as five years old—and are taken to the Jedi Academy to train in the ways of the Jedi. Known as Younglings, these candidates often don't see their parents again until they are adults, but hey, that's the price you pay for being able to wield the Force.[129]

Jedi Padawan: After completing their Initiate training, eligible Jedi candidates move on to become Padawans (derived from a Sanskrit word translating roughly to "learner"). Also known as Apprentices, Padawans continue their educational development under the tutelage of a Jedi Knight or a Jedi Master to whom they are assigned. Like many high schoolers, Padawans make some questionable choices in regards to their hairstyle, wearing a long braid on the right side of their head, which is removed with

a lightsaber once they reach knighthood.[130] As part of their training, they must construct their own lightsabers, a ritual depicted during the *Star Wars: The Clone Wars* episode "The Gathering."

During The Great Sith War, the practice of a Jedi Knight/Master only having one Padawan at a time was formalized. However, there was a provision that allowed the policy to be revoked if a declining membership necessitated it.[131]

Jedi Knight: After nearly a decade of continuous, one-on-one training with their master, a Padawan could partake in the Jedi Trials. Those who successfully completed the tests would have their Padawan braids severed and become Jedi Knights. No longer having to answer to a master, Knights were free to pursue one of three paths of specialization—Jedi Guardian (warriors, starfighters, and combat trainers), Jedi Consular (healers, diplomats, and lore keepers), and Jedi Sentinel (intelligence agents, security officers, and investigators). In addition, Knights were eligible to participate in missions issued by the Jedi Council.[132]

Jedi Master: For extraordinary Jedi who demonstrated an exceptional mastery of the Force or particularly great wisdom, the High Council could raise them to the rank of Master. These are the greatest Jedi of them all, paragons of wisdom, courage, strength, and serenity from whom younger members of the Order could draw inspiration. The Council itself was comprised of 12 Jedi Masters, five of them serving for life, four serving for a longer term, three serving for a shorter tem.[133] Essentially, they're the United Nations Security Council combined with the Supreme Court combined with, well, magic space powers.

The ancient order of warrior-monks use the light side of the Force to preserve the order of the universe, and ensure that peace reigns. The proud organization boasted a variety of enclaves across the galaxy, including their massive headquarters, the Jedi Temple on Coruscant that serves as a training academy and the home base of the Jedi Council. For more than one thousand

generations—that's generations, not years—the Jedi served as intergalactic peacekeepers. However, the reemergence of the Sith, an ancient sect of rogue Jedi who use the dark side of the force to promote an agenda of hate and destruction, threatened their very existence.

The Clone Wars, secretly orchestrated by the Sith Lord Darth Sidious, would prove to be the beginning of the end for the Jedi Order as it once existed. As the conflict spread across the galaxy, the typically peaceful Jedi knights found themselves forced into service, acting as generals, and compromising their ideals. Toward the end of the war, Sidious issued the fateful Order 66, a command that labeled all Jedi enemies of the state and demanded their heads on a platter. With their numbers decimated and the survivors scattered to the wind, the Jedi operated in secret, chipping away at the ever-expanding Galactic Empire until the emergence of the Chosen One, Luke Skywalker, who would eventually go on to overthrow Sith dominance of the galaxy.

Though Luke Skywalker restored the balance of the universe by the end of *Return of the Jedi*, it seems in *The Force Awakens* that the Jedi will be needed more than ever. Whether we can expect the emergence of a *new* Jedi, however, is the matter of much speculation. If I were a betting man, I'd say that we will absolutely see a new Jedi appear in the J.J. Abrams–directed film. Then again, if I were Han Solo, I'd say, "Never tell me the odds!" So, for now, let's make like Jedi and practice being patient.

22 The Sith Order, Warriors of the Dark Side

"Peace is a lie, there is only passion.
Through passion, I gain strength.
Through strength, I gain power.
Through power, I gain victory.
Through victory, my chains are broken.
The Force shall free me."

—The Code of the Sith[134]

Every hero needs a villain, and in the *Star Wars* universe, it's hard to find people more abjectly evil than the Sith. Wielding their trademark red-bladed lightsabers, clad primarily in black, and seething with hatred, the ancient order of Force-wielders devotes themselves to the dark side of the Force. Just how evil are they? Well, their code, written above, is permeated by a philosophy inspired by *Mein Kampf*—you know, Adolf Hitler's autobiography?[135] (Not the art student; the dictator.) Though some will tell you that the dark side reportedly has cookies, they are ones made with deception, greed, genocide, and acrimony. In other words: oatmeal raisin.

Much like the Jedi Order, the Sith employ a rigid hierarchical structure with masters and apprentices. Traditionally, the Sith give themselves new names, typically prefaced by the title "Darth." A mandate known as the "Rule of Two" was instated by Darth Bane, stating that only two Sith could exist at any given time: a Dark Lord of the Sith to embody power, and an apprentice to crave it. Darth Bane, the sole survivor of a war with the Jedi Order nearly one thousand years before the Clone Wars, realized that in-fighting and avarice led to the Sith's ultimate

destruction. To counteract this, he created the Rule of Two so that the Sith could operate in secret, masking their true intentions from those who might try to stop them.[136]

It was with this in mind that Darth Sidious, a.k.a. Chancellor Palpatine, launched his master plan, setting into motion one Machiavellian machination after another to destabilize the Republic so that he could seize ultimate power. With his apprentice, Darth Maul, Sidious worked to orchestrate the Trade Federation's invasion of Naboo, while simultaneously making a play to consolidate his political influence. Though Darth Maul died in a showdown with Qui-Gon Jinn and Obi-Wan Kenobi, he managed to take Qui-Gon with him as he shuffled off this mortal coil, falling into a seemingly never-ending chasm. Yet, the emergence of the young Force-sensitive boy Anakin Skywalker gave Sidious hope for the future, one in which he could lure the child to the dark side.

After Darth Maul's untimely death, Count Dooku forsook his Jedi oath in order to become the Sith warrior Darth Tyranus. Making himself the face of the Separatist movement, Dooku made aggressive maneuvers that plunged the galaxy into war. As a result, the Jedi order was forced to respond by making its knights generals. Forced to take up arms, the Jedi generals ultimately had to compromise their ideals, which weakened their resolve—and played right into Sidious' hand. With the Jedi weakened, it put the Sith in the perfect opportunity to strike, chipping away at the Jedi Order as the Clone Wars ravaged the galaxy.

Three years into the conflict, Darth Sidious launched his most ambitious gambit yet: he manipulated the young Jedi Anakin Skywalker into violently executing Count Dooku. Though he sacrificed his apprentice, the ploy worked, and Anakin soon sought advice from the "Senator." Spinning Anakin a yarn about the ancient "Sith legend" Darth Plagueis, a powerful Sith who used the dark side to prevent people from dying, Sidious had

Anakin hooked. The troubled Jedi feared for his wife, Padmé Amidala, because he had experienced visions of her dying during childbirth, and wanted to find a way to save her. The promise of such unholy power proved too much for Anakin to resist, and he became the Sith apprentice Darth Vader.

Now with Anakin by his side, Sidious issued Order 66, an executive order branding all Jedi traitors and demanding their execution. Leading the assault on the Jedi Temple was none other than the newly christened Vader himself. Using the confusion and terror to his advantage, Sidious dissolved the Republic and formed it into the Galactic Empire, declaring himself to be the Emperor. With the Jedi Order practically obliterated and the galaxy plunged into a time of darkness, Darth Sidious and Darth Vader brought much of the galaxy under their control, tightening the reins of their autocratic regime by constructing a supermassive moon-sized space station, the Death Star. The Sith ruled the galaxy once more, and only a few surviving Jedi scattered across the galaxy knew the truth.

However, soon a new enemy emerged: the young Jedi Knight Luke Skywalker. Under the tutelage of Vader's old mentor Obi-Wan Kenobi, Luke would become the biggest threat the Empire had ever faced. Fearing that the young Skywalker would undo everything they had done, Darth Sidious baited Luke into fighting his father, hoping that by embracing his inner hatred and killing Vader that he would turn to the dark side and become a powerful new agent of darkness.

(Fun fact: George Lucas originally wanted Luke Skywalker to slay his father and become the new Vader. His last lines would have been "Now I am Vader. Now I will go and kill the [Rebel] fleet and I will rule the universe." Lawrence Kasdan agreed that it was a great ending for the saga, but in the end Lucas refrained from going too dark because "this is for the kids.")[137]

A father's love proved stronger than the hate that had flowed through his veins for so many years, and Vader saved Luke's life by lifting the Emperor up above his head, and throwing the wretched, lightning-spewing crone to his death. Thus ended the tyranny of the Sith, and a new age began at last. However, as we'll soon see in *The Force Awakens*, the Sith won't stay dead for long. Like cockroaches after a nuclear holocaust, these nasty little buggers have a way of worming their way back to prominence. If Kylo Ren, the mysterious man wielding the crossguard lightsaber in the now-iconic first trailer is any indication, the Sith are alive and well, even some thirty years after the Battle of Endor and the destruction of the Sith order. Bad news for the Jedi, but great news for *Star Wars* fans.

The Force

"May the Force be with you."
—General Dodonna

Fantastical creatures, laser swords, interstellar dogfights—these are but a few of the things that have attracted millions of fans to *Star Wars*' galaxy far, far away. What makes George Lucas' space fantasy such a resonant story is the way in which it pits the forces of good and evil against one another, epitomized by the Jedi and the Sith, two diametrically opposed orders of warriors with awe-inspiring powers. But where do these powers come from? They are manifestations of a connection to the Force, a metaphysical and omnipresent power that binds together all living things. This all-encompassing energy has dazzled and enthralled viewers—but

what exactly is it? In short, the Force is the essence of life itself, and it is manifested on the big screen as an epic morality play between the light side and the dark side, two halves of the same spiritual coin.

While Luke Skywalker tries to telekinetically lift his X-wing out of the swamps of Dagobah in *Empire Strikes Back*, Yoda drops some wisdom on the young Jedi. "For my ally is the Force, and a powerful ally it is," the wizened green Jedi master says. "Life creates it, makes it grow. Its energy surrounds us and binds us. Luminous beings are we, not this crude matter. You must feel the Force around you; here, between you, me, the tree, the rock, everywhere, yes." This idea of an energy, a power, a *Force* that is greater than the sum of its parts yet manages to be one with all things in the universe is one that permeates the world of *Star Wars*. It is a prism through which characters' faith is tested. Han Solo writes it off as religious mumbo jumbo; Vader believes the Force can triumph over everything, including technology like the Death Star; and Luke is just trying to make sense of it all. A stand-in for religion, a manifestation of morality, or crazy blood-based space-magic—the Force is all things to all people, and that is the beauty of Lucas' creation; it holds an intrinsically universal value for viewers regardless of the culture in which they grew up. It is a distillation of beliefs which many people already held into their base elements, the very stuff of good versus evil.

Though the Force flows through all things, those who are particularly attuned to the Force are much rarer. Those who are Force-sensitive—as it is called in the *Star Wars* universe—are able to tap into the power of the Force itself, which manifests in mysterious and often awe-inspiring ways. Whether it is the ability to sense emotional distress from half a galaxy away or the power to lift foreign objects using one's mind, Force-sensitivity lies at the core of it all. With training, Force-sensitive people can learn to harness their ability, tapping into the Force on a deeper level and

accessing advanced, highly technical abilities (which are detailed next chapter).

With the addition of the prequel trilogy, Lucas expanded our understanding of the Force through the controversial addition of midi-chlorians. Microscopic lifeforms that exist within the cells of all living beings, midi-chlorians are the conduits through which the Force works, allowing those who are sensitive to the Force to use its powers. They are also a determining factor in assessing Force sensitivity and potential power levels. By sampling a subject's blood, midi-chlorian levels and, hence, Force sensitivity can be quantified; for example, Anakin Skywalker has the highest known midi-chlorian count ever recorded, exceeding 20,000. According to legend, midi-chlorians originated on a mysterious planet at the heart of the galaxy, the source from which all life is said to have been born.[138] Just as they are connected to life, midi-chlorians have a connection to death as well, allowing those who had knowledge of the Force and its secrets to manifest themselves after death in the form of Force ghosts.[139]

As for the *actual* origins of the Force, one need simply look back at Lucas' time at Modesto Junior College. While recovering from a traumatic automobile accident, Lucas found himself with a budding interest in film, particularly arthouse cinema. One of the most formative films of Lucas' creative career was *21-87*, a short film made in 1963 by Montreal filmmaker Arthur Lipsett. About three minutes into the film, we hear a disembodied conversation between artificial intelligence scientist Warren S. McCulloch and Roman Kroitor, the cinematographer who went on to develop IMAX. In the film, Kroitor says, "Many people feel that in the contemplation of nature and in communication with other living things, they become aware of some kind of force, or something, behind this apparent mask which we see in front of us, and they call it God."[140] Though it is far from the only influence on what we would eventually see in *Star Wars*, Lucas would

later acknowledge that the Force as we know it is an echo of Lipsett's film. However, the idea of a pervasive life force is much more universal.

Ever since he was a boy, Lucas found himself fascinated by the different notions of God and the human spirit from different cultures and religions all over the world. To Lucas, there seemed to be some sort of unifying force behind it all. "The 'Force of others' is what all basic religions are based on, especially the Eastern religions," said Lucas, "which is, essentially, that there is a force, God, whatever you want to call it."[141] Indeed, notions similar to the Force are found across world cultures—*prana* is an ancient Sanskrit term for "life force"; in Chinese Buddhism, the notion of chi is often translated as "natural energy";[142] a traditional Navajo prayer almost literally translates to "May the Force be with you."[143] In short, when Lucas took us to another universe, he made sure to take things that were universal with him.

These mythic themes weighed heavy on Lucas, who often ruminated on what the Force truly meant. "I have come to the conclusion that there is a force larger than the individual," explained Lucas during a 1975 conversation with Alan Dean Foster, who was tapped to write the novelization of the original *Star Wars* film. "It is controlled by the individuals, and it controls them. All I'm saying is that the pure soul is connected to a larger energy field that you would begin to understand if you went all the way back and saw yourself in your purest sense."[144] In another interview, Lucas elaborated further, saying, "The Force is really a way of feeling; it's a way of being with life. It has nothing to do with weapons. The Force gives you the power to have extrasensory perception and to be able to see things and hear things, read minds and levitate things."[145]

Then again, maybe Obi-Wan Kenobi said it best with his 28-word explanation to Luke Skywalker: "The Force is what gives a Jedi his power. It's an energy field created by all living things. It

surrounds us, penetrates us. It binds the galaxy together." In cases like this, it's best not to put a label on things; rather, just embrace it and let the Force of it all flow through you.

24 Every Force Power Explained

As inexplicable as the Force may seem to the layperson, it manifests itself in some truly spectacular ways in the *Star Wars* universe. Mind control, lightning blasts, telekinesis, trachea-crushing choking, communing from beyond the grave like Tupac's hologram at Coachella 2012—these are just a few of the jaw-droppingly awesome powers we've seen from the Force-wielding Jedi and Sith. But what exactly does each power *do*? What the hell is a Jedi mind trick anyway? Can I use the Force to fold my laundry? All of these questions and more will be answered as I catalog each and every Force power that you need to know. And as for the laundry thing, come on—this is the freakin' *Force* we're talking about; think a little bit bigger than permanent press, will you?

Typically speaking, Force abilities are broken into three categories—Control, Sense, and Alteration. Control was about looking inward and harnessing the Force to manipulate and enhance one's own body; self-control is a core tenet of Jedi teachings. Sense abilities required a deeper understanding of the Force, and they were typically taught to Padawans in order to expand their understanding and command of the Force. Lastly, Alter abilities were among the most volatile and destructive of the Force powers, allowing those who wielded them to affect the environment and objects around them. Though certain abilities were typically wielded exclusively by light side users or dark side

users, they are not restricted to Force-sensitives of a particular side. For example, the Jedi Kyle Katarn from the *Jedi Knight* video game series was able to use dark side powers like Force Lightning. For a light side user like Katarn, this meant that they were a Jedi of considerable mental fortitude as they were able to wield the dark side without succumbing to its siren song and corrupting themselves in the process.

Here are all of the Force powers as laid out by *Star Wars* Databank and Wookieepedia:

Control

Art of Movement: Harnessing the Force to improve one's reflexes and agility; often an essential part of Jedi training.

Force cloak: By manipulating both light and sound waves, the user can become practically invisible. This is extremely difficult to master and, thus, is rarely seen.

Force Speed: Users can employ the Force to achieve a heightened speed for a short period of time. While moving at an increased speed, the Force-user is able to perceive the world around them in what is essentially slow motion, allowing them increased time to make decisions, dodge attacks, and finish their crossword puzzles.

Breath Control: A Jedi can use the Force to reserve the amount of air in the lungs and prevent the body from shutting down after an extended period without oxygen. Very handy for avoiding drowning, poisonous gases, and pretty much any other situation in which one might suffocate.

Detoxify Poison: Certain Force-users were able to harness the Force to cleanse poisons from their body. Likewise, it can be used to clear the body of alcohol, allowing for sobriety even after a seemingly inhuman number of cocktails.

Force Healing: By using the Force, users can accelerate the natural healing process. Though it can mend broken bones, it

cannot repair and replace lost matter (e.g., Luke Skywalker's hand). According to Senator Palpatine, the Sith Lord Darth Plagueis may have used a dark side variant of this to manipulate midi-chlorians in order to stave off death and possibly create life; however, it was never fully proven.

Force Ghost: Not all Force-users shuffle off this mortal coil on the moment of their death; some learned an advanced ability to project their form into the world for a little while longer as a "Force ghost." They can neither harm nor be harmed by physical entities; rather, they are simply able to commune with the living. As far as we can tell, they only like to show up during Ewok dance parties.

Force Trance: By slowing the user's metabolism and breathing, an individual could reduce their oxygen intake to one-tenth of what a normal person would require. By all outward appearances, the Force-user would appear dead. Only other Force-users or individuals with highly advanced medical training and equipment would be able to know the truth. The user could maintain their trance-state for up to one week in a dry climate, or one month in a wet climate before dying of dehydration.

Morichro: Similar to the Force Trance, Morichro is an extremely dangerous, difficult, and powerful technique taught to very few Jedi that allows the practitioner to suspend their biological functions, allowing the user to survive without food, water, or oxygen for extended periods of time (e.g. over a year). It can also be turned on others as a means of subduing enemies, but the target must then be monitored closely lest they die of dehydration or starvation, or if they slip into a permanent coma.

Sense

Force Listening: By using the Force, users can understand words in other languages and listen to other beings talk to one another from a distance. Ahsoka Tano employed this ability to ferret out

clues about Aurra Sing's location when she was in the Coruscant underworld during the "Lethal Trackdown" episode of *Star Wars: The Clone Wars.*

Force Meld: The conference call of the Force, users of Force Meld are able to join their minds together and draw strength from one another.

Force Sense: Much like Spider-Man's "spider-sense" tingles when danger is nearby, users trained in the ways of the Force can tap into it to detect danger, other people's feelings, ripples created in the Force by important events, and the presence of other Force-users. It's considered to be one of the most basic of Force abilities

Shatterpoint: An ability accessible only by those of immense innate talent, Shatterpoint allows advanced Force-users to perceive "fault lines" in both people and events. Basically, it allows the user to perceive critical points in space and time where an action can and should be taken. You know how your mother-in-law always knows *exactly* what to say to make you reassess everything you've ever done in your life? She can see your Shatterpoints.

Psychometry: The ability to discern information and impressions about an object and the events in which it was involved by touching it.

Farsight: By using the Force, the user can gain insight into events happening across space and time, such as when Palpatine discovered that Darth Vader was critically injured following his battle with Obi-Wan Kenobi on Mustafar. The insight that comes isn't exactly explicit; rather, it comes in the form of Force visions, premonitions that are steeped in emotions and strong imagery. Though the future is fluid and subject to change, visions seen through farsight can provide valuable knowledge about potential outcomes.

Force Sight: Also known as "combat sense," Force Sight is a basic Force ability that enhances the user's visual perception, sometimes allowing users to see in the dark and through walls.

Force Empathy: A subset of Force Sense, Force Empathy allows the user to discern another individual's emotional state. No need to ask your girlfriend, "Are you mad at me?" She is, and you'll know it when you use Force Empathy to find out!

Force Telepathy: Whereas Force Meld allows users to harness the mental ability of multiple people, Force Telepathy allows users to mentally communicate with other people without speaking a word.

Alter

Alter Environment: The ability to manipulate nature itself by using the Force. Those who employ Alter Environment can use the Force energy inherent to the world around us to raise or lower the temperature, increase air pressure to rupture ear drums, create localized earthquakes, and enhance existing weather patterns to make them more intense (e.g., cause rain clouds to unleash torrential downpours).

Animal Friendship: Like a Jedi Mind Trick for all manner of beasts, Animal Friendship enables the Force-user to bring an animal under their control or calm an enraged creature. Basically, you can become the Cesar Milan of the galaxy far, far away with a wave of the hand.

Battle Meditation: Meditation and finding one's center are core tenets of Jedi teachings, but sometimes battles pop up. Hence, Battle Meditation, an ability that allows the user to act as a conduit for the Force, channeling the energy in order to enhance their allies' stamina, combat prowess, and overall morale.

Combustion: Though it is rarely seen—and even more rarely used on a living being—Combustion is a Force ability that enables the user to make objects explode.

Dark Transfer: Another extremely rare Force ability, Dark Transfer enabled the user to bring others back to life from death's door.

Deadly Sight: An ability typically associated with the dark side of the Force, Deadly Sight allowed the user to manifest their hatred as murderous energy. All those caught in the user's gaze would suffer intense pain and injury as they began to immolate.

Doppelganger: The user can create a seemingly perfect illusion of oneself by channeling the Force. Though the doppelganger is incorporeal in nature, many Force-users would employ telekinesis to move objects in order to really sell the illusion.

Drain Knowledge: Why bother asking people questions when you can extract the answers by force? Or should I say *by Force*? Drain Knowledge is a dark side ability that allows the user to violently extract memories and information from a subject.

Force Bellow: Whereas most people simply use their diaphragm when they want to project their voice, Force-users can amplify their dulcet tones to absurd decibel levels by employing this ability.

Force Choke: A favorite move of Darth Vader's, Force Choke is an ability that allows the Force-user to telekinetically crush a target's wind pipe. This ability could also be applied to other internal organs like the lungs and heart, but that took greater precision.

Force Deflection: Jedi and Sith who are without their lightsabers aren't defenseless; rather, they can employ Force Deflection to repel incoming attacks. Advanced users like Master Yoda are able to use Force Deflection to deflect and redirect other Force abilities like Force Pushes and Force Lightning.

Force Destruction: A powerful dark side ability that enabled wielders to tap into vast internal energy reserves and redirect them as deadly energy bursts that could annihilate those who came within their blast radius.

Force Drain: An ability that uses the dark side of the Force to drain a target's life force. See also: spending more than 20 minutes on the phone dealing with your cable company's customer service department.

Force Leap: A powerful ability that allows the user to augment their natural jumping ability to leap across great distances and achieve otherwise impossible heights. Basically this is some next-level parkour.

Force Levitation: The ability to telekinetically manipulate the forces of gravity in order to suspend oneself in mid-air, hovering above the ground. In some extreme instances, Force-users could actually fly for short distances by pushing Force Levitation to its limits.

Force Lightning: A powerful manifestation of the Force primarily used by the Sith, Force Lightning is an offensive, energy-based attack that allows the user to hurl lightning bolts from the user's fingertips at an enemy. The lightning itself not only inflicts grievous injury on the target, but causes them immense pain as well. It can be deflected, but it requires a Force-user of great skill and ability to do so.

Force Orb: Harnessing the Force, the user can create a bubble of air that can allow for underwater breathing for short durations.

Force Pull: No need to ask someone to pass the salt! By using Force Pull, one can pull objects and people closer to the user.

Force Push: The power to create a telekinetic pulse which the Force-user could use as a concussive burst of energy that would push a target away from the user. This was frequently employed when an enemy was standing a *little* too close to a precipice or on a balcony.

Force Stun: An ability that allows the user to disable a target's movement, senses, and perception, effectively incapacitating them.

Force Wave: An extremely potent form of the Force Push, Force Wave enabled the user to create what was tantamount to a telekinetic explosion, pushing back multiple targets. Very effective as a form of crowd control.

Ionize: Similar to Force Lightning, Ionize allows the Force-user to send a targeted beam of energy that will disable droids by overloading their electrical systems.

Mind Trick: Better known as the "Jedi Mind Trick," this is an ability that allows the user to manipulate and affect a subject's thoughts, usually in the Force-user's favor. When Obi-Wan convinces a detachment of stormtroopers that "these aren't the droids you're looking for," he was using a Jedi Mind Trick. Not everyone will succumb to a Jedi Mind Trick though; certain races like Hutts and Todarians (e.g., Watto from *The Phantom Menace*) aren't affected by them.

Protection Bubble: An ability that allows the user to create a defensive sphere that surrounds their body, shielding them from a wide array of attacks.

Pyrokinesis: By using the Force to manipulate air molecules, the wielder can rub them together and heat them up to create fire.

Sever Force: A non-lethal ability that allows the user to interrupt another's connection to the Force. Though the disruption was temporary, it is an extremely powerful and taxing technique, requiring immense concentration in order to sever the connection.

Telekinesis: One of the most ubiquitous abilities among Force-sensitive individuals, Telekinesis allows the user to control and move physical objects by using the power of the Force. Telekinesis had a number of applications among Force users.

Thought Bomb: Easily one of the deadliest powers in the dark side's arsenal, the Thought Bomb is a powerful technique

that requires the willpower of many Sith Lords working in tandem to channel the dark side into a powerful orb-like weapon that, upon detonation, would utterly destroy all Force-sensitive beings caught in its blast radius.

Transfer Essence: One of the most arcane and dangerous dark side powers, Transfer Essence allows the user to move their consciousness from one body to another vessel as a means of cheating death.[146, 147]

Please note: although not all of these abilities are considered official canon, they have appeared in other parts of the Star Wars *universe, including entries under the* Legends *banner, and should be considered a part of the overall fandom. Besides, who doesn't want even more wacky Jedi and Sith superpowers, anyway?*

A Brief Guide to the Galaxy Far, Far Away: The Most Important Planets

Like so much of fantasy and science fiction, *Star Wars* hits the ground running, hurling its own unique lexicon at the audience faster than Anakin Skywalker Tokyo drifting his podracer around a breakneck Beggar's Canyon curve during the Boonta Eve Classic on Tatooine. With so many disparate, diverse locations, it can be difficult to make heads or tails of *where* everything is happening in the galaxy far, far away, let alone *why* it's all happening. Fortunately, you are as wise as you are attractive and you purchased this book, so it's only fair that I give you a breakdown of the most important planets in the *Star Wars* universe. Please note: this is by no means a comprehensive encyclopedia of planets; rather, it is meant to give you a working understanding of where the main action takes place.

Alderaan: If you're hoping to meet your life partner here, you're looking for love in Alderaan places. A beautiful, verdant, and peaceful world, Alderaan was once home to famous political figures like Bail Organa, Bail Antilles, and Princess Leia Organa. Despite its pacifist exterior, it was also home to a hotbed of Rebel activity, which the Empire sought to stamp out. To make an example for the rest of the galaxy and show that the Death Star was fully operational, Grand Moff Tarkin unleashed the deadly battle station's superlaser on the planet, detonating it like a super-nova and killing billions of innocent civilians in the process. The only remnants of the once-vibrant world are cold hunks of lifeless rock forming a graveyard-like asteroid field.[148]

Bespin: Feeling above it all? Then Bespin is definitely the planet for you! Though the planet itself is a largely uninhabitable gas giant, there is a habitable layer of atmosphere in the clouds. In this narrow zone, massive mining colonies have arisen thanks to profit-minded businessmen who seek to extract the valuable gases from the planet's lower reaches. The most well known of these colonies is the aptly named Cloud City, which is run by the smoothest dude in the galaxy, Lando Calrissian. Just don't wear out your welcome; Darth Vader has been known to spend some time there, and he's even less fun than normal at altitude.[149]

Corellia: One of the Core Worlds, Corellia is among the most heavily populated, highly advanced, and best-developed planets in the galaxy. Renowned for its shipwrights and pilots, Corellia unsurprisingly counts flying aces like Han Solo and Wedge Antilles among its favorite sons.

Coruscant: Imagine a planet entirely covered by a sprawling metropolis and you have Coruscant, the seat of government for both the Galactic Republic and eventually the Empire. Coruscant was also home to the Jedi Temple and Archives, a training center and repository for generations of ancient Jedi knowledge, which were destroyed and desecrated during the horrific events of

Dan Casey

Order 66. Making the most of its densely packed urban areas, Coruscant's Skytowers stretch high into the stratosphere, up to Level 5127, which is the highest level from the surface. The lower levels of Coruscant are home to an unsavory criminal element that gets worse the deeper one goes. In fact, Level 1 is essentially deemed uninhabitable for all intents and purposes. Whereas up above airspeeders zip through the skies ferrying people to and fro in the cosmopolitan city, down below people take dingy trains to reach their destinations and the only light they receive is artificially generated. So, when you book your hotel stay there, make sure you get a room with a view. Trust me.[150]

Dagobah: If you're an impish, wizened old Jedi Master trying to evade Imperial notice, then Dagobah is just the planet for you! With its noxious swamps, acrid environment, and oppressive humidity, it's a real nightmare of a place to live, but it's perfect for people like Master Yoda. Its remote location and complete lack of development make it an ideal place to train Luke Skywalker in the ways of the Jedi too. Just watch out for the local wildlife; still waters run deep and there are some creepy crawlies to be seen in these murky depths.[151]

Dantooine: No, this isn't a weird *Star Wars*-ified nickname I came up with for myself (I prefer The Dan Star); rather, Dantooine is a remote planet that once housed a Rebel base. Tarkin considered unleashing the Death Star's might on it instead of Alderaan, but said it was "too remote to make an effective demonstration." During the Clone Wars, Mace Windu led his troops in battle on the remote world, and suffered grievous losses.[152]

Endor: In truth, Endor is a giant gas planet in the Outer Rim, but if you make a detour to its forest moon, you'll have an enchanting time in the heavily wooded, sylvan sprawl. Home to many diverse species, including the diminutive Ewok people. Don't let their relative short stature fool you; they can take down

an Imperial speeder bike and boogie at a treetop dance party with the best of them. Yub-nub indeed![153]

Felucia: If you're a fanatical fan of fungus, then look no further than the primordial plant life that populates Felucia. Located in the Outer Rim, the colorful, constantly humid jungle planet was the site of many battles during the Clone Wars, and eventually housed an Imperial outpost. After Order 66 went into effect, the Jedi Knight Aayla Secura was summarily executed on Felucia by Commander Bly and the 327th Star Corps. So, you know, there might be some bad juju in addition to the kaleidoscopically colored wildlife.[154]

Geonosis: Come for the inhospitable, rocky desert landscape, but stay for the massive droid and weapons factories! Inhabited by highly advanced, sentient insectoids known as Geonosians, the planet served as a base of operations for the Separatist movement during the Clone Wars, providing soldiers and munitions for the militant uprising. After the Clone Wars, the Empire selected Geonosis as the site where they would construct their greatest and most terrible weapon, the Death Star.[155]

Hoth: Nearly as frigid as Han Solo in carbonite, Hoth is a profoundly inhospitable world covered in ice and snow. Surrounded by many moons, Hoth is the sixth planet in a remote, desolate system of the same name, and home to murderous, mean-spirited Yeti-like creatures called wampa. Naturally, it's also the site of the Rebel Alliance's Echo Base because you can't beat the price (even if it is utterly devoid of curb appeal).[156]

Kamino: If Seattle were a planet, it would probably be Kamino. The world is covered in seemingly never-ending oceans and faces constant rainstorms, which makes this land beyond the Outer Rim a lonely and quiet place. The planet's denizens, the Kaminoans, dwell within massive stilted cities that rise above the crashing waves below. Though you might expect its main export to be wistful gazes into the middle distance, Kamino is renowned

for its cloning facilities. In fact, the majority of the clone army of the Galactic Republic was created here.[157]

Kashyyyk: Where do Wookiees come from? It's a question that every parent dreads hearing their child ask. Let me make it easier on you: they come from Kashyyyk, a heavily forested planet in the southwestern quadrant of the galaxy. Despite their animalistic aesthetics, the Wookiees are a highly progressive race, and so their architecture incorporates their advanced technology too. With a location of prime strategic importance, Kashyyyk found itself the site of a massive battle between the Republic and the Confederacy of Independent Systems during the Clone Wars.[158]

Mustafar: Located in the Outer Rim, Mustafar is a small, searingly hot planet situated in between two gas giants, around which it orbits erratically. Though it is filled with valuable minerals, Mustafar's lava floes and molten rivers make it a dangerous place to live. Accordingly, its natives have developed tough skin that is capable of withstanding extreme temperatures. Mustafar is also famous as the place where Obi-Wan Kenobi and Anakin Skywalker had their fateful duel that led to Skywalker's transformation into the jet-black asthmatic robot man we know and love.[159]

Mygeeto: Another planet in the Outer Rim Territories, Mygeeto is the ancestral homeworld of the Muuns, as well as the InterGalactic Banking Clan. Its vast mineral deposits and strategic value made it the object of several skirmishes between the Republic and the CIS during the Clone Wars.[160]

Naboo: Located along the border of the Outer Rim Territories, Naboo is a picturesque planet of rolling hills, vast plains, verdant hills, and crystalline lakes. Sprawling urban centers sit along the river, renowned for their classical architecture and abundant flora. Unfortunately, even paradise has its terrible secrets, and in the case of Naboo, it is the Gungan people. Well, that's not

fair—the Gungans aren't all bad; it's mainly just Jar Jar Binks who gives the amphibious underwater civilization a bad name.[161]

Saleucami: Yet another member of the Outer Rim Territories, Saleucami boasts a diverse array of environs. From arid deserts to strange swamps, Saleucami has a little bit of everything. Actually, it pretty much only has deserts and swamps, but that's still plenty of biodiversity for a backwater burg like this. Though the populace preferred pacifism to the wicked ways of war, conflict eventually found its way to Saleucami as Separatist droid armies battled the Republic forces toward the end of the Clone Wars.[162]

Tatooine: Life on Tatooine can be difficult to say the least. Between its twin suns beating down on the desert planet and a rampant criminal element, danger lurks around every corner. With legalized gambling, podracing, and slavery, Tatooine is a desolate world devoid of a moral compass, especially in spaceport cities like Mos Eisley and Mos Espa. Both Anakin Skywalker and Luke Skywalker grew up here, so at least it has a couple of home-town heroes to idolize.[163]

Utapau: If you have a sinking feeling about visiting Utapau, that's probably for the best as the dry, dusty planet is peppered with massive sinkholes. Unlike Tatooine, these sinkholes have glorious, life-giving water at the bottom, which has given rise to cities that plumb the depths of the planet's caves and crevasses.[164]

Yavin 4: One of the moons of the red planet Yavin, Yavin 4 is covered in greenery as far as the eye can see with forests and jungles covering much of the planet's surface. It was from this foliage-filled world that the Rebel Alliance launched their attack on the Death Star during the famed Battle of Yavin.[165]

26 Episode VII: The Force Awakens

Have you felt it? There has been an electricity in the air ever since *Star Wars Episode VII: The Force Awakens* was announced on October 30, 2012. Three years later, on any single day during the year 2015, if you were to go outside, stop a random person on the street and ask what their most anticipated film of the year is, there is a 99 percent chance that they would say *Star Wars Episode VII: The Force Awakens*. That remaining 1 percent was weirdly excited for *Pitch Perfect 2* because they are still way too into a cappella. For most of the world, though, each day is just a countdown until December 18, 2015, when *The Force Awakens* blasts off into theaters, taking movie audiences back to the galaxy far, far away for the first time in a decade. Considering that it is the first official *Star Wars* film to emerge out of Disney's $4 billion acquisition of Lucasfilm, it's fair to say that there is more than a little scrutiny surrounding the sequel.

Directed by J.J. Abrams, *The Force Awakens* was originally written by Michael Arndt. His draft was later rewritten by the duo of Abrams and longtime *Star Wars* screenwriter Lawrence Kasdan. Interestingly enough, George Lucas had provided a story to Disney to use for *Episode VII,* but the House of Mouse declined to use his ideas. That isn't to say that Lucas was advocating for a story revolving around a cyborg Jar Jar Binks exacting revenge on a galaxy that scorned him; rather, it simply signals that the torch has indeed been passed from Lucas to Kathleen Kennedy and J.J. Abrams, and Disney is confident in its new generation of *Star Wars* storytellers.

Much of *The Force Awakens'* story is shrouded in secrecy—which is a good thing; nobody wants to have the whole damn

movie spoiled for them, after all. Still, a considerable number of Bothans died to bring us this information: the story takes place 30 years after the fateful events of the Battle of Endor, which resulted in the second Death Star exploding and Luke Skywalker and Darth Vader defeating Emperor Palpatine. Though the Galactic Empire may not be what it once was, two monolithic forces are pitted against each other—the Resistance, which bears a striking resemblance to the Rebel Alliance, and the First Order, which is the new incarnation of the Empire.[166]

Among other locations, the story will take us on an intergalactic journey from a brand new desert planet known as Jakku, a veritable elephant graveyard of scuttled Imperial ships, the grim totems of the Battle of Jakku fought between the Empire and the Rebel Alliance some years prior. Living among the ruins is Rey (Daisy Ridley), a scavenger who forages from the wrecked starships to carve out a meager existence for herself. She also may or may not be Force-sensitive, but that has been kept tightly under wraps. For now, my money is on her *definitely* being the next in line for Jedi training.

Rey will cross paths with Finn (John Boyega), a stormtrooper who experiences a crisis of conscience (and apparently wields a lightsaber as we learned from Drew Struzan's limited edition poster at D23 in August 2015), and Poe Dameron (Oscar Isaac), a maverick X-wing pilot for the Resistance who actor Oscar Isaac describes as "the best frickin' pilot in the galaxy," on a mission from "a certain princess."[167] As tends to be the case with *Star Wars* films, the unlikely trio's fate is forever intertwined, sending them on an intergalactic adventure of untold proportions. Considering that most of the original cast—including Mark Hamill, Carrie Fisher, Harrison Ford, Anthony Daniels, Peter Mayhew, and Kenny Baker—are reprising their roles, this will serve as an excellent bridge between the older generation of *Star Wars* films and the next generation of storytelling in the galaxy far, far away.

This is also to say nothing of new additions to the series like flamethrower-wielding stormtroopers known as flametroopers; a mysterious new black-masked Sith named Kylo Ren (played by Adam Driver) who wields a red lightsaber with crossguard lightsaber blades projecting from the side of the hilt; the seriously awesome-looking chrome stormtrooper who is a commanding officer in the First Order named Captain Phasma, and will be played by Gwendoline Christie; and General Hux (Domnhall Gleeson), a villainous military leader in the First Order who, alongside Kylo Ren and Captain Phasma, resides at Starkiller Base (itself a reference to Luke Skywalker's original surname, Starkiller). In short, there's plenty of new reasons to be excited about the latest chapter in the *Star Wars* saga apart from revisiting old favorites. With a cast boasting talents like Max von Sydow, Andy Serkis, Adam Driver, and Lupita Nyong'o, in addition to those listed above, you can bet your last Imperial credit (or maybe they're called First Order bucks now) that they are pulling out all the stops.

Obviously, after the mixed critical response toward the prequels, and the eyes of the world watching him—88 million people watched the *Star Wars* Celebration trailer in 24 hours, mind you—J.J. Abrams is not oblivious to the pressure; rather, he is keenly aware of it.[168] "It is, without question, an intense and terrifying prospect," Abrams said in an interview. "The opportunity, I think, is greater than the fear, greater than the risk." [169] Taking into account Abrams' apparent commitment to special effects—something exemplified by BB-8, the adorable ball droid first spotted in early *The Force Awakens* teasers, and later seen in the metallic flesh at *Star Wars* Celebration Anaheim 2015—one gets the distinct feeling that this is a watershed moment not only for the *Star Wars* franchise, but pop culture at large. J.J. Abrams and company have a tremendous opportunity to make a statement here, launching the next phase in what is arguably the biggest pop cultural juggernaut in history.

27 Master Yoda

Who lives in a swamp, has horribly wrinkled skin, and speaks in terrible riddles and aphorisms? No, not your uncle Jeff, but that's a good guess. I am, of course, referring to Yoda, the wizened, wise Jedi Master who has been a stalwart of each and every chapter in the *Star Wars* saga. With his distinct elfin ears, creased green skin, slight stature, and a strange linguistic tendency to place verbs after both the subject and the object, Yoda made an immediate impact on *Star Wars* canon when he appeared in the bubbling bogs of Dagobah in *The Empire Strikes Back*. Little is known about his early life—including the name of his small species—but few have had a more indelible impact on the Jedi Order than Yoda. Serving on the Jedi Council, often as its de facto leader, Yoda has had a hand in training pretty much every Jedi to pass through the Jedi Order. After all, you don't live to be 900 years old without making at least a little bit of an impact.

With age comes wisdom, and Yoda wisely believed that Anakin Skywalker was too dangerous to admit into the Jedi Order, sensing the boy's innate fear. "Fear is the path to the dark side," he told the young slave boy. However, after Qui-Gon Jinn's death and Anakin's heroic actions during the Battle of Naboo, Yoda decided to honor his comrade's final wish, albeit with some reservations. Even though Darth Maul had been slain, Yoda remained uneasy that another Sith Lord was still out there, lurking. Unfortunately, Yoda's suspicion was right, and his former student Count Dooku, a former Jedi, had turned to the dark side, under the leadership of the mysterious Darth Sidious, and was leading the Separatist movement to drag the galaxy into chaos. The Master and his former student wind up locked in a

deadly lightsaber duel at the Battle of Geonosis, in which Yoda leads an army of clone troopers against the Separatist droid army, officially marking the start of the Clone Wars.[170]

In an effort to help Anakin grow as a Jedi and curtail his lingering weaknesses, Yoda assigned Anakin a Padawan learner of his very own, a strong-willed Torguta girl named Ahsoka Tano. During the Clone Wars, Yoda served as a Jedi general, leading clone troopers into battle, but he also went on a bit of a spiritual journey when he heard the voice of his dead friend Qui-Gon Jinn. After medical tests showed that what Yoda heard wasn't a psychosomatic auditory hallucination, he was visited by the spirit of his deceased comrade, who had somehow been able to manifest his consciousness even after death. At Qui-Gon's behest, Yoda journeyed to the planet Dagobah, a swampy world with a deep connection to the Force. Once there, Yoda underwent a series of intense, upsetting visions that showed him possible future realities, including a battle with Darth Sidious, his friends perishing, and the dark side version of himself. Yet, Yoda was made of sturdier stuff, and emerged with a new sense of self and a unique understanding of the Force. He had unlocked the essence of Force immortality, the ability to project oneself as a Force ghost even after death.[171]

A pall hung over the Jedi Order. Both Mace Windu and Yoda sensed a darkness that hampered their ability to access the Force, but they could not quite figure out why. In spite of Yoda's deep, innate understanding of the Force, he could not foresee that Supreme Chancellor Palpatine was secretly the Sith Lord Darth Sidious, who had been manipulating both sides of the Clone Wars as part of his master plan to destabilize the galaxy and undermine the Jedi Order. While Yoda was on Kashyyyk, Palpatine enacted his most malevolent plan yet, Order 66, which branded all Jedi enemies of the state and led to their systematic slaughter by the very clone troopers that were accompanying

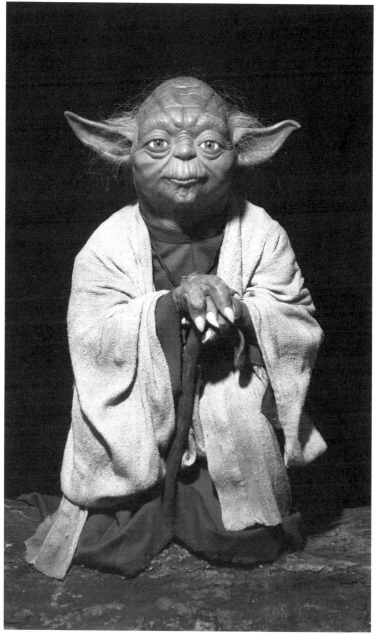

The wax figure of Yoda at Madame Tussauds. Somehow this green-skinned alien is infinitely less creepy than any of the wax statues of real humans. (Jens Kalaene)

them. Fortunately, Yoda escaped with his life intact thanks to Chewbacca's help during an ambush. With countless Jedi dead and Anakin Skywalker now fully embracing the dark side and his new identity as Darth Vader, Yoda made a beeline for Coruscant to confront Sidious in person.[172]

What followed was an epic lightsaber battle between the two masters of the Force, each one using it to its full potential. After enduring countless blasts of Force lightning and having massive platforms telekinetically hurled at him, Yoda was overwhelmed and forced to flee, barely escaping with his life thanks to Senator Bail Organa. Returning to the swampy sanctuary of Dagobah, Yoda went into hiding, using his newfound isolation to meditate on the Force and bide his time. For what, you ask? For Luke Skywalker, Anakin's long-lost son, to come of age and seek out the Jedi Master to continue his training. While training Luke, he neither told the young Jedi that he was training with a Master nor that Darth Vader was actually his father, hoping to help curtail the same sense of fear and rashness that pushed Anakin to the dark side so many years prior. However, the young Skywalker still left before his training was complete, learning the pain of having a hand sliced off and learning that your father is a mass-murdering space fascist in a disastrous battle with Darth Vader.

When Luke returned to Dagobah after his defeat at Vader's hands, Yoda was on his last legs. Using the last of his strength, he told Skywalker that he required no more formal training. The only way to become a true Jedi was for Luke to confront his father, to square off with Darth Vader once and for all. With his last breaths, Yoda revealed another stunning revelation to his star pupil: there was another Skywalker. He had a sibling. And so, after 900 long years and one hell of a mic drop, Yoda finally closed his eyes, accepted his fate, and became one with the Force.[173]

Yoda was a character partially born of necessity, serving as a successor to Obi-Wan Kenobi, who perished at the end of *A New Hope*. "One of the challenges was I had to replace Obi-Wan Kenobi," Lucas said. "I wanted something like Guinness; I wanted to transfer his performance into Yoda, so I worked on Yoda with Joe Johnston at first. I wanted someone very old and very unassuming."[174] According to Johnston, the initial designs "went off in a hundred different directions," with some resembling Big Bird, others featuring a fur-covered body, and others still making Yoda look like a sort of "miniature Santa Claus." Eventually, Lucas and Johnston settled on the three-toed alien elf motif that we know and love today.

This Little Piggy

Among his many other credits, including voicing and operating Yoda, Frank Oz was also the puppeteer and voice of Miss Piggy from *The Muppet Show*. One day while filming a very serious scene in *Empire Strikes Back*, Yoda said to Luke Skywalker, "Adventure, excitement. A Jedi craves not these things. Follow your feelings." Luke's response to Yoda is, "I have followed my feelings…." However, what came next was wholly unexpected. Oz had a black velvet bag over his arm, and suddenly Miss Piggy, wearing her lavender ball gown and costume jewelry, popped up, immediately at odds with the dreary Dagobah set. "Feelings? You want feelings?" Oz asked in Miss Piggy's voice. "Get behind the couch and I'll show you feelings, punk. What is this hole? I've been booked into dumps before, but never like this. Get me my agent on the phone."

Stunned by the switcheroo, Mark Hamill and the rest of the crew doubled over with laughter. Well, everyone except for producer Gary Kurtz and director Irvin Kershner, that is. Apparently, shooting Yoda's scenes was so difficult that they hated to lose even a few precious minutes. For posterity's sake, though, thank goodness Oz wasn't afraid to clown around.

Rinzler, J. W. *The Making of Star Wars: The Empire Strikes Back*. New York: Ballantine, 2010. p. 1705-1706. Print.

"I don't really remember how we ended up with that par-ticular design, except we sort of combined a leprechaun and a troll and a gnome," Johnston recalled of the now-legendary design.[175] Fitting that a story so steeped in the mythic would turn to a mélange of mythological creatures to design one of its most iconic characters. As for Yoda's face, it was actually an amalgama-tion of Albert Einstein's face and makeup artist Stuart Freeborn's face.[176]

When it came time to actually bring Yoda to life, the pro-duction crew was at an impasse. They considered everything from stop-motion animation to dressing up a trained monkey before ultimately settling on the idea of a puppet. Lucas asked his friend Jim Henson, who he had met in London previously, if he would build the puppet and voice the character, but Henson was too busy; instead, he recommended another key player in his organization: Frank Oz. Originally, Lucas wanted Oz only for puppeteering, because he was nervous about Yoda sounding too much like Miss Piggy, Oz's famous character from the Muppets. However, he soon changed his tune after watching Oz's perfor-mance and realizing how intricately tied together a puppeteer becomes with the role he is inhabiting as he is quite literally bringing it to life.

Shooting scenes with the mysterious little Jedi proved to be an arduous task, as technical complications kept piling up. For example, all of Hamill's scenes with Yoda were a one-sided affair. "Yoda gave me no lines while we were shooting," he said. "For a number of reasons, the earpiece [given to Frank Oz] never worked, so it was abandoned. Frank was in a pit with the [other puppeteers] and they were off at the end of cable and wires. So the whole relationship with Yoda had to be developed without dialogue."[177] Nowadays, acting against a green screen while speak-ing to a tennis ball might be commonplace, but it definitely wasn't par for the course back then.

Though a team of puppeteers—including Kathryn Mullen, Wendy Froud, David Barclay, Mike Quinn, David Greenway, Kathy Smee, and Don Austen—helped bring Yoda to life with their unparalleled craftsmanship, he too was ultimately transformed into CGI for *Episode II: Attack of the Clones* and *Episode III: Revenge of The Sith*. Sure, it allowed for some seriously impressive acrobatics and frenetic lightsaber fights, but one can't help but miss the practical magic of the original puppet.

So, what does the future hold for dear old Yoda? Probably nothing as his saga came to an end with *Return of the Jedi*, where we saw the little green Jedi go gently into that good night, and reappear at the end as a Force ghost. However, given that Yoda mastered the secrets of Force immortality, there's always a chance we could see his spectre looming on the horizon in *The Force Awakens* and beyond.

28 Obi-Wan Kenobi

"Help me, Obi-Wan Kenobi; you're my only hope."

With those eight little words, generations of *Star Wars* fans had their first inkling that the white-haired, robed hermit who saved Luke Skywalker's life was part of something far larger. As the saga of *Star Wars* unfolded over the course of six films and *The Clone Wars* animated series, Obi-Wan emerged as one of the linchpins around which much of the narrative revolves. A Jedi Knight, a veteran of the Clone Wars, and a mentor to two generations of Skywalkers, Obi-Wan Kenobi occupies a unique space in the *Star Wars* universe. Much like R2-D2 and C-3PO, he provides connective tissue between the past and the future, helping

to shape the course of galactic history on multiple occasions. Plus, Obi-Wan has the unique distinction of being portrayed by two award-winning actors, Sir Alec Guinness and Ewan McGregor, which makes him doubly awesome.

Within six months of his birth, Obi-Wan Kenobi, who hails from the planet Stewjon, was identified and tapped for Jedi training, taught from a very young age to control his darker impulses and emotions like fear and anger. Chronologically, our first introduction to Obi-Wan Kenobi is as a member of the Jedi Order, the Padawan of Jedi Master Qui-Gon Jinn. Together, the pair are tasked with mediating diplomatic disputes across the galaxy, including ongoing negotiations between the Trade Federation and the planet Naboo. However, the negotiations were a trap set by the Sith Lord Darth Sidious as a means to orchestrate a blockade of the planet and murder the Jedi. Surviving the attack, Obi-Wan and Qui-Gon Jinn fled to the planet's surface, linking up with Queen Amidala and, much to Obi-Wan's chagrin, the bumbling Gungan, Jar Jar Binks. Together, the motley crew managed to break through the Trade Federation blockade, making their way to the backwater burg of Tatooine.[178]

On the desert planet, Obi-Wan's life would be forever changed, although he wouldn't realize that for many years. They crossed paths with a young slave boy named Anakin Skywalker, an audacious and inquisitive youth who had a deep connection to the Force. He also happened to be an accomplished podracer, winning a competition at the Mon Espa Speedway to earn them fare off the planet. Before they could leave, however, Obi-Wan and Qui-Gon did battle with a mysterious, shrouded warrior in black, who came at them with a deadly ferocity. They escaped with their lives, escorting Amidala back to Naboo in order to retake the planet from the invading Trade Federation forces. However, the dark menace from Tatooine had followed them there, and little did they know but he was actually Darth Maul,

a Sith warrior dispatched by Darth Sidious to take them and Queen Amidala out once and for all. In a furious fracas, the two Jedi battled against Darth Maul, who cut a terrifying swath with his demonic red-and-black visage and his double-bladed lightsaber. In the course of the lightsaber duel, Darth Maul fatally wounded Qui-Gon Jinn, but Obi-Wan pressed his advantage, somersaulting over Maul's head, drawing Qui-Gon's discarded lightsaber and slicing Maul's torso in half, sending the Sith to fall to his presumed demise in a seemingly never-ending chasm.[179]

Unfortunately, it was too late to save his mentor; Qui-Gon Jinn died on Naboo, leaving Obi-Wan to carry on his dying wish: to train Anakin Skywalker in the ways of the Force as a Jedi. Though both Obi-Wan and the Council had their doubts, the Council obliged, granting Obi-Wan Jedi Knighthood and naming Anakin his Padawan. While he trained Anakin in the ways of the Jedi, the two were named Queen Amidala's official security detail. However, a number of assassination attempts on the Queen prompted Obi-Wan to dig deeper. His first lead, a bounty hunter named Zam Wesell, was cut short when a second assailant shot her dead with a poison dart. The plot was thickening faster than Han Solo making the Kessel Run.

Tracking his lead to Kamino, a world seemingly erased from the Jedi Archives, Obi-Wan not only discovered the attack, but he found a massive clone army that had been created to fight for the Republic. What was more troubling though was the fact that the Jedi who ordered the army's creation had been dead for nearly a decade, and the army was modeled off of the second mystery assailant, the Mandalorian bounty hunter Jango Fett. Tracking Fett to Geonosis, Obi-Wan was ambushed, held hostage, and sentenced to death by combat in the arena. After surviving a vicious attack from the monstrous acklay, Obi-Wan found himself fighting alongside a strike force of nearly 200 Jedi and the newly minted clone army. However, the Geonosians and

Separatists fought back with battle droids of their own. Obi-Wan and Anakin took on the fallen Jedi Count Dooku, who led the Separatist uprising, in lightsaber combat, but were unable to stop him; Dooku escaped and both Jedi suffered intense injuries. With that, the rescue mission became something much larger, the Battle of Geonosis, and the official beginning of the Clone Wars.[180]

With the galaxy in open rebellion, the civil war between the Galactic Republic and the Separatists intensifying, Obi-Wan and Anakin were named Jedi generals of the Grand Army of the Republic. Together, the duo travels the galaxy, helping to turn the tide in some of the most pivotal moments and battles of the war. Though skilled in combat, Obi-Wan's true strength lay in diplomacy, using his sound mind, level head, and sterling reputation to effect bloodless change, preventing battles before they ever began. He would earn the title "The Negotiator" for his work. That being said, Obi-Wan was not afraid to take up arms either. When the Sith Lord Darth Maul returned, he sought vengeance on Obi-Wan, who had previously bested him. The two crossed swords countless times throughout the Clone Wars, and Maul even murdered Obi-Wan's former flame, Duchess Satine, in a twisted form of vengeance. However, the Force was strong with Obi-Wan; he neither gave in to anger nor hate, and instead walked the high road.[181]

Obi-Wan was of sound mind and able to keep his emotions in check; the same could not be said for Anakin Skywalker. Though he loved Anakin like a brother, Obi-Wan grew increasingly concerned for his Padawan. It was a concern that would eat away at the Jedi Knight, particularly when he proved unable to save his longtime friend. When Anakin turned to the dark side, becoming the Sith Lord Darth Vader, it was Obi-Wan who had to travel to the burning lava planet of Mustafar to deal with the traitorous Jedi. A brutal battle followed as Obi-Wan and Anakin

proved an equal match for one another. Ignoring Obi-Wan's pleas for peace, Anakin attempted to leap over his former friend and mentor, and Obi-Wan responded in kind by severing his legs and arm with a swing of his lightsaber. Leaving Anakin to die on the banks of the lava river, Obi-Wan fled the planet. It was one of the hardest things he ever had to do.

With the Clone Wars ended, the Jedi Order slaughtered, and two children to protect—the infant twins Luke and Leia— Obi-Wan took on a new identity, "Ben" Kenobi. Living in secret on the planet Tatooine as a hermit, "Ben" kept a watchful eye on Luke Skywalker, protecting him from those who would harm him. It was the last act of compassion he could provide for Anakin. Nineteen years after the end of the Clone Wars, however, fate pushed Luke and Obi-Wan together as Obi-Wan saved the boy's life from a band of attacking Tusken Raiders. Back in his hut, Obi-Wan revealed that not only was he friends with Luke's father, but his father was a Jedi Knight—until a former Jedi named Darth Vader murdered him in an act of betrayal. It was stretching the truth, yes, but a necessary lie to impel the boy to action. Knowing that if the Empire ever got their hands on Luke, he would be killed or turned to the dark side, he tried to take preemptive action by giving the boy his father's lightsaber and encouraging him to leave Tatooine and study the Force.[182]

When the duo discovered a hidden distress call in the droid R2-D2, they contracted a pair of pilots, Han Solo and Chewbacca. When they attempted to deliver their precious cargo—the hidden Death Star blueprints—to Alderaan, they found the remains of the recently obliterated planet. To make matters worse, they were caught in the tractor beam of the supermassive space station known as the Death Star. Dividing and conquering, Luke, Han, and Chewbacca rescue Princess Leia while Obi-Wan disabled the tractor beam. Though the Jedi Master managed to release

the ship from the station's grasp, he encountered a familiar face: Darth Vader, now clad in terrifying, jet-black armor. In an eerie echo of the events of Mustafar, the Master and his fallen student drew their lightsabers and dueled once more. This time, though, Obi-Wan fell, accepting his death as a necessity so that Luke and his friends could escape.

Though Obi-Wan's body had been disintegrated, he was not gone. Using the Force, Obi-Wan reappeared to Luke on a number of occasions, projecting his form into a Force ghost in order to give the young Skywalker crucial advice. "The Force will be with you. Always," he told Luke after the young Jedi trusted in his feelings and used the Force to destroy the Death Star with an apparently impossible shot. Whenever Luke seemed lost in the world, Obi-Wan was there for him like a beacon of light shining in the darkness. It was Obi-Wan who directed Luke to Dagobah to seek out Master Yoda, and it was Obi-Wan who was forced to explain to the troubled boy why he had to keep the identity of Luke's father and sister from him. It was not out of any cruel or selfish desire; rather, it was to train Luke as Obi-Wan had once been trained, to get him in tune with his emotions and prevent him from falling into the same pitfalls and traps that turned his father from one of the greatest champions of the Jedi Order into an avatar of evil, serving the will of a fascist Empire. When Luke finally triumphed over evil and redeemed his father through an act of love and compassion, Obi-Wan was able to appear one last time, smiling and watching proudly over the son he never had.[183]

29 Boba Fett

In a galaxy full of stone cold badasses, it can be hard to stand out from the pack. Yet with his customized Mandalorian armor, signature jetpack, and silent demeanor, Boba Fett epitomizes a sense of effortless cool in the *Star Wars* universe. Played by Jeremy Bulloch, Boba Fett instantly became one of the most memorable characters in *Star Wars* canon when he appeared in *The Empire Strikes Back*. Though he rarely pipes up himself, his jet pack, blaster pistol, and wrist-mounted flamethrower speak volumes. In truth, Boba Fett is actually the offshoot of early designs for Darth Vader, who Lucas envisioned as a spacefaring bounty hunter in a specialized space suit rather than a dark knight.

According to Lucas, "He is also very much like the man-with-no-name from the Sergio Leone Westerns."[184] Honestly, the only thing missing from those movies is Clint Eastwood with a jetpack, so it adds up. Interestingly enough, before Boba Fett ever appeared in the galaxy far, far away, he made an appearance at a parade in San Anselmo, California, marching alongside Darth Vader (and subsequently collapsed as a result of dehydration from the 94-degree heat).[185] The original costume was stark white, with the intent of Boba Fett being something of an elite stormtrooper. However, that design was scrapped, and retooled by designer Joe Johnston. "I painted Boba Fett's outfit and tried to make it look like it was made of different pieces of armor," said Johnston. "It was a symmetrical design, but I painted it in such a way that it looked like he had scavenged parts and done some personalizing of his costume; he had little trophies hanging from his belt, little braids of hair, almost like a collection of scalps."[186]

With that design, a bounty hunter was born, one that would be forever ingrained in our memories and pop culture writ large.

During the Clone Wars, the Mandalorian mercenary Jango Fett served as the genetic template from which all of the clone troopers would be wrought. As part of the deal, he asked for an unaltered clone of himself to raise as the heir to his legacy. That child was Boba Fett, who grew up on Kamino, where the clone troopers were churned out like Doritos (except way deadlier than trans fats could ever be). During his youth, he would often accompany his father on their ship, *Slave I*, to track down bounties. After Obi-Wan Kenobi discovered the cloning operation on Kamino, Jango and Boba were forced to flee to Geonosis. However, when a Jedi strike force invaded the planet—under the auspices of stopping an execution—young Boba Fett saw his father beheaded by Mace Windu's lightsaber, which is pretty brutal even if your father was a morally questionable soldier of fortune.[187]

Newly orphaned, Boba Fett steeled himself and began a long, arduous path of preparing himself to avenge his father's death. Seeking tutelage from the assassin Aurra Sing, young Boba fell in with a crew of cold-blooded bounty hunters, including Bossk, Castas, Sing, and several others. Posing as a clone cadet, Boba engineered a bombing of the Republic vessel *Endurance* in an attempt to assassinate Mace Windu, but it failed. Though he wanted vengeance more than anything, Boba was not entirely heartless; when he was commanded to murder clone trainees—who were genetically identical to him, essentially making them his brothers—he refused. In the wake of his assault on the *Endurance*, Boba did a stint in prison, but managed to organize a breakout. Once free, he made his way to the desert planet of Tatooine, where he assembled another bounty hunting crew, consisting of Asajj Ventress, C-21 Highsinger, Latts Razzi, and Bossk.[188]

Over the years, Boba Fett made a name for himself as one of the most fearsome bounty hunters in the galaxy, donning his now-signature customized Mandalorian armor in homage to his late father and tracking down targets aboard the *Slave I*. As a result of his ruthlessness and cold, calculating efficiency, Boba Fett became Jabba the Hutt's go-to mercenary. His reputation also meant that Boba Fett was one of a group of elite bounty hunters—including IG-88, Dengar, Zuckuss, 4-Lom, Greedo, and Bossk—tasked by Darth Vader himself with tracking down Han Solo and the *Millennium Falcon* in the wake of the Battle of Hoth. Outsmarting the scruffy-looking nerf herder, Boba Fett and the Empire made a beeline for Cloud City, coercing Solo's old friend Lando Calrissian into laying a trap that would help them capture Solo and his friends. Just how much of a badass is Boba Fett? If Darth Vader is on the warpath, most people shut their mouths—without the aid of a Force choke, mind you. When Boba saw that Vader was going to freeze Han Solo in carbonite, he insinuated to the Sith Lord that time-tested principle of "you break it, you buy it." Rather than having his larynx crushed telekinetically, Boba was assured by the Dark Lord that "The Empire will compensate you, if he dies."[189]

With his handsome Harrison Ford–shaped prize in tow, Boba lugged the frozen smuggler all the way back to Jabba the Hutt's palace on Tatooine. Unluckily for our helmeted antihero, he was also present for Luke Skywalker's daring rescue of Han Solo and his friends. During the ensuing melee on Jabba's pleasure barge, Boba Fett tried to subdue Luke Skywalker with blaster bolts and a grappling rope. Yet, the bounty hunter's luck was about to run out as Han Solo accidentally ruptured his jet pack with a long pole, igniting the flying device and sending Boba flying over the side of the barge into the Sarlacc pit.[190] What is the Sarlacc pit, you ask? Well, imagine a Venus flytrap had a baby with an antlion, and was imbued with the appetite of a drunken college

student at an all-you-can-eat pizza buffet. Indeed, things looked bleak for the Mandalorian mercenary, and most assumed that he perished. However, since we never saw the body some fans held out hope…which was rewarded in 2014 when *Star Wars* historian confirmed that George Lucas had told him personally that Fett survived the fall.[191] Now, I wouldn't hold out too much hope to see Boba Fett flying around in *Star Wars Episode VII: The Force Awakens*, but one can rest easy in the knowledge that he wasn't an armored appetizer for the voracious beast.

30 Mark Hamill

In 1975, a 24-year-old Mark Hamill was feeling nervous before an audition. He was already starring on a television series called *The Texas Wheelers*, but his agent, Nancy Hudson, had landed him a general meeting for an up-and-coming feature film. The only thing his agent knew about the role was that Hamill was being considered for the role of a farm boy. To prepare, Hamill prepared a Midwestern accent—better safe than sorry. After waiting nearly two and a half hours and watching dozens of other actors file in and out of a meeting room every 15 minutes, it was Hamill's turn. In the audition room, Hamill talked with Brian De Palma, telling him all about his siblings and the itinerant nature of his youth, which saw his family moving to Japan. Another man in the room sat there stonefaced and silent the entire time, never saying a word. And just like that, the meeting was over. Hamill left the room, exited the studio, and went about his day. Little did he know, but he had just auditioned for *Star Wars* and the silent, ponderous man was none other than George Lucas.

Hamill would return on December 30, 1975, for another audition, this time a screen test with Harrison Ford. After reading four pages of dialogue, once off-camera and once on-camera, Hamill was dismissed. It was an excessively wordy bit of dialogue, but Hamill nailed it in the room. Once again, Lucas offered little to no feedback, and Hamill left thinking that it was a no-go. After several more months of deliberation, Lucas finally made up his mind, hiring Hamill to portray Luke Skywalker (then named Luke Starkiller). "My agent took me to lunch, and she was going down a list of business matters, like a grocery list," Hamill reflected, "when in the very middle she said, 'You have the part in *Star Wars*,' and then she went on with the next item. 'Wait a minute—back up!' I interrupted." The role, and a weekly salary of $1,000, was his for the taking.

Hamill played Luke with a boyish earnestness and the endearing whininess of a teenager being forced to grow up quickly. However, it would seem that his understanding of the film's tone was a bit different than most viewers'. "I thought they were comedies," Hamill confessed. "It was absurd having a big giant dog flying your spaceship, and this kid from the farm is wacko for this princess he's never met, that he's seen in a hologram, the robots are arguing over whose fault it is.… They hook up with a magic wizard and they borrow a ship from a pirate.… It was goofier than hell!" Well, when you put it like that, it's hard to argue. Certainly there is comedy ingrained in *Star Wars*' DNA, but part of that comes from how earnestly and honestly everything—even the more ridiculous elements—are played. Who knows? Maybe that deadpan quality was part of Lucas' plan all along.

Though his performance on screen went over well, Hamill encountered disaster off-screen. After *Star Wars* had wrapped filming in January 1977, Hamill was in a terrible car accident, flipping his BMW while trying to exit a highway off-ramp. He suffered terrible injuries, necessitating facial reconstructive

surgery, which sent Hamill into a downward spiral of depression as he waited for his face to heal. Thankfully, the surgeons acted quickly enough that they were able to rebuild Hamill's face almost exactly as it once was. *Star Wars* pick-up shots that required Luke Skywalker tooling around Tatooine on his landspeeder had to be shot without him. Eagle-eyed fans noticed a slight alteration in his appearance in *The Empire Strikes Back*, but mostly they were grateful to have Hamill back and in one piece. Never deterred by an unexpected hurdle, Hamill's altered appearance was explained away by having Luke attacked by the Wampa at *Empire*'s outset.[192]

After completing *The Empire Strikes Back* and *Return of the Jedi*, Hamill desperately tried to avoid typecasting, taking roles

Get Me Outta Here

Be honest—at least once in your life you've thought about what it would be like to put on stormtrooper armor of your very own. Many enterprising fans, like the members of the 501st Legion, have taken it upon themselves to build screen-quality stormtrooper armor for themselves. However, before you invest your time, energy, and hard-earned cash on vacuum-forming plastic into a perfectly molded piece of body armor, you might want to hear what Mark Hamill had to say about donning the iconic duds.

"When we were wearing the stormtrooper uniforms, you couldn't sit down," Mark Hamill said in an interview in J.W. Rinzler's *The Making of Star Wars*. "They built us some sawhorses to sit on and that's the most we could rest all day. It was terrible. You get panicky inside those helmets. You can see the inside of the helmet and it's all sickly green, plus you've got wax in your ears, because of the explosions, and you just feel eerie. I only once freaked out and said, 'Get me outta here!' It really was uncomfortable."

So when it comes time to choose your cosplay, maybe pick out something a little more comfortable and free-flowing, like a Jedi. Those robes *do* look awfully comfortable.

in projects like the World War II film *The Big Red On*e and a Broadway adaptation of *The Elephant Man*. Even though most of us would commit heinous crimes to be Luke Skywalker, it was not without its limitations. Case in point, certain studio executives still found it difficult to separate Hamill from his Luke Skywalker persona and passed on him as a result. Though Hamill had a number of live-action roles, including a turn as The Trickster on *The Flash* in the early 1990s, he eventually found tremendous success in an arena where his stunning Luke Skywalker-like resemblance would not hold him back: voiceover.

Having previously done voiceover work for Ralph Bakshi's *Wizards* in 1977, Hamill landed roles in *Batman: The Animated Series* as the Joker, Hobgoblin on the early '90s *Spider-Man* animated series, and even returned to the *Star Wars* universe as Darth Bane in the series finale of *Star Wars: The Clone Wars*, among others. It's safe to say though that apart from Luke Skywalker, the Joker is the role with which Hamill has become most synonymous. His dynamic performance as the Clown Prince of Crime was not only critically acclaimed, but it helped make him one of the most consistently in-demand voice actors, particularly for villains.

When *Return of the Jedi* wrapped in 1982, Hamill was at the outset of his career and seemed to grow mildly resentful of his role as Luke Skywalker over the years. After all, no one likes to be pigeonholed or typecast, especially actors who pride themselves on being chameleons. With time comes perspective, however, and now as Hamill prepares to return to the galaxy far, far away and the role that launched his career, he is grateful. "It's kind of like Scrooge on Christmas morning. 'Oh my God, this time I'm going to appreciate it in a way I wasn't able to as a young man,'" Hamill said in an interview after the insane reaction to the film's first trailer. "The fact that it is so special to so many people…it's hard to believe you could take something for granted like that."[193]

Even though Hamill is grateful to be reprising the role of Luke Skywalker, it certainly wasn't something he expected. Previously, Lucas had assured him that any sequels in the *Star Wars* universe would not push past the continuity of *Return of the Jedi*; however, as we learned in October 2012 with the Disney acquisition, things change. "I don't know that I'm even completely recovered from my state of shock," Hamill said. "Part of the experience of [*Star Wars*] in my life was coming down from that, putting it behind me. We had a beginning, middle, and an end. And I certainly, in a million years, never expected to return. I thought, even if they do more trilogies, my story is over."[194] Fortunately for all of us, Luke's story hasn't come to an end quite yet. Whether it continues beyond *The Force Awakens*, however, is something that remains to be seen.

31 Carrie Fisher

All good fairy tales have a princess, and *Star Wars* is nothing if not a good fairy tale. But Princess Leia Organa isn't your run-of-the-mill damsel in distress; she is a formidable tactician, a shrewd operator, and the leader of an upstart Rebel Alliance standing against a monolithic, fascist empire. Naturally, the role needed to be filled by someone who could exude grace, wit, and charm, but also hold her own both in battle and against a scruffy-looking nerf herder like Han Solo. After a lengthy search, the answer was plain to see: they needed Carrie Fisher. Long before she was Princess Leia Organa, though, Carrie Fisher was already Hollywood royalty, the daughter of singer Eddie Fisher and actress Debbie Reynolds. Growing up in Beverly Hills, Fisher

followed her parents into the world of entertainment, enrolling in the Central School of Speech and Drama in London in 1973. While studying there, she became friends with a casting director named Fred Roos, who just so happened to be helping out on an upcoming film called *Star Wars*. Much like Mark Hamill's experience, she was given little to no information about the project, and the audition materials contained some truly strange dialogue.

"Leia was unconscious a lot," Fisher said, recalling her audition script. "And I wanted to be unconscious; I have an affinity for unconsciousness. I thought I could play that very well. But I also wanted to be involved in all of it, with Wookiees, with the monsters in the cantina. I was caught by my mother and some of my family rehearsing it in my underwear. I would come out of the bathroom and say, 'General Kenobi!' My family thought I was crazy, because the dialogue was, 'A battle station with enough firepower to destroy an entire system.'"[195] To be perfectly honest, even after seeing the movies countless times, much of the dialogue still sounds a little crazy, but that's part of the charm, after all.

Having been told by Brian De Palma that Jodie Foster was favored to play the part, Fisher basically counted herself out. Nevertheless, she went in and auditioned, and after receiving very little direction and feedback, she left thinking that nothing would come of it. In truth, Fisher was the final of the three leads to be cast. After deliberating between Fisher and another actress who was slightly younger, Terri Nunn, Lucas decided to move forward with Fisher. "Carrie is a very warm person," Lucas said in an interview. "She's a fun-loving, goofy kid who can also play a very hard, sophisticated, tough leader.… If she played a tough person, somehow underneath it, you knew that she really had a warm heart." To her credit, when she finally landed the role, Fisher reportedly ran outside in excitement, "because I'd seen *American Graffiti* three times and liked it a lot," she explained. As

a relatively unknown actor, the weekly salary of $850 must have seemed like a small fortune at the time.[196]

Of course, she would not remain underpaid or unnoticed for long. In the wake of *Star Wars'* success, Fisher skyrocketed to international fame. After traveling around on what seemed like an endless press tour in the wake of *Star Wars'* success, the gravity of what she was a part of began to sink in for Fisher. "I only get a sense of *Star Wars'* importance when a child recognizes me and becomes speechless," she said. "Kids don't think I'm from this planet. Very little children even believe Princess Leia is a real human being who lives in outer space."[197]

However, like so many young actors who get a taste of the big time, Fisher soon found herself battling drug addiction. While on set for *The Empire Strikes Back*, Fisher did cocaine in ever-increasing amounts. "Slowly I realized I was doing a bit more drugs than other people and losing my choice in the matter," Fisher said.[198] Equally sobering was the death of her friend John Belushi, who died from an overdose of cocaine and heroin in 1982. A string of high-profile romances followed too, with an engagement to Dan Aykroyd (who proposed on the set of their movie, *The Blues Brothers*); an on-again, off-again relationship and year-long marriage to musician Paul Simon; and a relationship with casting agent Bryan Lourd, with whom she had a child, Billie Catherine Lourd. That relationship ended when Lourd left Fisher to be with another man.

Fortunately, Fisher was able to not only acknowledge her problems, but to embrace them and turn them into creative outlets. In 1987, she published *Postcards from the Edge,* a semi-autobiographical novel that made light of her late-'70s drug addiction and her tumultuous relationship with her mother. In the wake of *Star Wars*, Fisher landed a steady string of supporting roles in films like Woody Allen's *Hannah and her Sisters* (1986), *When Harry Met Sally* (1989), and *The 'Burbs* (1989). In addition

Carrie Fisher shares a laugh with (from left) Harrison Ford, Anthony Daniels (C-3PO), and Peter Mayhew (Chewbacca), as they take a break from filming the infamous Star Wars Holiday Special. (George Brich)

to publishing more novels, Fisher also became one of the top script doctors in Hollywood, doing uncredited passes on screenplays to punch them up. Among the films that she fixed from behind the scenes are *Hook*, *Lethal Weapon 3*, *Outbreak*, *The Wedding Singer*, and all three of the *Star Wars* prequels.[199] Leader of the Rebel Alliance *and* a highly sought-after screenwriter? Not too shabby, Ms. Fisher!

In 2006, Fisher wrote and performed an autobiographical one-woman show titled *Wishful Drinking*, which would later be transformed into an actual autobiographical book in 2008 and a Broadway show in 2009. In *Wishful Drinking*, Fisher revealed not only her struggles with drug abuse and her career in Hollywood, but that she suffered from bipolar disorder as well. In the autobiography, Fisher wrote, "George Lucas ruined my life, and I mean that in the nicest possible way." This seems to be a common sentiment among the Big Three—Mark Hamill, Carrie Fisher, and Harrison Ford—or at least it did for a long while. As mentioned in the previous chapter, people change over time and so has Fisher's outlook. "*Star Wars* has been my whole life," she said in a 2014 interview. "'I am Leia and Leia is me. We've overlapped each other because my life has been so cartoony or superhero-like. By this age, it would be ridiculous if I had a problem with it."[200]

Considering that the next time we'll see Fisher on the big screen, she'll be reprising her role as Princess Leia, it's probably for the best. Given recent interviews, it seems that Fisher is in good spirits, and just as acerbic and sharp as ever. When asked about seeing her old castmates again, Fisher said, "We all look a little melted. It's good to see other melted people."[201] Likewise, when asked about what Leia would be doing, Fisher replied with a laugh, "She's in an intergalactic old folks' home. I just think she would be just like she was before, only slower and less inclined to be up for the big battle."[202] Here's hoping that, if nothing else, we'll get to see the cool ferocity and quiet charisma that made us fall in love with Fisher's portrayal of Princess Leia in the first place. If nothing else, maybe we'll get to see those iconic cinnamon buns with a little more grey around the edges.

32 Harrison Ford

Harrison Ford is known by many names. Some call him Indiana Jones, others call him Rick Deckard, and still others call him "the *get off my plane* guy." (Ford is a certifiable badass in that scene in *Air Force One*, but his name was President James Marshall, for crying out loud.) However, long before he was known by any of those names, Ford burst onto the international stage and froze himself in the carbonite of pop culture as Han Solo, the scurrilous smuggler and suave sex symbol of *Star Wars*. With his effortless charisma, casual cynicism, and devilish good looks, Harrison Ford epitomized cool as Han Solo, effectively creating the mold from which countless sardonic, hypermasculine heroes would be wrought. However, in spite of all that, Ford nearly didn't make the cut. In fact, he was never supposed to audition for *Star Wars* in the first place.

After appearing in George Lucas' first film, *American Graffiti*, Ford had all but given up on acting. A small part in Francis Ford Coppola's *The Conversation* and roles in several TV movies followed, but nothing much materialized. He had worked as a contract player for Columbia Pictures until they cut his seven-year contract short. Afterward, he signed another contract player deal with Universal, but that too came to an unexpected end. With a wife and child to feed (and another baby on the way), Ford found work as a carpenter and kept in touch with both Lucas and Francis Ford Coppola by doing manual labor for them. When Lucas was casting *Star Wars*, Ford was working on a portico for Coppola's rented office on the Goldwyn lot. For some odd reason, Lucas had made it known that he was vehemently against using any actors who had appeared in *American Graffiti*.

It wasn't any coincidence that Ford was there though; casting director Fred Roos had surreptitiously hired Ford to make sure he would be in Lucas' line of sight.

"I thought, *Here's a possibility*," Lucas said after running into Ford. "Harrison was right for the part, so Fred suggested he read with everybody, which I thought was a great idea." Over the course of several weeks, Ford read with dozens of actors (50 to 60 by one count, 300 by another; the point is, it was a lot), and would often be tasked with explaining the basic premise of the story to his scene partners—"there was this farm boy sent off to the big city, who got involved in this adventure" in the most layman of layman's terms. Perhaps it was because he figured that he had no shot of landing the part or maybe it was due to the grueling number of auditions for which he had to read, but Ford, more so than anyone else, made Han Solo's dialogue sing. When Ford read the words, they didn't sound like a foreign language; they sounded like normal turns of phrase and elements of Lucas' vision of Solo began to seep through.[203]

After what seemed like an interminable deliberation process—which saw Lucas heavily consider a black actor named Glynn Turman and an older actor named Christopher Walken (yes, *that* Christopher Walken)—Lucas realized the answer to his Han Solo problem had been right there in the room all along. Ford landed the part, partially based on the strength of his test and partially due to the fact that he came with a low price tag. For his work as Han Solo in *A New Hope*, Ford made a cool $10,000, or roughly $750/week. It also helped matters that Ford had an instant chemistry with Mark Hamill, something that became apparent during their on-camera tests together.[204]

On the set of *Star Wars*, Ford showed up to work and genuinely busted his hump. That isn't to say that he kept quiet about everything that irked him, though. Fed up with the clunky dialogue, Ford infamously said to Lucas, "George, you can type this

shit, but you sure has hell can't say it." In spite of this outburst, his dedication impressed co-star Mark Hamill too, especially the way in which he approached some of the stiffer dialogue. "He'd written things in the margins, saying the same thing basically, but his way," Hamill recalled. "He had an amazing way of keeping the meaning but doing it in a really unique way for his character." When *Star Wars* opened in 1977, Ford became a household name overnight, and his character was an instantaneous fan favorite. Not afraid to eat his share of humble pie, Ford reportedly issued something of a *mea culpa* after seeing *Star Wars* for the

Ford the Flyboy

Ford doesn't just play a skilled pilot in *Star Wars*; he is something of an aviation expert in real life too. Over the years, he has logged thousands of hours of flight time, and has even rescued people on two separate occasions—a missing boy scout in Yellowstone National Park and a mountain climber in Wyoming. In addition, Ford has also volunteered to fight forest fires, using his expertise as a pilot to lend a helping hand against one of California's greatest ecological threats. On March 5, 2015, Ford's vintage 1942 Ryan Aeronautical ST3KR plane crash landed on the Penmar Golf Course in Los Angeles, California.

After suffering an engine failure, Ford made the split-second decision to make an emergency landing on the golf course, a move which was lauded by other pilots and emergency personnel for the precision it required and the grace under fire Ford showed. He survived the crash with a shattered pelvis and several other broken bones, and is expected to make a full recovery. This was only the second crash in which Ford has been involved; in 1999, a Bell 206LF LongRanger helicopter he was flying lost power and he lost a lot of altitude, forcing a hard landing. Looks like all that experience flying around in the fastest hunk of junk in the galaxy paid off!

Carroll, Rory, and Martin Pengelly. "Harrison Ford 'saved Several Lives' by Landing Plane on Golf Course—Witness." *The Guardian*. N.p., 6 Mar. 2015. Web. 11 May 2015.

first time. "I told George: 'You can't say that stuff. You can only type it.' But I was wrong. It worked," he said.[205]

"What *Star Wars* has accomplished is really not possible," said Ford of the original film's success. "But it has done it anyway. Nobody rational would have believed that there is still a place for fairy tales. There is no place in our culture for this kind of stuff. But the need was there; the human need to have the human condition expressed in mythic terms."[206] However, Ford was nobody's fool; he recognized that with success comes rewards, and negotiated a much higher payday for *The Empire Strikes Back*, earning $100,000 for his work.[207] Though *Empire* was a much more grueling shoot, Ford still seemed to be invested in the franchise, not yet displaying the grouchiness with which his name would become synonymous. However, he was unsure whether he wanted to return for a third film. Evidently, Ford kept asking George Lucas to kill his character at the end of *The Empire Strikes Back*. To make matters worse, Ford had yet to sign a contract for a third film, which forced Lucas and screenwriters Lawrence Kasdan and Leigh Brackett to come up with the creative solution of freezing Han Solo in carbonite.[208]

After much hemming, hawing, and hardballing, Ford agreed to return for *Return of the Jedi*, earning a cool $500,000 for his trouble.[209] By this point in Ford's career, his enthusiasm for *Star Wars* and the character that had made him a star seemed nowhere to be found. Ford was an international superstar, having starred in *Raiders of the Lost Ark* and earned accolades for his turn in *Blade Runner*. During the course of filming, Ford once again repeatedly advocated that Han Solo be killed by the film's end. "I thought he should have died in the last one to give it some bottom," Ford revealed in 2010. "George [Lucas] didn't think there was any future in dead Han toys."[210] In the intervening years, rumors flew that early drafts of *Return of the Jedi* featured Han Solo flying the *Millennium Falcon* during the assault on the

Death Star, and that he perished during the mission. However, as we now know, Han survived. To give you a sense of just how much Ford had cooled on the character, though, during a press tour to promote the movie, he plainly stated, "Three is enough for me. I was glad to see that costume for the last time."[211]

In fact, Ford seemed incapable of understanding Solo's appeal to the general public. Perhaps he grew weary of being so closely associated with the role, or maybe he was just tired, period. Han Solo is, inarguably, one of the most eminently quotable characters as far as most fans are concerned, Ford disagrees. "I never thought I had the best lines," he said matter-of-factly at a 2010 screening for the 30th anniversary of *The Empire Strikes Back*. "I was very happy to be involved. I was pleased to be a part of an ensemble. My character had a role en suite with the rest of the characters. I had a part to play that had kind of a keystone effect amongst the callow youth and the wise old warrior and the princess. There was this character that I thought the luck of the character was that he probably represented close to the audience's sensibility, because of his distance from the mythology, because of his resistance to the mythology."[212]

Of the three main leads, Ford has had the most successful career in the years following *Star Wars*, thanks in no small part to his starring role in another Lucasfilm franchise as Indiana Jones. (In another odd twist of fate, Ford only landed the role of Indiana Jones because Tom Selleck was unavailable to play the part. Just picture Indy with that mustache for a minute.) In the years following *Return of the Jedi*, Ford starred in Ridley Scott's sci-fi classic *Blade Runner*, Peter Weir's *Witness*, and Roman Polanski's *Frantic*. Ford continued to work throughout the 1990s as one of the world's most sought-after leading men, starring in *Patriot Games*, *Clear and Present Danger*, *The Fugitive*, *Sabrina*, *Air Force One*, and many more.

For a long time, Ford had a far more adversarial relationship with *Star Wars* than Hamill or Fisher ever did. However, clearly he has buried the hatchet with the galaxy far, far away, given that he will be appearing in *Star Wars: The Force Awakens* as a wizened version of Han Solo. (A hefty paycheck undoubtedly had something to do with his decision-making process too.) Thank goodness for that because I still get chills when I think about the moment at the end of the *Star Wars* Celebration trailer when Han and Chewie appear on the screen, with Han growling, "Chewie, we're home." Still, some things about Ford will never change. When doing an AMA on Reddit, one enterprising user asked Ford to settle the age-old bet of who shot first, Han Solo or Greedo? It is one of the great conspiracy theories in *Star Wars* fandom. However, to find out the answer, you'll have to read chapter 95 in this book. And no skipping ahead! Han Solo made the Kessel Run in under 12 parsecs; you should take the scenic route.

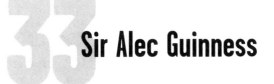

Sir Alec Guinness

When it came time to cast *Star Wars*, George Lucas wanted a prestige player among the core cast to give the film clout and raise the profile of the production, which was written off prematurely by many due to it having a cast of relative unknowns and being science fiction. In particular, the part of Ben Kenobi, the wise old hermit with a secret Jedi past, seemed perfectly tailored for an esteemed older actor. Initially, Lucas considered using legendary Japanese actor Toshiro Mifune, a frequent collaborator of Akira Kurosawa, whose film *The Hidden Fortress* largely inspired

A New Hope. "I was going to use Toshiro Mifune; we even made a preliminary inquiry," Lucas revealed in an interview. It would have resulted in a markedly different *Star Wars* story. "If I'd gotten Mifune, I would've also used a Japanese princess, and then I would probably have cast a black Han Solo."[213] Though I'm sure that version of the film exists in an alternate universe (that I desperately want to visit), it never came to pass because George Lucas also had his eye on another titan of the acting world, Sir Alec Guinness.

Though many only know Guinness from his role as Obi-Wan Kenobi, he is one of the greatest actors in the postwar era. Alongside Laurence Olivier and John Gielgud, he successfully transitioned from Shakespearean theater to star in Hollywood blockbusters in the years following World War II. He is renowned for collaborating with director David Lean on six separate occasions: *Great Expectations* (1946), *Oliver Twist* (1948), *The Bridge on the River Kwai* (1957, a role that would earn him an Academy Award for Best Actor), *Lawrence of Arabia* (1962), *Doctor Zhivago* (1965), and *A Passage to India* (1984). Over the course of his storied career, he won an Academy Award, a BAFTA Award, a Tony Award, a Golden Globe, and received a knighthood from Queen Elizabeth II for his contributions and services to the arts. (To put things in perspective, I once received several hundred retweets on a picture of a LEGO Harrison Ford falling over on the set of *Star Wars: The Force Awakens*.)

Recruiting Guinness was easier said than done, however, as the actor was predisposed to looking down the bridge of his nose at the production. Guinness was originally attracted to the project due to Lucas' involvement; he had seen *American Graffiti* and reportedly "admired [it] very much." His initial excitement would be short-lived, however. "When I opened the script and saw it was science fiction, I said, 'Oh lord," Guinness recalled in

an interview. "I've seen one or two of them and enjoyed them, but I always thought they were sort of cardboard, from an actor's point of view."[214] Yet, because of Lucas, he read on and found himself sucked into the weird, wild world the young filmmaker had dreamed up. The archetypal characters, mythic quality, and simple but relatable narrative throughline appealed to the actor. A successful lunch with George Lucas was a step in the right direction, but negotiations were only beginning.

Guinness played hardball with Lucas and the studio executives at 20th Century Fox, largely because he could. His tactics paid off, netting him a deal for £15,000 per week (approximately $150,000 total) and 2 percent of the film's net profits. That last bit would pay off in spades for the actor, earning him $3.3 million at the time. By the year 2000, it was estimated that Guinness had earned more than £56 million (approximately $88 million) from the original *Star Wars* alone, which was more money than he made from the next 40 biggest projects in which he was involved combined.[215] In spite of the financial windfall it brought him, Guinness was largely miserable throughout the production, writing it off as "fairy-tale rubbish."

In a letter to his longtime friend Anne Kaufman in March 1976, Guinness wrote:

"...[N]ew rubbish dialogue reaches me every other day on wadges of pink paper—and none of it makes my character clear or even bearable. I just think, thankfully, of the lovely bread, which will help me keep going until next April.... I must off to studio and work with a dwarf (very sweet—and he has to wash in a bidet) and your fellow countrymen Mark Hamill and Tennyson (that can't be right) Ford. Ellison (?—No!)—well, a rangy, languid young man who is probably intelligent and amusing. But Oh, God, God, they make me feel ninety—and treat me as if I was 106.—Oh, Harrison Ford—ever heard of him?"[216]

Harrison Ford, huh? Nope, doesn't ring any bells. That *Tennyson* Ford though, now there's an actor. Positively *loved* him in *Illinois Johnson and the Riders of the Last Arch.*

When the production was over, however, Guinness slightly changed his tune. "It's a pretty staggering film as spectacle and technically brilliant," Guinness wrote of *Star Wars* after the fact. "Exciting, very noisy and warm-hearted. The battle scenes at the end go on for five minutes too long, I feel, and some of the dialogue is excruciating and much of it is lost in noise, but it remains a vivid experience."[217] Even so, Guinness remained disdainful of the film and its effect on his legacy for years afterward.

In his 1997 memoir *A Positively Final Appearance*, Guinness wrote of a meeting with a young *Star Wars* fan who claimed to have seen the film more than 100 times. The fan asked for an autograph, and Guinness reluctantly agreed, but with a condition. "Well," he said, "do you think you could promise never to see *Star Wars* again?" The young fan immediately burst into tears. Though chided by the boy's mother, Guinness was undeterred in his conviction, writing, "I just hope the lad, now in his thirties, is not living in a fantasy world of secondhand, childish banalities."[218]

It just goes to show that even legendarily talented actors can be unrepentant jerks too, which is really a bummer considering the Scrooge McDuckian amount of money that Guinness made from *Star Wars*. Here's hoping that Ewan McGregor is a far sight kinder to his fans so as not to further muddy the Kenobi name. In all seriousness though, Guinness is an indelible part of the fabric of *Star Wars* history. Whether he liked it or not is irrelevant because he is part of something larger, something that lives on in the hearts of fans all over the world.

34 Emperor Palpatine, the Unseen Evil

Long before Voldemort ever waged a campaign of systematic extermination, the biggest name in pasty, craggy-faced, all-consuming evil was Sheev Palpatine. Like a horrifying blend of Hitler, Julius Caesar, and Machiavelli, Palpatine embodies opportunistic evil of the worst sort. Better known as Emperor Palpatine or Darth Sidious (if you're nasty), this man almost single-handedly plunged the galaxy into war, nearly exterminated the Jedi Order, and ruled a fascist empire with an iron fist from behind the scenes. Portrayed by Ian McDiarmid on the silver screen, Palpatine is the ultimate puppet master, manipulating everyone from the Galactic Senate to his own apprentices as a means to his malevolent ends. Quite literally, Palpatine is the Phantom Menace, the unseen evil lurking behind the scenes and the looming darkness that pervades the first six *Star Wars* films. And did I mention that he can shoot lightning from his hands? Because he can totally shoot lightning from his hands, and that makes him legitimately terrifying.

Getting into character was no easy process for McDiarmid, who spent four hours each day in the makeup chair. However, that time spent staring in the mirror at his transformation from man to monster gave him inspiration for Sidious' signature snarling voice. "It seemed to me that he should sound like a disgusting old toad," McDiarmid reflected. When leaving his first sound session with Lucas and producers Steven Spielberg and Kathleen Kennedy, he confirmed that his instinct was right on target: "After the first take Steven said, 'Oh my God, you're so evil!'" McDiarmid recalled with a laugh. "So I guess that was approving the voice, and I've had it ever since."[219]

Actor Ian McDiarmid looks far less sinister when he isn't wearing a mysterious shroud and shooting lightning out of his fingertips. (Eric Risberg)

When we first meet Sheev Palpatine, he is serving as Naboo's representative to the Galactic Senate and is in Queen Amidala's inner circle of trusted advisors. During the Invasion of Naboo by the Trade Federation, she turns to him for advice. What Amidala doesn't know, however, is that Palpatine is secretly the Sith Lord Darth Sidious, and he secretly engineered the invasion as part of his plot to restore the Sith to power for the first time in nearly a millennium. By planting the seeds of doubt in Amidala's mind about the efficacy of the Republic's leader, Supreme Chancellor Valorum, he tricks her into calling for a vote of no confidence in the Senate. However, much to Amidala's chagrin, Palpatine is

elected the new Supreme Chancellor. The dominos in Palpatine's sinister scheme had begun to fall.[220]

Though Palpatine's Sith apprentice, Darth Maul, was killed by Obi-Wan Kenobi, a new prospect had revealed himself: the highly gifted Force-sensitive boy, Anakin Skywalker. As the Separatist movement continued to grow in power, Palpatine appeared deeply concerned to the outside world; however, he was also pulling the secessionist strings behind the scenes with the aid of his new apprentice, the fallen Jedi Count Dooku. Together, they played both sides against each other, pushing the galaxy ever closer to war, and giving Palpatine cause to conscript an army of clone troopers to defend the Republic. With the discovery of massive factories on Geonosis being used to construct a Separatist droid army, Palpatine called for emergency powers to wield the military's full might against the Republic's enemies and further disenfranchise the Jedi Order. (The vote, of course, wound up coming from Jar Jar Binks, who was acting as Amidala's proxy and proving why there were never any Gungan senators in the first place.) All the while, Palpatine kept on mentoring Anakin Skywalker, nurturing the dark impulses in the boy's heart.[221]

During the Clone Wars, Palpatine, embracing his Sith side, had to deal with the reemergence of his former apprentice, Darth Maul, who had been presumed slain after being cut in half by Obi-Wan Kenobi on Naboo. However, Maul had not only survived, but he managed to amass a fair bit of power, taking over the planet Mandalore with his brother, Savage Opress. Realizing that the Sith was about to hit the fan, Darth Sidious decided to deal with his wayward ward personally by murdering Opress in cold blood and taking Maul captive, gleefully torturing him with Force lightning. Toward the end of the Clone War, Palpatine executed his master plan: seducing the heroic Jedi general Anakin Skywalker into joining the dark side as his apprentice, Darth

Say Hello to Empress Palpatine

Though Ian McDiarmid made Emperor Palpatine into one of the creepiest, most sinister villains in the Star Wars franchise, he wasn't the first to play the role. McDiarmid didn't join the cast until *Return of the Jedi*. When Palpatine appeared previously, he was played by—drumroll please—an elderly female woman, who served as a stand-in. To make her extra creepy, chimpanzee eyes were superimposed over her face. However, for the Special Edition releases, Ian McDiarmid recorded insert shots, which effectively erased all vestiges of the would-be Empress. Somewhere, though, I like to think that this malevolent monkey-eyed matron is still out there, biding her time, and waiting for the perfect time to strike.

"20 Things You Never Knew about Star Wars." Virgin Media. West10 Entertainment, 2010. Web. 19 May 2015.

Vader, and branding all remaining Jedi enemies of the state. It was a plan known as Order 66.[222]

When Palpatine issued Order 66, all Jedi were immediately targeted for execution, causing clone troopers to turn on their onetime allies and gun them down without hesitation. It was a devastating blow from which the Jedi Order would never recover. Yet, the cherry on Sidious' sinister sundae was revealing himself as a Sith Lord to Anakin Skywalker, playing on the troubled Jedi's fears of his wife, Padmé Amidala, dying in childbirth. By spinning him the yarn of his former master, Darth Plagueis, a Sith who had unlocked the secrets of eternal life, Sidious convinced Anakin to join his cause. Casting the Jedi Order aside, Anakin embraced his new identity as the Sith Lord Darth Vader, personally leading a detachment of clonetroopers to the Jedi Temple and slaying everyone within, including the younglings.[223]

With none to stand in his way—least of all the Jedi Order— Palpatine ruled over the universe as its Emperor, establishing the Galactic Empire to enforce his tyrannical rule across the galaxy. For 19 long years, Darth Sidious remained relatively

unchallenged in his power until the emergence of the Rebel Alliance threatened to destabilize everything. When the Rebels managed to destroy his orbital battlestation, the Death Star, Palpatine took notice of one among their number in particular, the young Jedi-in-training Luke Skywalker. Feeling a disturbance in the Force, Sidious foresaw that Luke could ultimately destroy him, and ordered his assassination. However, it was Darth Vader who suggested that the Jedi could be more useful to them alive if they converted him to the dark side, a prospect too tempting for Palpatine to pass up.

So, with the intent of luring Luke Skywalker to his side, Palpatine ordered the construction of a second Death Star, leaving his seat of power on Coruscant to oversee its progress personally. When Luke finally arrived, he entreated his father, Darth Vader, to return to the light side. Sidious scoffed at this show of affection, urging the young Skywalker to embrace his hatred and anger, and to strike him down. Luke nearly gave in to Sidious' urging, dueling Darth Vader with a savage ferocity. However, before he could deal the killing blow to his father, Luke threw his lightsaber away, refusing to turn to the dark side. Enraged, Sidious unleashed a barrage of Force lightning into Luke, with the intent of destroying him. Seeing his son in agony and finally realizing the depth to which he had been manipulated, Vader rose up against his Master, using the last of his strength to throw Sidious into a shaft leading to the Death Star's core. With that, Darth Sidious' reign of terror came to an end and his iron-fisted grip on the galaxy's throat went slack.[224]

While we have certainly seen the last of Emperor Palpatine in the primary *Star Wars* storyline, his effects will definitely be felt in *The Force Awakens*. After all, only three decades will have separated the film from the years of unspeakable evil and tyranny perpetrated by Palpatine and the Empire. However, there is still a chance we could see a younger version of Darth Sidious slink his

way back onto the big screen in the form of a *Star Wars Anthology* film. Though it is no longer officially canon, James Luceno's *Darth Plagueis* novel shed a fascinating light on Palpatine's rise to power and his complicated relationship with his former Sith Master. Granted, there's no shortage of *Star Wars* stories to tell, but don't "Sheev Palpatine: The High School Years" and "You Can't Be Sidious Right Now" sound like movies you *need* in your life? Wait, where are you all going? Come back!

35 Jabba the Hutt

As it turns out, you don't need a rock-hard body, lightning-fast reflexes, or even a spinal cord in order to be one of the most dangerous gangsters in the galaxy. As it turns out, all you need is a ruthless mindset, which is exactly what Jabba the Hutt has. The grotesque slug-like crime lord runs the back alleys of Tatooine like a corpulent, fleshy Don Corleone, operating a criminal empire from his very own den of iniquity. Smuggling, gambling, prostitution, forcing the Max Rebo Band to play horrifying lounge music—no matter what the racket is, Jabba has his hands in it. With an army of bounty hunters and assassins at his beck and call, and the capital to back it up, Jabba is one of the most powerful criminals in the galaxy, using his influence to affect both the criminal underworld and intergalactic politics.

Our first introduction to Jabba the Hutt comes in the original 1977 *Star Wars* film, when the subject of Han Solo and his debt to Jabba are mentioned. However, in the original theatrical releases of *Star Wars*, Jabba only appeared in *Return of the Jedi*, but was mentioned by name in *Star Wars* and *The Empire Strikes*

Back. In the controversial 1997 "Special Edition" re-releases, a scene was added to *A New Hope* in which Jabba is seen with an entourage of bounty hunters awaiting Solo's arrival outside the *Millennium Falcon*'s hangar. Evidently, Han had been contracted to smuggle a large amount of an illegal drug spice so that Jabba and his goons could sell it, but an Imperial search team boarded the *Falcon* and forced Solo to jettison his cargo. In the newly added scene, which was originally a deleted scene that didn't make it into the film, Jabba, played by Declan Mulholland, warns Solo that if he fails to deliver, he will place a bounty on him that is "so big, [he] will never be able to go near a civilized system." Yikes, Han—it's a good thing you picked up some new "cargo" in the form of Luke Skywalker and his pals, huh?

Our next encounter with the Hutt himself comes at the outset of *Return of the Jedi*. With Han Solo captured, encased in carbonite, and sitting pretty in Jabba's palace as a grisly trophy, Leia takes it upon herself to launch a rescue mission. Lando Calrissian, C-3PO, R2-D2, Leia (disguised as the bounty hunter Boushh), and Chewbacca (pretending to be Boushh's prisoner) infiltrate Jabba's palace to free their frozen friend. Though they succeed in defrosting Han, Jabba was wise to their schemes from the get-go, and imprisons the traitors in his midst, forcing Leia to wear a metal bikini and act as his slave girl, whom he keeps chained up by his throne. All seems lost until Luke Skywalker— with a brand new robot hand—shows up to "bargain for Solo's life," a request to which Jabba responds by dropping Luke into a dank, dark pit, the den of the monstrous rancor.

Unfazed, Luke slays the behemoth only to find himself, Han, and Leia sentenced to die by Sarlacc, which is essentially a giant tentacled, razor-toothed mouth that lives in a pit in the Dune Sea of Tatooine. Hovering on Jabba's sail barge outside the Great Pit of Carkoon where the Sarlacc resides, Luke retrieves the light-saber he stashed inside R2-D2, and vanquishes Jabba's guards.

During the ensuing melee, Leia takes her revenge by choking Jabba with her chains, strangling the slimy slug until he dies. In keeping with the Don Corleone motif, Jabba's death came about after Lawrence Kasdan watched Luca Brasi's death scene in *The Godfather*, in which an assassin garrotes the gigantic enforcer from behind.[225] Most doctors presumed that strangulation would factor into Jabba's death, but they all figured it would have involved the phrase "unlimited breadsticks" too.

Jabba also makes a cameo appearance in 1999's *The Phantom Menace*, appearing in the grandstand at the Boonta Eve Classic podrace in which Anakin Skywalker competes in order to win his freedom. Evidently, *Star Wars'* answer to NASCAR doesn't appeal to the hedonistic Hutt, who is so bored by the proceedings that he actually falls asleep. Jabba made another appearance during the pre-Galactic Civil War era in *Star Wars: The Clone Wars*, both the 2008 film and the television series of the same

Talk Nerdy to Me

As we well know, the *Star Wars* universe is a rich, vibrant world full of myriad alien species, many of who speak strange, arcane-sounding languages. Yet in spite of their extraterrestrial appearance, many of these fictional languages are rooted in real world linguistics. For example, Jawaese, the language spoken by the diminutive, brown-hooded Jawas, is based on the Zulu language, but sped up and altered so as to appear alien. The Ewok language employs Tibetan phrases, which sound designer Ben Burtt included after interviewing people from Tibet, Sri Lanka, and Inner Mongolia. Jabba the Hutt may sound like he's speaking guttural nonsense, but the phonology of Huttese is rooted in Quechua, the language of the Incas. Even though the galaxy may be far, far away, its linguistic roots are closer than you might expect.

Katzoff, Tami. "'Return Of The Jedi' Turns 30: Secrets Of Ewok Language Revealed!" MTV News. MTV, 24 May 2013. Web. 01 Feb. 2015.
"BlueStage Story: The Scream of the Jedi Knight." Sennheiser.com. *BlueStage Magazine*. Web. 31 Jan. 2015.

name. In the 2008 film, Anakin Skywalker and his padawan Ahsoka Tano rescue Jabba's son from kidnappers in order to gain passage through his territory. In the series, we see the origins of Jabba's unholy alliance with the Empire begin to take shape. Not only do we meet the Hutt Council, which is sort of the Cosa Nostra for unreasonably obese criminal overlords, but we also see Jabba butt heads with and ultimately ally with Darth Maul.

Jabba's creation was an amalgam of two of Ralph McQuarrie's sketches, one of which rendered the Hutt as a massive, apelike figure while the other was more worm-like. A creative chimera of sorts, Jabba's biology is modeled after annelid worms, but his face has distinctly serpentine qualities, including slit-pupilled eyes. Jabba's skin has an amphibious nature to it, which accounts for his signature sliminess.[226] The creature speaks a language known as Huttese, a fictional language based on an ancient Incan dialect that was created by sound designer Ben Burtt. Though he isn't credited for it, Hutt's dialogue was performed by actor Larry Ward, whose voice was pitch-shifted to be an entire octave lower and run through a subharmonic generator.[227]

Though he was replaced with CGI in later editions of the film—widely considered one of the greatest sins of the Special Editions—Industrial Light & Magic's Creature Shop created an elaborate puppet version of the crime lord for his appearance in *Return of the Jedi*. The one-ton puppet took three months and $500,000 to construct, and required a team of trained puppeteers to operate it, three from inside the giant creature. A trio of puppeteers from Jim Henson's Muppet team—David Alan Barclay, Mike Edmonds, and Toby Philpott—operated Jabba originally. Barclay manipulated the right arm and mouth, and read the Hutt's dialogue in English, while Philpott operated the head, tongue, and left arm. Edmonds had a very special job—operating the tail. As for the eyes and facial expressions, they were operated via radio control rather than traditional puppetry.[228]

In fact, the puppet itself has become such an object of adoration and fascination among fans that it was the subject of a short documentary, *Slimy Piece of Worm-Ridden Filth—Life Inside Jabba the Hutt*. In the documentary, Philpott reveals that George Lucas wasn't as impressed by Jabba as everyone else was. "I think he would have liked to have done it by CGI, even then, but the technology wasn't there yet, and I'm not sure he was entirely convinced by a three-dimensional puppet," he explained. "He wasn't satisfied that Jabba couldn't walk around for instance, where I quite like that fact that he obviously was a gigantic slug who rarely goes anywhere and when he does, people carry him, I guess."

Whether you love him or hate him, prefer the puppet or the CGI, one thing is for certain: the only thing larger than Jabba the Hutt himself is our appetite to see more of the overstuffed evildoer wherever we can.

Jar Jar Binks, the Most Hated Character in Cinema

While there are many despicable characters in cinema history, few have engendered such universal hatred, such unparalleled loathing, and such fulminating rage as Jar Jar Binks. What George Lucas envisioned as a harmless jester of an alien has become a symbol for everything that diehard fans saw as the film's problems. It also didn't help that he was a ham-fisted, ill-advised, potentially racially insensitive caricature of a character. Yet to understand why Binks is so reviled, one must understand where the character came from, the filmmakers' intentions, and the missteps that gave birth to a legend.

Naïve, clumsy, but ultimately well-intentioned, Jar Jar Binks, a computer-generated character voiced by Ahmed Best, is a Gungan outcast from the planet Naboo, banished by his tribal leaders as a result of his staggering ineptitude. Born to George R. Binks (not a typo) and Otoh Gunga, Jar Jar Binks was raised to be a whaler, a trade his family trafficked in for centuries. However, Jar Jar's innate clumsiness (a recurring theme, you'll notice) meant that he couldn't take up the family trade, a reality that became all too clear when Jar Jar accidentally scuttled his family's whaling ship while on an expedition. Marooned alongside his idiot son, George Binks attempted suicide, preferring that to spending a lifetime stranded with his own progeny.[229] And you thought Luke Skywalker and Darth Vader had a complex father-son relationship.

After narrowly dodging death at the hands of Federation transport, Jar Jar is saved by Qui-Gon Jinn and his padawan, Obi-Wan Kenobi. Thanks to his knowledge of Basic (the English of the Star Wars universe), Jar Jar wound up becoming their traveling companion, eventually following Queen Amidala to Tatooine, where he befriends young Anakin Skywalker. Later in *The Phantom Menace*, Jar Jar gets the promotion of a lifetime, ascending to the rank of general and leading the Gungan army into battle against the nefarious Trade Federation.

While Jar Jar played a central role in *The Phantom Menace*, he was widely panned by fans and critics alike. As a result, his role would be greatly diminished in *Attack of the Clones* and *Revenge of the Sith*. Even so, in *Attack of the Clones*, 10 years have passed and Jar Jar is serving as a delegate to the Galactic Senate. If you thought the Gungan military was misguided in their battlefield promotions, then Jar Jar's appointment to senator should leave no doubt in your mind that the Galactic Senate is a deeply corrupt, broken instrument of legislation.

To make matters worse, Jar Jar is essentially the reason that the evil Galactic Empire exists; while speaking on behalf of Naboo in front of the Senate, Jar Jar advocated granting Chancellor Palpatine increased legislative powers, which Palpatine immediately used to overthrow the Senate and bring the galaxy under the Sith's control. By the time *Revenge of the Sith* rolled around, Jar Jar's role was reduced to the point where he only appeared in a handful of scenes and all of his dialogue was cut.

So what happened to Jar Jar Binks? It's difficult to say for certain. In the 2008 video game *Star Wars: The Force Unleashed*, he can be seen frozen in carbonite on the wall of Ozzik Sturn's trophy room. In the 2004 remastered version of *Return of the Jedi*, several Gungans can be seen celebrating during a scene on Naboo. In particular, one of the Gungans can be heard shouting, "Wesa free," a line which many fans presumed was Ahmed Best as Jar Jar Binks. In truth, the voice belongs to Skywalker Sound editor Matthew Wood, who inserted the line as a joke. The joke, however, was on Wood because Lucas wound up liking it so much that it made the final version.[230]

Pop culture writer Nathan Rabin may have put it best when he wrote, "*The Phantom Menace*'s introduction of Jar Jar Binks into the *Star Wars* universe was akin to following up the New Testament with an even Newer Testament where Jesus comes back and spends all his time waterskiing with Guy Fieri and Brett Ratner."[231]

Others found Jar Jar to be an ill-advised amalgam of various racial stereotypes, the alien equivalent of blackface. In his scathing review in *The Wall Street Journal*, Joe Morgenstern referred to Binks as "a Rastafarian Stepin Fetchit on platform hoofs, crossed annoyingly with Butterfly McQueen."[232] To his credit, insensitivity was never Lucas' intention. "How in the world could you take an orange amphibian and say that he's a Jamaican?" Lucas demanded of the BBC in a frustrated post-*Episode I* interview.

"If you were to say those lines in Jamaican they wouldn't be anything like the way Jar Jar Binks says them," he continued.

So what was the impetus behind Jar Jar? Clearly it wasn't to portray Afro-Caribbean people in a negative light. Some have theorized that it was an effort to mitigate the perceived darkness of the prequels, which dealt with the collapse of the Old Republic, the corruption of Anakin Skywalker and his transformation into Darth Vader, the apparent death of the Jedi Order, and the rise of the Galactic Empire. Others have reasoned that Jar Jar Binks is meant to be comic relief, a goofball of a character that would appeal to children and push merchandise simultaneously. After all, Lucas was in the process of raising three children of his own while the prequels were being made, so why wouldn't he want to include a theoretically lovable character for them to glom on to? Alas and alack, the adoration of the Lucas children would not be enough to redeem the bumbling Gungan in the eyes of most fans.

As for Lucas himself, he writes off Jar Jar's hostile reception as a casualty of the generation gap. "We now have three generations of *Star Wars* fans," he told Jon Stewart on *The Daily Show* in 2010. "The first generation saw *Episode IV*, and the next two. Then when the next three came out they hated it, couldn't stand it. And that's when we first discovered that there was a whole new group of kids out there that *loved* it. And they didn't like the first three. They said, '*Episode IV* is boring, we don't want to see that. We love Jar Jar Binks.'"[233]

You know what? Maybe you're right, George. Maybe parents just don't understand.

37 Grand Moff Tarkin

When it comes to galaxy-threatening evil in the *Star Wars* universe, it's easy to point to characters like Darth Vader, Emperor Palpatine, and Boba Fett. After all, between the three of them alone, they murdered Obi-Wan Kenobi, dissolved the Galactic Senate, and sold Han Solo's carbonite-frozen body to a treacherous gang lord. However, none of these men are responsible for the creation of the Death Star or a political doctrine that resulted in a sprawling civil war and the deaths of hundreds of thousands of people. The man responsible for such grievous actions is none other than Grand Moff Wilhuff Tarkin, a Machiavellian operator with ice running through his veins and pure disdain etched into the crags of his face.

How important is Tarkin to the *Star Wars* mythos? After Lucasfilm hit the reset button and effectively erased years and years of storylines, one of the first pieces of new canon material they produced was the novel *Tarkin*, written by James Lucerno. Centering on the eponymous Imperial commander, *Tarkin* tells the story of Wilhuff Tarkin's rise to power from Imperial governor to authoritarian autocrat behind some of the most insidious policies in the Empire. Darth Vader may have been a terrifying, one-man army of an enforcer, but Tarkin is a tactical genius with a keen eye for stamping out insurrection in new and uniquely brutal ways. After all, in *A New Hope*, Darth Vader takes his marching orders from the Emperor *and* Tarkin. Ordering around one of the biggest, baddest Sith in the galaxy isn't something that just anyone can do.

Born to a powerful and influential family, Wilhuff Tarkin started his career serving in the Republic Outland Regions

Security Forces. During the Clone Wars, he served as a Captain in the Republic Navy, eventually rising to the rank of Admiral. While serving under Jedi Master Evan Piell, he came under attack from Separatist forces acting on Count Dooku's orders. It seemed as though Tarkin might perish in captivity but he was saved in the nick of time by the Jedi Ahsoka Tano before his head could bid adieu to his neck.[234] Unfortunately, he would never show similar leniency and compassion toward those who had saved him.[235]

Tarkin moved into politics, where he served as lieutenant governor of his homeworld of Eriadu, and developed a reputation for being militaristic, authoritarian, and xenophobic towards non-humans.[236] While serving as governor, Tarkin became an increasingly vocal supporter of Senator Palpatine, who himself was secretly the Sith Lord Darth Sidious. With similar political agendas and philosophical leanings, the two worked in tandem to consolidate their power, discredit the Jedi, and prepare for Palpatine's secret Sith order to assume control of the galaxy as we know it. When the Senate dissolved and Palpatine was named Supreme Chancellor, he named Tarkin the Grand Moff.

As mentioned before, Darth Vader may be the most intimidating character in *A New Hope,* but the primary antagonist of *Episode IV* is none other than Grand Moff Tarkin (played by Peter Cushing), who is the Governor of the Imperial Outland Regions, which includes much of the Outer Rim, as well as the commander of the Death Star. The giant floating orb of doom isn't just a cool-looking set piece; it's the centerpiece of The Tarkin Doctrine, Tarkin's political philosophy of harnessing fear and using that to coerce people into doing what he and his cohorts want.[237]

The premise behind the Death Star is simple—if you have an orbital space station with a superlaser death ray capable of turning plants into minute particles of space dust, then people

will be less likely to rebel against the yoke of Imperial rule. It's not exactly easy to rise up against those who are oppressing you when they have a gigantic weapon of mass destruction aimed squarely at your homeworld. In *A New Hope*, in order to demonstrate the station's fearsome power, Tarkin obliterated Alderaan as Princess Leia watched in utter horror.

Unfortunately for ol' Wilhuff, as anyone who has seen *A New Hope* can tell you, Tarkin dies a hot, fiery death when Luke Skywalker destroys the Death Star. A casualty of his own insane convictions, Tarkin died on the monument to hubris that he helped to construct in the first place. Even though his master plan failed, Tarkin's legacy is undeniable. Without his cold, calculating approach to politics and his conviction that waging a campaign of excessive force was the surest path to conquering the galaxy, he helped propel the Empire to a position of immense power and nigh total control over the universe in the aftermath of the Clone Wars.

It is also worth noting that while Tarkin cut an imposing swath across the screen, his anger may have been the result of boots that were a few sizes too small. According to a widely circulated anecdote, Peter Cushing found Tarkin's boots to be exceedingly uncomfortable, so George Lucas was forced to find creative ways to frame Cushing where his feet were not in frame.[238] What you didn't see in many of those shots is that Cushing is actually wearing a pair of his own slippers, a happy and delightful compromise for an all-around misanthropic, bastardly character. Here's hoping they'll keep that tradition in place should he wind up making an appearance in *Star Wars: Rogue One*.

38 Lando Calrissian

Before he was Harvey Dent in Tim Burton's *Batman*, before he was the spokesman for Colt 45 brand malt liquor, Billy Dee Williams was Lando Calrissian, the smooth-talking, mustachioed crook-turned-political leader of Cloud City. Apart from James Earl Jones' dulcet tones as Darth Vader, Lando is seemingly the only black man in the original *Star Wars* trilogy. (Okay, that's obviously an exaggeration, but the only others that come to mind are Femi Taylor, who played Jabba the Hutt's Twi'lek dancer Oola, and actor Tony Cox, who played an anonymous Ewok in *Return of the Jedi*.) Matters of race notwithstanding, Lando is a fascinating character as a result of Williams' exuberant charisma, undeniable sex appeal, and the character's redemptive arc. Equal parts snake oil salesman and soldier of fortune, Lando Calrissian is a character not designed for the kids who fell in love with the saga, but rather the adults who brought them there.

In his youth, Lando Calrissian traveled the galaxy, working as a smuggler and a gambler, plying his trade in the game of sabacc (a high-stakes card game). Lando actually used to own the *Millennium Falcon*, but lost it to his old friend Han Solo in a game of sabacc gone awry. (Whether or not the game was rigged is a matter of some heated debate.) After his smuggling days, Lando carved out a cushy role for himself as the administrator of Cloud City, a gas-mining colony floating above the planet Bespin—a position he won through, you guessed it, a game of sabacc. Though it seemed like everything was on the up and up, Lando, like all great politicians, operated outside the realm of the law, which made him eager to keep his little colony's operations off the Empire's radar.

Unfortunately for Lando, the Empire was like the NSA and my text messages—they saw and knew about everything. When Darth Vader, Boba Fett, and a detachment of stormtroopers arrived in town, Lando knew his days as a legitimate businessman were numbered. The Empire gave him a simple choice: lay a trap for Han Solo and his friends or have the life Force-choked out of you and everyone you love by an increasingly displeased Darth Vader. Like any sensible smuggler worth his salt, Lando lured his friend Han Solo to the mining colony, offering to fix the *Millennium Falcon*'s busted hyperdrive. Rather than fix his onetime ship, however, Lando handed over his pals to the Empire.

Yet, all was not lost for our velvet-voiced, cerulean-caped hero. When he realized that Vader had no intention of honoring their deal, Lando turned on the Empire, freeing Princess Leia and Chewbacca from Imperial clutches. Though he was too late to save Han, who had been frozen in carbonite and spirited away by Boba Fett, Lando helped the others safely escape. Once off of Cloud City, Lando reevaluated his role in the conflict, and joined up with the Rebel Alliance (after getting choked by Chewbacca for his treachery, of course). His first mission? Helping Chewbacca recover Han Solo by infiltrating Jabba the Hutt's palace on Tatooine. Biding his time until Luke Skywalker gave the signal, Lando and company launched a surprise attack on Jabba and his men aboard a floating sail barge. With Han rescued, Lando fulfilled his promise to the wild-eyed Wookiee—but he wasn't done there. Lando remained a part of the Rebel Alliance, serving as a general and using his expert piloting skills to fly the *Millennium Falcon* in a direct assault on the Death Star II. Navigating the ship all the way to the space station's main reactor, Lando fired a barrage of proton torpedoes into the reactor, and narrowly escaped the skeletal superweapon's innards before it, along with the Empire's control of the galaxy, exploded into a million little pieces.[239]

Outside of the original trilogy, Lando's character has a storied history, featuring prominently into post–*Return of the Jedi* Expanded Universe stories like the Thrawn Trilogy and the Corellian Trilogy, as well as many of the Marvel *Star Wars* comics produced throughout the 1980s. Though many of these stories now fall under the *Star Wars* Legends banner since Disney hit the reset button on official canon, Lando remains a fan favorite. After all, he's essentially Han Solo's brother from another planet. As Han says, "He's a card player, gambler, scoundrel. You'll like him." Though Billy Dee Williams reprised his role as the debonair ne'er-do-well in *Star Wars Rebels*, there's no telling whether we can expect to see the silver-tongued smuggler in *The Force Awakens*. I'll be keeping my fingers crossed for a quick cameo—maybe something where he's knocking back an icy cold glass of blue milk, just for good measure.

39 The Death Star

"That's no moon. It's a space station." With those immortal words, Obi-Wan Kenobi gave us a sense of the massive scale of the Empire's ultimate weapon, the Death Star. When Grand Moff Tarkin used the massive space station's orbital laser to obliterate Princess Leia Organa's homeworld of Alderaan in front of her, killing billions in the process, we saw just how terrifying its awesome power could be. "No star system will dare oppose the Emperor now," he declared after.

Though as viewers we first encountered the Death Star during the events of the Galactic Civil War in *A New Hope*, its history stretches back before the Clone Wars. Working in secret

with the Geonosians, Senator Palpatine hatched a plan to construct the sprawling space station, a weapon unlike any in history. Palpatine, secretly the Sith Lord Darth Sidious, tasked his apprentice Darth Tyranus (better known as Cont Dooku) with delivering the plans from Geonosis to Coruscant at the outset of the Clone Wars. Even as war ravaged the galaxy, the Death Star slowly began to take form in the space above Geonosis. Access to the planet was restricted, even to Imperial officers, and only a select few were privy to its existence.

In the bleak period between the Clone Wars and the Galactic Civil War, construction proceeded at a breakneck pace. Faced with raw material shortages, shipping delays, intelligence leaks, and even attempts at sabotage, a young Imperial officer named Wilhuff Tarkin was tasked with getting the project back on track. Imperial engineers faced great difficulty with the original Geonosian model, so Tarkin assembled a think tank of engineers in order to improve upon the schematics and create a prototype. When it proved successful, construction resumed on the main Death Star; for his hard work, Palpatine rewarded Tarkin with the title of Grand Moff, granting him nigh total control over the battle station.[240]

In fact, Tarkin would come to see the Death Star as the Empire's greatest asset, making it the crux of his grand strategy to rule the universe through a campaign of fear. Better known as the Tarkin Doctrine, the theory implies that the Death Star represents the threat of force, one which all who opposed them would be unable to ignore for long. Those who did would be summarily exterminated like the citizens of Alderaan. With 10,000 turbolaser batteries, 2,600 ion cannons, 768 tractor beam projectors, and a superlaser capable of destroying a planet with a single blast, the Death Star made an extremely effective bargaining chip for the Empire. Plus, with its linked bank of 123 hyperdrive field generators, the Death Star was able to travel at superluminal

velocities (e.g., faster-than-light speed), zipping across the galaxy was no problem for the floating murder machine.[241]

Measuring 160 kilometers in diameter (900km for the second Death Star), the station boasted a crew of 265,675, in addition to 52,276 gunners, 607,360 combat troops, 25,984 stormtroopers, 42,782 additional support staff, and 167,216 pilots and flight crew. The station itself had 7,200 starfighters, four strike cruisers, 3,600 assault shuttles, 1,400 AT-ATs, 1,400 AT-STs, 1,860 dropships, and many more vehicles. The Death Star is divided into 24 zones, 12 on each hemisphere, which were controlled by a bridge deck. That's really saying something considering that John Stears and his team of modelmaking magicians at Industrial Light & Magic brought the massive, spherical space station to life by using a 120-centimeter model, matte paintings, and sectional models.[242]

However, the Death Star had one crucial weakness: in the original design, there weren't enough turbolaser batteries to prevent starfighters from reaching the trenches. From said trenches, expert pilots could maneuver past the defenses to fire a proton torpedo into the exposed thermal exhaust port through which excess energy was vented. It was a one in a million shot, but a chink in the armor nonetheless, and one the Rebels intended to exploit after they discovered its existence in the stolen plans Leia squirreled away within R2-D2. During the Battle of Yavin, Luke Skywalker exploited this by using the Force to guide a missile into the thermal exhaust port, which caused the station to explode, killing everyone aboard.

The second Death Star, located by the forest moon of Endor, boasted far more turbolaser batteries as a means of preventing this from happening again because, you know, putting all of your eggs in one exceedingly evil basket has a way of backfiring when the basket can be easily exploded. Though the station was behind schedule in its construction, it was a "fully armed and

operational battle station" that managed to blow up one of the Rebel fleet's Mon Calamari star cruisers. Ultimately, though, the Empire's strategy didn't quite work out as intended because after Han Solo's strike team destroyed the station's shield generator on Endor, Lando Calrissian, piloting the *Millennium Falcon,* and Wedge Antilles, piloting an X-wing, were able to knock out the main reactor and blow the Death Star II to smithereens as well.[243]

In 2012, in a galaxy not so far away, a petition appeared on the White House's website requesting that the United States government construct an actual Death Star as a means of stimulating the economy. Since it garnered more than 25,000 signatures, it qualified for an official response from the White House (34,435 signatures, to be precise). In January 2013, the response was released, assuring Americans that though they share the petitioners' desire for "job creation and a strong national defense," there were no plans to build a Death Star. Chief among their reasons is that actually building an orbital superweapon would cost an estimated $850 *quadrillion* dollars—a price tag that would make fiscal conservatives freeze up like they'd been dipped in carbonite.

Furthermore, the response noted that the administration "does not support blowing up planets," and expressed concerns over spending "countless taxpayer dollars" on a device "with a fundamental flaw that can be exploited by a one-man starship."[244] Better luck in 2016, guys. Then again, according to the economics blog Centives, based on current steel production rates, a Death Star wouldn't be ready for 833,000 years, so you might want to come up with a backup plan.[245] And considering *Star Wars: Rogue One* is all about the Rebel plot to steal the Death Star plans, you can bet your bottom dollar that this is going to be a real hot button issue.

40 Peter Mayhew

Many characters cast a long shadow over the Star Wars universe, but few stand as tall as Chewbacca, and that is almost entirely thanks to the man beneath the mask, Peter Mayhew. Even at 70 years old, Peter Mayhew's 7'2" frame dominates the room. Unlike his on-screen counterpart, however, Mayhew is a gentle giant, and significantly less hairy. (Okay, he's pretty hirsute in his own right, but it's all relative.)

Though Mayhew is an Englishman by birth, he lives in Texas—maybe because the desert climate reminds him of Tatooine? Regardless, Mayhew spends most of his time traveling on the sci-fi and comic convention circuit, making as many as 20 appearances a year where he gives talks, does interviews, autographs memorabilia, and generally delights fans of the galaxy far, far away.

Born in Barnes, Surrey, England on May 19, 1944, Mayhew has always stood taller than his peers. The towering thespian's colossal height is the result of a genetic condition known as Marfan Syndrome. Thanks to an overactive pituitary gland, Mayhew grew to an enormous height from a very young age; thankfully, at age 15, Mayhew received treatment that curtailed his condition.[246] While working as a hospital worker in 1976, Mayhew's life changed when producers from the film *Sinbad and the Eye of the Tiger* cast him as a Minotaur.[247] Mayhew followed that role up with another fantastical creature—Chewbacca, the lovable Wookiee sidekick to Han Solo, and the bowcaster-wielding badass aboard the *Millennium Falcon*.

Mayhew wasn't intended to play Chewbacca originally, though; Lucas had intended to cast British bodybuilder David

Peter Mayhew (Chewbacca) poses with Kenny Baker (R2-D2). (Michael Stephens/PA Wire)

Prowse, who stood 6'6", but then changed his mind and cast him as Darth Vader. Lucas then went on a search for actors to play the gigantic, hairy creature. According to Mayhew, all he had to do in order to get cast was to stand up. This may be a bit of friendly exaggeration, but considering the actor stands more than seven feet tall, it's easy to imagine.

Having stood up to claim what was rightfully his, Mayhew set to work creating the look and feel of Chewbacca's physicality by studying the movements of animals. He would visit the local zoo and observe the ways in which bears, gorillas, and monkeys moved around their environment. According to Lucas, "It's very unique the way he has created the character and the way he walks and tilts his head. The way he looks and uses his eyes. You can't put anybody else in the suit."[248] Indeed, no one else *could* play Chewbacca. During the filming of *Empire Strikes Back*, when Mayhew was out sick, director Irvin Kershner placed a stand-in in the suit. However, the replacement actor wasn't able to match Mayhew's mannerisms, thus securing the role for Mayhew and silencing all doubters.

One of the questions Mayhew is asked most frequently seems like something of a no-brainer: is it hot in the suit? According to the actor: yes, yes it was. "It was pretty warm, it depended on where you were," Mayhew revealed in a 2014 interview. "The only place I really appreciated it was when we did *Empire [Strikes Back]* in the scenes up in Norway in the snow and ice. Desert work's not too bad, because you've always got a wind. It's when you're in studio under constant lighting. It's like sitting in a kitchen when the oven door is open and turned right up. It gets pretty warm. You get used to it."[249] Having spent time under glaring studio lights *outside* of a gigantic Wookiee suit, I can assure you that they're just short of sweltering.

Not even that sauna of a suit could keep Mayhew away from returning to the galaxy far, far away for a new generation. The

veteran actor has confirmed that he will indeed be returning for *Star Wars: The Force Awakens*. Considering that Chewie is the only character from the main films to die in the Expanded Universe stories, I'm keeping my fingers crossed for the big ol' furball going forward. After all, Peter Mayhew still has plenty of life left in him, and these films are all planned out through *Episode IX*.

41 Anthony Daniels

Behind every shiny golden robot, stands a smarmy British actor. I believe it was Chaucer who said that, or maybe Yeats. The point is that it holds true for *Star Wars*' resident worrywart/protocol droid C-3PO, and the actor who played him, Anthony Daniels.

Born in Salisbury, England, Anthony Daniels was the son of a plastics company executive, but rather than following in his father's footsteps, he chose a life in the arts. After two years of law school, Daniels dropped out in favor of attending acting school, where he studied in the mime and radio departments, skills that would serve him well in his future roles. In 1974, after leaving college, Daniels began working as a professional actor on BBC Radio (for which he won a BBC Radio Award) and with the National Theater of Great Britain at the Young Vic.

While performing in a production of *Rosencrantz & Guildenstern Are Dead,* he was invited to meet with a young American director who was in the midst of casting a space-fantasy film that was set to film in Tunisia. Of course, that director was a young George Lucas, and the film in question was *Star Wars.* Though Daniels' star was on the rise, he was one of hundreds

of actors invited to meet with the director to discuss the role of C-3PO. Given the complexity of the golden droid's costume, Lucas was attracted to Daniels' mime and voiceover experience. Daniels, however, wasn't interested at all—in the character, the genre, any of it. (Daniels once famously demanded his money back after walking out during a screening of Stanley Kubrick's classic *2001: A Space Odyssey*.)

Although Daniels would go on to appear in all six *Star Wars* films (and is set to appear in *The Force Awakens*), he initially declined the meeting. After his agent harangued him, Daniels finally met with Lucas, who by this point was exhausted from having met with a litany of actors. So what made Daniels stand out from the crowd? "I think it was a refreshing change for him because I didn't do what so many people apparently did—this stiff robotic dance," Daniels revealed in an interview. "He had lots of people coming in being a robot, which to me is slightly embarrassing. What do you say to somebody who comes in like that? Apparently he would say, 'No, no, no!' I was utterly relaxed because I didn't want the job anyway."[250]

Indeed, though Daniels intended to turn down the role, a painting of C-3PO by Ralph McQuarrie caught his eye. "It almost was inviting to come through the frame of the painting and be with him, or it, on this lonely moonscape," Daniels recalled.[251] Ultimately, it was the painting—not George Lucas—that led him to accept the role. The day after he accepted the role, artisans covered Daniels' face in plaster—not as a cruel prank, but rather to make a mold of his body in order to construct the now-famous costume.

Even though the suit was molded to Daniels' body shape, putting it on proved a difficult and uncomfortable task. "There wasn't really room for me inside, let alone a cooling system that was always promised," Daniels explained, "and finding somewhere to put the radio transmitter was a delicate task. I won't say

where it ended up!"[252] In fact, the costume was so jury-rigged that it could take as long as thirty minutes in order to line up the three screws that kept the halves of the headpiece together. "It was like being inside a Rubik's cube with people on the outside arguing over the instructions," said Daniels. "And it seemed as though it was my fault that Threepio took so long to construct each time."

Ultimately, though, it was Daniels' performance that imbued the fussy robot with a decided sense of humanity, a quality that makes Threepio an enduring character to this day. Interestingly enough, Lucas intended to only use Daniels' physical performance of Threepio, and planned to overdub his voice using a Hollywood star. Ultimately, Lucas abandoned this plan and asked Daniels to overdub himself.[253]

In addition to appearing in all of the films, Daniels has been quite active in other promotional works, appearing in character on *The Muppet Show* and *Sesame Street*, the ill-fated *Star Wars Holiday Special*, and commercials for licensed *Star Wars* products like Kenner Toys and C-3PO's, a cereal based on his worrywart of a protocol droid. Daniels also holds the distinction of being the only cast member of the original *Star Wars* trilogy to voice his character in all three parts of NPR's radio serial based on the original films. Likewise, Daniels has provided voiceover work for Expanded Universe offerings like four animated series—*Droids*, *Star Wars: Clone Wars*, *Star Wars: The Clone Wars,* and *Star Wars: Rebels*—as well as theme park attractions like Disneyland's Star Tours and audiobooks like *Dark Force Rising* and *The Last Command*.[254]

Like the other half of his droid duo, actor Kenny Baker, Daniels made a cameo appearance as other characters in the series. In *Star Wars Episode II: Attack of the Clones* and *Episode III: Revenge of the Sith*, Daniels can be seen as the humanoid character Lieutenant Danni Faytonni, a modified, *Star Wars*-ified version of his own name. In particular keep your eyes peeled in the

Outlander nightclub scene in *Episode II* and the Galaxies Opera House in *Episode III* for a glimpse of Faytonni in the flesh.[255] When it comes to *Episode VII*, however, there is no doubt as to which version of Daniels we'll see on screen: the golden droid himself, C-3PO.

Not just any version of Threepio, mind you—this will be the protocol droid in the flesh, er, the cybernetic exoskeleton. Daniels cleared the air by explaining, "[W]hen J.J. Abrams rang me to ask about filming *Episode VII*, one of the first things he said after he told me how wonderful I was—and that didn't take long—but he then said, 'Would you be interested in being in the film just doing the voice?' I said, 'No,' and he said, 'Right!' He knew I'd say that. There's no way I would just do the voice."[256] So rest easy, Threepio fans. Daniels may not be fluent in more than 6 million forms of communication, but he speaks the one that matters—driving a hard bargain.

42 Kenny Baker

Star Wars is a universe of extremes. The Jedi are paragons of goodness and light, whereas the Sith are the living embodiment of darkness and evil. The same principle holds true in the cast as well; just as Peter Mayhew (Chewbacca) stands a staggering 7'2", Kenny Baker measures a mere 3'8". In spite of his relative diminutive stature, however, Baker casts a large shadow across the *Star Wars* franchise, thanks to his long-running role as everyone's favorite astromech droid, R2-D2.

Born in Birmingham in the West Midlands, England, on August 24, 1934, Kenny Baker grew up an only child. Educated

at a boarding school in Kent, young Baker never intended to pursue a career in acting; rather, he wanted to follow in his father's footsteps and be an engraver. However, he lacked the sufficient education. Eventually in 1951, he went to live with his stepmother in Hastings, whereupon a woman on the street approached him and invited him to join Burton Lester's Midgets, a traveling theater troupe of dwarves and little people. After getting his first taste of show business, Baker went on to join the circus, and after learning to ice skate, appeared in many ice shows.[257]

Alongside British actor Jack Purvis—who also happened to be a dwarf—Baker formed a successful comedy group known as the Minitones. Then in 1977, some 27 years after his career began, a meeting with Lucas changed his life, landing him the role of R2-D2 in *Star Wars*. Ever the team player, Baker insisted as a condition of his casting that Purvis receive a role as well. Fortunately, Lucas was able to find roles for both of them in all three of the original trilogy films.[258]

Although Baker was playing a core character, he received no script. Rather, in order to achieve the desired performance, Lucas would direct him with a megaphone. As there were no electronics inside the suit, it was up to Baker to make the droid seem expressive and reactive. However, this evidently rubbed his co-star Anthony Daniels the wrong way. Daniels, who plays C-3PO, "was a little bit annoyed with me because I couldn't respond—I just couldn't hear it," Baker explained. "Even if I had heard him, he wouldn't have been able to hear me."[259]

Indeed, the suit proved a tight squeeze even for Baker. There were multiple R2-D2 units constructed for the shoot—some with remote control capabilities, others without. According to Baker, the way to tell whether or not he was in the R2-D2 suit on-camera is whether or not it is the two-legged or three-legged Artoo model. "The R2 I use is the two-legged one, the one that

reacts to dialogue," said Baker. "When it is moving, chasing or rolling; no way can my R2 do that! That one has the third leg, the motor, and the steering device."[260]

Although most of Baker's scenes were filmed in the company of Anthony Daniels' C-3PO, the two have a frosty working relationship. In one interview, Baker pulled no punches, revealing that Daniels was the rudest man he had ever met in his life. "I thought it was just me he didn't get on with but recently I've found out he doesn't get on with anyone," Baker explained.[261] "He's been such an awkward person over the years. If he just calmed down and socialized with everyone, we could make a fortune touring around making personal appearances. I've asked him four times now but, the last time, he looked down his nose at me like I was a piece of s**t. He said: 'I don't do many of these conventions—go away little man.' He really degraded me and made me feel small—for want of a better expression. He's rude to everyone though, including the fans."

Fortunately for Baker, he didn't have to spend all of his time cooped up inside of R2-D2's lifeless droid body. In *Return of the Jedi*, Baker plays the Ewok Paploo, which he describes as "a cute, beautiful thing" and mentions that "to work with [the Ewok costume] was a nightmare and you'd just melt."[262] That wasn't the only Ewok Baker was supposed to play; evidently, he was going to play Wicket as well, but he took very ill when his scenes opposite Carrie Fisher were set to be shot, so Warwick Davis was cast in his stead. "I wasn't too upset because I much preferred playing the role of Artoo," Baker confessed.[263]

Much like his protocol droid counterpart, Baker will reprise his role as R2-D2 in *Star Wars: The Force Awakens*, which is great news especially considering how important practical effects have been to the aesthetic of the franchise. They could have easily gone a CG route with the iconic droid, but considering how much animatronics technology has improved since 2005's *Star Wars*

Episode III: Revenge of the Sith, having a live-action version is still a viable option. Plus, this time around, R2-D2 is being built and operated by members of the UK chapter of the R2-D2 Builders Club who have officially joined the creature effects team, so hopefully Baker's latest trip into Artoo's innards will be his most comfortable yet.

43

The Seven Vaders

Between his iconic scarlet lightsaber, the billowing black cape, and the constant asthmatic breathing, there is no mistaking Darth Vader. The sinister Sith Lord cuts an impressive swath across the screen with his silent sci-fi samurai aesthetic, but behind the scenes, one might be hard-pressed to pin down exactly who Darth Vader is. You would be well within your rights to be confused too, because no fewer than seven people have played Darth Vader over the years on the silver screen. Just to put things in perspective, Jabba the Hutt, that slimy slug of a Tatooine crime lord, only required three puppeteers to operate. Still, when it comes to bringing the most menacing man in the galaxy to life, it would seem that seven is the lucky number.

When it came time to cast the Dark Lord, not just anyone would do. George Lucas needed someone with an imposing physicality and screen presence, so he turned to British body-builder David Prowse, who had a few film credits under his belt and was already independently wealthy thanks to a chain of weightlifting gyms he owned. "George told me he was making a space fantasy and asked me to consider playing either Chewbacca or Darth Vader," the Bristol-born Prowse recalled. "I turned

down Chewbacca at once. I know that people remember villains longer than heroes. At the time I didn't know I'd be wearing a mask. And throughout production I thought Vader's voice would be mine."[264] Even on set, though, Prowse realized something was amiss. "I kept turning to George and saying, 'What are we going to do with Darth Vader's dialogue, because everything I'm saying is coming muffled through the mask?'" Prowse said. "[George] said, 'Oh yeah, don't worry, we're going to the sound studios and we'll record all of your dialogue at the end of the movie.'"[265]

Indeed, while Prowse provided the lines on set during filming, he would later be overdubbed in post-production—and for good reason too. "It was hard to be afraid of Darth Vader," said Carrie Fisher. "They called him 'Darth Farmer' because David Prowse had this thick Welsh accent, and he couldn't remember his lines—I guess I could've been afraid of that."[266] So what voice could inspire terror in the hearts of men, women, and children all over the world? After an arduous search that included golden-throated actors like Orson Welles, Lucas landed on the American actor James Earl Jones. Initially, Lucas was hesitant to cast Jones in the film on the grounds of casting a black man in the film only for him to be the main villain. However, casting director Fred Roos prevailed, impressing upon Lucas that skin color had nothing to do with it; rather, Jones simply had the best baritone in the business. For Jones' part, he was paid $7,000 for his voiceover work on the first film, and he actually refused to take credit for his role until *Return of the Jedi*, referring to himself jokingly as "special effects."[267] To be fair, the ability to make someone both victoriously pump their fist and void their bowels with a single word is a pretty special effect.

Though Prowse and Jones are best known for playing the part throughout the original trilogy, there were two others who helped bring the role to life. Though he was quite strong and exceedingly physically fit, Prowse couldn't keep up with some

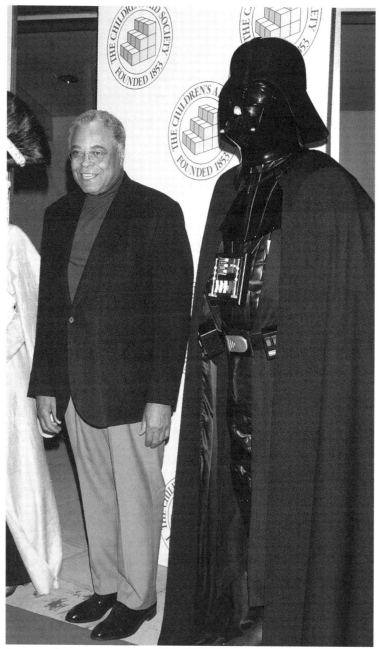

James Earl Jones, arguably the most important of the seven Vaders, poses at the premiere of Attack of the Clones. (Star Max)

of the more intense sword combat sequences. Plus, he had a tendency to shatter the lightsabers as a result of his brute strength. So, for those particularly taxing fight sequences that required a defter hand, stuntman Bob Anderson, a professionally trained fencer and swordsmaster, filled in as Vader. By the time *Return of the Jedi* was underway, relations had soured between Prowse and Lucas; Prowse felt an intense sense of ownership over the character and chafed at the fact that neither his likeness nor his voice made it to the screen. To make matters worse, a UK newspaper incorrectly pegged Prowse as the source for a story revealing that Darth Vader was going to die. As a result, Prowse found himself sidelined for much of the production as Anderson stepped in to film many of the scenes originally intended for him.[268]

A New Vader Emerges

In Lucas' original plans, *Return of the Jedi* was going to have a much darker ending. Transcripts from the famous story conferences held during pre-production reveal an alternate ending to the famous scene at the end in which Vader sacrifices himself to save his son, Luke Skywalker. This time around, rather than the light side prevailing, Luke reveals a very different plan:

"**[George] Lucas:** Vader gets his cape caught in the door and says, 'Leave without me' and Luke takes his mask off. The mask is the very last thing—and then Luke puts it on and says, 'Now I am Vader.' Surprise! The ultimate twist. 'Now I will go and kill the fleet and I will rule the universe.'
[Lawrence] Kasdan: That's what I think should happen.
[George] Lucas: No, no, no. Come on, this is for kids."

You have to admit, though, it would have made for one hell of a twist. Plus, the kids already got their Ewoks. Why can't we adults have fun too?

Rinzler, J. W. *The Making of Star Wars Return of the Jedi: The Definitive Story.* New York, NY: Del Rey, 2013. p. 408. Print.

If that wasn't bad enough, no one told Prowse that actor Sebastian Shaw had been cast to be the face of the unmasked Darth Vader during his death scene, a fact which rankles Prowse to this day. A quick sidebar on Shaw: since the death sequence was the emotional climax of the film, they wanted an experienced actor to play the role; Shaw had a resume including productions of *Hamlet* and *Henry V* at some of London's most prestigious theaters. Though Shaw was only on screen for two minutes and seven seconds and spoke 24 words of dialogue, it is among the most affecting scenes in the entire *Star Wars* saga.

In spite of his recasting, Prowse still came in handy during some of the film's final moments. When it came time to film the scene in which Darth Vader lifts Emperor Palpatine over his head and throws the wretched crone into a chasm, production came to halt; they just couldn't get the shot right. Reminding the powers that be that he was, after all, the British weightlifting champion, Prowse came to the rescue. "I got dressed up, everything was ready, and I picked him up like I was lifting a barbell," Prowse said. "I put him across my chest, took a couple steps towards the balcony and threw him over! All in one shot. The whole thing was ridiculous."[269] That, dear reader, is a case study in why you should never skip leg day.

For the prequels, we got a glimpse of Darth Vader back when he was a young Force-sensitive boy as he rose to become a Jedi Knight and one of the great generals of the Clone Wars. In *The Phantom Menace*, young Anakin Skywalker was portrayed by Jake Lloyd, and later played by Hayden Christensen in *Attack of the Clones* and *Revenge of the Sith*. When it came time for the Special Edition reshoots, George Lucas and company looked a little bit closer to home to fill the Dark Lord's considerable shoes; Industrial Light & Magic VFX supervisor C. Andrew Nelson was tapped to play Vader for reshoots. Though they may not be as memorable as the men who donned the iconic black suit, they

are no less of a part of the DNA of one of the most important characters in the *Star Wars* canon and the greater pantheon of pop culture as we know it. So, thank you, Darths, for all the memories—all seven of you.

Ahsoka Tano

What has orange skin, wields two lightsabers, and has a nickname for everything under the twin suns of Tatooine? Ahsoka Tano, that's who. The sassy young Togruta woman wasn't just Anakin Skywalker's Padawan during the Clone Wars; she was a catalyst for character growth, helping to explain his metamorphosis from the headstrong Padawan seen in *Attack of the Clones* to the more somber, serious Jedi Knight in *Revenge of the Sith*. Though she has never appeared in a live-action film, Ahsoka Tano is undeniably one of the most popular characters in the entire franchise, as well as one of the most integral characters to the mythos created by the long-running *Star Wars: The Clone Wars* series.

From a very young age, Ahsoka Tano was groomed to be a Jedi Knight. After being abandoned by her parents, Ahsoka was discovered by the Jedi Master Plo Koon, and accepted to the Jedi Order at the tender age of three years old. (To put things in perspective, I was lucky to be forming partial sentences by age three, let alone being inducted into an elite organization.) Though she was a fast learner, Ahsoka displayed a rebellious attitude during her Jedi training. Even so, Master Yoda saw her potential, raising her to Padawan at age 14—a full two years before most reach that rank—and placed her under the tutelage of another rash, rebellious Jedi, Anakin Skywalker, to serve as his apprentice.[270]

Initially, their relationship was volatile to say the least. Anakin bristled at the idea of having to deal with a Padawan, let alone one as impetuous and bull-headed as Ahsoka. One of the most iconic and endearing manifestations of Ahsoka's typically flippant attitude was her tendency to refer to people by nicknames rather than their given names. Case in point, Anakin was "Skyguy," rather than "Master." Anakin retorted by calling her "Snips," a reference to the "snippy" attitude she had when they first met. However, they would soon come to respect one another—Anakin for his bravery in battle, and Ahsoka for her creative thinking when she managed to destroy a Separatist shield generator, saving Anakin's life in the nick of time. Ahsoka would eventually give Anakin the appropriate honorific, but "Snips" remained a playful nickname that stuck with her.[271]

Though Ahsoka experienced many triumphs during the Clone Wars—like saving the life of Clone Captain Rex by facing off against the notorious robotic Jedi killer General Grievous—she was not without her defeats. When Anakin lost R2-D2 during the Battle of Bothawui, Ahsoka introduced her master to a replacement droid, the gold-tinted astromech R3-S6, who she dubbed "Goldie." Blinded by her insistence on trying to see the good in the droid, she failed to notice it was, in fact, a Separatist spy. That stubbornness would prove far costlier during her first stint as a commander in which she led a starfighter squadron in an assault on a Separatist blockade of the planet Ryloth. She disobeyed a direct order to retreat, and her squadron was butchered as a result.[272] It was a hard pill to swallow, but it was a lesson in responsibility that she would not soon forget, and one that would steel her going forward.

As the war progressed, Ahsoka grew up quickly, maturing into a more confident warrior and a worthy leader. Combining her outside-the-box inclinations with the wisdom that comes with experience, Ahsoka went on to perform heroic deeds like

destroying a Geonosian droid factory, exposing deep-rooted political corruption on Mandalore, and preventing the bounty hunter Aurra Sing from assassinating Senator Padmé Amidala. When captured by Trandoshan slavers, Ahsoka found herself and her fellow prisoners hunted for sport. Rather than give up hope, she rallied her fellow captives—among them, the Wookiee Chewbacca—and staged a revolt against her jailers. Later, Ahsoka faced her toughest challenge: accepting that not all Separatists were inherently evil. When she met young Separatist politician Lux Bonteri, she not only realized that they had valid reasons for wanting to break away from the Republic, but she found herself developing feelings for him too.

After a deadly bombing at the Jedi Temple, Ahsoka Tano's life was turned upside-down when she was framed for perpetrating the terrorist attack. With mounting evidence pointing toward the young Padawan, Ahsoka turned tail and fled, running for her life and desperately trying to prove her innocence.[273] However, she was soon captured and expelled from the Jedi Order, stripped of her Padawan rank. In spite of the horrendous accusations against her, Anakin never stopped believing in his young ward, eventually clearing her name by uncovering the true culprit: Ahsoka's friend, the Padawan Barriss Offee. Though all charges against Ahsoka were dropped and the Jedi Order offered to reinstate her membership, her faith in the Order was justifiably and irrevocably damaged. Rather than resume her role as Padawan, she walked away from the only life she had ever known.[274]

For a time, it was presumed that Ahsoka had perished in the holocaust that was Order 66, the systematic extermination of the Jedi ordered by Senator Palpatine/Darth Sidious. However, this was revealed to be a vision that appeared before Yoda, not reality. In fact, since she had severed ties with the Jedi Order, she escaped Order 66 unscathed, disappearing into the shadows for nearly a decade. During the first season of *Star Wars Rebels*, however, a

hooded figure known as "Fulcrum" emerged, providing the rebel crew of the *Ghost* with valuable intelligence. The mysterious informant revealed that the *Ghost* was but one of many rebel cells that were fighting back against the Empire, that they were not, in fact, alone after all. In the season finale, "Fulcrum" removed the hood, revealing herself to be none other than Ahsoka Tano, who was now working for the group that would become known as the Rebel Alliance.

For fans, it was an emotional return. On March 2, 2013, Ahsoka had essentially walked out of their lives in the season 5 finale of *The Clone Wars.* Exactly two years later, on March 2, 2015, she returned in the most shocking reveal of *Rebels'* entire season. The biggest question is "just what the hell was Ahsoka doing for the 14 intervening years?" In an interview, voice actress Ashley Eckstein admitted that not even she knows for sure. "I know it's out there as a complete joke that she was on a pony farm eating cupcakes," she joked. "But we all know with Ahsoka that was not the case. Whatever she did and wherever she was has to be beyond fantastic, and I'm dying to know what that story is."[275] So are we, Ashley, so are we. As for what the future holds for Ahsoka Tano, only time will tell, but with another season of *Star Wars Rebels* on the way, one gets the distinct feeling that Snips is more important than ever, and won't be going anywhere anytime soon.

Qui-Gon Jinn, the Maverick Mentor

He doesn't know who you are or what you want, but Liam Neeson has a very specific set of skills. Namely, the Irish actor harnessed his considerable artistic talents to bring the maverick

Jedi Master Qui-Gon Jinn to life on the big screen in *Star Wars Episode I: The Phantom Menace* and in the 2008 *Star Wars: The Clone Wars* animated series. (Though he was later voiced by Fred Tatasciore in Genndy Tartakovsky's *Star Wars: Clone Wars* microseries, that had no effect on Qui-Gon's overall badassery.) Wielding a green lightsaber, Qui-Gon Jinn played a brief, but important part in the *Star Wars* saga, acting as the catalyst for Obi-Wan Kenobi's development into a leader, and the discovery of Anakin Skywalker as the Chosen One, the Force-wielder for whom the Jedi had been waiting thousands and thousands of years. (To paraphrase Michael Bluth, "*Him?*")

Trained by Count Dooku, Qui-Gon Jinn developed a reputation within the Jedi Order as something of a non-conformist. Rather than following the Order's stringent rules and precepts, Qui-Gon often chose to blaze his own trail, preferring to live in the moment rather than lose himself in the meditative contemplation so characteristic of many Jedi. His philosophy could best described as one of "Feel, don't think—use your instincts."[276] Many posited that he could have been appointed to the Jedi Council himself one day if he had not so consistently gone against its wishes. Yet, that mattered not to Qui-Gon; he was a student of the Force, first and foremost, and he devoted his life to its study in an attempt to learn its secrets, including that of eternal consciousness, the ability to retain one's identity and project one's spirit even after death (the phenomenon behind Force ghosts).

While on a diplomatic mission to Naboo, things went awry for Qui-Gon Jinn and his Padawan Obi-Wan Kenobi when Trade Federation warships invaded the verdant planet. In the process of escaping, Qui-Gon rescued the Gungan pariah Jar Jar Binks from a stampede of wildlife, leading the bumbling Gungan to swear a life-debt to him. During his time on Naboo, he felt the living Force at work, but the escalating conflict forced him

to flee and escort Queen Padmé Amidala to the desert planet of Tatooine. On Tatooine, Qui-Gon discovered a young slave boy named Anakin Skywalker, who demonstrated tremendous Force sensitivity. The judicious Jedi believed that Anakin wasn't any mere Force sensitive; rather, he was the Chosen One, a mythical figure prophesized to bring balance to the Force, and their meeting was destiny. After freeing Anakin from slavery, Qui-Gon decided that young Anakin should train as a Jedi, and brought him to Coruscant. During their departure from the backwater Outer Rim world, Qui-Gon faced his toughest challenge yet—a ferocious battle with a mysterious dark warrior wielding a lightsaber.[277]

However, not everyone on Coruscant shared Qui-Gon's faith in the young Skywalker; the Jedi Council grew angry with Qui-Gon and refused to train the young boy on the grounds that his future felt clouded and uncertain, and that he was too old. Furthermore, no one believes Qui-Gon that the mysterious man in black with whom he fought was a Sith Lord, as the race of Dark Jedi had not been seen for nearly a thousand years. Undeterred, Qui-Gon promised Anakin that he would train him in the ways of the Jedi.[278] It was a promise that Qui-Gon would not be able to keep, however.

Back on Naboo, Qui-Gon and Obi-Wan came face to face with the man in black—who was, in fact, the Sith Lord Darth Maul. Though they outnumbered the Sith, the deadly Dathomirian managed to separate the two Jedi, and seized his opportunity to strike Qui-Gon Jinn down, mortally wounding him. Though Obi-Wan defeated Darth Maul by separating his torso from his body with a well-timed swing of the lightsaber, it was too late to save his dying master. With Qui-Gon's final breath, he asked Obi-Wan to continue Anakin's Jedi training, a wish which he would fulfill.[279]

Though Qui-Gon Jinn had seemingly shuffled off this mortal coil, he was not necessarily gone from this plane of existence. Nearly a decade after Qui-Gon's death, after the fall of the Jedi Order, Obi-Wan and Anakin traveled to the planet Mortis, a world heavily saturated by the Force. There, they encountered the spectral form of Qui-Gon Jinn, who warned Obi-Wan that Anakin is a conduit through which the Force flows, a powerful nexus between good and evil. It was a dangerous position for the Chosen One, to say the least, but it was essential to maintain if Anakin was to bring balance to the Force. In classic Qui-Gon fashion, he urged Anakin to remember his training and trust his instincts.[280]

Later, this ghostly form of the dearly departed Jedi would guide Master Yoda to the swampy planet of Dagobah, speaking to him through the Force. Once on the remote world, Qui-Gon helped usher Yoda through his study of the Force, teaching him the secrets of the living Force that he had learned, like the exceedingly difficult-to-master notion of eternal consciousness. He would also teach the ancient lore to Obi-Wan Kenobi, too, which explains the slightly insane number of Force ghosts running around at the end of *Return of the Jedi*.[281] Seriously, though, Qui-Gon Jinn makes a powerful case for a *Ghostbusters* crossover, what with the apparent ease and willingness with which he teaches nice, normal mortals how to live forever as judgmental specters.

46 Darth Maul

With terrifying features, a demonic visage, a double-bladed red lightsaber, and an acrobatic fighting style to put the fear of God in you, Darth Maul is one of the most visually striking characters in the *Star Wars* saga. Trained by the malevolent Darth Sidious, the Sith Lord blended deadly agility and superior swordsmanship to cut an imposing swath across the screen when he made his debut in *Star Wars Episode I: The Phantom Menace*, due in large part to actor/martial artist Ray Park's dynamic physicality. Yet, in keeping with the grand tradition of the *Star Wars* universe, what really sets Darth Maul apart from the rest is his eye-catching aesthetic.

When it came time to create a new villain for *The Phantom Menace*, George Lucas asked concept designer Iain McCaig to create "a figure from your worst nightmare." What he drew was so frightening that Lucas turned it over and asked him to draw his "second worst nightmare" instead, which happened to be clowns. "Clowns have always scared the pants off me," he revealed in an interview. "Who knows what they're feeling behind those painted smiles? I've had nightmares about Bozo the Clown since I was three."[282] (Really? Bozo? Hopefully he has never seen *It*.)

Originally, McCaig envisioned someone for whom pain was a central focus. "I had Maul bind his head with razorwire interspersed with black feathers, an excruciating ritualistic device to center his dark side energy," McCaig said of initial designs. Maul's face markings also have a grisly origin story. "The markings are also meant to be reminiscent of what you'd see if you were to flay the flesh from a face to reveal the muscle patterns underneath," he explained.[283] So Darth Maul is equal parts

murderous clown and flayed fighter? That sounds like definite nightmare fuel to me. Thank goodness they made him wear those black hooded robes or adult diapers might have been in order.

Darth Maul's origin story, however, is nearly as frightful as his design process. Born on the faraway planet of Dathomir, Darth Maul is a Zabrak Sith Lord, who was born to Mother Talzin, leader of the Nightsisters witch coven, and raised as a Nightbrother until Darth Sidious took him on as an apprentice. Under Sidious' tutelage, Maul learned the ways of the dark side, specializing in the art of lightsaber combat in order to become a weapon of darkness to strike at the Jedi Order. After years and years of indoctrination, Maul seethed with hatred and longed for revenge against the Jedi Order that had defeated the Sith a millennium prior. Together with his master, he hoped to eradicate the Jedi and restore the Sith to their former glory.[284]

Darth Maul's moment to strike finally came on the desert planet of Tatooine, where Sidious unleashed his living weapon in an attempt to assassinate the Queen of Naboo, Padmé Amidala. Unfortunately, Maul had not counted on the Queen having a Jedi escort; he clashed with the Jedi Master Qui-Gon Jinn, and was ultimately unable to reach his quarry. Retreating to Naboo, Maul set another trap for the unsuspecting Queen, only to find himself locked in combat with both Qui-Gon and his apprentice, Obi-Wan Kenobi. Tapping into heretofore-unseen levels of rage, Maul fought with a frightening ferocity, battling both Jedi at once. After managing to separate the two, Maul pressed his advantage, skewering Qui-Gon Jinn with his double-bladed lightsaber, a wound that would ultimately kill him. However, not even Maul could match Obi-Wan Kenobi, who outwitted the Sith Lord, slicing him in two and leaving him to fall to his apparent death.[285]

What's that? Why did I say "apparent death," you ask? Surely a man who was cut in half while plummeting down a bottomless

chasm for what one can only assume is the rest of eternity can't come back from the dead, right? Well, to paraphrase Mark Twain, the reports of Darth Maul's death have been greatly exaggerated. Using the power of hatred (huh, maybe all that Internet cynicism and bile is good for something after all…), Maul focused on his burning rage toward Obi-Wan Kenobi, a force that sustained in spite of his grievous wounds. His crumpled, crippled body wound up amidst the garbage heaps of Lotho Minor, a junk planet, where he survived by eating whatever vermin he could get his hands on. While on Lotho Minor, Maul essentially lost his mind, losing his memory of who he once was, speaking in garbled tongues, and replacing his severed legs with grotesque, jury-rigged spider-like legs of his own design. So, basically, if you thought he was scary before—think again.[286]

When Maul was discovered by his brother, Savage Opress, he seemed like a lost cause. Yet, his brother persevered, taking the shattered Sith back to Dathomir, where Mother Talzin used her fell magicks to restore both Maul's body and his mind. Obsessed with Obi-Wan Kenobi, Maul took Opress on as his Sith apprentice, and together they lured the Jedi into a trap.[287] Though they failed to kill him, the duo went on a murderous campaign of terror across the galaxy, aligning themselves with an array of space pirates and the Mandalorian Death Watch to form a new army called the Shadow Collective. With his new axis of evil in tow, Maul conquered the planet Mandalore, and tightened his grip by slaying Death Watch leader Pre Viszla to assume total control of the planet.[288]

While Maul was ultimately unable to kill Obi-Wan Kenobi, he did deal the Jedi an emotional blow by killing Duchess Satine Kryze, Obi-Wan's former lover, in cold blood. Maul's reigns of terror would prove short-lived though; deciding that the galaxy wasn't big enough for two monolithically evil megalomaniacs, Darth Sidious came to Mandalore. Declaring the two Zabrak

brothers to be his competition, Sidious killed Savage Opress and took Maul captive, gleefully torturing his former ward with Force lightning. Just remember that the next time you think about how *your* teachers were unfair to you.

As the Clone Wars wore on, Maul managed to escape, eventually working with Count Dooku and the Shadow Collective to strike out at the Jedi and, in particular, Obi-Wan Kenobi. However, Maul's schemes proved unsuccessful in the face of Sidious' superior machinations and killer instinct. During a Separatist attack on Dathomir, Maul fled, disappearing into the shadows, never to be heard from again. Now, does this mean that the dark warrior is dead? Not by a longshot, especially since we never saw a body and Lucasfilm has now effectively hit the reset button on Expanded Universe continuity. Actor Ray Park has expressed an interest in reprising his role too, and it doesn't sound like he's being a diva about it either. "Just give me food and water, and I'm there," he said in a 2013 interview.[289] Though considering the amount of money *Star Wars* films make at the box office, something tells me they would be able to give Park a little bit more than that. So, Darth Maul solo movie, anyone?

47 Jango Fett

At its core, *Star Wars* has always been a story of fathers and sons, but that theme isn't limited to Darth Vader and Luke Skywalker; it also extends to a Mandalorian bounty hunter named Jango Fett. He wasn't just the best damn bounty hunter in the galaxy, he wasn't just a sharpshooter with unrivaled skills in hand-to-hand combat; he was the genetic blueprint for the clone troopers

created to serve in the Grand Army of the Republic. In exchange for handing over his DNA to the clonemakers on Kamino, he was given an unaltered clone to raise on his own; in short, he was given a son, Boba Fett, who he would groom to carry on the Fett family legacy.

As the old saying goes—like father, like son. Much like Boba Fett made waves in 1980 when the armored, jet pack-toting bounty hunter appeared in *The Empire Strikes Back*, Jango Fett rocks a similar look. Chronologically, though, if we're following in-universe canon, Jango did it first with his signature Mandalorian armor, a helmet to cover his facial scars, a jet pack (of course), and a vast array of weaponry (including, but not limited to, dual blaster pistols, retractable wrist blades, and a backpack-mounted rocket launcher).[290]

Much like Han Solo tools around in the *Millennium Falcon*, Jango has a starship of his own, the *Slave I*, a fearsome craft that is shaped like a light post, an iron, or a satellite dish depending on who you ask. A modified prototype *Firespray 31*-class patrol craft, the *Slave I* is one of only six vessels of its class in the entire galaxy. However, none of the others have the sheer maneuverability and firepower of the *Slave I*, which boasts cloaking devices, laser cannons, proton torpedo launchers, seismic charges, and senor jamming arrays, making it ideal for hunting down and disabling bounties.[291]

Having captured Zam Wesell, the shapeshifting assassin who tried to murder Padmé Amidala, Obi-Wan Kenobi and Anakin Skywalker found their interrogation cut short when an armored assailant shot a toxic dart into her neck. After tracking the weapon back to the watery plant of Kamino, Obi-Wan discovered a massive intergalactic secret: the Kaminoans were manufacturing an army of clone troopers based on the DNA of Jango Fett. When Obi-Wan finally confronted Jango Fett, he also realized that the Mandalorian mercenary had been the one who

deep-sixed Zam Wesell. Though he revealed that the Kaminoans had conscripted him through a mysterious man named Tyranus, Jango refused to go back to Coruscant for additional questioning, escaping on the *Slave I* with his clone-son Boba, making a beeline to the Separatist stronghold on Geonosis.[292]

Unfortunately for the Fetts, Obi-Wan Kenobi managed to follow them to Geonosis, where he discovered that the "Tyranus" they were working with was, in fact, Count Dooku and his Separatist movement. A massive battle ensued as a Jedi strike force and Republic soldiers deployed onto the planet. During the melee, Jango Fett helped defend Count Dooku from the attacking Jedi, but not even the mighty Mandalorian could withstand the brutal bite of Mace Windu's lightsaber blade. With a single, decisive swing of his purple lightsaber (amethyst, if you're a stickler), Mace Windu decapitated Jango, thus ending the career of the galaxy's most notorious soldier of fortune.[293] Though Jango's tale came to an end, his legacy lived on in each and every clone trooper, but most especially through his son, Boba Fett, who would go on to become the most infamous bounty hunter in the galaxy during the Galactic Civil War era. Isn't there something just so cute about when kids follow their parents into the family business? (Even if that business does happen to be kidnapping, extortion, and murder for hire.)

48 Padme Amidala

She may not have had fancy Force powers, but Padmé Amidala had something that many in the *Star Wars* universe lack: conviction and integrity. During an age rife with corruption, war, and

malfeasance, Padmé served not only as the Queen of Naboo, but the representative of her homeworld in the Galactic Senate. A firm believer in civic duty and the efficacy of the political system, Padmé remained an optimist and an idealist to the bitter end. Some might call her naïve, but in truth she was one of the rare incorruptible few who populate the galaxy far, far away. It was her influence that kept Anakin from succumbing to the dark side and, ironically, her frailty that pushed him over the edge. Still Padme, portrayed on film by Natalie Portman, is an adept public speaker, as persuasive as she is beautiful, a shrewd operator, and awfully handy with a blaster pistol, which made the quiet way she went out all the more frustrating.

Born to a pair of humble, unassuming parents, Padmé Amidala dedicated her life to public service, serving for two years as the city supervisor of Naboo's capital Theed before being elected Queen of Naboo at the tender age of 14. (Now that's a far sight more impressive than student body council.) During the Trade Federation's blockade of Naboo and their surprise invasion, Amidala relied on two Jedi Knights, Qui Gon-Jinn and Obi-Wan Kenobi, to spirit her away from the conflict. Fleeing to Tatooine to regroup and repair their damaged starship, Padmé and company encountered a young slave boy named Anakin Skywalker. The precocious youth entered an elite, highly dangerous podrace at the Mon Espa Speedway in order to win the money needed to repair their ship. Little did Padmé know, but that one day Anakin would also win her heart, growing up to become a powerful Jedi Knight and her eventual husband.[294]

Padmé was a firm believer in the Republic's political system as a tool for change. Arriving on Coruscant, Padmé, with the encouragement of her friend and confidante, Senator Sheev Palpatine, called for a vote of no-confidence in Supreme Chancellor Valorum's leadership. In the emergency election that followed, Palpatine was named the new Supreme Chancellor,

a post which he readily accepted. Though she was happy for her friend, she had no idea that Palpatine had forced her hand, manipulating her from behind the scenes to put himself into a position of immense power. In the meantime, Padmé was busy making moves of her own, forging an unprecedented alliance with the Gungan people, and staging a multi-pronged attack on the Trade Federation and its invading droid army. Proving that she is more than just an administrator, Padmé tracked down the Trade Federation leader Nute Gunray, and brought the traitorous warmonger to justice.[295]

In the years that followed, Padmé continued to faithfully serve the people of Naboo as their senatorial representative, even in the face of escalating conflict and an ever-growing Separatist movement. However, being in the spotlight also put a target on Padmé's back, putting her in the crosshairs of multiple assassination attempts. They were ultimately unsuccessful, but they did drive her back to Naboo, where she found herself suddenly reunited with an older Anakin Skywalker, who confessed his feelings for Padmé. After going through a series of difficult trials together—including the murder of Anakin's mother and a near-death encounter on Geonosis during a mission to prevent Obi-Wan Kenobi's execution at the hands of the Separatists—Padmé could not deny her feelings any longer. Maybe it was the fact that Anakin resembled a young Hayden Christiansen, or maybe it was the thrill of kicking a nexu beast in the face and escaping what seemed like a suicide mission with her life intact, but Padmé was in love. Back on Naboo, the two had a secret, forbidden marriage ceremony with only R2-D2 and C-3PO as witnesses.[296] (It's a shame that they couldn't get the Max Rebo band to play.)

As the Clone Wars progressed, their marriage grew strained. Anakin's effectiveness in battle and duties as a Jedi General in the Republic's army meant that he was often gone for long stretches

of time. Further complicating matters was the fact that neither of them could talk about their relationship openly; marriages were in direct violation of the vows Anakin took as a member of the Jedi Order. During one of their brief moments together, Padmé dropped a bombshell on Anakin: he was going to be a father. Though they were excited to raise a family together, they were also worried about what might happen to Anakin if anyone found out. To make matters worse, Anakin began experiencing intense visions of Padmé dying during childbirth, which made him grow cold and distant as he obsessed over ways to prevent that future from coming to pass.[297]

In his desperation, Anakin turned to the dark side, seduced by the promise of powers that could help him save his loved ones from death itself. Who was whispering in Anakin's ear? None other than Sheev Palpatine, who was secretly the Sith Lord Darth Sidious, of course. In addition to manipulating Anakin into becoming his Sith apprentice, he continued consolidating his power in the Senate too. With the war at its peak, Palpatine coerced the Senate into granting him emergency powers, declaring himself Emperor in the process. It was an act that deeply disturbed Padmé. "So this is how liberty dies," she declared bitterly. "With thunderous applause."[298]

Palpatine wasn't the only one who disappointed Padmé; Anakin, under Palpatine's orders, committed a number of atrocities at the Jedi Temple, which repulsed Padmé. When she confronted him on Mustafar, he Force choked her into an unconscious state after seeing Obi-Wan Kenobi aboard her ship and accusing her of bringing Obi-Wan there to kill him. After Obi-Wan defeated Anakin in a brutal lightsaber duel, he took Padmé to a medical facility. However, it was too late for Padmé. Although she delivered a pair of twins, a girl and a boy who she named Leia and Luke, respectively, she had lost the will to live and passed away. Ironically, Anakin's greatest fear had come to

pass, and he caused the very thing he sought to prevent. Most tragically, though, one of the galaxy's great political leaders was gone and one of the brightest lights in the Republic had been extinguished. Plus, it just felt like a waste of potential for what had heretofore been a seriously promising character.[299]

Mace Windu

He decapitated the bounty hunter Jango Fett with a single swing of his lightsaber. He led a strike force of clone troopers to retake the planet Ryloth. Most importantly, he's tired of these mother#$@&ing Sarlaccs on this mother#$@&ing plane. (Okay, I might be mixing up movies now.) His name is Mace Windu and he is an intergalactic badass here to uphold the integrity of the Jedi Order. With a steely gaze, intense focus, and his signature amethyst-bladed lightsaber, Mace Windu is one of the most powerful members of the Jedi Order, second in reputation only to Master Yoda. Naturally, only Samuel L. Jackson could play a character with this commanding of a presence.

A high-ranking member of the Jedi Order, Mace Windu was one of the Jedi Masters who held a permanent seat on the Jedi Council, helping to shape policy for the Order as a whole. With a deep attunement to the Force, Mace Windu sensed strange forces at work in the final years of the Republic. However, Windu's main priority was to preserve the Jedi Order's ancient ways and traditions, which seemed increasingly at odds with an era rife with corruption, strife, and unrest. So, when the maverick Jedi Qui-Gon Jinn came to Windu with claims that the Sith had returned after nearly a millennium in hiding, he was skeptical of

the rule-breaking Jedi Knight. That being said, Mace was able to admit when he was wrong too. After the Sith warrior Darth Maul murdered Qui-Gon Jinn and, in turn, was slain by Obi-Wan Kenobi, Mace was forced to ask himself a difficult question: Was Darth Maul the Sith Master or merely the apprentice?[300]

Mace had misgivings about whether Anakin Skywalker belonged in the Jedi Order, and had trouble accepting that a former Jedi like Count Dooku could be behind a Separatist movement that targeted senators for assassination. However, when Obi-Wan Kenobi discovered a massive Separatist plot to create an army of battle droids on Geonosis, there was no denying it: the dark side was encroaching from all sides and the Separatists had to be stopped at any cost. While Obi-Wan Kenobi, Anakin Skywalker, and Padme Amidala were facing execution on Geonosis, Windu personally led a task force of 200 Jedi to do battle with the Separatist forces. What followed was the first battle of the Clone Wars as Republic clone troopers clashed with Separatist battle droids on the Geonosian surface. During the battle, Windu tried to force Count Dooku to surrender, but wound up locked in a one-on-one battle with Dooku's Mandalorian enforcer, the bounty hunter Jango Fett. As mentioned above, things didn't go particularly well for Jango, who found himself suddenly separated from his head after Windu decapitated him with a swift slash of his purple lightsaber.[301]

During the Clone Wars, Mace Windu became a Jedi General in the Grand Army of the Republic, serving as both a frontline combatant and a military strategist. In addition to mounting a campaign to retake Ryloth, including an assault on the city of Lessu, Mace proved that he could play the part of diplomat as well. Though Mace loathed politics, he managed to broker an understanding between the Twi'lek rebel Cham Syndulla and the corrupt Senator Orn Free Taa. Mace also found himself the target of multiple assassination attempts mounted by Boba Fett,

Samuel L. Jackson, the baddest mother$@!#er on Earth, meets Darth Vader, the baddest mother$@!#er in the galaxy far, far away. (Kevork Djansezian)

the son of Jango Fett, who he had killed on Geonosis. As the war intensified, Windu became increasingly obsessed with solving the mystery behind the dark side's role in the conflict, seeking to out the Sith pulling the strings from behind the scenes.[302]

Back on Coruscant, Mace Windu tried to preserve the Jedi Order's independence from the bureaucracy of the Galactic

Senate. Though he tried to uphold Jedi values and traditions when dealing with military and political leaders, it grew increasingly difficult, particularly as Supreme Chancellor Palpatine continued to steadily increase his power and purview. Though he didn't trust Palpatine, Windu was unable to see that the Supreme Chancellor was secretly leading a double life as the Sith Lord Darth Sidious. It was a mistake that would ultimately cost him his life.

When Palpatine appointed Anakin Skywalker to be his representative on the Jedi Council, Mace immediately balked at the idea. If Palpatine refused to relinquish his increased wartime powers after the conflict concluded, the Jedi should remove him from office and take control of the Senate themselves, Mace argued. Anakin Skywalker discovered Palpatine's secret Sith identity and revealed the truth to Mace. Wasting no time, Windu went to confront Palpatine and bring him into custody. With his lightsaber raised in striking position, Mace Windu had Palpatine cornered, but then his worst fears came to pass as Anakin Skywalker attacked the Jedi Master, severing his forearm.[303]

Stunned by the betrayal, Windu was caught off guard long enough for Palpatine to get the drop on him, electrocuting the Jedi with painful blasts of Force lightning, sending him tumbling over a railing to his untimely death. With Windu dead, there was little to stop Sidious and his new apprentice, Anakin Skywalker, from carrying out their campaign of terror.[304] Mace Windu may be dead and gone, but here's hoping that eventually we'll get a *Star Wars Anthology* film centering on the mighty Jedi Master in his younger days. Because, honestly, what could be better than more Samuel L. Jackson?

50 General Grievous

There's something intrinsically terrifying about the prospect of an evil, sentient machine rising up against mankind with murderous intent. There's something even scarier when that machine is a deadly droid wielding four separate lightsabers programmed to do nothing but kill Jedi in cold blood. As the commander of the Separatist military, General Grievous embodied those fears as an avatar of unrelenting, ceaseless terror. Trained in lightsaber combat by Count Dooku, Grievous' primary mission was to traverse the galaxy, invading foreign worlds and hunting down Jedi. Carrying around his slain enemies' lightsabers like trophies, Grievous would clash many, many times with Ahsoka Tano and Obi-Wan Kenobi, who always managed to elude his grasp.

Grievous was not always a cold-blooded killing machine, though. Once, he was a cold-blooded killing *man*. From his secret lair on one of the moons of Vassek, Grievous led the military might of the Separatist army. However, when a detachment of Jedi and clone troopers discovered the hidden base, they caught the General off guard, demanding his surrender. Grievous suffered nearly fatal injuries, but managed to escape with his life. However, the only way to keep the General alive was by outfitting the feared Kaleesh warrior with a plethora of cybernetic implants, leaving him more machine than man. With a single-minded purpose, the newly-crafted cyborg tracked down his assailants and savaged them, killing a Padawan named Nahdar and besting the Jedi Master Kit Fisto in a lightsaber duel.[305]

During the Clone Wars, General Grievous was tasked with a variety of black ops and high-profile missions by Count Dooku and Darth Sidious. On Dathomir, Grievous wiped out an

entire clan of Nightsisters—Force-sensitive witches—at Dooku's behest. Likewise, on Naboo, Grievous forced Queen Amidala into a tense prisoner exchange in order to save Anakin Skywalker's life. Most famously, Grievous, using the Battle of Coruscant as a pretext, led a mission to kidnap Supreme Chancellor Palpatine, bringing the Senator back to Count Dooku's flagship. With the high-value asset in their custody, Grievous and Dooku laid a trap for the Jedi Knights Obi-Wan Kenobi and Anakin Skywalker, who arrived in short order to mount a rescue.[306]

The Jedi proved victorious, with Anakin using Dooku's lightsaber and his own like a pair of plasma-powered scissors to decapitate the nefarious Count. Apprehended by Grievous' droids, the fleeing Jedi are brought before the cretinous cyborg, who blusters that their lightsabers will make fine additions to his collection. Unfortunately for our mechanical miscreant, the devious droid R2-D2 turns the tables on Grievous, giving the Jedi back their weapons and cornering the General. Outmatched and outnumbered, Grievous shattered the bridge's viewport, escaping into the infinite blackness of space.[307]

While the Jedi Council is distracted with the conflict consuming the galaxy, Grievous makes a beeline to Utapau. After establishing communication with Darth Sidious, Grievous is assured that the war will soon come to an end and the Separatists will prove triumphant. However, in classic Sith fashion, Sidious had double-crossed his underling, cluing Obi-Wan Kenobi in to his location. With an army of clone troopers at his back, Obi-Wan led the Republic to war at the Battle of Utapau, culminating in an epic duel between Kenobi and Grievous, who was wielding four lightsabers simultaneously. Dismembered and outclassed, Grievous tried to flee, leading to a brutal brawl between the two. The fight ended on a cliffhanger quite literally, with Obi-Wan Kenobi holding on to a cliff face for dear life, having lost his lightsaber. Grievous prepared to deliver the

final blow when Obi-Wan, ever resourceful, used the Force to draw Grievous' blaster to him, using the firearm to blow a hole in Grievous' chest, destroying what little "man" remained of the murderous warmonger, killing him once and for all.[308]

51 The Hunt for Wedge Antilles

Wedge Antilles is a familiar name to the *Star Wars* faithful. A veteran of Rogue Squadron from the assault on the first Death Star, Wedge Antilles is one of the finest X-wing pilots in the Rebel Alliance. He also took to the skies in a snowspeeder in the Battle of Hoth, and led Red Squadron's assault on the second Death Star during the Battle of Endor. "That's impossible, even for a computer," Wedge said in disbelief upon hearing that the only way to destroy the Death Star was to attack its exposed thermal exhaust port. Unflappable as ever, Luke Skywalker assured him that things weren't quite as bad as they seemed. After all, Luke had no problem nailing womp rats with his T-16 back home, so a measly thermal exhaust port was a cakewalk.[309] And that was our first introduction to Wedge Antilles…or was it?

The answer is yes *and* no. Wedge Antilles was actually played by three different actors during the course of *Episode IV.* Most viewers associate the role of Wedge with Denis Lawson, who reprised the role in *The Empire Strikes Back* and *Return of the Jedi.* However, during that briefing scene in *Star Wars Episode IV: A New Hope*, Lawson is nowhere to be seen. But it's still Wedge. The voice coming out of the dark-haired mystery man's mouth belongs to actor David Ankrum, but the identity of the man standing in the room seemed all but lost to the sands of

time. Fans took to calling the mystery man, with his heavy brow and pinched features, "the fake Wedge."[310] It was an enigma that plagued fandom for years until Lucasfilm brand communication manager/Story Group member Pablo Hidalgo took it upon himself to find the answer.

Hidalgo had his first taste of the Wedge conspiracy while working as a freelancer at West End Games in the 1990s. His editor, George S. Strayton, noticed the discrepancy between Antilles actors while writing flavor text for the Wedge Antilles card in the *Star Wars* Customizable Card Game. The production still on the card displayed not Lawson, but the mystery man. The popular theory at the time was that this was an actor named Jack Klaff, who was credited with the role of "Red Four" in *A New Hope*. However, such was not the case; Klaff can be seen during the Battle of Yavin, shouting "I'm hit!" as his X-wing is blown to smithereens by an attacking TIE Fighter.[311]

When *Star Wars Episode III: Revenge of the Sith* was filming in 2004, Hidalgo was sent to Shepperton Studios in London, the legendary film studio where films like *Lawrence of Arabia, Dr. Strangelove, 2001: A Space Odyssey*, and, yes, the original *Star Wars* were made. While there, Hidalgo took it upon himself to dig through old daily production reports, looking for something, anything that would clue him in to the identity of the Fake Wedge. Finally, he struck paydirt—after noticing that the Rebel briefing scene was, in fact, shot at Shepperton, he secured a production report listing all of the actors with speaking parts. The list read "Mark Hamill, Carrie Fisher, Harrison Ford, Anthony Daniels, Kenny Baker, Peter Mayhew, Alex McCrindle, Angus McInnis, and Colin Higgins." Most of those names are probably familiar to you, and all were accounted for in the film's credits, save for one: Colin Higgins. Hidalgo had a name, but now he needed to prove his theory. (And no, as Hidalgo discovered, it wasn't the same Colin Higgins who wrote *Harold and Maude*.)[312]

According to the Internet Movie Database, there were four Colin Higgins with entertainment industry credits to their name. The Higgins he needed would have been young and British, but none of those details were listed on any of the pages in question. (Quick sidebar: all of the British pilots were dubbed over by American actors in post-production; as mentioned before, Dave Ankrum's dulcet tones can be heard in the briefing scene.) One of the Higginses had a particularly fascinating credit, having appeared as the character "Tak" on an episode of *Blakes 7*, a British sci-fi series. Hidalgo followed the digital rabbit hole further, scouring *Blakes 7* fan sites to no avail…until he discovered a picture of Tak. The resemblance was unmistakable; this was the man for whom he had been searching. Having unearthed the truth at long last, Hidalgo had Colin Higgins' IMDB page updated to reflect his quintessential portrayal of Wedge Antilles in *A New Hope*. Moreover, thanks to Hidalgo's discovery, Higgins began appearing at *Star Wars* conventions like Celebration, able at long last to officially reap the rewards of his involvement in the galaxy far, far away.[313] Now, if only Hidalgo could make the universe *forget* about Jar Jar Binks, he would be a true hero.

The Must-Play *Star Wars* Games

Watching the *Star Wars* movies and reading the books offer their own unique pleasures, but neither really put you in the driver's seat. Sometimes you just want to pick up a blaster or a lightsaber, hop into the cockpit of an X-wing or a TIE Fighter, and be the hero of your own story. Fortunately, there are a plethora of games

that let you do just that. While most of them are more than worth your while, it can be a bit daunting to figure out where to start, so I have assembled a list of the ones that you absolutely can't shuffle off this mortal coil without playing. Okay, technically you can do whatever you want; it's your life, and I'm not going to tell you how to live it, but you'd really be missing out.

Star Wars: X-Wing Alliance (Windows)

From Red Squadron's epic assault on the Death Star trenches to snowspeeders weaving in between the giant mechanical legs of AT-ATs stomping across Hoth's frozen landscape, there's something so compelling about being in the cockpit of *Star Wars'* iconic starships. While *Star Wars: TIE Fighter* launched a generation of *Star Wars*-centric flight simulators, its follow-up, *X-Wing Alliance*, set the gold standard by which the genre would be judged. With the ability to pilot a variety of fan favorite ships—including the X-wing, Y-wing, A-wing, and the *Millennium Falcon*—and the chance to design your own battles, *X-Wing Alliance* is about as close as you can come to joining Red Squadron without years of flight school and an increased likelihood of dying from a stray proton torpedo.

Star Wars: Rogue Squadron (Windows, N64)

Of course, if you prefer your flight simulators with a healthy dose of shooter DNA, then the *Rogue Squadron* series might be for you. Modeled after *Star Fox 64*, the game put you in the cockpit of a Rogue Squadron X-wing, taking you around the galaxy to levels fraught with danger, endlessly replayable challenges, and familiar sights and sounds. The best part? Most of the levels are easily digestible and can be completed in approximately 10 minutes. That being said, the game was not without its challenges; you'll likely spend countless hours trying to earn enough gold medals to unlock the game's many bonuses, including levels

like the Death Star trench run and the Battle of Hoth, as well as vehicles like the *Millennium Falcon*. If you're looking for a story-driven arcade shooter that holds up well more than a decade later, look no further.

Star Wars: Edge of the Empire (Tabletop)

Back in 1974, Gary Gygax and Dave Arneson brought *Dungeons & Dragons* into the world. Two years later, George Lucas gave us *Star Wars*. Ever since then, enterprising nerds have been looking for unique, dynamic ways to blend the pen-and-paper role-playing game mechanics with the galaxy far, far away to create the ultimate escapist fantasy. Nowadays, the best bang for your tabletop RPG buck is *Star Wars: Edge of the Empire*, an expansive role-playing game setting that puts you in the shoes of scoundrels, bounty hunters, rebels, droids, or pretty much whatever you can dream up in the *Star Wars* universe. With one player functioning as the GM (Game Master) and driving the narrative, you and your party can seek out adventure on the Outer Rim, in the lower levels of Coruscant, and beyond.

Star Wars: Knights of the Old Republic (Windows, Mac, Android, Xbox, iOS)

If you prefer your *Star Wars* RPGs based on Wizards of the Coast's old d20 system, then *Knights of the Old Republic* might be for you! Set roughly 4,000 years before the rise of the Galactic Empire, *Knights of the Old Republic* is a world in which the Jedi Order has been scattered to the wind by Darth Malak, a former Jedi-turned-Sith Lord, and his evil armada. With a complex, branching story that changes based on your decisions, *Knights of the Old Republic* lets you assemble a crew of mercenaries, smugglers, Wookiees, droids, and pretty much anything your little heart could desire. Whether you save the universe or usurp Darth Malak's position as its destroyer, however, is up to you.

Star Wars: Battlefront (Windows, PS4, Xbox One)

Do you watch the Battle of Hoth scene from *The Empire Strikes Back* on repeat while thinking, "I want to go to there?" If so, you should pick up one of the *Star Wars: Battlefront* titles. The team-based first-person shooters put you on the ground and in the air for some of *Star Wars'* greatest battles, facing off against massive enemy armies. Unleash a hail of blaster bolts as a stormtrooper, launch wrist-mounted rockets as a super battle droid, launch the tow cables from your snowspeeder to take out an AT-AT as a Rebel pilot, and much more. The objective-based gameplay also lets you become some of the greatest heroes and villains of the *Star Wars* universe, including Darth Vader, Yoda, Obi-Wan Kenobi, and Darth Maul. Let me tell you—few things are more fun than swinging around a double-bladed lightsaber at your friends and a squadron of enemy reinforcements. Plus, there's a brand new *Battlefront* on the way, so dust off your copy of Sun Tzu's *The Art of War* and brush up on some battlefield tactics. Trust me—you're going to need them.

Dark Forces (Windows, PlayStation, PS3, Linux, Mac, PSP)

Released back in 1995, *Dark Forces* blew *Star Wars*-hungry gamers away with its compelling cutscenes, then-innovative gameplay, and the first chance to blast stormtroopers in 3D. Playing as Imperial soldier-turned-Rebel defector Kyle Katarn, you must infiltrate the Death Star to steal the blueprints for the orbital superweapon. Sound familiar? It should because that's the plot of the upcoming *Star Wars Anthology* film *Rogue One*. *Dark Forces* may not have been as technically proficient a shooter as *Doom*, and it may have been outdone by subsequent titles like *Jedi Knight: Jedi Academy* and *Jedi Knight 2: Jedi Outcast,* but it's worth going back and seeing where it all started. Honestly, the story is just that good.

53 *Star Wars* Weekends

Let's face it: as much as we would like to travel to the galaxy far, far away, the cost of interstellar travel is prohibitively expensive. So, what are fans who want to make their vacation experience as *Star Wars*-y as possible to do? Simple—go to *Star Wars* Weekends at Disney's Hollywood Studios in Orlando, Florida. Held annually at Walt Disney World, *Star Wars* Weekends are a month-long celebration of *Star Wars* fandom at Disney's biggest theme park. With special celebrity guests, original Disney characters dressed in their finest *Star Wars* duds, and interactive events like the Jedi Training Academy, there's plenty of fun to be had for everyone from Padawan learners to jaded Jedi alike.

With tickets starting at $97, visitors will get the chance to speak with luminaries like Ray Park (Darth Maul), Frank Oz (Yoda), Taylor Gray (Ezra Bridger), Ashley Eckstein (Ahsoka Tano), and Ian McDiarmid (Emperor Palpatine). In addition, the aforementioned Jedi Training Academy will put on a live show in which children are given a practice lightsaber and the chance to become a real Jedi Knight-in-training by learning a variety of basic swordfighting techniques. The 501ˢᵗ Legion and Rebel Alliance will also don their intergalactic Sunday best for a parade through the park, to boot. With exclusive merchandise, a newly revamped version of Star Tours, and gourmet food inspired by *Star Wars*, these weekends are a great way to show your love for the franchise that made you want to get away in the first place. Plus, after reading this book, you'll be able to flex your newly reinforced gray matter at the Padawan Mind Challenge, an interactive trivia contest for fans aged four to 11.

Considering that this year, the newly introduced Rebel Hangar will feature delectable dishes like The Dark Fried—fried chicken and Darth Vader-shaped waffles served with maple syrup and barbecue sauce—you should consider attending for your stomach's sake if nothing else. For the parents out there—or simply just the adult fans—there is a menu of *Star Wars*–themed cocktails to help take the edge off of the Happiest Place on Earth. Honestly, after writing this book, I could go for a Dagobah Swamp Juice myself. Just remember—whether it's Force-crisped fried chicken or a beverage that could put hair on Chewbacca's chest, moderation is key. Unless, of course, you're talking about the number of fireworks you're going to see. Each evening ends with an epic celebration of all things *Star Wars* called "Symphony in the Stars." The frenzied fireworks festival is filled with explosive encounters with everyone's favorite *Star Wars* characters, as well as ebullient explosives to boot. And with a dedicated 14-acre *Star Wars* land on the way at both Disneyland and Walt Disney Hollywood Studios, these weekends are only going to get bigger and bolder.

Kathleen Kennedy, the Next George Lucas

When Disney announced in 2012 that it was purchasing Lucasfilm for $4 billion, there were two questions on everyone's mind: 1) When would we see the next *Star Wars* movie? 2) Who would replace George Lucas? The answer to the latter came in the form of one woman, a single-minded juggernaut of producing quality entertainment named Kathleen Kennedy. In order to take it into the next generation of *Star Wars* stories, Lucasfilm

didn't just need someone who lived and breathed their franchises to steer the ship; they needed someone like Lucas who was a tireless workhorse, a shrewd negotiator, and someone who wasn't afraid to go toe to toe with some of the biggest heavyweights in Hollywood. Kennedy is a seasoned veteran of the entertainment industry with countless films and accolades under her belt. Not only that, Kennedy also co-founded Amblin Entertainment with Steven Spielberg and her husband Frank Marshall, formed her own production company, and became co-chair of Lucasfilm Ltd. alongside George Lucas prior to the acquisition. So, in the wake of the Disney sale, the choice was clear: the filmmaking Force is very, very strong with Kathleen Kennedy.

Born in Berkeley, California on June 5, 1953, Kennedy had, by all accounts, a relatively pleasant youth, and actually never wanted to go into entertainment; in fact, when she started college at San Diego State University, she intended to become a nurse. However, those plans soon changed after volunteering at a local TV station during the 1972 election. Soon thereafter, she was hired as a camera operator on a program called *Dialing for Dollars*, and she switched majors to film and telecommunications. In the fall of 1977, she saw Steven Spielberg's *Close Encounters of the Third Kind,* and realized that film was her true calling. Little did Kennedy realize but fate would soon bring her into contact with Spielberg on the set of *1941*, where she served as a production assistant to producer John Milius.

Though Kennedy's first task on set was to catalogue and organize Milius' considerable collection of firearms, she managed to ingratiate herself to Spielberg. "Kathy was working for John Milius, and yet she kept hanging around my area of the office," Spielberg recalled in a 2013 interview.[314] She must have made a good impression because he immediately stole her from Milius to be his own assistant, and together they set to work on *Raiders of the Lost Ark*. Having gone over budget making *Close Encounters*

of the Third Kind and feeling the sting of *1941*'s soft box-office performance, Spielberg relied on Kennedy to help him make sure the project stayed under budget. Not only did she rise to the task, but she met her future husband, producer Frank Marshall, while making the film too.

With *Raiders* in production, Spielberg offered Kennedy something unheard of for a 26-year-old: the chance to produce his next movie. That movie would be *E.T.: The Extra-Terrestrial*, and Kennedy would be paid $50,000 to produce the story of a young boy helping his alien friend to phone home. When it made over $350 million, however, Kennedy wound up with a $700,000 payday.[315] At nearly the same time, Spielberg had hit paydirt with *Poltergeist*, which he had tapped Marshall to produce. Realizing that they needed to be able to produce multiple projects at once and that they made great creative partners, the trio of Kennedy, Marshall, and Spielberg formed Amblin Entertainment in 1983. Rather than resting on their laurels, they immediately set to work producing Spielberg's films, Robert Zemeckis' *Back to the Future* trilogy, Martin Scorsese's *Cape Fear*, Richard Donner's *The Goonies*, and many more.

In those heady days, Kennedy took charge of development, focusing primarily on producing the movies that Spielberg directed himself, like *Jurassic Park* and *The Color Purple*. "When we built Amblin, we even put Murphy beds in there because we thought that was so practical," Kennedy revealed. "Why would anybody, if you were working on something, need to go home at night? You'd just stay there, wake up in the morning and carry on."[316] For three decades, Kennedy worked alongside Spielberg and Marshall, producing more than 60 feature films, which earned over 100 Academy Award nominations and grossed $11 billion globally at the box office. With titles like *E.T.: The Extra-Terrestrial* (her first producing credit), *Who Framed Roger*

Rabbit?, Jurassic Park, Lincoln, and countless others, her resume is unassailable.

However, all good things come to an end; after an enormously prolific period working with Spielberg and serving as Amblin's president, Kennedy left Amblin to form a new production shingle with her husband. "They're able to accomplish in a day what mere filmmaking mortals do in a few—and they don't seem to finish a lot of sentences," remarked *Jurassic Park* screenwriter David Koepp of their unique connection. In particular, Koepp said, Kennedy is "great at correcting him and being straight with him.... Finding someone whom you trust and know will be honest with you is difficult for most directors and super-difficult for someone of Steven's stature. That has to feel irreplaceable."

Certainly, it is something that Spielberg misses having in his corner. "She always gets things done with modesty and confidence, so she's flown beneath the radar for many decades," he said in an interview with *USA Today.* "Her satisfaction all this time has always simply been her checklist of daily things to do [on a movie]. Checking that box, that's Kathy's reward."[317] Though the duo found success producing on their own, turning out films like *Seabiscuit* and *The Sixth Sense,* she would continue to work on and off with Spielberg over the years. Plus, with the announcement that Lucasfilm will make a new *Indiana Jones* film, the two could find themselves reunited sooner rather than later.[318] Some partnerships are just too good to die, I suppose.

When it came time for Lucas to maneuver the pieces into place for the next generation to carry on the Lucasfilm legacy, he pondered for weeks and months as to who could serve as his successor. In hindsight, it seems like a no-brainer. "Why didn't I see this before?" Lucas asked himself after finally thinking of Kennedy. "She's always been standing right there in front of me."

In the relatively brief time that she has steered the ship at Lucasfilm, Kennedy has made quite the splash. After a series of secret meetings, she managed to coax a reluctant J.J. Abrams into taking on the daunting task of directing *Star Wars Episode VII: The Force Awakens.* "We spent a lot of time talking about how meaningful *Star Wars* is and the depth of the mythology that George has created and how we carry that into the next chapter," she said in an interview. For Abrams, who has said that *Star Wars* was "the first movie that blew my mind in that way," it all boiled down to four simple words from Kennedy: "Please do *Star Wars.*"[319]

Of course, the fact that she had already recruited Oscar-winning writer Michael Arndt (*Little Miss Sunshine, Toy Story 3*) to pen the script and series veteran Lawrence Kasdan (*The Empire Strikes Back, Return of the Jedi*) to consult helped too. Yet, in the end, it was her reputation for being direct, filmmaker-focused, and highly collaborative (but not in a helicopter mom kind of way), that meant Kennedy had what it took to convince Abrams to tackle yet another mammoth sci-fi series.

Kennedy doesn't just have a soothing effect on filmmakers; she is able to put fandom at ease too. During the *Star Wars: The Force Awakens* panel at *Star Wars* Celebration Anaheim, moderator Anthony Breznican asked Kennedy an innocuous question: which *Star Wars* character would she be? "I don't have many choices," Kennedy shot back. "But that's going to change." After the thunderous applause, Kennedy added, "Going forward with all we're talking about there are going to be a lot of wonderful new [female] characters."[320] Judging by how awesome Captain Phasma (Gwendoline Christine), Rey (Daisy Ridley), and Maz Kanata (Lupita Nyong'o) look and the fact that Felicity Jones will star in *Star Wars Anthology: Rogue One*, it seems that Kennedy is already making good on her promise.

Most importantly—or most drastically depending on who you ask—Kennedy is responsible for forming the Lucasfilm Story Group. Established in 2012, the organization is essentially the Illuminati of determining how *Star Wars*' winding, weaving narrative intersects with its considerable business interests. Led by writer-producer Kiri Zooper Hart, the LSG consists of Leland Chee, the guardian of the Holocron (the sprawling internal database of *Star Wars* content and canon); brand communications manager Pablo Hidalgo; as well as representatives from Lucasfilm's business strategy department, brand communications team, various licensing groups, and other assorted departments. Its purpose is single-minded: to ensure that every single piece of *Star Wars* content—movies, TV shows, video games, comic books, etc.—are all working in service of telling one big story.[321]

Their first course of action? Doing away with the Expanded Universe as we know it, rendering decades of stories invalid according to official canon standards. Instead, they were rebranded as *Star Wars* Legends, making them effectively the equivalent of old Marvel *What If?!* comics. To many fans, this was tantamount to treason as it instantly devalued years and years of storytelling. Unlike the Death Star obliterating Alderaan, this was a necessary destruction. Much like the problem faced by Marvel Comics and DC Comics, years and years of storytelling create complex continuity issues. By hitting the reset button, Kennedy and company effectively created a fresh slate for themselves, unshackling themselves from the burden of the past. Whether or not this makes Kennedy more of an Obi-Wan Kenobi or a Darth Vader is irrelevant; she is taking control and confidently striding forward into the future, leaving no doubt in anyone's mind that Lucasfilm 2.0 is, once more, fully operational.

Make Your Own Death Star Scarf

When the weather outside gets colder than Hoth in December and there are no Tauntauns in sight, what is a *Star Wars* fan to do? Well, if moving to Mustafar is out of the question, then you should take your fate (and your core temperature) into your own hands. Fortunately, the Force is strong with author Bonnie Burton and she created a unique tutorial to show you how to recreate the Battle of Yavin in the form of an ultra-fashionable, uber-comfortable fleece scarf. Well, with just a few pieces of fabric and some basic tools, you can wear the excitement of Luke Skywalker's Death Star trench run around your neck!

Over the past several years, between working at Nerdist and writing these books I have come into contact with some truly incredible people. With her passion, creativity, and whipsmart writing, Bonnie Burton is one of the coolest folks I have had the pleasure of meeting. One of the distinct pleasures of being a *Star Wars* fan is seeing all the incredible creations that fandom creates from whole cloth. In Bonnie's case, sometimes her fan-inspired creations are quite literally created from cloth. In fact, she found such unique ways to express love for all things *Star Wars* that she created *The Star Wars Craft Book*, an officially licensed tome of arts, crafts, and killer creations that you can make from the comfort of your own home. And this book would not be complete without an awesome activity from Bonnie's brain for you to make from your very own hidden Rebel base.

This tutorial and these images were reprinted with the express permission of Bonnie Burton.

Fleece *Star Wars* Battle Scarf

by *The Star Wars Craft Book* author Bonnie Burton

Using geometric shapes you can show an epic space battle of X-wings and TIE fighters on your scarf.

What You Need:

- Black fleece scarf
- White and light colored felt
- Fabric glue
- Scissors
- Needle and thread

How to Make a Fleece Space Battle Scarf:

1. Cut out squares, rectangles, and circles from the felt. Set aside.
2. Play with the felt pieces to make fighter ships, bullet fire, explosions, and more.

3. When you're happy with the way it looks, use fabric glue to keep them in place.
4. After the glue dries, sew the design in place.
5. Brave the cold with an epic battle waging on your scarf.

Now that you've created haute Hoth couture of your very own, you should go explore what other awesome DIY projects await enterprising *Star Wars* fans. In addition to *The Star Wars Craft Book*, Burton has penned *You Can Draw: Star Wars, Girls Against Girls: Why We Are Mean to Each Other and How We Can Change, Draw Star Wars: The Clone Wars*, and many more. You can keep up with all of her assorted projects on http://grrl.com.

Count Dooku, the Separatist Saboteur

As the famous Chinese military strategist Sun Tzu wrote in *The Art of War*, "Keep your friends close, and your enemies closer." When it came to plunging the galaxy into a bloody universe-wide conflict, Darth Sidious decided to take things further and make his enemies and his friends one and the same. Enter Count Dooku. Once a Jedi who trained under Master Yoda himself and took Qui-Gon Jinn as his Padawan, Count Dooku (played by the legendary Christopher Lee) yearned for more power, chafing under the bureaucracy and impassivity of the Jedi Council. Turning away from the light side, Dooku left the Order to learn the ways of the Sith from Supreme Chancellor Palpatine, who was secretly the Sith Lord Darth Sidious. While it may not be the most appealing career change from a moral standpoint, it's hard

to argue when your benefits package includes the ability to shoot lightning from your fingertips.

Adopting the name Darth Tyranus, Dooku supervised the creation of the colossal clone army on Kamino for his Sith master. Simultaneously, Dooku emerged as the leader of the Separatist movement, persuading thousands of star systems to break away from the Republic and form the Confederation of Independent Systems. With Dooku leading the Separatist army and Palpatine in control of the Republic, they are able to secretly pull the strings behind these two politically charged organizations and ignite a war that would consume the galaxy.[322] The plan remained a secret until Obi-Wan Kenobi stumbled upon a secret facility on Geonosis where Dooku and other leaders were constructing a massive droid army with which to overtake the Republic.[323] In classic Bond villain fashion, Dooku tried to recruit the Jedi Knight to his side, and—when Obi-Wan flatly refused—revealed the entirety of the evil plan for the Sith to destabilize the galaxy. Honestly, the only thing missing was a hairless cat for Count Dooku to menacingly stroke.

During the Clone Wars, Count Dooku led the Separatist battle droids armies. Alongside his Sith apprentice Asajj Ventress and the cyborg Jedi hunter General Grievous, Dooku launched a number of secret missions, covert schemes, and Machiavellian machinations. Most famously, Dooku tried to kidnap Jabba the Hutt's son in a gambit to pit the Hutts against the Republic, but the Jedi thwarted his efforts. He also abandoned his apprentice, Asajj Ventress, discarding her like a half-eaten meatball sub (with an extra dash of evil for flavor) after Darth Sidious decided that she was no longer of value to their nefarious purposes. In retaliation, Ventress conspired with the Nightsisters of Dathomir to send him a new apprentice, the Nightbrother Savage Opress. Once by his side, Opress and Ventress planned to assassinate Dooku, but he proved too strong for his would-be assailants. Not

one to take threats on his life lightly, he responded by launching a brutal attack on the Nightsisters' stronghold.[324]

All seemed to be going according to plan for the Sith puppet masters—or so Dooku thought. In order to set a trap for Anakin Skywalker, Count Dooku and General Grievous launched an assault on Coruscant, kidnapping Supreme Chancellor Palpatine and holding him "hostage" aboard the *Invisible Hand*.[325] Naturally, Anakin and Obi-Wan took the bait, making a frantic flight to General Grievous' flagship. While Palpatine pretended to be a helpless prisoner, Count Dooku launched into a lightsaber duel with both Anakin Skywalker and Obi-Wan Kenobi. Though he was outnumbered, Dooku held his own at first, dispatching Obi-Wan by Force choking the Jedi Knight and trapping him under a large, heavy piece of metal.[326] During the battle, Anakin boasted to the Sith that his power had doubled since the last time they crossed paths, and he was right—Dooku found himself locked in an intense duel with the increasingly powerful young Jedi.

After unleashing a heretofore unseen level of ferocity and strength, Anakin overpowered Dooku, disarming the Sith quite literally by cutting off both of his hands. Picking up Dooku's fallen lightsaber, Anakin held both blades to the Sith Lord's throat like a pair of plasma-powered scissors, debating what to do. "Kill him now," Palpatine growled. Clearly Count Dooku wasn't anticipating his master's betrayal because the dumbfounded look on his face spoke volumes. Fortunately (or unfortunately depending on how you look at it), Dooku didn't have to process those complex emotions for very long, because Anakin decapitated him with his own lightsaber.[327] And that, dear reader, is a case study in why you should never trust the new guy at work—especially if they get their hands on your laser-powered murdersword.

57 Darth Plagueis; or the Sith Who Knew Too Much

Just as Luke Skywalker learned the ways of the light side of the Force from Yoda in the swamps of Dagobah, so did Emperor Palpatine train in the dark side under the tutelage of the terrifyingly named Darth Plagueis. A member of the spindly, towering Muun race, Darth Plagueis led a dual life: in public, he was Magister Hego Damask II, the leader of a powerful banking consortium, a position he used to finance all manner of criminal enterprises, intergalactic wars, and businesses in order to destabilize the Galactic Republic. In private, he was Darth Plagueis, the powerful Sith Lord who mastered the art of midi-chlorian manipulation, a science he studied obsessively as part of his quixotic quest to achieve eternal life. Alongside his apprentice, Palpatine/Darth Sidious, he orchestrated the Invasion of Naboo, a conflict that blossomed into the Clone Wars and led to the destruction of the Jedi Order and the Republic as we knew it. Honestly, the only way he could be more evil would be if he Force pushed a box of puppies off of a cliff—and there's no evidence that he *didn't* do that. Just saying.

Although it is now no longer considered part of the official canon, James Luceno's 2012 novel *Star Wars: Darth Plagueis* revealed the sinister Sith's rise to power over nearly half a century leading up to the events of *The Phantom Menace*. (It is also widely considered one of the best entries in the considerable Expanded Universe catalogue, but that is neither here nor there.) The novel chronicles Plagueis' rise to power and his evolution from Sith apprentice to Sith Lord under the stewardship of Darth Tenebrous, who he ultimately betrays in order to claim the title of Sith Lord for himself. In his quest for immortality,

Plagueis systematically hunts down and kills Force-users who he views as a threat, using them in his highly unethical midi-chlorian manipulation experiments before they shuffle off this mortal coil. The book also suggests that Plagueis is responsible for killing the former king of Naboo in order to pave the way for Padmé Amidala's ascendancy and commissioning a human clone army on Kamino. Craziest of all, the book suggests that Plagueis may have been behind the birth of Anakin Skywalker (a result of trying to create life through the Force; it was never proven though), who was seemingly born without a father to the slave Shmi on Tatooine.[328] Who's your daddy indeed, Anakin?

The only current canonical mention of Darth Plagueis comes in *Star Wars Episode III: Revenge of the Sith,* when Senator Palpatine regales a troubled Anakin Skywalker with an "old Sith legend," *The Tragedy of Darth Plagueis the Wise,* in order to sway the young Jedi to the dark side. According to the "legend," Darth Plagueis was "so powerful and so wise he could use the Force to influence the midi-chlorians to create life," to the point where he could prevent people from dying. As Plagueis grew in power, he grew increasingly scared that he would lose his power. Perhaps his fear was justified, though, because his apprentice ultimately killed him in his sleep. The tragedy, according to Palpatine, is that Plagueis could save others from death, but he couldn't save himself. Of course, what Palpatine neglected to mention in his initial telling of the story is that he was the murderous apprentice in question; he must not have wanted to spoil that little plot twist for Anakin until the young Jedi was ready to take the plunge into the dark side, once and for all. No one likes spoilers, it would seem—not even the monolithically evil.

After years of studying under Plagueis, Sidious learned everything that he could from his master. To complicate matters further, Sidious had kidnapped a young Dathomirian Zabrak child named Darth Maul, who he was grooming to be a Sith

apprentice of his very own. The only problem? According to the Rule of Two, there can only be two Sith at any given time—a master and an apprentice. Given that Plagueis was now the odd man out, Palpatine followed the letter of the law and murdered his former master. It is for this precise reason that I categorically refuse to speak to any of the interns in my office; it's just safer that way.

Though Plagueis was seemingly slain by his treacherous apprentice, reports of his death may have been greatly exaggerated. One of the most popular theories concerning *Star Wars Episode VII: The Force Awakens* is that Darth Plagueis could play a major role, perhaps as the film's main villain. James Luceno's 2012 novel is no longer considered officially canon, but elements of that story were recanonized in the 2014 novel *Tarkin*, which would make the Sith ripe for revival. Between leaked concept art that resembles the malevolent Muun, the fact that motion-capture expert Andy Serkis is playing an as-yet unidentified mystery role, and Plagueis' own history with death-defying powers, it's entirely possible that this diabolical Sith Lord could rise from the grave to wreak havoc on the galaxy far, far away.

58 The Expanded Universe: What Happened?

Once upon a time, the galaxy far, far away was a wild, woolly place full of hundreds of stories, with sagas of ancient battles between the Jedi and Sith, a renegade admiral leading the remainder of the Empire against a new Republic, and alternate universes in which Luke froze to death on Hoth, leaving Leia to seek out Yoda on Dagobah. Beginning with Marvel Comics' 1977 *Star*

Wars comics and Alan Dean Foster's 1978 novel, *Splinter of the Mind's Eye*, these stories were known as the Expanded Universe, officially licensed material that existed outside of the six feature films, the animated *Clone Wars* movie, and the two television series. Consisting of novels, comic books, video games, toys, and all manner of media, the Expanded Universe offered *Star Wars*–hungry fans multiple access points to continue consuming their favorite fandom during the interminable waits between films. For over 35 years, the Expanded Universe dazzled (and disappointed) fans with scores of stories, quite literally expanding the scope of the massive world of *Star Wars*. Then, on April 25, 2014, Lucasfilm effectively charged the Death Star's superlaser and unleashed its terrible power on the Expanded Universe, obliterating any semblance of canon. It was as if millions of stories suddenly cried out in terror, and were suddenly silenced.

With the sale of Lucasfilm to Disney, *Star Wars* was charting a new course that would bring the iconic franchise back to the big screen. With decades of convoluted, sometimes conflicting Expanded Universe stories muddying the waters, Lucasfilm saw a need for clarity. Much like Marvel Comics and DC Comics have done countless times in the past, they opted to hit the reset button on continuity, retconning all previous Expanded Universe stories under a new banner, titled *Star Wars* Legends. Essentially, these stories became the equivalent of old wives' tales, tall tales of the galaxy far, far away that are passed down through the ages. It was a move that set the Internet ablaze with controversy, igniting heated discussions on comment threads across the land and prompting many diehard fans to cry "Noooooooooooo!" to the heavens like Darth Vader at the end of *Revenge of the Sith*.

"We have an unprecedented slate of new *Star Wars* entertainment on the horizon," said Lucasfilm president Kathleen Kennedy in a statement. "We're set to bring *Star Wars* back to the big screen, and continue the adventure through games, books,

comics, and new formats that are just emerging. This future of interconnected storytelling will allow fans to explore this galaxy in deeper ways than ever before."[329] In order to keep tabs on what would now be considered "official canon" and streamline the *Star Wars* storytelling process, Lucasfilm created a new organization, the Lucasfilm Story Group. The group itself is a veritable Jedi Council of *Star Wars* creatives, including Lucasfilm continuity expert Leland Chee (who maintained the Holocron, Lucasfilm's internal continuity database, for years), brand communications manager/*Star Wars* expert Pablo Hidalgo, director of creative content strategy Carrie Beck, producer Diana Williams, as well as representatives from Lucasfilm and Disney Publishing, DK Publishing, Marvel Comics, and more.[330]

Their mission statement can be boiled down to three simple words: "One Big Story." Essentially, their job is to work behind the scenes to make sure that all future *Star Wars* stories, from *Episode VII-IX* to comic books to novels and beyond, are all working synergistically to tell a massive, cohesive story. Considering that the old Expanded Universe necessitated five levels of canonicity, ranging from "established history" to "alternate universe make-em-ups," change was long overdue.[331] At *Star Wars* Celebration Anaheim, the Lucasfilm Story Group fielded all manner of continuity questions from confused fans. For example, Boba Fett is essentially Schrodinger's cat in Mandalorian armor, "both simultaneously alive and dead, in that Sarlacc pit until a story pulls him out." On the other hand, Hutts (as in "Jabba the") are no longer hermaphroditic, which is disappointing to learn if you have a weird and abiding interest in alien genitalia. In short, the answer to all ongoing questions of canonicity is "it's not canon until it is."[332] That may be of little comfort to some, but look on the bright side: the glass is still half-full of blue milk.

Though the Expanded Universe stories are no longer considered officially canon, many elements of these Legends are

being folded into future *Star Wars* stories. For example, in *Star Wars Rebels*, The Inquisitor, the Imperial Security Bureau, and Sienar Fleet Systems are all originally from *Star Wars* role-playing game materials published in the 1980s. Now that storytellers are no longer beholden to preexisting stories, they are able to mix and match, plucking the best parts of the Expanded Universe/Legends in order to create the best product possible. Considering the breadth of the Expanded Universe—which includes some tremendous highs and embarrassingly bad lows—this is probably the best thing that could have happened to the franchise. For those who still cling to the past like Jar Jar Binks to Qui-Gon Jinn, perhaps it's time that you learned to let go and looked to the future. Lucasfilm already has, and if you're that attached to the stories you love, you can still read them; you'll just have to get used to a slightly different label. (Or pony up $4 billion to buy the franchise yourself.)

59 Star Wars Anthology

Since May 25, 1977, the ultimate level of canon in the *Star Wars* universe was the films themselves. Sure, the chance to read tie-in novels, comic books, and play video games in the Expanded Universe was nice, but it wasn't quite the same as the electric energy that comes with seeing *Star Wars* up on the big screen. Now, it seems, that Disney is listening to film-hungry fans, who yearn for even more of the galaxy far, far away in their local theaters. In addition to the previously announced trilogy of *Episode VII, VIII,* and *IX,* Disney and Lucasfilm announced that, as part of the acquisition deal, they were planning on releasing

standalone films that would come out in between the main *Episode* movies. At 2015's *Star Wars* Celebration Anaheim, it was revealed that these films would be released under the banner *Star Wars Anthology*, marking the first time that the Expanded Universe would appear on the silver screen.

Officially launching the series will be director Gareth Edwards' *Star Wars Anthology: Rogue One*, which tells the story of an elite group of Rebel soldiers on a suicide mission to steal the plans for the Death Star. (Interesting side note: Edwards is such a *Star Wars* super fan that he spent his 30th birthday traveling to Tunisia to visit Luke Skywalker's home.) Actress Felicity Jones will star as one of the rebel soldiers tasked with stealing the Death Star's schematics. Part heist movie, part action-thriller, *Rogue One* will also be the first *Star Wars* movie not to focus on Jedi. It is more of a war movie than anything else. "It's called *Star Wars*," Edwards remarked at *Star Wars* Celebration, emphasizing the word "Wars."[333] By putting the focus on the brave men and women who risked their lives to steal essential intelligence, we'll get the chance to explore the rich universe that exists outside the galaxy-spanning saga of Luke and Anakin Skywalker.

Director Josh Trank was supposed to direct the second installment in the *Star Wars Anthology* series, but he suddenly left the project earlier this year. Rumors of bad blood behind the scenes of his previous big-budget studio film, *Fantastic Four*, and a no-show appearance for his panel at *Star Wars* Celebration left many worried about the production. Though he and Disney/Lucasfilm have officially parted ways, the project lives on. What exactly will it be about, you ask? Why, everyone's favorite jet pack-wearing bounty hunter, of course: Boba Fett! (Sorry, if you're the one person who said, "Jango" instead.) The film is reportedly an origin story about the galaxy's most notorious bounty hunter, who we have seen previously in the prequel trilogy and in *Star Wars: The Clone Wars*.[334] Now, that doesn't

mean that we'll be seeing Baby Fett, per se; rather, I would expect the film to focus on Boba Fett's rise as a bounty hunter under the tutelage of the assassin Aurra Sing, and his rise to prominence during the end of the Clone Wars and the period leading up to the Galactic Civil War.

As for what else the future holds for *Star Wars Anthology* movies, it's difficult to say. According to reports from May 2014, a leaked Hasbro training presentation revealed the working titles of several *Star Wars Anthology* movies. Granted, plenty has changed in a year, but the inclusion of titles like *Solo*—which has since been confirmed; Han Solo will get a standalone movie of his very own from Phil Lord and Chris Miller in 2018—and *Red Five*—Luke Skywalker's call sign during the Battle of Yavin, which could mean *Top Gun* in space—still seem plausible even today.[335] One thing is for certain, though. With so many characters and stories that have yet to be writ large on the silver screen, they won't be wanting for subject matter for many, many years to come. (Seriously, though, Lucasfilm, if you want to read my spec script about an elite group of Gungan commandos, titled *The Binkspendables,* you know where to find me.)

60 Stormtroopers vs. Clonetroopers: A Guide to the Expendable

Let's face it. In the world of *Star Wars*, not everyone can be a Jedi or a Sith or even a seven-foot-tall bowcaster-wielding Wookiee; some people were just born to be cannon fodder. After all, if our heroes don't have to fight their way through a horde of nameless goons on their way to the big bad guy behind the scenes, the story would be awfully boring. That is precisely why we love the

stormtroopers and clone troopers, the shock-and-awe troops of the *Star Wars* universe that were born to die, ineffectually shooting their blaster rifles and pistols at one another, bumping their heads on low-hanging door frames, and stealing our hearts.

With their imposing white battle armor (a hallmark of both stormtroopers and clone troopers, and a stylistic choice to differentiate them from the other darkly dressed villains), these infantrymen are symbolic of not only the Empire, but of the *Star Wars* franchise. The majority of the armor pieces were made from fiberglass molds, constructed by Brian Muir at Elstree Studios, at Shepperton Design Studios as a collaboration between Nick Pemberton, Liz Moore, and Andrew Ainsworth.[336] Interestingly, they were among the most expensive costumes produced for the original *Star Wars* film, running up a tab of nearly $93,000.[337] Considering the impact they have had on our collective memories and pop culture as a whole, that was clearly money well spent.

The costumes themselves were uncomfortable, restrictive, and seemed to offer little to no protection against blaster fire. In short they managed to look simultaneously badass and a little bit goofy, functional and superfluous all at once. The original costumes felt more than a little bit jury-rigged. "We had a black all-in-one leotard for the stormtrooper costume," costume designer John Mollo explained of the original outfits. "Over which the front and back of the body went together; the shoulders fit onto the body, the arms were slid on—the top arm and the bottom arm were attached with black elastic—a belt around the waist had suspender things that the legs were attached to. They wore ordinary domestic rubber gloves, with a bit of latex shoved on the front; the boots were ordinary spring-sided black boots painted white with shoe dye. Strange to say, it all worked."[338]

With stormtroopers, snowtroopers, darktroopers, clone troopers, and many more, it can be difficult to tell one from the other. As it turns out, there are only two real categories that

Carrie Fisher cuddles up to a stormtrooper while the two of them were in London promoting The Empire Strikes Back. (Dave Caulkin)

matter: stormtroopers and clone troopers; everything else is a specialized subset. It is essential that you understand that, though they look alike, stormtroopers and clone troopers are fundamentally different—namely in their DNA. The clone troopers were the antecedent to the stormtroopers, serving as the brunt of the battle force for the Republic during and before the Clone Wars. Deadlier in battle than battle droids, the clone troopers were emblematic of the Republic's military campaign against the Confederacy of Independent Systems. After all, why else would they call that conflict "the Clone Wars"?

Believing that the galaxy was on the verge of war, the Jedi Master Sifo-Dyas advocated for the creation of an army to defend the Galactic Republic. Though the Jedi Council rejected his ideas and ultimately cast him out for his militaristic tendencies, Sifo-Dyas secretly contacted the Kaminoans, a species renowned across the galaxy for having expertise in the science of human cloning. Shortly after secretly commissioning the clone army, Sifo-Dyas was murdered on the orders of the Sith. Darth Tyranus, the apprentice of Darth Sidious who you may know better as Count Dooku, took over the cloning program, recruiting the Mandalorian bounty hunter Jango Fett to serve as the mold from which the other clones would be wrought.

Using Fett's DNA as a genetic template, the clone troopers were grown in a massive facility on Kamino, and crafted into an efficient, renewable fighting force. Although most Kaminoans believed that the army was meant to defend and serve the Republic, they were secretly a weapon developed by the Sith to use against the Jedi Order. Each clone was implanted with an inhibitor chip at the third stage of their development under the auspices of mitigating their aggressive tendencies. However, they were designed to compel the clones to obey Order 66, an executive order to exterminate all Jedi.[339] (Kind of like when iTunes

asks if you want to sync your library after an update, but way, way worse.)

Within a decade of Sifo-Dyas' secret order, more than 200,000 clones had been produced, and over 1 million more were on the way.[340] By the time that Obi-Wan Kenobi discovered the secret clone project and alerted the Jedi Council, it was too late; the wheels of war were already turning and Darth Tyranus, acting as the face of the secessionist movement, had fomented enough dissent to form the Confederacy of Independent Systems and break away from the Republic. With the conflict rapidly escalating, the ability of the Jedi to defend the entire Republic was called into question, prompting an impromptu vote of the Senate over whether or not to grant the executive branch of the Senate emergency powers. After a tiebreaking Senate vote by Representative Jar Jar Binks (yes, you read that right), the Supreme Chancellor was granted authority to use the army. Calling them into action, Palpatine deployed them in what would come to be called the Battle of Geonosis, showcasing their strength against the CIS battle droid army, and plunging the galaxy into a war that would last for three long, arduous years.[341]

In the wake of Order 66 and the end of the Clone Wars, the Jedi were practically wiped out, and Darth Sidious (a.k.a. Supreme Chancellor Palpatine) had free reign over the galaxy, using the clone troopers—now known as Imperial stormtroopers—as the Empire's elite shock troops. As time wore on, clones were gradually phased out of the stormtrooper ranks because the accelerated aging process reduced their efficacy as soldiers in the long term. Taking their place were conscripts and recruits, conditioned for zealotry and fanaticism, trained to blindly serve the Emperor's will, to defeat his enemies and enforce his increasingly autocratic and authoritarian laws.[342]

Stormtroopers followed a rigid military hierarchy, with rank denoted by color-coded pauldrons on the left shoulder. The

standard issue equipment included an E-11 blaster rifle and a utility belt (complete with grappling hook). In addition to standard infantry, the Empire introduced a number of specialized stormtrooper units too. Scout troopers wore lighter armor and patrolled the perimeter of Imperial outposts on highly maneuverable speeder bikes; sandtroopers wore armor that allowed them to survive intense heat on desert planets like Tatooine and Jakku; dark troopers wore heavy armor and were used for attacking heavily defended enemy enclaves; snowtroopers wore special masks and armor optimized for cold-weather assaults; and seatroopers were specially outfitted and trained to attack aquatic environments. Basically, if there's a unique situation or environment, the Empire had a highly trained, elite stormtrooper unit ready and waiting to tackle it.[343]

As for when we'll next see the stormtroopers on the big screen, one need only wait until December 18, 2015, for the launch of *Star Wars Episode VII: The Force Awakens*. Taking place roughly 30 years after the Battle of Endor, the stormtroopers feature a new design hearkening back to some of Ralph McQuarrie's early concept art. In addition to the new design, the First Order (the new name for the remains of the Empire) will employ a new specialized stormtrooper variant, the pyromaniacal flametrooper. This is also to say nothing of the much vaunted chrome trooper, the shiny new stormtrooper who many people are referring to as Captain Phasma (presumably played by Gwendoline Christie). Here's hoping that they managed to properly measure the height of interior doorways this time around so we can avoid any OSHA-worthy workplace mishaps. From what I understand, filing for workman's comp in an inherently fascist regime is a beast.

61 Splinter of the Mind's Eye: the Almost Sequel

Somewhere out there across the space-time continuum exists a universe where people went to one of the 32 theaters showing *Star Wars* on May 25, 1977, and decided that rather than an epic tale of space fantasy that it was utter tripe with little-to-no redeeming qualities, something that is, as the teens might say, a pile of hot garbage. In that universe, rather than *The Empire Strikes Back*, audiences were treated to a low-budget sequel starring Luke and Leia trapped on a swamp planet searching for a mysterious crystal than enhances the powers of the Force. Oh, and there's a mud wrestling scene between Luke and Leia, who most definitely *aren't* siblings. Thankfully, we don't live in that alternate universe, but that *Star Wars* story lives on in the form of Alan Dean Foster's *Splinter of the Mind's Eye*, the very first Expanded Universe *Star Wars* story, and it was published in 1978.

The basic plot of *Splinter of the Mind's Eye* revolves around the titular "Mind's Eye," a massive red gem known as the Kaiburr crystal that magnifies and focuses the power of the Force. The crystal was actually based on a similar object, the Kiber crystal, which appeared in earlier drafts of the *Star Wars* scripts as the power source of the Force before Lucas opted for a more spiritual route. In the story, Luke and Leia are on a recruitment mission for the Rebel Alliance when an energy storm causes their ship to crash-land on the planet Mimban, a mysterious, swampy world. However, when they go to find help, they discover that the Empire is already there, operating a secret mining operation to extract a mysterious ore (later revealed to be dolovite in another Expanded Universe title).

While trying to keep a low profile, Luke and Leia encounter an old woman named Halla, who is Force-sensitive and can detect Luke's connection to the Force. She shows him a shard of the Kaiburr crystal (the titular splinter), and offers them safe passage off the planet if they help her find it. Of course, nothing in the *Star Wars* universe is quite so cut-and-dry; they wind up attracting the attention of Darth Vader after a playful fight in the mud between Luke and Leia turns into a spirited brawl with local miners which lands all of them in jail. What follows is an all-out race to find the crystal, as our heroes battle local wildlife, Imperial soldiers, and a race of cave-dwelling warriors. All in a day's work for a guy who blew up the Death Star.

After narrowly escaping with his life, Luke faces off with Vader for an epic showdown, which Luke manages to win thanks to the power of the Kaiburr crystal and some totally clutch advice from the ghost of Obi-Wan Kenobi. Severing Vader's sword arm—an interesting reversal of what happens in *Empire Strikes Back*—Luke thinks victory is in his grasp, but Darth Vader is like a honey badger. You cut off his arm? He don't care. The one-armed Sith Lord battles Luke with a ferocity that is cut short when he, wait for it, falls into a pit. That's right, he just falls into a pit, end of story. Luke senses that the fall didn't kill his asthmatic space dad, and so he rides off into the sunset with Leia and Halla, and his droids, R2-D2 and C-3PO, who were here all along, but didn't really matter much to the story.

That's the story inside the novel, but equally fascinating is the story behind it. Author Alan Dean Foster had previously ghostwritten a novelization of *Star Wars*, and his contract stipulated that he had to write a second book. This book was intended to be something of an insurance policy in case *Star Wars* bombed at the box office like a proton torpedo in a thermal exhaust port. Foster was tasked with turning out a novel that could serve as the basis for a possible low-budget sequel, one that would make

use of previously used props and require far fewer special effects (not only to reduce costs, but also to spare Lucas the agony he experienced working with special effects guru John Dykstra).[344]

The actual content of the book was shaped more by Lucas' constraints than by any lack of imagination on Foster's part. For example, the book centers on Luke and Leia largely because Harrison Ford was not yet signed on for a sequel, so they needed to downplay Han Solo's importance. Likewise, they did not have the rights to Mark Hamill and Carrie Fisher's faces, so on the Ralph McQuarrie-painted cover only Vader's face is visible, the heroes' backs to the reader. "The book originally opened with a fairly complex space battle that forces Luke and Leia down on this planet," Foster revealed in an interview. "George had me cut that out because it would have been expensive to film."[345]

The plot, goofy though it was, resonated with readers who were hungry for more *Star Wars* stories, and the novel turned out to be a best-seller when it was published in February 1978, nine months after the first film's release. The book was such a success that the publisher, Del Rey, offered Foster more *Star Wars* book deals, but he turned them down, as they were, in Foster's words, "the story of Chewbacca's second cousin's uncle, that kind of thing."[346] It was probably for the best; after all, we wouldn't want to meet Chewbacca's extended family before the infamous *Star Wars Holiday Special*.

One of the most fascinating and controversial aspects of the book is the romantic subplot between Luke and Leia, which is completely at odds with where the series winds up going. Though Lucas has often gone on record saying he always intended that the two would be siblings, one gets the distinct sense that is not true. Based on the tone of the first film and the relative creative freedom he had, Foster could hardly be faulted for thinking that was the direction in which the characters were heading. Complicating matters further is the existence of a deleted scene

from *The Empire Strikes Back* depicting a near-kiss between Luke and Leia, which is much more in keeping with Foster's rendition.

Given that a number of things happen in the book that would invalidate or lessen the impact of events in *Empire Strikes Back* and *Return of the Jedi*, one gets the distinct sense that, unlike many Expanded Universe stories, this was never intended to be canon. With moments like the wise Force-sensitive teacher on a swampy planet and a limb being severed in a father-son lightsaber duel appearing in *Splinter of the Mind's Eye* first, one cannot help but wonder whether or not Lucas cherry-picked some of his favorite elements of the story for the big screen. Regardless, *Splinter of the Mind's Eye* remains an important piece of *Star Wars* history, thanks in part to the veritable empire of side stories, alternate takes, and expanded lore that it helped launch. To be perfectly fair, it's not like Foster introduced a surly, green anthropomorphic rabbit in a red jumpsuit into the mix. No, that would be a job for Marvel Comics, and a story for another chapter entirely.

62 The Essential *Star Wars* Expanded Universe Stories

While Lucasfilm may have stripped the majority of *Star Wars* Expanded Universe stories of their canonicity, there are still plenty of reasons to dive headfirst into the wild world of *Star Wars* Legends tales. But with more than 35 years of stories and a wide spectrum of quality, it can be difficult to know where to begin. Fortunately, you have already made the supremely wise decision of purchasing this book, so I'll do the hard work for you by letting you know which Expanded Universe/Legends stories

are absolutely 100 percent, no foolin', swear on Yoda's grave worth your time.

Genndy Tartakovsky's *Clone Wars*

Before *The Clone Wars* epic six-season run, there was another series inspired by the tumultuous period in between *Attack of the Clones* and *Revenge of the Sith*, a microseries by animation auteur Genndy Tartakovsky called *Clone Wars*. The man behind cult classic programs like *Samurai Jack* and *Dexter's Laboratory* created *Clone Wars*, a 25-episode animated microseries consisting of three-minute shorts that blew the competition out of the water. Obi-Wan kicked ass and took names while wearing stormtrooper armor, Mace Windu battled hundreds of Super Battle Droids sans lightsaber, and General Grievous was a genuinely threatening, terrifying villain. The promise of Grievous as a legitimate Jedi-killing threat never quite came across in the films the way that it did in *Clone Wars*.

Just how good was Tartakovsky's tale of Anakin Skywalker and Obi-Wan Kenobi battling against the Separatist threat? One rumor said that George Lucas commanded Cartoon Network to stop making them because he was *jealous* that they were too good. It's probably not true, but that's one hell of a vote of confidence.[347]

Shadows of the Empire

During the mid-1990s, *Star Wars* made a big push in the Expanded Universe with the multi-pronged release of *Shadows of the Empire*. Getting a novel, a Nintendo 64 video game, a comic book, and even a soundtrack, *Shadows of the Empire* sought to bridge the gap between *The Empire Strikes Back* and *Return of the Jedi*. The novel focuses mainly on the Rebels—especially Luke, Leia, and Lando—as they attempt to track down their frozen friend, Han Solo. Meanwhile, the evil Prince Xizor, leader of the

Black Sun crime syndicate, tries to supplant Vader as Palpatine's right-hand man *and* murder our heroes. That's a no-no, Xizor!

The video game, which hasn't aged quite as well, put players in the shoes of bounty hunter Dash Rendar as he attempts to help Luke Skywalker rescue Princes Leia, taking players from the Battle of Hoth to the Mos Eisley cantina to rescuing Leia on Coruscant and beyond.

The Thrawn Trilogy

Over the course of three novels—*Heir to the Empire, Dark Force Rising,* and *The Last Command*—author Timothy Zahn set the gold standard for Expanded Universe stories, introducing beloved characters Jaina and Jacen Solo, Mara Jade, Grand Admiral Thrawn, the planet Coruscant, and much more. The Thrawn Trilogy not only told a sweeping saga over the course of three books, but had an indelible impact on the greater course of the Expanded Universe as we know it. Coming at a time when the toy line had all but disappeared and the cartoons were nowhere to be found, Zahn's books effectively rekindled interest in both the EU and the franchise as a whole.

Set five years after the events of *Return of the Jedi*, which saw the destruction of the second Death Star and the Star Destroyer *Executor*, the trilogy focuses on Grand Admiral Thrawn, an Imperial leader who rallies the fractured remnants of the Empire and leads them against the New Republic. In a time when our heroes expected peace, Thrawn proves to be a chilling new threat, a merciless tactician, and a formidable foe. Plus, when you realize he has blue skin and blood-red eyes, it makes him extra terrifying!

Dark Empire

Long before *Star Wars* ever had its army of clone troopers, the most terrifying clones in the galaxy far, far away belonged to Emperor Palpatine. In 1991 Dark Horse Comics published the

Dark Empire miniseries, written by Tom Veitch and drawn by Cam Kennedy. The 12-issue limited series spun out of Timothy Zahn's Thrawn Trilogy, finding Emperor Palpatine cheating death by reincarnating his consciousness into cloned bodies. Of course, the series' biggest mic drop moment came when Luke Skywalker, of all people, succumbed to the dark side, kneeling by the Emperor's side. Talk about an unexpected twist of fate! Hopefully, old daddy Darth wasn't watching as a Force ghost.

The Han Solo Trilogy
It's hard to imagine that the coolest character in the *Star Wars* canon doesn't carry around a lightsaber, but Han Solo just exudes charisma from every pore. If the rumors are true and Disney wants to make a standalone film based on the adventures of young Han Solo, then look no further than the *Han Solo* trilogy. Composed of three novels—*The Paradise Snare, The Hutt Gambit,* and *Rebel Dawn*—author A.C. Crispin's trilogy revealed how Han Solo and Chewbacca first met, explained the nature of Han's debt to Jabba the Hutt, and Han Solo's first encounters with Lando Calrissian. With swashbuckling smuggling action and attitude to spare, these books are must-reads for any fan of the scruffy-looking nerf herder.

63 Lawrence Kasdan, the Write Stuff

George Lucas may have dreamed up the galaxy far, far away, and Ralph McQuarrie (as you'll read next chapter) gave the franchise its signature visual splendor, but only Lawrence Kasdan was able to find the delicate balance needed to make the narrative shift

in *The Empire Strikes Back* and *Return of the Jedi* come alive for audiences. After becoming a cultural phenomenon and a box office juggernaut, *Star Wars* faced the challenge of avoiding a sophomore slump. Thanks to Kasdan, however, *Empire Strikes Back* not only found its focus by honing in on the humanity of its core cast, but went on to be regarded as one of the greatest sequels of all time.

Born in Miami, Florida, on January 14, 1949, Lawrence Kasdan grew up in Morgantown, West Virginia, going on to work as a freelance advertising copywriter after graduating from the University of Michigan with a degree in education. However, Kasdan had no taste for advertising; what he longed to do was write films. After penning a screenplay titled *The Bodyguard*, Kasdan's first encounter with Hollywood was getting rejected 67 separate times.[348] It was regarded as one of the best unproduced scripts in Hollywood at the time. Finally, Warner Bros. took the bait and bought the script, intending to package it as a vehicle for Steve McQueen and Diana Ross. However, the project soon took a detour to a place all too familiar to working screenwriters: development hell. Unfortunately, the project went on what seemed like permanent hiatus.

Undeterred, Kasdan wrote his next script, *Continental Divide*, a rom-com which told the story of a Chicago newspaper reporter who meets and falls for a hardcore environmentalist. It became the subject of a bidding war amongst producers before ultimately landing in Steven Spielberg's hands. While on the backlot at Universal, Spielberg told Kasdan, "You know, I'm gonna do this movie with George Lucas and I want you to write it!" Kasdan was more than game, but Spielberg had a caveat: "But listen, George is going to try and get you to write *More American Graffiti*. Don't do it!" The movie in question, though, wasn't *Star Wars*; in fact, it was, in George Lucas' own words: "this adventure movie. I don't know much about it, but the hero is named after

J.J. Abrams, Lawrence Kasdan, John Boyega, Daisy Ridley, and Oscar Isaac attend Lucasfilm's Star Wars: The Force Awakens *panel at Comic-Con 2014.* (Richard Shotwell/Invision)

my dog Indiana, and he has a whip." As you can probably well guess, it was *Raiders of the Lost Ark.*[349]

That wasn't the only project Lucas would tap Kasdan for that year, though. In early 1978, George Lucas, Irvin Kershner, and Ralph McQuarrie met at the Beverly Hills Hotel to discuss *The Empire Strikes Back*'s concept. Writer Leigh Brackett had turned in a draft previously, but they were concerned that the draft lacked that certain *je ne sais Star Wars.* However, Brackett was sick and in the hospital with a terminal illness, so hiring a replacement for her became of paramount importance for Lucas and company. Immediately, Lucas thought of the enterprising young writer who had just been hired to pen *Raiders of the Lost Ark.* Even though Kasdan had relatively little experience writing science fiction and/or space fantasy, Lucas felt a kinship with the writer, something that drew them together, and so he offered him the job of taking over writing duties on *Empire Strikes Back.*

It was an offer that Kasdan couldn't refuse and, after a short vacation, he immediately set to work. "The reason George wanted me to write it is because I'm really strong in people," Kasdan said in an interview when asked how he landed the *Empire Strikes Back* gig. "That's what all my original screenplays are about. They tend to be much smaller stories about a smaller number of people, comedies and thrillers, but they're still entertainment. George thought it was very important that *Empire* have that. If anything, we wanted *Empire* to have deeper characterization, more complex psychology for the characters than the first *Star Wars*."[350]

Together, Lucas, *Empire* director Irvin Kershner, and Kasdan would sit for lengthy script meetings, discussing the intricacies of the plot and the nature of the film. These infamous story conferences would become something of a tradition that they repeated in order to suss out storytelling beats and massage the script on *Return of the Jedi* as well. Using McQuarrie's paintings, Lucas' notes, and Leigh Brackett's initial draft as his basis, Kasdan began writing at a furious pace, even though he was still somewhat in the dark. "At the point we were writing, we didn't have sets or special effects to work from," said Kasdan. "It was sheer dreaming. We ran the risk of writing words and not really knowing what they would mean physically."[351] That's okay, Mr. Kasdan— most people don't know what half the words in *Star Wars* mean, but that has always been part of the fun.

When *The Empire Strikes Back* wrapped, Kasdan made his directorial debut with *Body Heat*, which he also wrote. During that same period, he also completed work on *Raiders of the Lost Ark*, which he created from whole cloth. When it came time to write the script for *Return of the Jedi*, however, Kasdan wasn't immediately tapped for the role. This was partially due to the fact that Lucas took it upon himself to write the first draft, and partially because now that Kasdan was able to write and direct

his own material, he had little intention of writing for other people. "I was surprised to find myself writing *Jedi,*" Kasdan confessed, "because I was already a director and I had no intention of writing for anyone ever again." However, Kasdan also knew which side his bread was buttered on, and did not want to leave his friend and creative collaborator hanging high and dry: "George asked me as a favor and he'd already been so helpful to me in my career—not just on *Raiders,* but in helping me get *Body Heat* made."[352] And so, as a favor to his friend, Kasdan settled in to complete the original *Star Wars* trilogy.

In the wake of *The Empire Strikes Back* and *Return of the Jedi'*s success, Kasdan parlayed his newfound cache into plum writing and directing gigs for his passion projects. Over the years, he wrote and directed *The Big Chill, Silverado, The Accidental Tourist,* and *Dreamcatcher,* among others; and as for his original script that was stuck in development hell, *The Bodyguard,* well it finally did get made—in 1992, starring Kevin Costner, Whitney Houston, and one hell of a ballad. (For the record, I would *love* to see that Diana Ross/Steve McQueen version.)

Now, some three decades later, Kasdan is returning to the world of *Star Wars* as the co-writer of *Star Wars Episode VII: The Force Awakens.* Although initially only tapped as a creative consultant, Kasdan became co-writer alongside director J.J. Abrams after the first screenwriter, Michael Arndt, left the project. Kasdan isn't the only person who is excited for his return to the galaxy far, far away. "[My] kids are looking forward to it," Kasdan said to *The L.A. Times.* "It's a movie that my grandson, who's not even three, is already excited about. There are not many movies like that."[353] Considering that Kasdan will have a hand in *Episode VIII, IX,* and the *Star Wars Anthology* movies like *Rogue One,* as well, it's safe to say that we'll have many more movies like that in the days, months, and years to come.

64 Ralph McQuarrie, the Conceptual Mastermind

George Lucas may have dreamed up the galaxy far, far away, but only Ralph McQuarrie could bring his intangible vision to life with a simple stroke of his paintbrush. The famed concept designer was responsible for creating some of *Star Wars'* most indelible images and characters, including Darth Vader, R2-D2, C-3PO, and Boba Fett. McQuarrie is often credited with creating the striking aesthetics of the *Star Wars* universe, and his concept art has had such a deep and lasting impact on the franchise that it is still being used to this day for new characters in *The Force Awakens*. (Example: the adorable ball droid BB-8 is based on the unused original concept art for R2-D2, which depicted him as "running on a giant ball bearing—just a sphere, a circle, wheel-like.") In fact, McQuarrie was so essential to the process that he was the very first person that Lucas hired to help him realize *Star Wars*. "When words could not convey my ideas," said Lucas, "I could always point to one of Ralph's fabulous illustrations and say, 'Do it like this.'"

Born in Gary, Indiana, on June 13, 1929, Ralph McQuarrie grew up with art all around him; in fact, both of his parents were artists, and they introduced him to the art of watercolor and illustration at an early age. At age 10, McQuarrie began formally studying art, learning the art of technical drawing in high school. With a diverse skillset, McQuarrie landed a job at Boeing as a technical artist in the 1960s, drawing diagrams of 747 jumbo jet manuals, and later as an animator for NASA and CBS News, animating sequences of the Apollo lunar missions. With the nation's attention focused on the space race—and, by proxy,

McQuarrie's illustrations—the artist had effectively put himself on the world's radar.

In 1965, McQuarrie made the fateful move to Los Angeles, setting up shop on Venice Beach and beginning to work as a free-lance illustrator for the film industry. At first, this consisted largely of contributing artwork for movie posters, but McQuarrie's life changed when a pair of artist friends introduced him to George Lucas in 1975. At the time, Lucas was shopping around his little space fantasy, *Star Wars*, which he was actively in the process of retooling and refining. It had already been rejected outright by both United Artists and Universal, and Lucas realized he would need an ace in the hole for his meeting with 20th Century Fox.

Lucas tapped McQuarrie to create a series of paintings that he could show during the pitch meeting. Using Lucas' script for inspiration, McQuarrie created breathtaking images that breathed new life into Lucas' pitch. The most iconic of the initial batch was a lightsaber battle between Darth Vader and Deak Starkiller (who would evolve to become Luke Skywalker). It was a scene fraught with danger, bursting with kinetic violence and drama, and it instantly gives the sense that this isn't your average sci-fi film. Lucas' gambit paid off in spades; the paintings convinced 20th Century Fox to take a chance on a sweeping tale of spaceships, laser swords, and mysterious robots. Indeed, without McQuarrie, it is arguable that there might not have been a *Star Wars* at all.

McQuarrie's paintings didn't just sell Fox on the idea of *Star Wars*; they sold many of the actors on the project, too. When Anthony Daniels was approached for the role of C-3PO, he was initially hesitant, prepared to reject the project outright. However, a painting of McQuarrie's caught his eye, a portrait of C-3PO and R2-D2 standing in the desert plains of Tatooine. "He had painted a face and a figure that had a very wistful, rather yearning, rather bereft quality, which I found very appealing."[354]

There was an asymmetrical quality to Threepio's face that resonated with Daniels. "It almost was inviting to come through the frame of the painting and be with him, or it, on this lonely moonscape."[355]

Among McQuarrie's most iconic contributions to the *Star Wars* saga is in Darth Vader's design. "For Darth Vader, George just said he would like to have a very tall, dark fluttering figure that had a spooky feeling like it came in on the wind," McQuarrie said in an interview. Lucas had communicated to McQuarrie that he wanted the figure to have a samurai influence and a cape, but McQuarrie noticed that something was missing. The script called for Darth Vader to travel in between spaceships in the infinite blackness of space, exposing himself to the elements (or relative lack thereof). "I thought, 'Gee, Darth Vader has to function in a vacuum,'" McQuarrie said. "So I suggested to George that [Vader] might have some sort of spacesuit to enable him to survive this trip through the vacuum, and George said, 'Well, okay, give him some kind of a breathing apparatus.' So along with the big helmet, I put a mask on him."[356] The mask, in turn, influenced Vader's breathy, labored voice and the rest, as they say, is history.

Ralph McQuarrie remained an integral part of the design process for all three films of the original trilogy—*A New Hope, The Empire Strikes Back*, and *Return of the Jedi*. Though he was offered the opportunity to work on the prequels, McQuarrie declined the offer. He wasn't just handy behind the scenes, though; the artist also made a splash in front of the camera too. McQuarrie even managed to find his way on to the big screen himself, appearing in Echo Base on Hoth during the opening sequence of *The Empire Strikes Back* as the uncredited General Pharl McQuarrie.

His designs are so beloved that they've even been the subject of coffee table books. Though McQuarrie's concept paintings are

revered among fans and filmmakers alike, McQuarrie was always quick to point out that they were never intended to be seen by anyone not involved in making the film. This wasn't because he wanted to deprive the public of his amazing work, but because they were rough sketches, not polished enough by his standards for public consumption. Still, in an era during which most sci-fi was anesthetized, monochromatic, and soulless, McQuarrie imbued a lived-in quality, creating an aesthetic that has been described as "used future," which "imagined a lived-in galaxy that was gritty, dirty, and in advance states of decay."[357]

McQuarrie passed away on March 3, 2012, at his home in Berkley, California, at the age of 82 from complications due to Parkinson's disease. His legacy is unassailable, having contributed designs to films like *Raiders of the Lost Ark, E.T.: the Extra-Terrestrial, Nightbreed, Star Trek IV: The Voyage Home,* and *Cocoon* (for which he won an Oscar for Best Visual Effects in 1986), and giving form to a franchise that would take over the world, one that is still feeling his considerable influence some 35 years later.

The Kessel Run; or How Han Solo Learned to Time Travel

"You've never heard of the *Millennium Falcon*? It's the ship that made the Kessel Run in less than 12 parsecs."—Han Solo

Ever since Han Solo uttered those fateful words in a desperate attempt to build up his signature spacecraft in the face of his skeptical clients, Luke Skywalker and Obi-Wan Kenobi, fans have wondered just what the hell the Kessel run *is* anyway. Is it a 5K fun run? Is it a treacherous obstacle course rife with asteroids

and danger? Is it some combination of both? Though its presence in *Star Wars* canon is limited to its mention in *Star Wars Episode IV: A New Hope*, the Kessel Run has a rich history in the *Star Wars* Legends stories.

The Kessel Run is—drum roll, please—one of the most heavily used smuggling routes in the entire galaxy. The 18-parsec route spans from Kessel, an Imperial prison world and mining colony, to an area of safe space just south of the Si'Klaata Cluster, enabling smugglers to run glitterstim spice—a psychoactive narcotic that gives the user a telepathic boost, feelings of euphoria, and a heightened mental state—without getting caught by the Imperial vessels that patrol Kessel's mines. The route would take pilots around a cluster of black holes dubbed The Maw, detouring through an uninhabitable asteroid cluster called The Pit. Since The Pit was inside of a nebula arm, sensors would often go haywire, meaning that while pilots would have to fly blind, they wouldn't be able to be tracked as easily by anyone giving chase.[358]

But, wait, didn't Han Solo say he made the Kessel Run in *12* parsecs? And just what the hell is a parsec anyway? Well, a parsec is actually a unit of time, a portmanteau of "parallax" and "second" first coined by British astronomer Herbert Hall Turner in 1913. It is defined as "the distance from the Sun to an object that has a one-arcsecond (1/3,600 of a degree) parallax." Think of it like a straight line between an object and the sun, as well as an object and the Earth. The angle between the lines is one-arcsecond, making the objects 1 parsec away from one another, which translates to roughly 3.26 light-years.[359] Are you still with me? Good—I'm not much of a math guy, myself, but basically the Kessel Run is measured in the amount of *time* it takes to get from one end to the other, not just *distance*. So, what did Han Solo do?

Well, he essentially time traveled. By skirting the edge of the Maw, Han Solo essentially drifted (as in Tokyo Drifted) his

way around the black holes, cutting out additional time needed to make the trip, and reducing the overall voyage take only 11.5 parsecs. That is nearly 20 light-years that he managed to shave off of his trip

In a fascinating 2013 article by *WIRED*, it was determined that in order to make such good time, the *Millennium Falcon* would have to be capable of traveling at what is essentially the speed of light. Though "jumping into hyperspace" seems like a convenient *deus ex machina*, the speed of light is, in fact, the universal speed limit—there is nothing faster. Essentially, the *Falcon* is traveling at 99.9 percent of the speed of light. However, when one travels at such ludicrous speeds, time begins to contract, meaning that the faster you travel, the slower time passes for you—but only for you.[360]

For the outside world, time progresses at a normal rate. For Han Solo and those aboard the *Millennium Falcon*, one hour spent on the *Falcon* would translate to roughly three years of real time. Remember that scene in *Interstellar*? Yeah, it's kind of like that, but with 100 percent less Anne Hathaway. So, by making the Kessel Run in 12 parsecs, Han Solo would speed along for roughly 40 years. Yowza! No wonder Jabba the Hutt was furious that Han Solo took so long to pay him; the dude skipped out on his bill for like four decades![361]

Now obviously, this is where the "fiction" part of science fiction comes into play, but it's still fun to play devil's advocate with this sort of thing. The one thing it can't explain though is why Han Solo looks so haggard in the new *The Force Awakens* trailers. Our favorite scruffy-looking nerf herder is looking even scruffier than usual. Maybe all that time dilation is starting to catch up with him.

66 Order 66 and Operation Knightfall

At its roots, *Star Wars* has been a saga rooted deep in myth, using powerful archetypes to tell an elemental story of good versus evil. In order to illustrate that quintessential struggle, each trilogy—original and prequel—is characterized by one overwhelming act of evil, a deed so nefarious that it marks the point of no return for our heroes, spurring them to action, or setting the stage for the story to come. In *Star Wars Episode IV: A New Hope*, that moment came when Grand Moff Tarkin obliterated the planet Alderaan in a demonstration of the Death Star's terrible power. In the prequel trilogy, that moment didn't come until the story was nearly at its end, when Supreme Chancellor Palpatine initiates Order 66, a clone protocol which branded the Jedi Order traitors to the Republic. Though it didn't happen until *Star Wars Episode III: Revenge of the Sith*, the groundwork had been laid years prior, leaving a trail of murderous bread crumbs all along.

Order 66 is, arguably, the most important part of the long-simmering Sith plot to render the Jedi Order effectively extinct. Nearly 10 years before the outset of the Clone Wars, the Jedi Master Sifo-Dyas ordered the creation of a clone army on Kamino in order to defend the Galactic Empire. Shortly thereafter, Sifo-Dyas was murdered by the Sith, who installed one of their own, Darth Tyranus/Count Dooku, to take over the program. It was Dooku who provided the biochips with which each and every clone would be outfitted under the auspices that it would help mitigate their overly aggressive, antisocial tendencies. Did these tendencies actually exist? Probably not, but Count Dooku essentially prescribed them the biotech equivalent of Ritalin, making him the Dr. Oz of the *Star Wars* universe.

The plan was nearly exposed when, toward the end of the Clone Wars, the microchip embedded in the clone trooper CT-5385, a.k.a. "Tup," malfunctioned. The error caused Tup to go into a violent, trancelike state and while in this state he murdered the Jedi Master Tiplar in cold blood.[362] When Count Dooku and Supreme Chancellor Palpatine learned what happened, they attempted to have him kidnapped by the Confederacy of Independent Systems. However, they failed to capture him, and Tup was taken to Kamino for further study by the Republic. Though the Kaminoans, who were privy to the truth behind the bio-chips, claimed it was a virus that caused Tup's fugue state, the story did not sit well with CT-5555, another clone-trooper nicknamed "Fives."[363]

After running tests with a medical droid, Fives discovered a "tumor" inside Tup's brain, which was actually a malfunctioning biochip. After discovering he had a biochip in his brain too (and having it removed), Fives realized that all clones had these chips embedded within them. This discovery prompted the Jedi to bring Fives to Coruscant for additional examination, but Palpatine, as always, was one step ahead.[364] Framing Fives for an assassination attempt, Palpatine effectively discredited Fives' story. To make matters worse, the clone was assassinated himself before he could reveal the truth to Anakin Skywalker and Captain Rex. The truth died with him, and it would not come out until Palpatine's moment of triumph.[365]

As the war wore on, the Jedi grew weaker and weaker as the conflict stretched their resources and their resolve ever thinner. When the conflict finally ended, public support for the Jedi Order was at an all-time low, Count Dooku and General Grievous had been killed, and Palpatine was more popular than ever. After revealing his secret Sith identity to Anakin Skywalker, the troubled Jedi informed Jedi Master Mace Windu of the truth. Windu retaliated by assembling a strike team including

Kit Fisto, Saesee Tin, Agen Kolar, and himself to arrest Palpatine for treason. Revealing his true power, Palpatine handily killed all of them and, in doing so, convinced Anakin to finally give in to the dark side.

But Palpatine wasn't done there, not by a long shot; using the dead Jedi as a pretext, Palpatine claimed that they were traitors who attempted to seize control of the Republic for themselves by assassinating him. Palpatine uses this as a pretext to form the Galactic Empire, installing himself as emperor. "So this is how liberty dies—with thunderous applause," Padmé Amidala remarked sadly as Sheev Palpatine's scheme to seize control of the Senate came to pass. In a testament to just *how* evil this guy is, he managed to convince the Senate to hand over power to him willingly, rather than seizing it by force. His first official act, though, would be an unparalleled use of force—Order 66.

According to the novel *Star Wars Republic Commando: True Colors*, the text of Order 66 reads as follows:

"In the event of Jedi officers acting against the interests of the Republics, and after receiving specific orders verified as coming directly from the Supreme Commander of the Republican Army (Chancellor Palpatine), the army commanders will remove those officers by lethal force, and command of the army will revert to the Supreme Commander until a new command structure is established."

In layman's terms, it labeled all members of the Jedi Order enemies of the state, and activated the genetic killswitch protocol embedded in the clone troopers, leading them to systematically gun the Jedi down where they stood.

Though Jedi across the galaxy were murdered by their own soldiers, the most grievous betrayal and gratuitous slaying occurred when Anakin Skywalker, newly pledged to the dark side, lead the 501st Legion of clone troopers (the eventual stormtrooper regiment known as "Vader's Fist") to the Jedi

Temple. Executing "Operation: Knightfall," the newly anointed Darth Vader infiltrated the Jedi Temple on Coruscant, modifying a communications beacon to lure Jedi back. Alongside the stormtroopers, Vader quickly and deliberately killed countless Jedi, including many Jedi Masters, nearly all the Jedi Knights, and even some of the younglings who were training there. It was an act of heinous evil and unthinkable betrayal, one that would come to be known as the Great Jedi Purge in the years to come. You know, like in this book that you're holding right now.

Though Order 66 was remarkably effective in its brutality, a few Jedi managed to slip through the Emperor's grasp. Branded traitors and seditionists, these few survivors were forced to go on the lam, lying low and living in exile, constantly keeping one eye over their shoulder. Obi-Wan Kenobi fled to Tatooine, bringing Vader's infant son Luke Skywalker with him, and keeping a close eye on the boy. (Leia had been taken to Alderaan by Bail Organa.) Yoda departed for the swampy planet of Dagobah in order to seek solitude and continue studying the Force, particularly the secrets of immortality discovered by Qui-Gon Jinn. The Padawan Caleb Dume managed to escape as well, adopting the name "Kanan Jarrus" and living as a civilian for nearly 14 years before he found himself back fighting the good fight with the crew of the *Ghost*. The Jedi Order may not have been totally eradicated, but its remaining members were in no position to fight the Empire by themselves, and were forced to go into hiding.

67 The Jedi Council: A Who's Who

The Jedi are an ancient and powerful order of quasi-religious warrior-monks who wield the Force, the living energy that binds the universe together, in order to defend the galaxy from evil. Yet even they need oversight; after all, you can't just have a bunch of telekinetic introverts running around the galaxy with lightsabers dispensing justice all willy-nilly, now can you? (Even the Sith have a set of evil rules that they try to follow.) Thus, we have the Jedi Council, the governing body of the Jedi Order comprised of 12 of the wisest Jedi Masters from their ranks. From the Jedi Temple on Coruscant, they convene in the Jedi High Council Chamber, a room with 12 seats of varying heights and styles, positioned in a circular fashion around the brightly lit room.

The Jedi Council is essentially the United Nations Security Council of the *Star Wars* universe, comprised of five lifetime members, four long-term members, and three members who serve for limited terms. Our first glimpse of the Jedi Council comes during the Trade Federation's invasion of Naboo during *The Phantom Menace*. Over the course of the prequel trilogy and the attendant television series, the Council's ranks would shift, form, and reform, leading many to wonder *who* exactly is on the council. Well, fortunately for you, I have a handy-dandy guide to identifying the contestants in this intergalactic game of musical chairs.

Yoda: At more than 850 years old, Yoda served as the Grand Jedi Master and held the distinction of being the most senior Jedi; he was also one of the few Jedi to survive Order 66, going on to teach Luke Skywalker the ways of the Force years later. His exceptional power was only exceeded by his incredible wisdom, traits which he used to guide the Jedi Order for years and years.

Mace Windu: The second-most senior Jedi under Yoda, Mace Windu was one of the most celebrated generals of the Clone Wars, known for his signature purple lightsaber and his expertise in lightsaber combat. He was also deeply troubled by the idea that the Sith could return. His concern was well-founded as Darth Sidious struck him down during a frantic duel, an act aided by a newly treacherous Anakin Skywalker that ended with Windu being electrocuted and defenestrated.

Plo Koon: The vaguely insectoid-looking fellow with a breathing apparatus and goggles is Plo Koon, a Kel Dor from Dorin, who required the aforementioned breathing gear to survive in certain atmospheres. Most notably, he discovered Ahsoka Tano and went on to serve as a general during the Clone Wars until he was slain during Order 66.

Ki-Adi-Mundi: Though he may resemble a Conehead from the old *Saturday Night Live* sketches, Ki-Adi-Mundi was an adept Jedi Master who sat on the Council and served as a Jedi General during the Clone Wars. Though the Cerean alien was a wise Jedi, his binary brain was skeptical of Qui-Gon Jinn's initial reports of the Sith's return. Likewise, he refused to believe that Count Dooku was secretly villainous, working behind the scenes to destabilize the galaxy. The Jedi ultimately paid for it with his life when his own clone troopers shot him dead.

Saesee Tiin: The stone-faced, ram-horned Iktotchi known as Saesee Tiin wasn't just a skilled starfighter pilot with the complexion of a sunburned demon; he was an expert with a lightsaber, which served him well on both the Council and as a general during the Clone Wars. He was one of four masters sent to arrest Supreme Chancellor Palpatine, and was quickly killed during the ensuing melee.

Yaddle: Imagine a younger, sexier Yoda with long, brown hair. Are you picturing it? Congratulations, you just thought about Yaddle, a member of Yoda's mysterious species. Yaddle was

only 477 years old during the invasion of Naboo, nearly half of Yoda's age yet somehow three times as disconcerting to look at.

Even Piell: Remember the one Jedi Master who looked like Bat Boy from the old *Weekly World News* tabloids? That is the diminutive Lannik Jedi known as Even Piell, a senior member of the Jedi Council who discovered the Nexus Route, a highly strategic hyperlane that connected the Separatist and Republic homeworlds. He was captured by a Separatist crew, including then-Captain Wilhuff Tarkin, and imprisoned on the Citadel. He ultimately died while escaping the prison, gored by a hyena-like Anooba.

Adi Gallia: With hair tentacles and a fierce thousand-yard stare, Adi Gallia was a female Tholothian Jedi Master who served as a General in the Grand Army of the Republic. Alongside Obi-Wan Kenobi, she went to investigate the havoc being wrought by the Sith siblings Darth Maul and Savage Opress. Unfortunately, she was slain in battle by Opress.

Oppo Rancisis: Oppo Rancisis was a Thisspiasian male Jedi Master who once trained under Yaddle as a Padawan and eventually joined the Council's ranks. The Jedi Master resembled a cross between a serpent and a yeti—or maybe like one of those carnival games where you shoot water into a clown's mouth—and faithfully served the Jedi Council throughout the Clone Wars.

Yarael Poof: If you crossed a giraffe with a jaundiced Teenage Mutant Ninja Turtle, you would be able to create a fairly convincing forensic sketch of the Jedi Master Yarael Poof. The Quermian Jedi rarely used his lightsaber, preferring instead to use the Affect Mind ability, over which he had near-total mastery. Though the long-necked Jedi was active on the Council around the Battle of Naboo, his seat was filled by Coleman Trebor by the time of the Battle of Geonosis.

Eeth Koth: The Iridonian Zabrak Jedi (think Darth Maul, but with brown skin and white horns) fought in many battles

throughout the Clone Wars, as well as serving on the Council. Though he was kidnapped and tortured by General Grievous, his fellow Jedi managed to rescue him

Depa Billaba: A female Chalactan Jedi Master who served on the Council during the Jedi Order's final years, Depa Billaba is notable for training under Mace Windu's tutelage and joining the Order at a very young age. While under attack by clone troopers at the outset of Order 66, she sacrificed her life to save her Padawan, Caleb Dume, who would go on to adopt the name Kanan Jarrus in order to keep a low profile.

Yoda the Vampire Slayer

Okay, so that title is a little misleading, but there *is* a reason that I invoked Joss Whedon's famously plucky scourge of the undead. Everyone knows and loves Yoda, the puckish Jedi Master who trains Luke Skywalker in the art of the Force amidst the swamps of Dagobah. But Yoda very nearly wasn't his name. In one of the earliest outlines for *The Empire Strikes Back*, notes reference a new character named Buffy or Bunden Debannen, who appears as a sort of manifestation of the Force:

"Luke unconscious—awakes to find Bunden Debannen (Buffy). Buffy very old—three or four thousand years. Kiber crystal in sword? Buffy shows Luke? Buffy the guardian. 'Feel not think.'"

The outline finishes by calling Luke "the chosen one—the human Buffy." In later drafts, the Buffy name was abandoned and Yoda was reimagined as a small, froglike figure named "Minch Yoda." Here, Minch Yoda makes sly reference to the Vader connection, saying, "Skywalker. Skywalker. And why do you come to walk my sky, with the sword of a Jedi knight? ... I remember another Skywalker."

Eventually, though, the Minch was dropped and the enigmatic little mystic we know and love emerged from the primordial ooze of creative development. Thank god for that, too, because Yoda rolls off the tongue *way* better than "Bunden Debannen."

Anders, Charlie Jane. "10 Things You Didn't Know About The Empire Strikes Back." Wired.com. Conde Nast Digital, 12 Oct. 2010. Web. 18 May 2015.

Shaak Ti: The Togruta warrior Shaak Ti fought in the Battle of Geonosis and helped train clone troopers on Kamino. The latter was something with which she struggled, trying to strike a balance between giving the clones a sense of compassion and turning them into elite soldiers. During the Separatist attack on the facility, she defended the Kamino facility from attack. She later appears in one of Yoda's visions, having been killed.

Coleman Trebor: A male Vurk Jedi, Coleman Trebor resembles a scaly, sharklike alien who served as both Jedi Master and Council member during the final years of the Galactic Republic. Trebor traveled to Geonosis as part of a Jedi assault team led by Mace Windu in order to rescue Obi-Wan Kenobi. However, he was murdered by Jango Fett during a confrontation with Count Dooku during the Battle of Geonosis.

Obi-Wan Kenobi: The former Padawan of Qui-Gon Jinn and master to Anakin Skywalker, Obi-Wan Kenobi was both a great Jedi and a great general during the Clone Wars. Though Anakin would eventually turn to the dark side, becoming the Sith known as Darth Vader, Obi-Wan would serve as a mentor to his son, Luke.

Kit Fisto: If the Creature from the Black Lagoon had a toothy white grin, big bug eyes, and dreadlocks made of tentacles, he would be Kit Fisto, the Nautolan Jedi Master who used his intense combat focus to serve the Jedi Council. With a laid-back demeanor and a sense of humor, the aquatic alien served valiantly throughout the Clone Wars, but was ultimately slain by Supreme Chancellor Palpatine.

Coleman Kcaj: One of the 212 Jedi Knights assembled by Mace Windu to free Padmé Amidala, Anakin Skywalker, and Obi-Wan Kenobi from execution on Geonosis, Coleman Kcaj assumed the role of Jedi Council member during the Clone Wars. The Ongree Jedi was slain during the Great Jedi Purge.

Agen Kolar: Another Zabrak Jedi, Agen Kolar was appointed to a seat on the Council during the Separatist crisis. He fought during the Battle of Geonosis as part of the Jedi strike team dispatched to rescue allies facing execution. He was later killed in a lightsaber duel with Darth Sidious.

Stass Allie: Another female Tholothian Jedi Master, Stass Allie was a Jedi Master/Council member who died on Saleucami, when the clone commander Neyo shot her dead as a result of Order 66.

Anakin Skywalker: Appointed to the Council largely against its wishes and not conferred the title of Jedi Master, Anakin served at the behest of Supreme Chancellor Palpatine, who wanted the young Jedi on the Council to serve as his personal spy.

Sifo-Dyas: The human male Jedi Master was responsible for the creation of the clone program on Kamino, born out of his desire to create a standing army with which to defend the Republic. His radical views led to his expulsion from the Jedi Order, and he was ultimately murdered by the Sith, so yeah, he's had a rough go of things one might say.

Jocasta Nu: The Chief Librarian of the Jedi Archives, Jocasta Nu was a female human Jedi who sat on the Council prior to the Battle of Naboo. Like so many others, she was slain during the brutal assault on the Jedi Temple during Order 66.

Admiral Ackbar

"It's a trap!" With those three words, a humble squid-faced alien went from odd-looking background character to one of the single most beloved figures in the *Star Wars* canon. Moreso than other

fandoms, *Star Wars* fans have a tendency to latch on to minor characters, and that is precisely what happened with Admiral Ackbar. The Mon Calamari military commander has earned a cult following over the years in spite of only having a dozen or so lines in his brief appearance in *Return of the Jedi*. (And yes, they named the race of alien squid people Mon Calamari. What of it? At least their homeworld is called Mon Cala and not Long John Silveria.) However, Ackbar was undeniable, and the character went on to feature in the fourth season of *Star Wars: The Clone Wars*, as well as becoming a mainstay of the Expanded Universe. And he might not have existed at all had it not been for *Return of the Jedi* director Richard Marquand.

During a production meeting between George Lucas, Marquand, and creature designer Phil Tippett, the creative team realized they still needed to decide who Admiral Ackbar would actually be. Turning to Marquand, Lucas said, "Who's going to play Admiral Ackbar? I just decided he should be a creature, so you can pick out Admiral Ackbar." Without hesitating, Marquand pointed to "the most delicious, wonderful creature out of the whole lot, this great big wonderful Calamari man with a red face and eyes on the side."[366] Though a few people at the meeting objected ("People are just going to laugh when they see this guy," one said), Marquand prevailed. Though Ackbar is certainly entertaining to look at, Marquand had a deeper purpose in mind. "I think it's good to tell kids that good people aren't necessarily good-looking people and that bad people aren't necessarily ugly people," the director explained in an interview.[367] Promoting body positivity with space-faring cephalopods? You're the man, Richard Marquand.

When it was decided that Ackbar would be a Mon Calamari creature, they also mandated that his head should be fully articulated. The U.S.-based creature shop had already cost the production $97,933, and that figure would rise to $126,500 by

the end of July. Now, I'm not saying that Admiral Ackbar cost the company $28,567, but if he did, it was certainly money well spent, especially considering the headaches that came with coordinating complex creature construction across two continents.[368] Though he looked like the bastard child of a beat-up old shoe and an anthropomorphic squid-beast, Admiral Ackbar was, at long last, part of the picture. Operated on set by puppeteer Tim Rose during production and voiced by Erik Bauersfeld, the suit was often so hot that Tippett helped Rose cool down in between takes by using a hair dryer to blow air into the restrictive suit.[369] Such were the sacrifices that men like Rose had to make to bring one of the most incredible characters ever conceived to the celluloid.

Admiral Gial Ackbar—a first name that was not officially established until the April 2012 release of Paul R. Urquhart's reference book, *Star Wars: The Essential Guide to Warfare*—first made a name for himself during the Clone Wars, during which he served as a captain in the Mon Calamari Guard. While Separatists sought to fan the flames of civil war on his homeworld of Mon Cala by trying to disrupt the chain of succession of the Mon Calamari throne, Ackbar played a crucial role. Separatist droids invaded the capital, gunning for Prince Lee-Char, the rightful heir. The Republic responded in kind by providing underwater clone troopers and a detachment of Jedi to help, but the Separatists managed to overwhelm the fighting force. Realizing that discretion was the better part of valor, Ackbar advised the prince to retreat into the nearby sea caves, then stayed behind to beat the invaders back, leading a counterassault on the would-be conquerors.[370]

By the time of the Battle of Endor, Admiral Ackbar had risen through the ranks of the Rebel Alliance, being named the leader of its fleet. Aboard his massive MC80 star cruiser, the *Home One* (a.k.a. the Headquarters Frigate), Admiral Ackbar commanded the full might of the Rebel Alliance fleet, personally leading them

in the assault on the second Death Star. With triple-strength shields, heavy hull plating, and 20 hangars for housing warships and starfighter squadrons, the *Home One* proved more than up to the task of serving as a mobile headquarters for Ackbar and the Rebel leaders. Standing at the helm of the Rebel fleet, Ackbar served as a symbol of hope and justice, representing an all-inclusive Alliance of freedom fighters who would stand up to an Empire that consistently marginalized, subjugated, and oppressed non-humans.[371] If nothing else, it proves that the Rebel Alliance has a much more enlightened policy when it comes to equal opportunity employment.

Though it cannot technically be considered canon, it's worth recounting a few of the Mon Calamari's most famous Expanded Universe exploits. A pacifist by nature, Ackbar learned the efficacy of force after being enslaved by the Empire and forced to be a personal servant to Grand Moff Tarkin. During that time, he learned of both the Rebel Alliance and the moon-sized super-weapon known as the Death Star. When he was freed during a Rebel assault intended to capture Tarkin, Ackbar not only

It's a…What Now?!

With three short words, Admiral Ackbar cemented his place in the heart of every man, woman, and child on Earth. Okay, so maybe "It's a trap!" didn't have quite the reach I'm claiming here, but it's one of the most infamous lines in *Return of the Jedi*. What's more, it nearly didn't come to pass because it isn't even in the screenplay. In the script, the line is written as "It's a trick!" However, it was changed during post-production after a test screening because "It's a trick!" sounds like something you would shout after seeing a magician perform an amazing card trick. "It's a trap" is what you shout when you're a badass Mon Calamari general realizing you have been outmaneuvered by a fascist intergalactic empire.

McMillan, Graeme. "30 Things You Didn't Know About Return of The Jedi." Wired.com. Conde Nast Digital, 24 May 2013. Web. 18 May 2015.

joined the Rebel Alliance, he helped convince the people of Mon Cala to lend their might—and their starships—to the cause.[372] His shrewdness as a military leader was only paralleled by his ingenuity as an engineer; by helping to design the B-wing line of starfighters, the Rebel leader Mon Mothma promoted him to Admiral, a position he would take to like a Mon Calamari to water.[373]

Just how popular is Admiral Ackbar? Back in 2010, the University of Mississippi nearly made him the official mascot of their collegiate athletic teams. Since 2003, the school found itself lacking a mascot after the college decided to ban their previous mascot, Colonel Reb, whose connection to slavery and southern plantation culture was uncomfortable to say the least.[374] As Ole Miss' team name was the Rebels, who better to represent them than the leader of the Rebel Alliance, Admiral Ackbar? If it sounds crazy, that's because it is. Then again, the UC Santa Cruz mascot is a banana slug, a slimy mollusk that, as far as I know, has never led an army of ragtag freedom fighters against a monolithic fascist state. After students launched a campaign to make the Mon Calamari the official mascot, more than 1.5 million people registered on the website to make it come to pass.[375]

Of course, not everyone was on board. "The closest relation between Admiral Ackbar and of Mississippi is the fact that our state does a lot of shrimping," one student remarked to ESPN. Ultimately, Lucasfilm declined to grant the rights to the school, noting that "Admiral Ackbar would be unavailable because he's fighting evil in another galaxy."[376] The school settled on the Black Bear as their mascot and the hopes of football-loving *Star Wars* fans were dashed upon the rocks of reality. But perhaps it's for the best. After all, doesn't the leader of the Rebel Alliance deserve better than to do the worm in front of drunken undergraduates who have spent the better part of a Saturday morning eating grilled sausages and drinking light beer faster than a *Star Wars*

character can say, "I've got a bad feeling about this"? Actually, you know what? That sounds like a lot of fun. Let's get Ackbar attached to a Division I team—stat! And while you're at it, grill me up a cheeseburger.

69 Blasters

There are plenty of epic gun battles in the world of *Star Wars,* but none of them involve bullets. That is because the firearm of choice in the galaxy far, far away isn't anything like what we would use here on Earth; rather, it is what is known as a blaster, a ranged weapon that fires concentrated bursts of energy called blaster bolts. Instead of popping in a new clip when one runs out of ammunition, the particle beam energy is derived from replaceable power packs. Han Solo, Leia Organa, Boba Fett, every stormtrooper ever—they all used blasters, the standard ranged weapon of both military personnel and civilians alike.

Much like lightsabers, blasters come in all shapes and sizes and offer all manner of augmentations. Stormtroopers carry E-11 blaster rifles, Han Solo uses an illegally modified DL-44 heavy blaster pistol, and other options include ascension guns with grappling hooks, scoped carbine rifles, and models with targeting modules capable of integrating with the user's helmet. The most typical option featured on blasters was the ability to set them to stun, a reduced power setting designed to incapacitate rather than kill.[377]

Inspired by the British Sterling sub-machine gun, the original blaster props used by stormtroopers were created from a variety of found parts, including the post-WWII-era Sterling Arms

Mk4/L2A3 sub-machine gun.[378] When it came time to create the blaster's signature sound effect, not just any series of synthesized bleeps and bloops would do; these weapons called for a little more than making "pew, pew, pew" sounds with one's mouth. Sound designer Ben Burtt created the iconic sound effect while on a 1976 camping trip in the Pocono Mountains in Pennsylvania. While on the trip, Burtt took a tape recorder, a microphone, and climbed a nearby radio tower. By hitting the guy-wires (read: tension cables to add stability to the structure) with a hammer, he was able to produce the indelible sound effect.[379]

Though the term "blaster" is often used interchangeably with "laser," it is actually a misnomer. Lasers move at the speed of light, which would be far too fast for the human eye—or most alien eyes—to see. Rather, blaster fire is a burst of energized particles that deals a concussive blast of concentrated energy. They can be defeated by magnetic seals and deflector shields, and according to a study by *WIRED* dissecting the physics of blasters, the average blaster bolt travels at 34.9 m/s (78 mph). That means that when a Jedi deflects a blaster bolt with a lightsaber, it is akin to a baseball player hitting a professionally pitched ball.[380] Now obviously, these numbers aren't perfect, but it's helpful to put these things in context. In other words, while Aroldis Chapman may have thrown a 105 mph fastball against the San Diego Padres, a blaster might be deadlier simply because it can keep firing bolt after bolt. (Whew, at long last we can stop debating which is deadlier, blasters or baseballs.)

As for the stylized coloration of the blaster bolts, you can thank Japanese director Akira Kurosawa. The films of Akira Kurosawa had a tremendous influence on George Lucas when he was creating *Star Wars*; just watch *The Hidden Fortress* then re-watch *Star Wars Episode IV: A New Hope* if you need further proof. Author Michael Kaminski also theorized that Kurosawa's *Ran*, itself an adaptation of William Shakespeare's *King Lear*, had

a tremendous effect on the visual aesthetic of the blasters. Those who have seen *Ran* will recall the brightly colored, color-coded armies that would attack from a particular angle in order to create a cohesive onscreen sense of direction to depict battling armies. It was a tactic employed by *Star Wars* too; in the original trilogy, the Empire used green blaster fire and would attack from the right, whereas the Rebels used red blaster fire and would typically attack from the left.[381] It may seem like a minor detail, but those are precisely the things that make the space opera of *Star Wars* stand the test of time. Well, that and the fact that firing energy blasts in outer space and on strange, alien worlds is straight up awesome.

 Lightsabers

Let's do a little thought experiment, shall we? Try and think of a weapon more recognizable than the lightsaber. Did you come up with anything? The Noisy Cricket from *Men in Black*? Ash's chainsaw arm from *Evil Dead*? Dirty Harry's .44 Magnum? Indiana Jones' whip? Sure, they're all iconic in their own way, but they all pale in comparison to the lightsaber. Honestly, the only other acceptable answer would have been "The Death Star," so I'm pretty disappointed that you didn't say it sooner. (Unless you did, in which case I *knew* I liked you.)

While blasters and proton torpedoes exist in the world of *Star Wars*, George Lucas envisioned a more elegant weapon for a more civilized age that would come to characterize his space fantasy. "The whole premise of *Star Wars* was that it was a romantic fantasy," Lucas said in a 2004 featurette titled *Birth of*

the Lightsaber. "So in developing a group of peacekeepers who were above everything and honorable and could make decisions and bring peace to the galaxy, I needed a weapon that was appropriate for those kinds of Jedi." In the earliest drafts of *Star Wars*, Lucas referred to them as "lazerswords," which goes to show that sometimes "a more elegant weapon for a more civilized age" takes some time to get just right.

Lightsabers are the signature weapon of the Jedi, the champions of the light side, and their evil counterparts, the Sith, who embrace the dark side. Traditionally, a Jedi's lightsaber is colored blue or green, while Sith almost uniformly use red-bladed lightsabers. Other colors are rare, but not impossible as we saw with Mace Windu's bright purple lightsaber. Most lightsabers have a simple metal hilt capable of projecting a blade of concentrated plasma from one end. Though this model is most common, other variations exist, like Darth Maul's deadly double-bladed lightsaber and the crossguard saber that sent the Internet into a tizzy after the first teaser trailer for *The Force Awakens* hit the Internet.

Assembling the necessary parts to build a lightsaber is an important part of Jedi training. In a ritual known as the Gathering, Jedi younglings travel to the frosty ice world Ilum in order to search for kyber crystals to build their first lightsabers. After navigating a labyrinthine cave network and finding the appropriate crystal, the younglings meet with an ancient droid named Huyang, who assists them with choosing the parts necessary to build the weapon they'll use to take the next step in their development as Jedi knights.[382]

Although we most associate the beam weapons with the galaxy far, far away, one can trace their origins back to a 1933 science fiction story written by author Edmond Hamilton. The story, titled "Kaldar, Planet of Antares," first ran in the pulp magazine *Weird Tales*, and described a now-familiar-sounding weapon wielded by its hero, a sword comprised entirely of light:

"The sword seemed at first glance a simple long rapier of metal. But he found that when his grip tightened on the hilt it pressed a catch which released a terrific force stored in the hilt into the blade, making it shine with light. When anything was touched by this shining blade, he found, the force of the blade annihilated it instantly.

He learned that the weapon was called a lightsword."[383]

Sounds familiar, right? While *Star* Wars is a vibrant fictional universe, it is not without its fair share of influences, literary and otherwise. Other references to energy and/or beam-powered swords appeared in Fritz Leiber's *Gather Darkness* (1943), Isaac Asimov's *Lucky Starr* series (1952), Larry Niven's *Ringworld* (1970), and M. John Harrison's *The Pastel City* (1971).[384] Speaking of influences, the combat originally took its cues from the Japanese art of kendo, fitting due to the samurai influence on the design of Jedi and the Sith.[385]

Though the props would grow more sophisticated in later years, Luke's lightsaber in the original trilogy was made using a Graflex camera side-attaching flash, and Vader's was constructed from a Micro Precision Products flash attachment. Both sabers' handles were made from rubber windshield wipers, and they had D-ring attachments on the bottom so that they could be attached to belts. The most complex of them all belonged to Obi-Wan Kenobi, whose hilt was a Frankenstein's monster comprised of parts from a Browning ANM2 machine gun booster, WWI No. 3 Mk. 1 British Rifle Grenade, a Rolls-Royce Derwent Mk.8/Mk.9 Jet Engine Balance Pipe, and an Armitage Shanks Starlite model Handwheel.[386]

The original lightsaber effects were nothing like what wound up on the big screen. Using reflective, three-sided rods with motors embedded in the hilts, the "blades" were intended to rapidly spin in order to constantly reflect the stage lights, creating the sensation of a sword made of light. Naturally, it didn't

quite pan out, so animation was added in post-production, along with distinct coloration. Evidently, the lightsabers were originally intended to be white.

After those early missteps, Lucasfilm turned to Korean animation guru Nelson Shin for advice on what to do next. Suggesting that the swords should look "a little shaky" and akin to fluorescent tubes, Shin helped pioneer the look and feel of the lightsabers by using a rotoscope to animate over the live-action footage, as well as adding a degausser sound to replicate a magnetic field and using an optical printer for filming to make the light appear to vibrate.[387] Though it was a time-consuming process, it was ultimately what VFX chief John Dykstra relied on to composite the final image and create the awe-inspiring look of the final films.

Like the majority of living, breathing humans on planet Earth, I have spent an unreasonable amount making lightsaber

Saber the Moment

Though Luke Skywalker lives in the galaxy far, far away, actor Mark Hamill has been decidedly earthbound. However, back in 2007, a space shuttle carried his lightsaber in outer space for two weeks. The elegant weapon for a more civilized age was presented by Chewbacca himself to NASA officials outside Oakland International Airport in California. Escorted by an honor guard of stormtroopers and bounty hunters, the NASA officials brought Hamill's lightsaber from *Return of the Jedi* to Space Center Houston, where it was loaded for transport to the International Space Station as a passenger on NASA's STS-120 mission. Unfortunately, the astronauts aboard the ISS were unable to engage in zero-gravity lightsaber duels; the prop remained safely packed away in storage for the duration of the mission. But the fact remains that for a brief, shining moment in history, *Star Wars* was as close to another galaxy as it had ever been.

Hill, Kyle. "Luke Skywalker's Actual Lightsaber Has Been to Space | Nerdist." Nerdist. Legendary Digital Network, 04 May 2015. Web. 19 May 2015.

sounds with my mouth while swinging a stand-in saber. I'm not entirely sure about the proper onomatopoeia, but it sounds something like "Zhoooom, zhoooom." The one man who *does* know is sound designer Ben Burtt. After looking at a painting by Ralph McQuarrie, Burtt knew what he had to do. "I could kind of hear the sound in my head of the lightsabers even though it was just a painting of a lightsaber," he said in an interview.[388]

Using the hum of idling interlock motors from older model simplex film projectors, Burtt was able to generate the baseline sound. "It would slowly change in pitch, and it would beat against another motor," Burtt recalled. "There were two motors, and they would harmonize with each other."[389] It wasn't enough for Burtt though. "It was just a humming sound," he said. "What was missing was a buzzy sort of sparkling sound, the scintillating which I was looking for."[390] As it happens, Burtt found what he was looking for by accident. While he was carrying a shieldless microphone across a room, it picked up interference from a television set, which produced the sound Burtt had been missing. Later, he recorded the standard lightsaber sound through a moving microphone, creating a Doppler shift that replicated the sense of a lightsaber swinging through the air.

Though lightsabers may seem like the ultimate weapon in the *Star Wars* universe, they are by no means infallible; there are certain materials through which not even they can slice. The most popular of which is Cortosis, a rare, brittle material with energy-resistant properties that make it ideal for defending against lightsaber strikes and blaster fire. Another substance, known as Beskar or Mandalorian iron, is used to create supremely strong suits of armor used by Mandalorian mercenaries. Unfortunately for Boba Fett, not even Mandalorian armor could save him from a Sarlacc pit, but those are the risks you take when you fly around on a jetpack all willy-nilly.

As for what seems to be the most popular use for a lightsaber in *Star Wars*—cutting off someone's hand—that's actually a legitimate technique. In lightsaber combat, it is known as "Cho mai," or the act of cutting off someone's weapon hand. If you move farther up and slice off the opponent's entire weapon-wielding limb, it is known as "Cho Sun," and if you manage to remove several limbs in a single attack, congratulations, you've just performed "Mou Kei."[391] Considering just how frequently people have their extremities chopped off in the world of Star Wars, it's probably for the best that we have all this terminology. Now if only we had a term that expressed, "Hey scientists, hurry up and make this technology possible already!"

71 The *Millennium Falcon*

She's the fastest hunk of junk in the galaxy and is maybe the only spacecraft that can give the Starship *Enterprise* a run for its money in terms of being the most recognizable spacecraft in the realm of pop culture. After all, what other ship could make the Kessel Run in less than 12 parsecs? Certainly not my 1997 Nissan Maxima—and believe me, I've tried. And, yes that's accounting for the fact that parsecs are units of distance, not time (an infamous technical goof in the *Star Wars* canon). Though Han Solo and Chewbacca's signature mode of transportation is known to *Star Wars* fans across the world as one of the most iconic symbols of the franchise, its origins are far humbler than one might imagine.

Though George Lucas drew inspiration from sources like *Flash Gordon* and Akira Kurosawa's *The Hidden Fortress* for crafting his epic space fantasy, he had to look no further than

his dinner plate to design the *Millennium Falcon*. Legend has it that Lucas was eating a hamburger with an olive on the side when he realized he wasn't holding a bovine by-product at all; rather he had the blueprints for a spaceship in his hand (the olive would become the cockpit). Another online conspiracy theorist posits that Lucas was inspired by Austrian architect Otto Wagner, whose never-built 1880 design for the central offices of the Vienna Giro und Kassenverein bears a striking similarity to the starship.[392] As odd as it sounds though, drawing inspiration from a half-eaten hamburger seems to be the likelier of the two stories.

Another major influence on the *Millennium Falcon* seems to have been World War II–era aircraft, particularly the American B-29 Superfortress, one of the most advanced bombers of the era. Much like the *Falcon*, it boasts a greenhouse-style window in the cockpit, and exterior is made of model pieces from the likes of "Panther tanks, Tiger tanks, Messerschmitt 109 fighters, Kubelwagons, and many more."[393] Even the ship's sound effects hearken back to classic aircraft of a bygone era. The *Falcon*'s sound effects are largely derived from a P-51 Mustang fighter plane, which sound designer Ben Burtt recorded in the Mojave Desert, then slowed down to achieve the desired effect.

"While at the races, I just said, 'I want to record some planes,' and they said 'Yeah? Then go on out there,'" Burtt explained in an interview. "You could never do that nowadays—I was out at the pylons, and planes were passing 15 feet above my head. They were so fast that I could hardly see them go by; they were just a blur, though I could smell the oil and exhaust. I was lying flat on the ground with my microphones, recording these airplanes for a couple of days in the desert. I got lots of great stuff. Almost all of the spaceships came out of those Mojave recordings, including the *Falcon*. Using piston-engined aircraft is one of the things that distinguishes *Star Wars* vehicles from most movie vehicles. Sound

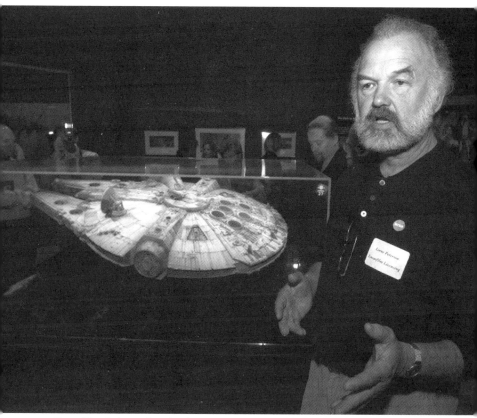

Lucasfilm Industrial Light & Magic master model maker Lorne Peterson talks about the making of the Millennium Falcon, *shown here in a display case.* (David J. Phillip)

editors always seem to go with just the rumble and the roar of a rocket or jet."[394]

As for the sound of the ship traveling into hyperspace, Burtt recorded two tracks of a McDonnell Douglas DC-9 aircraft's engine noise. To create a phasing sensation, Burtt recorded one track slightly out of sync with the other, then added the hum of cooling fans on the motion-control rig at ILM for special effect.[395]

The *Falcon*'s original design was actually much more elongated, but aesthetic similarities to *Space: 1999*'s Eagle

Transporters prompted Lucas and company to reimagine the ship. The original design wasn't entirely scrapped though; after some modification, it was repurposed as the *Tantive IV*, Princess Leia's ship from the beginning of *A New Hope*.[396] After all, if *Star Wars* subscribed to any maxim, it was one of waste not, want not.

A YT-1300 class freighter, the *Millennium Falcon*'s shabby exterior belies one of the most powerful—and heavily modified—ships in the galaxy. Its exterior looks dilapidated and battleworn, but the *Falcon*'s owners over the years have outfitted her with an advanced hyperdrive system, which makes it one of the fastest ships around. Though it primarily relies on its speed and advanced maneuverability, the *Falcon* is also armed with laser cannons and concussion missiles, which make it formidable in combat too.

Manufactured 60 years before the Battle of Yavin (a.k.a. BBY), the *Millennium Falcon* has gone by a number of names over the years, including *Gone to Pieces*, *Second Chance*, *Jackpot*, *Hardwired*, *Fickle Flyer*, *Correll's Pride*, *Meetyl's Misery*, *Wayward Son*, and the *Stellar Envoy*.[397] Clearly, all of these names were vastly inferior, but neither Han Solo nor previous owner Lando Calrissian (from whom Han won the ship in a game of sabaac on Cloud City) are responsible for the ship's nom de guerre. Rather, that honor belongs to Rebel agent Quip Fargil, who stole the ship from an Imperial impound and named it after a creature called the "bat-falcon."[398]

The interior of the *Falcon* has changed over time too. Well, at least the decorations in the cockpit have. As our heroes fly away from Mos Eisley, a pair of decidedly un-fuzzy metal dice can be seen dangling in the cockpit. They then disappear for the rest of the trilogy. Maybe Han and Chewie had to pawn them to buy spare parts for their old hunk of junk, maybe they'll reemerge in *The Force Awakens*—only time will tell.

On the set of *A New Hope*, the exterior set of the *Falcon*, which was seen in the Docking Bay 94 and Death Star scenes, consisted

only of the starboard half of the ship. Interior sets were built for the many of the ship's inner workings, and a five-foot-long effects model was used for shots of the ship in flight. A full-size replica was actually constructed in secret for *The Empire Strikes Back* in the Eastern hangar of the Royal Dockyard in Pembroke, Wales. "It weighed 23 [tons] and was 70 [feet] in diameter," special effects supervisor Brian Johnson said of the model. The model could even fly, although only a measly sixteenth of an inch off the ground. Still, it just goes to show that the galaxy far, far away might be closer to reality than we originally thought.[399] Just how close are we? Well, the government likely has one waiting at a CIA black site in the New Mexico desert, but for the rest of the world, the best we can do are customized radio-controlled quad-copter drones made to look like the famous starship, like the one built by YouTube's Oliver C in France. I would embed the video here, but that's not how books work, so you'll just have to trust me on this one.

The X-wing: the Honda Civic of the *Star Wars* Universe

It may not be as intimidating as a TIE Fighter or have as much character as the *Millennium Falcon*, but the X-wing is the work-horse of the *Star Wars* universe, the iconic starfighter in which millions of children (and adults) across the world pictured them-selves soaring through a hail of laser fire to fire a proton torpedo into the Death Star's thermal exhaust port. The primary inter-ceptor and dogfighting craft of the Rebel Alliance and the New Republic, the X-wing provides an incredible balance of speed and firepower. It is, for lack of a better term, the Honda Civic of

the *Star Wars* universe—reliable, great gas mileage (presumably), and packs enough of a punch to get the job done without breaking the bank. Considering the Rebel Alliance's relative lack of resources, that was a quality prized above most.

There have been many, many models over the years, but the most famous one is the T-65 X-wing starfighter, which is the ship Luke Skywalker famously flew during the Battle of Yavin. The all-purpose ship measures 12.5 meters long, and comes equipped with its S-foil wings. During battle, the S-foils spread apart to form the signature X shape, allowing for its multiple wing-mounted laser cannons to achieve a broader field of fire. Using the onboard targeting computer, pilots are also able to fire proton torpedoes from the side-mounted torpedo launchers on the fuselage. Shield generators protect the X-wing from enemy laser fire, and a hyperdrive allows for long-range, faster-than-light travel. In addition to the computer, there is a socket behind the cockpit that allows for an astromech droid to ride shotgun, calculating hyperspace jumps and performing basic repairs during the flight.[400] Basically, imagine if Siri could help you jump from one star system to the next, but had all the sass of R2-D2.

During their first meeting in November 1974, George Lucas sketched three crude images—a TIE fighter, the Death Star, and the X-wing—to give artist Ralph McQuarrie an idea of what he had in mind. "I wanted a dragster," said Lucas, "with a long narrow front and a guy sitting on the back. Then Colin [Cantwell] came up with the split-wing thing."[401] From those initial meetings, McQuarrie refined Lucas' scribblings into workable concept art, and thus, the X-wing was born. In fact, it is one of the few ships mentioned by name in the original trilogy—although that mention only occurs in *Empire Strikes Back*. (An added scene in the 2004 special edition of *A New Hope* mentions a T-65.)

Though they constructed a full-sized X-wing for the Yavin hangar sequence in *A New Hope*, most of the X-wings you

actually see on the screen were miniature-scale models. "The X-wing had a box inside of it, with gears made of rubber bands, pipes, and motors, and it was constantly evolving," visual effects artist Grant McCune reflected. The X-wing went through six or seven body changes over the course of the production, with the nose proving to be most troublesome. "From the front, you need that little lip on there," Cantwell explained. "We worked with that a long time, getting it into a shape that didn't look obscene."[402] As Sigmund Freud might say, sometimes an X-wing is just an X-wing.

As for when we'll see our favorite starfighter in the galaxy far, far away again, one must only wait until *The Force Awakens* hits theaters. Not only do we know that Oscar Isaac's Poe Dameron is one of the best X-wing pilots in the galaxy, but J.J. Abrams revealed the newly designed X-wing models in a video he released in support of the Star Wars: A Force For Change campaign, a charitable project benefiting UNICEF that gave fans who donated a chance to win a walk-on role in *Episode VII*. The single-passenger, twin-nacelle engine design hearkens back to some of McQuarrie's early designs for the fabled fighters. Early speculation led some eagle-eyed fans to posit that it was the Z-95 Headhunter, a starfighter that appeared in the Expanded Universe book *Han Solo at Star's End* from 1979, but Lucasfilm took to Twitter to confirm what we all knew in our heart of hearts, that it was in fact an X-wing after all.[403] Now if we can get one of these purported *Star Wars* standalone spin-off films to be the equivalent of *Top Gun* in space with a squadron of X-wing pilots, I can die a happy man. (And, yes, I would insist on the space equivalent of the volleyball scene, as well as a Kenny Loggins/John Williams mash-up score.)

73 The TIE Fighter: the Evil Honda Civic of the *Star Wars* Universe

Just as the Rebel Alliance has their trusty X-wing starfighters, the Empire relies on TIE fighters to form the brunt of their aerial armada. The menacing starships were among the first ships that Lucas envisioned, looking like an eyeball with batwings, and inspired by the World War II bombers and the paintings of John Berkey. The single-pilot ships were designed for high-speed, fast-paced dogfights with Rebel X-wings. Other models like the dagger-shaped TIE interceptor and the bulkier TIE bomber were introduced later for more specific purposes, but the TIE fighter is the bread and evil, evil butter of the Empire's fleet. When you hear that terrible roar of their engines, you know that laser-fueled doom can't be far behind. (Speaking of that terrible roar, sound designer Ben Burtt made it by combining the sound of an elephant trumpeting with a car driving over wet pavement.)[404]

Unlike their Rebel counterparts, TIE fighters are considerably more fragile, a testament to the Empire's strategy of throwing sheer numbers at a problem in order to overwhelm their opponents. Case in point, the TIE fighters lack hyperdrive, shield generators, and life support systems, meaning that they can neither take a beating the same way an X-wing can, nor can they achieve faster-than-light travel on their own. Cheap, efficient, and expendable, TIE fighters were the kamikazes of the *Star Wars* universe, a fitting analogy given that the TIE fighter/X-wing battles were meant to evoke the feeling of a World War II dogfight. In fact, actual air combat clips were used as placeholders while Industrial Light & Magic finished the film's special effects.[405]

The acronym TIE was created by George Lucas, but it didn't stand for anything, at least not initially. "I came up with 'twin ion engine fighter,'" said designer Joe Johnston. "There were other ideas, like 'Third Intergalactic Empire,'" but ultimately Johnston's idea won out given that they were, in fact, powered by twin ion engines.

"The TIE has different technology," visual effects artist Colin Cantwell explained. "It has no regular engines and it has just this ball in the middle and the two solar fins. But especially you can't tell how Darth Vader gets in; it's something alien."[406]

As the Empire tightened its grip on the galaxy, TIE fighter production increased, and they soon became a common sight in every sector with an Imperial presence. Though the baseline models remained cheap and dangerous, the Empire enlisted corporations like Sienar Fleet Systems to create prototypes for their best pilots to fly. With additional shielding, advanced weaponry, enhanced maneuverability, and tracking abilities, these prototypes continued to push the envelope. The crown jewel of this R&D session was the TIE Advanced, a craft eventually piloted by Darth Vader during the Battle of Yavin, and one that was first flown by the Imperial agent known as the Inquisitor, who used it against the rebel group lead by Hera Syndulla on Lothal. To be fair, the rebels had destroyed another prototype TIE Advanced fighter in front of a crowd of horrified Imperial officers and citizens *during* Empire Day. (Just trying to play devil's advocate for a fascist dictatorship, you guys.)[407]

Fans wondering whether or not we'll hear the familiar screech of TIE Fighter engines in *Star Wars: The Force Awakens*, take heart—we've seen glimpses at slightly updated models in the first batch of trailers for the December 2015 release. While they may not be exactly how you remember, keep in mind that 30 years have elapsed; technology is bound to have improved in the interim. In the meantime, I'll happily ply my craft as a digital

pilot by flying one in *Star Wars: Battlefront II*, one of the greatest *Star Wars* games of all time. (At least until the new *Battlefront* drops on November 17, 2015.) Seriously, I have an extra controller. Come on over and we'll play. Or you could make like French YouTube sensation/drone customizer extraordinaire Olivier C, who has transformed his quadcopter into a TIE interceptor to terrorize the French countryside. You just know that, somewhere, Darth Vader is smiling down on him.

74 Asajj Ventress: the Dark Side's Deadly Assassin

If you thought Darth Maul was the only badass, death-dealing Dathomirian on the block, then think again. Asajj Ventress is an adept assassin learned in the ways of the dark side thanks to Count Dooku. Yet, unlike Darth Maul, Ventress could not be considered a true Sith as a result of the Rule of Two, the Sith code which states that there can only be two active Sith—an apprentice and a master—at any given time. In spite of this, Ventress wrought havoc wherever she went, using her trusty twin red-bladed lightsabers to do righteous battle with the likes of Obi-Wan Kenobi and Anakin Skywalker throughout the Clone Wars. Not too shabby for someone who effectively encountered the evil equivalent of a glass ceiling,

Born on the planet Dathomir, a remote red-hued world along the Outer Rim that is home to a powerful society of witches known as the Nightsisters, Asajj Ventress was destined to lead a difficult life. When her clan was forced to give her up, she was taken by the pirate Hal'Stad. When he died, she was discovered by the Jedi Knight Ky Narec, who trained her as a

Jedi after recognizing her intrinsic Force sensitivity. However, death seemed to follow Ventress wherever she went; Ky Narec was gunned down by a Weequay raider. The loss of her mentor devastated the young Ventress, whose feelings of loneliness, fear, and rage festered and fulminated until she was ready to give in to the dark side. With hatred in her heart, Ventress became Count Dooku's apprentice, a position she could not technically hold in keeping with the Rule of Two.[408]

While training under Count Dooku as his apprentice, Asajj Ventress helped execute his sinister schemes with a deadly precision. On the desert planet of Tatooine, she kidnapped Rotta the Hutt, the slimy, slithering offspring of the corpulent crimelord Jabba the Hutt. Her mission wasn't just to kidnap the child, but to frame the Republic for the heinous deed in order to convince the Hutts to join the Clone Wars on the side of the Separatists. Ahsoka Tano proved to be a thorn in her side once again during a mission to liberate Nute Gunray from a Republic cruiser and transport him to Coruscant. Just when Ventress was on the verge of victory, battling the Jedi Master Luminara Unduli, Ahsoka Tano appeared and turned the tide against her. Later, on Kamino, Ventress' attempt to steal the clones' DNA was also foiled—this time by Anakin Skywalker, rather than Ahsoka Tano. Whatever goodwill she had once harbored toward the Jedi Order was now gone, replaced by disdain and annoyance for light side nemeses like Anakin Skywalker, Ahsoka Tano, and Obi-Wan Kenobi, who she battled time and time again.

Unfortunately for Asajj Ventress, the Sith had no intention of inducting her into their evil order. When Darth Sidious decided that her usefulness to the dark side had ended, he ordered Count Dooku to dispose of her, which he did by ordering his troops to murder her. Seeking refuge on Dathomir, Ventress learned from a woman known as Mother Talzin that she was, in fact, one of the Nightsisters. As Ventress underwent a Rebirth Ritual

to swear her allegiance to the ancient order of witches, Dooku dispatched the deadly droid General Grievous to exterminate the Nightsisters. Though she preferred to stay and fight, Mother Talzin urged Ventress to flee the planet and fight another day, which she reluctantly did, vowing revenge on Count Dooku for the suffering of her fallen sisters.[409]

On the run and thoroughly friendless, Asajj Ventress staked out a new life for herself as a bounty hunter. One of her missions saw her hunting down the Jedi Ahsoka Tano, who had been framed for murder and was on the lam. Though Ventress was the first to ferret out her location, she ultimately let the young Jedi go free because she believed her story of innocence.[410] It just goes to show that even ruthless killing machines can have moments of empathy from time to time. Later, Ventress proved that she was willing to let bygones be bygones when it suited her. After tracking down her quarry, the Nightbrother known as Savage Opress, she discovered that Darth Maul and he had taken Obi-Wan Kenobi prisoner. Freeing Obi-Wan, the two joined forces to fight their way out, surviving by the skin of their teeth.[411] Though Obi-Wan would try to enlist her to fight for the Republic, she refused him, preferring to walk her own path since she had been burned by both sides of the Force previously. Where she'll turn up next is anyone's guess, but you can bet your life on it that she'll be armed to the teeth and won't give up without a fight.

The Imperial Walkers: AT-ATs, AT-STs, and Beyond

Starships like the X-wing, the TIE Fighter, and the *Millennium Falcon* were indelibly and inextricably attached to people's notions of iconic *Star Wars* vehicles after the events of *A New Hope*, but with *Empire Strikes Back*, fans were introduced to a whole new breed of visually striking vehicles: the Imperial Walkers. These massive, mechanical machines of war thundered on to the screen during the Battle of Hoth and have remained deeply ingrained in our collective imagination ever since. What began for George Lucas as an analogy the "kind of unwieldy armament and tactics the U.S. military forces used in the jungles of Vietnam, with the Empire using inappropriate equipment for its attack on the ice planet base," evolved into one of the most enduring semiotic signifiers of the Empire and its fascist agenda.[412]

These three primary models—the All Terrain Armored Transport (AT-AT), the All Terrain Scout Transport (AT-ST), and the All Terrain Tactical Enforcer (AT-TE)—not only proved pivotal in some of the most important battles of the *Star Wars* saga, but they made the Galactic Empire just as terrifying on land as they were in orbit.

AT-AT Walker

According to George Lucas on *The Empire Strikes Back* DVD commentary, the AT-AT were inspired by the alien tripods from H.G. Wells' *The War of the Worlds*. For years, many Oakland natives assumed that container cranes at the Port of Oakland inspired the design, but Lucas flatly denied it in a 2008 interview.[413] What actually inspired the war machine were vehicle designs by Joe Johnson, which the effects geniuses at Lucasfilm

used to bring the AT-AT to the big screen through intricate models and stop-motion animation.[414] First appearing in *The Empire Strikes Back* during the Battle of Hoth, the AT-AT is the bread and butter of the Empire's armored division. These massive quadrupedal combat vehicles stand an imposing 22.5 meters tall (approximately 73.8 feet), creating an immediate aura of fear for the unfortunate ground troops facing them in battle.

Although they are equipped with dual cockpit-mounted heavy laser cannons (on the "chin") and light blasters (on the "temple"), these elephantine mechs serve as armored personnel carriers, transporting up to 40 troops in addition to the pilot, gunner, and commander in the cockpit. With heavy armor plating, they are impervious to blaster fire, but weak to attack on the underbelly, where it is vulnerable to mounted cannons and portable missile launchers. Additionally, its high center of gravity makes it vulnerable to tripping, a tactic which the Rebel Alliance took advantage of during the defense of Echo Base. Using their snowspeeder's harpoon and tow cable, Wedge Antilles and his gunner Wes Janson managed to tie up the massive machine, sending it crashing to the ground.[415]

Fun fact: neither the term "All Terrain Armored Transport" nor "AT-AT" are actually spoken in any of the films. It's just one of those terms that diehard fans somehow managed to figure out.

AT-ST Walker

Better known as the "Chicken Walker" or the "Scout Walker," the AT-ST is a smaller, bipedal version of its larger cousin, the AT-AT. Standing approximately 8.6 meters tall (28 feet), the lightweight mech was ideal for reconnaissance, perimeter defense, and providing agile armored support. The two-man vehicle is armed with chin-mounted laser cannons with a range of two kilometers, a side-mounted concussion grenade launcher, and light blaster cannons on either side of the head for close-range

anti-infantry combat. Like the AT-AT, the AT-ST can repel light blaster fire, but it is vulnerable to missiles, laser cannons, and other heavy weapons.[416]

What they lack in durability, though, they make up for in maneuverability and sheer speed. Quite often, AT-STs would dart around the battlefield, engaging ground forces and cleaning up Rebel Alliance hideouts while the AT-ATs lumbered around the battlefield, dealing massive amounts of damage. Like a remora on the underside of the steel sharks that were AT-ATs, the Scout Walkers would play clean-up, preying on unsuspecting infantry and protecting the AT-AT's weak, exposed underbelly.

During the nearly 50 shots in which it was featured in *Return of the Jedi*, the AT-ST—also based on Joe Johnson's designs—was the result of miniatures, a forest mode, and filming on a combo of bluescreen and in camera. The models were painstakingly detailed, with four-foot versions created by ILM's Paul Huston for destructive purposes. The heads were made from a thin epoxy and an aluminum-filled epoxy, while others were made from urethane, brittle wax, and even .05-inch nickel to capture the shot in which the Ewoks use two logs to smash the AT-ST's head into tiny pieces.[417]

Just how detailed were these models? The cockpit interiors were excruciatingly hand-crafted and even featured character models within. "It actually had little men inside it," Muren says. "The little guys never showed up, though. We were hoping as the door flew open, one would flop out. They even had lead weights in their bodies so that they would flop correctly rather than bounce like little rubber men."[418] So you're telling me we got baby Warwick Davis dressed like a maniacal little teddy bear, but we never got to see miniature pilots fly out of an exploding cockpit? Man, the universe can be a cruel, unfair place sometimes.

AT-TE Walker

Before there were AT-ATs, before there were Scout Walkers, the AT-TE—a.k.a. the All Terrain Tactical Enforcer—was the primary battle tank of the Grand Army of the Republic. With a low center of gravity and six mechanical legs, the AT-TE lacked for speed and maneuverability, but made up for its comparative sluggishness with increased stability. The legs could actually be magnetized, and were capable of climbing sheer surfaces, making this mobile armored death spider a force with which to be reckoned.[419] Remember that dumb mechanical spider that Kenneth Branagh tried to use in *Wild, Wild West*? Yeah, this is like that, but actually effective.

The actual vehicle itself was constructed of two armored halves connected by what is described as a "flexible sleeve." Armed with six laser cannon turrets—four on the front, two on the rear—and a powerful mass driver cannon on top, the AT-TE proved a fearsome foe in combat during the Clone Wars. Like the AT-ST, the walker's armor could withstand blaster fire, but stronger weaponry, especially rockets and missiles, could penetrate the AT-TE's armor, effectively destroying the machine in the process. Considering they could carry 38 clone trooper passengers, in addition to a crew consisting of a pilot, a spotter, and five gunners, that relative lack of durability could prove problematic in the event of an errant artillery assault.[420] That might explain why it eventually evolved into the comparatively invincible AT-AT though.

76 Red Squadron/ Rogue Squadron

While they may not spend their spare time wearing aviator glasses, flashing their pearly whites, and playing shirtless beach volleyball, the brave pilots of Red Squadron and Rogue Squadron are as close as the *Star Wars* universe will come to having a *Top Gun* crew of its very own. From flying through a barrage of enemy fire to assault the Death Star during the Battle of Yavin to defending Echo Base from an Imperial assault force including massive AT-ATs, these fearless flyboys have been part of some of the most dangerous, high-risk missions ever undertaken by the Rebel Alliance. Under the leadership of men like Luke Skywalker and Wedge Antilles, the Red/Rogue Squadrons are essentially the equivalent of the Navy SEALs…except with proton torpedoes instead of big, bushy beards and assault rifles.

Red Squadron was assembled in advance of the Battle of Yavin, one of dozens of starfighter squadrons the Rebel Alliance intended to throw at the planet-sized problem called the Death Star. In Alan Dean Foster's novelization of *A New Hope*, it was originally called the Blue Squadron and the ships were detailed accordingly, but since special effects were done in front of a blue-screen, they had to retitle the fighting force. Thus Red Squadron was born, a 12-man X-wing starfighter squadron comprised of pilots from various fighting forces to form an elite group of ace pilots. The original 12 members were Garven Dreis, Wedge Antilles, Biggs Darklighter, John D. Brano, Luke Skywalker, Lt. Jek Tono Porkins, Elyhek Rue, Bren Quersey, Lt. Nozzo Naytaan, Theron Nett, Lt. Wenton Chan, and Puck Naeco.[421] The group fought valiantly during the Battle of Yavin, and even gained the distinction of being the squadron that disabled the

Death Star's defenses and ultimately destroyed the battle station. However, their victory came at a terrible cost—all but two pilots, Luke Skywalker and Wedge Antilles, died during the mission, shot down by Imperial TIE fighters. The men of Red Squadron were down, but they were not out—not by a long shot.

Though they were known for undertaking dangerous missions, they weren't reckless. When the Rebel Alliance evacuated their base on Yavin 4 in the wake of the destruction of the Death Star, Princess Leia Organa and the Alderaanean pilot Evaan Verlaine ignored direct orders and set out on a covert mission to find surviving Alderaaneans and offer them protection from the Empire. The only two surviving members of Red Squadron's initial assault, Luke Skywalker and Wedge Antilles attempted to stop them. However, not even these ace pilots could outsmart two badass women on a mission like Leia and Evaan; they punched the hyperdrive and left our pilot pals to twiddle their thumbs.[422]

In the wake of the Battle of Yavin, a new group formed, the Rogue Squadron, and the starfighters refilled their ranks in order to rise from the ashes like a glorious phoenix. During the Battle of Hoth, they were among the first to scramble their snowspeeders to defend Echo Base from invading Imperial forces. When the AT-AT's armor proved too strong for Rebel blaster cannons to penetrate, it was the men of Rogue Squadron who discovered a way to defeat them. Wedge Antilles and his gunner Janson were the first to take down the armored assault vehicles, using their snowspeeder's harpoon and tow cable to hogtie the giant war machines and trip them up, effectively disabling them. This battle also marked the last time that Luke Skywalker would officially fly with the Rogue Squadron in the official canon, although in *Star Wars* Legends stories, he plays a much more central role. Regardless, the Rogues were Wedge's to command, a role he filled with aplomb.[423]

The Rogues also proved crucial in the Battle of Endor, reforming under their original Red Squadron moniker for the final fight. While Han Solo and Princess Leia led a strike force on the forest moon's surface to disable a shield generator, the Red Squadron, alongside the *Millennium Falcon*—this time piloted by Lando Calrissian and Nien Nunb—launched an all-out assault on the second Death Star.[424] The Rogues' experience taking down a Death Star before proved crucial as they shot down multiple TIE fighters in frenzied dogfights and deftly navigated the tight, compact inner workings of the Death Star as they flew toward its core. Once again, they proved crucial in taking down the fully operational battlestation; Wedge Antilles managed to take out a power regulator, which gave Lando an opening to destroy the core, obliterating the second Death Star of the Galactic Civil War.[425] All in all, not bad for a group of ragtag flyboys staring death in the face.

Given the presence of X-wing pilots in the first trailers for *Star Wars: The Force Awakens*—and the fact that Poe Dameron (Oscar Isaac) is one of the best pilots in the galaxy—there's a chance we might see our the radical Rogues or righteous Reds take flight once more on the big screen. If not there, then perhaps in Gareth Edwards' forthcoming standalone film, *Star Wars Anthology: Rogue One*, which details the story of a band of resistance fighters who come together for a daring mission to steal the plans for the Death Star. Given that there are no Jedi in that particular film, it's more than likely that we might be able to see the roots of Rogue Squadron at long last when the film drops on December 16, 2016. In the meantime, you can always see what it's like to join the squadron yourself by playing classic video games like *Star Wars: Rogue Squadron,* and its sequels *Rogue Leader* and *Rebel Strike*. Or you can be like me and painstakingly digitally insert Jek Porkins into every single frame of *Top Gun.*

77 Star Tours: How Movie Magic Met the Magic Kingdom

Now that Disney has added Lucasfilm to its considerable holdings, the House of Mouse is offering plenty of incentives for fans of the galaxy far, far away to make the trek to their theme parks. With events like *Star Wars* Weekends and *Star Wars*-themed half-marathons, families can spend every last waking minute (and every last penny) enjoying overpriced funnel cakes surrounded by their favorite characters at the Happiest Place(s) on Earth. Yet while the prospect of running 13.1 miles in a sweaty Chewbacca costume and meeting original saga cast members like Frank Oz and Ian McDiarmid is tempting, the single greatest reason for a *Star Wars* fan to make the trip to Disney is a little ride called Star Tours.

Located at Disneyland, Disney World, and Tokyo Disney (with a Disneyland Paris version on the way), the 3D motion simulator puts guests in the passenger seat of a Starspeeder 1000 that blasts off from a spaceport and takes them to places like Tatooine, Naboo, and Hoth, where they will encounter famous characters like C-3PO, Princess Leia, and even Darth Vader. Using 3D projection technology and a hydraulic motion base cabin that is able to move along the X- Y-, and Z-axes, the ride simulates the feeling of flying through space, creating an immersive three-dimensional audiovisual experience in the process. In its current iteration, known as Star Tours—The Adventures Continue, there are 11 randomized segments (two openings, three primary destinations, three hologram messages, and three ending destinations) that, when combined, allow for 54 possible ride experiences, so you can take the tour again and again without the fear of repeating yourself. (Then again, when have *Star Wars*

fans ever been squeamish about watching something over and over and over again?)

Disney had been eyeing a movie-themed expansion for its theme parks as early as 1979, going so far as to examine properties like *Tron* and *The Black Hole* to see what their Imagineers could do with them. However, the massive cost ($50 million) and the massive unpopularity of *The Black Hole* led them to look for another pop culture property around which to build an attraction. As luck would have it, George Lucas actually wanted to make a theme park of his own, but he wasn't able to afford it at the time.[426] As a Disney geek growing up, particularly one with a fondness for Disneyland, Lucas embraced the idea of a *Star Wars*–themed ride when he was approached by then-Disney CEO Ron Miller, who talked with Lucas about the idea of a *Star Wars* rollercoaster, and then with Michael Eisner, who had a slightly different idea in mind.[427]

Recently appointed Disney CEO Michael Eisner was in the process of overhauling the theme parks, seeking to lure in prospective guests with star-studded attractions. One of the first decisions Eisner made was to bring Michael Jackson, the world's biggest pop star, into the fold for an interactive video experience. A longtime Disney fan himself, Jackson agreed to work on a project, so long as it was made by a filmmaker like Steven Spielberg or George Lucas. When agreeing to meet with Eisner, Lucas was hesitant about the whole enterprise; however, Eisner's enthusiasm proved infectious, and Lucas agreed to produce the 3D musical *Captain Eo*, which would be directed by his mentor and friend Francis Ford Coppola. During that same meeting, Lucas agreed to bring *Star Wars* to the Disney theme parks. Thus, the seeds of Star Tours were planted.[428]

After considering everything from an underwater cruise in the swamps of Dagobah to a sprawling time travel story to a Jedi training idea (that would later blossom into the Jedi Training

Academy) and beyond, the Imagineers decided to tell a story set shortly after the events of *Return of the Jedi*.[429] In the wake of defeating the Empire, our heroic droid duo, C-3PO and R2-D2 found themselves in the possession of new masters, the Star Tours company. Inspired by the ubiquitous Hollywood bus tours, Star Tours would take prospective travelers on an intergalactic cruise from the remote ice world of Hoth to the desert climes of Tatooine, and all the way to the verdant forest moon of Endor. "The galaxy is safe for travel," the poster boasted. Of course, little did riders know that danger was lurking around the corner. (Fictional danger; the ride was quite safe, I should say. Please don't sue me, Disney.)

At Lucas' suggestion, they decided on having a droid pilot the Starspeeder and keep the story moving—quite literally—much like the Jungle Cruise skippers in Adventureland. The result was a nervous, rookie pilot, the droid RX-24 (a.k.a. "Rex"), who would be voiced by none other than Pee-Wee Herman himself, Paul Reubens. Joining Reubens/Rex was another famous protocol droid. Anthony Daniels, who reprised his role as C-3PO, would greet visitors waiting in line with a life-size Audio-Animatronic replica of the character. It's fitting that Threepio was involved because had he been on the Starspeeder that Rex was piloting, he definitely would have bellowed out, "We're doomed!" As Rex takes the passengers on a frenetic flight across the galaxy, they wind up the last place any passenger vessel belongs: in the middle of an epic dogfight between X-wing starfighters and Imperial TIE fighters at the Death Star. The chance to include the iconic trench run sequence was too tempting for the Imagineers to ignore—and it's a good thing they did because it's one of the most memorable moments from the original ride.[430] Clearly Rex was speaking for all of us when he said, "I've always wanted to do this!"

Shot on 70mm film at 30 frames per second, the actual film and special effects of the original Star Tours cost $6 million to

produce. Though the ride-film would only last 4.5 minutes, it had to appear as though it was one continuous uninterrupted take. To complicate matters further, the film had to be one long POV (point of view) shot as the audience would be facing forward the entire time, necessitating that the action constantly be coming toward them. It was as challenging of a feat as anything ILM had undertaken. Using practical models, miniatures, and electronically controlled cameras, the team approached it much like they did the original trilogy, even constructing a custom model of the Death Star for the iconic final moments.[431]

While Industrial Light & Magic took care of the filming and effects work, Walt Disney Imagineering constructed massive, full-size props and animatronics to enhance the attraction. As with any large-scale project, difficulties arose; synchronization issues between the motion base and the audiovisual experience proved problematic, and a last-minute change to the music (a $100,000 alteration in and of itself) pushed back the opening and raised the price tag to a staggering $32 million, which was well over budget and roughly double the cost of building Disneyland itself in 1955.[432] All fears were assuaged when, in June 1986, the ride previewed to an audience of 2,000 Disney employees and their families. The response was rapturous. Of course, ILM wasn't on their own; with the Imagineers know-how and mechanical manipulation, they were able to combine moving picture and the motion cabin to simulate the sensation of G-forces, pitches, yaws, and rolls that come with evading blaster fire at top speed.[433] The thrill of the *Star Wars* universe had, at long last, collided with the world of Disney.

"Blast into a whole new dimension," the one-sheet for the new attraction boasted in capital letters. Promising guests the ride of their life, Star Tours took flight on January 9, 1987, at Disneyland in Anaheim, California, and it instantly became a hit. The ride proved so popular that another version was built

at Disney-MGM Studios (now Disney's Hollywood Studios) in Florida and Tokyo Disneyland in 1989, and eventually in Disneyland Paris in 1992. In 2011, the original ride was replace by an updated 3D version that connected the original saga with the prequel trilogy, adding in new scenes and ride elements to create a wholly new experience. In fact, The Adventures Continue version is technically a prequel to the original Star Tours. As alluded to above, the attraction itself has a whole convoluted, canonical backstory of its own, involving using the poorly run Star Tours travel agency as a front for smuggling a Rebel spy through Empire-controlled space, dysfunctional droids, and gross corporate mismanagement. Quite a lot to pack into four-and-a-half minutes of animatronic action, but then again *Star Wars* is nothing if not dense. Considering we're about to get a 14-acre *Star Wars* land and a new *The Force Awakens*–inspired scenario, Star Tours is only going to get bigger.

78. Marcia Lucas: the True Hero of the Galaxy Far, Far Away

Behind every great man is an even greater woman. That maxim may not always hold true, but it certainly did in the case of George Lucas when he was making the original *Star Wars* trilogy. For George, the great woman was none other than his first wife, Marcia Lucas. A skilled film editor who worked on projects like *Alice Doesn't Live Here Anymore*, *Taxi Driver*, and *The Candidate*, Marcia first encountered George while they were at film school together at the University of Southern California. They married in 1969 and she became one of George's closet confidantes and constant creative collaborators. Alongside George, she worked on

American Graffiti, earning an Academy Award nomination for her editing work, and went on to edit *A New Hope, The Empire Strikes Back*, and *Return of the Jedi*. For a time, it seemed that they were unstoppable, but all of that changed in 1983.

Shortly after *Return of the Jedi*'s release in 1983, they got divorced. George stopped talking about her almost entirely and Marcia was largely scrubbed from the official history of *Star Wars*, but her impact was undeniable. When principal photography came to an end on *A New Hope* in 1976 and George's editor couldn't put together anything remotely acceptable, it was Marcia Lucas who found the phoenix within the ashes. Not only did she win an Academy Award (with Richard Chew and Paul Hirsch) for her editing work on *Star Wars*, but she helped her husband behind the scenes to create some of the most iconic moments in the entire franchise. She was the yin to his yang, the black to his white, and often found herself in heated creative arguments with her husband. Whereas he was concerned with the technological and intellectual aspects of the film, Marcia was attuned to matters of story and character development, without which this space fantasy would fall flatter than Salacious Crumb underneath Jabba the Hutt's considerable girth.

What sort of moments, you ask? Let's talk about the Death Star trench run, which is arguably the most famous, tense, and exhilarating moment in the original film. Luke Skywalker's squadron has been decimated and he is the only pilot with a hope of destroying the Death Star. However, Darth Vader and his detachment of TIE Fighters are hot on his tail. With Luke in his sights, Vader is about to obliterate the young Jedi with a well timed projectile when suddenly, as if from thin air, Han Solo appears in the *Millennium Falcon*, laying down a blanket of suppressive fire. With his tail well and truly covered, Luke uses the Force to launch a proton torpedo into the Death Star's exposed thermal exhaust port, detonating the battle station and saving the

day. It is one of the single most memorable sequences in cinema history and none of that would have happened without Marcia Lucas.

"The Death Star trench run was originally scripted entirely different, with Luke having two runs at the exhaust port," Michael Kaminski, author of *The Secret History of Star Wars*, revealed on his website. "Marcia had re-ordered the shots almost from the ground up, trying to build tension lacking in the original scripted sequence, which was why this one was the most complicated. ([YouTube's] Deleted Magic has a faithful reproduction of the original assembly, which is surprisingly unsatisfying.) She warned George, 'If the audience doesn't cheer when Han Solo comes in at the last second in the *Millennium Falcon* to help Luke when he's being chased by Darth Vader, the picture doesn't work.'"[434]

That wasn't the only major plot point from *A New Hope* for which Marcia was responsible; she proved pivotal in shaping Obi-Wan Kenobi's character arc. "I was rewriting, I was struggling with that plot problem when my wife suggested that I kill off Ben, which she thought was a pretty outrageous idea," said Lucas in a *Rolling Stone* interview. "I said, 'Well, that is an interesting idea, and I had been thinking about it.' Her first idea was to have Threepio get shot, and I said impossible because I wanted to start and end the film with the robots, I wanted the film to really be about the robots and have the theme be the framework for the rest of the movie. But then the more I thought about Ben getting killed the more I liked the idea."[435]

Yet it wasn't just major character arcs and story beats where Marcia had creative input; her influence can be felt on smaller, more intimate character moments too. "I know for a fact that Marcia Lucas was responsible for convincing him to keep that little 'kiss for luck' before Carrie [Fisher] and I swing across the chasm in the first film," Mark Hamill revealed in a 2005 interview. "She really was the warmth and the heart of those films,

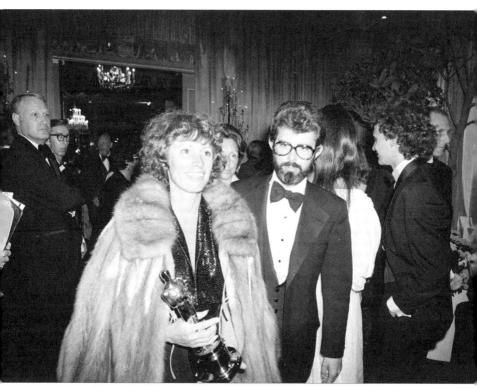

Marcia Lucas holds her best editing Oscar for Star Wars *as she and George arrive at a post–Academy Awards party at the Beverly Hilton Hotel on April 4, 1978.*

a good person [George] could talk to, bounce ideas off of, who would tell him when he was wrong," he continued.[436]

That was just the tip of the iceberg, according to Hamill. The actor reflected on another moment where Marcia implored her husband to keep something that he found abjectly silly: "When the little mouse robot comes up when Harrison and I are delivering Chewbacca to the prison and he roars at it and it screams, sort of, and runs away George wanted to cut that and Marcia insisted that he keep it."[437] It was that human touch, that certain sense of vibrancy that she lent to the *Star* Wars saga. After the divorce,

Dan Casey

her absence was noticeable both on set and in terms of Lucas' creative output. "You can see a huge difference in the films that he does now and the films that he did when he was married," Hamill reflected.[438]

Yet at the end of the day, Marcia and George Lucas wanted different things. While George was focused on continuing to build up his ever-expanding entertainment empire, Marcia wanted to raise a family. In 1981, the couple adopted their daughter, Amanda, after George decided he was going to bring the saga to an end. That, of course, wasn't really the end of *Star Wars* though, and it became a choice between his work and starting a life together. George chose the galaxy far, far away.

Though Marcia has been largely excised from the annals of *Star Wars* history, it is not as if she is living in ignominy and poverty; when they divorced, she owned half of Lucasfilm and reportedly got as much as $50 million in the settlement, as well as shared custody of their daughter. She took her share of the profits in cash and retired to private life to raise her family in peace.[439]

I Did Nazi That Coming

Marcia Lucas wasn't just a creative muse for the galaxy far, far away; she also made an important impact on 1981's *Raiders of the Lost Ark*, fixing the ending after it fell flat during a test screening.

"[Marcia] was instrumental in changing the ending of Raiders, in which Indiana delivers the ark to Washington," writer Dale Pollock revealed in *Skywalking: The Life and Films of George Lucas*. "Marion is nowhere to be seen, presumably stranded on an island with a submarine and a lot of melted Nazis. Marcia watched the rough cut in silence and then leveled the boom. She said there was no emotional resolution to the ending, because the girl disappears. ... Spielberg reshot the scene in downtown San Francisco, having Marion wait for Indiana on the steps on the government building. Marcia, once again, had come to the rescue."

Alas and alack, if only she had been there for *The Kingdom of the Crystal Skull*.

Even though she no longer wants anything to do with Hollywood or the empire she helped build, it is imperative that her name remains part of the conversation. As former Lucasfilm vice president of marketing and merchandising Charles Lippincott wrote in a post on his Facebook page titled "Marcia Lucas": "One way to gauge the veracity of any *Star Wars* history is whether or not Marcia is mentioned."[440] Strong words for a strong woman and rightly so because without Marcia, the entire *Star Wars* experience would be a pale imitation of what so many of us fell in love with in the first place.

79 Plan the Ultimate *Star Wars* Vacation

For some of us, simply watching the movies, thumbing through the comics, and reading the tie-in novels doesn't bring us close enough to the world of *Star Wars*. Instead of living vicariously through Lucasfilm's vibrant creations, some people need to have the tactile sensation of actually visiting and exploring where George Lucas' incredible world came to life. Fortunately, if you're a *Star Wars* fan with wanderlust, there are plenty of ways to plan a trek to the galaxy far, far away—and you don't need a hyperdrive engine to get there.

Tatooine: Want to visit Luke Skywalker's home planet where twin suns beat down on your back and moisture farming is a way of life? Well, simply book a flight to the real-world equivalent of the Outer Rim, the North African country of Tunisia. Though the official language of Tunisia is Arabic, many are bilingual with French as their second language. English is used sparingly, but it will help you navigate more touristy areas if you don't have

a handy protocol droid with you to translate. Given the recent political unrest in Tunisia, it may be wise to check with your country's foreign office before booking your trip.[441] After all, this beautiful country did once play home to a wretched hive of scum and villainy.

On the island of Djerba, two iconic movie locations can be found, Obi-Wan Kenobi's hermitage and Toshi Station. In the southwest of the country lies the desert oasis of Tozeur, which boasts several *Star Wars* sites around the city: the Mos Espa set (complete with the pod-racing arena and Watto's shop), the Lars homestead exterior, the *Star Wars* canyon where Luke was attacked by Tusken Raiders, and Darth Maul's landing site. The city of Tataouine actually inspired the name of the planet Tatooine, and served as the background for scenes during *A New Hope* and *The Phantom Menace*. The town of Medenine is home to Anakin Skywalker's home, and in Matmata, you can actually sleep in Luke Skywalker's childhood home at the Hotel Sidi Driss, which boasts a *Star Wars*–themed menu, to boot.[442] Believe me, after trekking through the desert, you're going to want a nice glass of blue milk.

Endor: Maybe you prefer your vacations to transport you to a mystical, wooded realm inhabited by a race of primitive, but adorable teddy bear-esque creatures? Look no further than the forest moon of Endor, which you may know better as northern California! Although there are no Imperial installations guarding top-secret Death Star–shield generators, there is plenty of resplendent, natural beauty, as well as some iconic locations from the original *Star Wars* trilogy.

Back in 1982, the Redwoods National Park in Crescent City, California, welcomed the cast and crew of *Return of the Jedi*, who filmed much of the major action set pieces at locations called Heart-Shaped Tree, Spaghetti Slump, and Norman's Log (which was named for production designer Norman Reynolds).

However, that land is now the private property of a lumber company, and heavy logging means that many iconic locations simply no longer exist; they have been wiped away from history, and are preserved only in the time capsule of *Star Wars* fandom.

Further south lies the Grizzly Creek Redwoods State Park and the Humboldt State Park, where the speeder bike chase sequence was filmed. Also located within Grizzle Creek is Cheatham Grove, a beautiful trail

Naboo: The idyllic planet of Naboo is renowned for its lush green terrain, verdant hills, and cerulean sea. However, you need not fear running into Jar Jar Binks if you want to visit Naboo's real life equivalent. Portrayed during the prequel trilogy, Naboo was actually a composite of two countries, Italy and Spain. So, if you're a massive fan of the prequel trilogy, then you're going to be eating awfully well in some of the most beautiful countries in the world. Maybe those films get a bum rap after all.

After flying into Rome, Italy, one can take the train to Caserta Central Station, which stops directly in front of Caserta Royal Palace, a lavish estate that was used to represent the interior of the Theed Royal Palace. The 11 acre estate was constructed in 1752, and boasts a throne room, royal staircase, massive library, and a garden modeled after the park of Versailles. Oh, and there's a waterfall. Did I mention the waterfall? Because it totally has a waterfall. Walking down the Royal Staircase, you might have a flashback to when Nute Gunray and Rune Haako captured Queen Amidala. Likewise, in the throne room, you can pretend that you're Padme as you gaze out the window at the Trade Federation troops amassing just outside.[443]

Those who make the trek north to Lake Como will be treated to a number of iconic shooting locations, including ones that are home to a number of deleted scenes. Pay a visit to the Tremezzo Public Garden by the edge of Lake Como, which was home to a scene where Anakin and Padmé depart via gondola to the

Lake Retreat. Overlooking Lake Como is the gorgeous Villa del Balbianello, built in 1787 for the Cardinal Angelo Maria Durini, better known as the Lake Retreat. Just how fancy is it? Well, you have to arrive by boat in order to access it, so that's a start. Eagle-eyed James Bond fans may also recognize it from *Casino Royale*, but the Villa is the site of the first kiss between Anakin and Padmé, as well as where they get married. Other parts of the Villa were used for a number of deleted scenes featuring Padmé's family, but mostly it's just a beautiful place to spend an afternoon walking around and taking it all in.[444]

Hoth: Was your first thought after seeing Luke Skywalker use a snowspeeder's tow cable to take down an AT-AT during the Battle of Hoth, "Holy cow, I want to visit that frozen hellscape?" Well, you're in luck because the small Norwegian village of Finse is a very real place. Though Finse may not have much to offer in the way of nightlife, in March 1979 it was home to the exterior shots of the ice planet Hoth in *The Empire Strikes Back*. During production, the cast stayed at the Finse 1222 Hotel, which features a Rebel trooper hat on display, as well as a wall full of behind-the-scenes pictures from the production. Thanks to inclement weather, the hotel served as a shooting location for multiple scenes, including when Luke escapes from the Wampa and when Luke sees Obi-Wan's ghostly figure. Behind the hotel, a little ways away is where Han Solo cut open the tauntaun in order raise Luke's core temperature.[445]

Located south of the village are a number of shooting locations used in the production, however booking a local tour guide is highly recommended, as the hike can be a bit arduous. For the hike itself, you'll need to pack warm clothes, trail rations, polarized sunglasses, and a thick pair of thermal underwear. Snowshoes are also recommended, but your guide will likely provide them. However, once you've taken all those necessary precautions, you'll be treated to a tour of the main Hoth

battlefield, the Imperial probe landing site, the spot where Luke attacked an AT-AT with a thermal detonator, and many more. Just make sure to take a nice, warm shower afterward—or else you'll wind up looking like a scruffy-looking nerf herder, which isn't as charming in real life as it sounded in the movie.[446]

Skywalker Ranch

It was a hot July day in Marin County. The sun was shining, but the outside air felt hotter and stickier than the desert planet of Tatooine. Yet, unlike the planet where we first meet Luke Skywalker, vegetation was abundant here. Rolling hills, thickly settled forests, and wildlife were everywhere as our bus hurtled down the winding, backcountry roads. This wasn't just any bus trip though; we were heading to a piece of cinema history: Skywalker Ranch. As we crossed the threshold of the property, the sheer beauty of the place immediately struck me. Amid the verdant hills and bucolic beauty were armor-clad stormtroopers riding bicycles, playing baseball, and generally going about their day. Perhaps it was due to the fact that I was there for Course of the Force, a *Star Wars*–themed charity relay race, but I prefer to think that's what it's like there year-round.

Originally known as Bulltail Ranch, Lucas purchased the initial plot of land with money he earned from the success of the original *Star Wars*. Starting in 1978, George Lucas assembled the sprawling estate parcel by parcel, investing more than $100 million in the property, which spans nearly 5,000 acres. Though the unauthorized 1999 George Lucas biography *Mythmaker* posits that Lucas—constantly at odds with his neighbors and

scared to death of being kidnapped—has security cameras moni- toring every inch of the grounds, it feels more like a national park than a CCTV-fueled police state.[447] The only visible security is the guard station at the front gate, but that is to be expected anywhere in the entertainment industry where there's sensitive material. Rather, Skywalker Ranch is relatively undeveloped, preferring to shine the spotlight on the natural world rather than the fictional worlds of the films made there.

Though some of Lucasfilm operates from the ranch, it was never meant to be a headquarters for the company; rather, it was intended to be an escape of sorts. "It's a nice, contemplative envi- ronment, which I need to think," Lucas once said of Skywalker Ranch. "Having a peaceful environment is very important to the creative process."[448] Such an environment was so important, in fact, that Skywalker Sound relocated to the ranch in 1987, where it occupies the Technical Building. (The majority of Lucasfilm and Industrial Light & Magic are headquartered in the Letterman Digital Arts Center in the Presidio in San Francisco.)

The Technical Building itself is a massive 153,000-square- foot complex with a scoring stage, six mix studios, ADR and foley stages, 34 editing suites, and a 300-seat screening room. From *Guardians of the Galaxy* to *Jurassic Park* to *Raiders of the Lost Ark* to *Spaceballs* and beyond, countless films have scored their soundtracks, recorded voiceovers, and mixed their sound at Skywalker Ranch. And for good reason too. Once you factor in the addition of office buildings, a daycare center, a gym, four restaurants, and many other amenities, it's easy to see that this is essentially a self-sustaining creative colony.

Though Lucas doesn't live on the campus as many would believe, he does keep an office inside the 50,000-square-foot Victorian mansion on the ranch grounds. The three-story build- ing serves as a centerpiece to the estate, with Norman Rockwell paintings adorning the walls. The first floor is filled with glass

cases containing relics from past works like the original *Star Wars* lightsabers, a license plate from *American Graffiti,* Howard the Duck's electric guitar, and Indiana Jones' hat.[449] Just make sure to keep your hands to yourself or you'll likely have a brigade of stormtroopers to answer to before you can say, "It wasn't me!"

While you aren't likely to spot any Wookiees emerging from the forest with their bowcasters in tow, you may encounter more familiar wildlife like pigs, goats, chickens, horses, and cows on the property. Plus, you could even go for a dip in Lake Ewok, the beautiful man-made lake at the estate's center. (Note: I don't know if you can actually go for a dip or not; there might be Gungans down there, and as we all know, they're probably better left undisturbed lest they start traveling with you for an extended period of time.)

But what if you do happen to be traveling for an extended period of time? Reserve a room at the on-site inn, which offers bedroom suites and apartments for filmmakers who are working on projects on the Ranch. Unfortunately, you can't just book a reservation with your travel agent; they are reserved specifically for people who are actively working on projects requiring them to be at Skywalker Ranch. That isn't the only way Lucas and company keep their guests and employees covered. As Smokey the Bear told us, only *you* can prevent forest fires. On Skywalker Ranch, however, a dedicated fire brigade is on hand to help make sure the facility isn't reduced to a pile of cinders. Thankfully, on-site incidents are far and few between, so in their spare time, they lend a helping hand to the neighboring area in times of emergency.

George Lucas was never one to rest on his laurels, and that same ethos extends to Skywalker Ranch. With more than 5,000 acres of fertile, arable land on the estate, it would be a crime not to use them to their full extent. In front of the Technical Building, there are grapevines where grapes are grown to make

Skywalker pinot noir and rosé. Olive trees dot the hillsides too, and are ultimately used to make extra virgin olive oil. From the many beehives across the property, wildflower honey is collected and bottled in small, two-ounce jars.[450] Though they sell these items in the campus gift shop, actually purchasing them might prove harder than anticipated. After all, not just anyone can schedule a tour of the ranch. You can find a virtual tour of the Technical Building on the official Skywalker Sound website, and the Internet has a wealth of behind-the-scenes pictures of the estate itself. Don't give up, though—consider this a personal challenge to make a film of your own so that one day you can record the ADR on these hallowed grounds. Bonus points if you manage to work in multiple Wilhelm screams.

81 Charles Lippincott, the Marketing Mastermind

Long before *Star Wars* was the pop cultural juggernaut that it is today, it was an unknown quantity. It may seem hard to believe that, once upon a time, the most famous franchise on Earth was just another science fiction film in development, something about which most people neither knew nor cared. But, hey—we all have to start somewhere. Though George Lucas had established some goodwill for his work on films like *American Graffiti* and *THX-1138,* he still needed some help getting the good word out there about his ambitious little space fantasy. Fortunately for Lucas, that help would come in the form of a man named Charles Lippincott. If one were prone to hyperbole, it could be said that Lippincott is largely responsible for pioneering the hype-driven pre-release marketing that dominates the blockbuster

movie landscape today. But before you sarcastically thank him for watching a teaser of a teaser of a teaser of a teaser trailer on Instagram, you should legitimately thank him for helping to bring *Star Wars* to the big screen and beyond.

In the summer of 1975, Lippincott was working on the Universal lot for Alfred Hitchcock when a chance encounter with Gary Kurtz and George Lucas changed everything. They told him about their new project—a science fiction film—and asked if he'd like to read it. Lippincott wound up loving it so much that he wanted to work on it, and sat down for a meeting with the duo to discuss marketing and merchandising strategies. Lippincott understood the challenges he was facing. "Kubrick's *2001* [which came out in 1968] didn't break even until late 1975," he explained in an interview, "and that was the most successful science-fiction film of all time." Compelling though it may have been, making *Star Wars* seemed like a fool's errand. "You had to be crazy to make a science-fiction film when we wanted to," Lippincott said.[451] Crazed though they may have been, Lippincott's outside-the-box thinking was exactly what the film needed to energize its fan base, and so he became the vice president of marketing and merchandising for Lucasfilm.

Kurtz, Lucas, and Lippincott's mutual love of science fiction, comics, and toys made one thing abundantly clear: they needed to unite their loves to help create a multi-pronged plan of attack in order to market the film. While using comic books as a promotional tool for films in order to created a fandom-fueled feedback loop may seem like common wisdom nowadays, it simply wasn't the case in 1976. San Diego Comic-Con wasn't the launching pad for Hollywood's blockbuster genre fare that it is today; rather, films were advertised through conventional marketing on television, radio, and in newspapers. But Lippincott had another idea—use the nascent comic book and sci-fi convention circuit

to market directly to the core audience who could then, in turn, evangelize the film.

His strategy had begun to pay off. They hired writer Alan Dean Foster to pen a novelization of the movie that would come out in advance of the film itself, taking it to Ballantine Books, which was then considered the best science fiction publisher in the market. The novelization was "the fastest sellout of a first edition for a sci-fi movie novelization [Ballantine] had ever had," Lippincott noted, "which surprised the hell out of me—and them. It had sold out by February [after being published in December 1976]."[452] Likewise, Lippincott brokered a deal with Marvel Comics to produce a six-issue comic book series based on the original film. Marvel had a solid track record of producing licensed comic books at the time, having turned Robert E. Howard's *Conan the Barbarian* into a highly successful comic series. "Marvel's aggressive expansion of characters was important," Lippincott wrote, "because we needed to be with a company who was actively building a science fiction base."[453]

To sweeten the pot, they didn't charge Marvel any licensing fees for the initial comic order, and royalties would only kick in after a certain threshold had been reached. They also brought the comic's creative team—writer Roy Thomas and artist Howard Chaykin—along with some advance artwork and production materials to the 1976 San Diego Comic-Con in order to promote the film in advance of its release. The only real demand that Lippincott and his team had was that two issues be released prior to the film's debut, so as to build word of mouth. It seemed like they were giving away money, but it wound up working in their favor when the comic became a hit. (In fact, it became such a hit that it turned Marvel's financial fortunes around, a fascinating story which I'll get to in a later chapter.)

"I went down on Monday [to a Los Angeles newsstand] and I noticed four tattered copies of the first issue of the comic book

on the ground," Lippincott reflected in a CNN interview. "And I said, 'Larry, is that all you got in of the *Star Wars* comics?' He said, 'No, that's what I got left.'"[454] It was an auspicious sign, to be certain. When *Star Wars* opened on Memorial Day weekend in 1977, it screened in just 32 theaters. Though it was projected to make roughly $30 million—an optimistic estimate for even

The Tale of the Missing Interview

Over the years, Charles Lippincott made many contributions to the *Star Wars* legacy: extensively interviewing the cast, securing the Marvel Comics deal, and generating considerable buzz leading up to the 1977 premiere. However, one of his greatest contributions happened before *Star Wars* even started shooting. Before they went to the UK to film, Harrison Ford and Mark Hamill were in Los Angeles doing *The Hour 25 Show*, a Friday night science fiction radio show on KPFK. It would have been an interview for the ages— except the tape disappeared.

Before the interview, Lippincott took the young actors to dinner at an Italian restaurant where they evidently had a little too much to drink. That wasn't the only thing purportedly in their system. "I knew Harrison was always prepared to toke up, but didn't think much of it," Lippincott wrote on his blog. "As the interview gets going, I realize both the boys are drunk and stoned." Yikes! To make matters worse, roughly 30 minutes into the interview, a call comes in for Harrison Ford. It's not a fan; it's his *father*, who proceeds to berate his sloshed son *on the air*.

Fortunately, Lippincott used to have a radio show at that very station, so once the broadcast was over, he snuck back into the studio and stole the reel that was used to record the show. A few days later, he got a call from the station asking about the interview tape's whereabouts, but Lippincott—cool as a cucumber—feigned ignorance. Hmmm—smuggling an important tape with secret information on it from a highly secure area? Now the beginning of *A New Hope* is starting to make a lot more sense.

Lippincott, Charles. "The True and Unadulterated Story of How I Became a Thief for Star Wars." From the Desk of Charles Lippincott. N.p., 12 Mar. 2015. Web. 18 Apr. 2015.

the best of sci-fi films—it wound up netting more than $300 million in the domestic box office alone, a figure that was previously unheard of.[455]

Though Lippincott faithfully served as the vice president of marketing and merchandising for Lucasfilm during the mid-'70s, helping to guide the film from fledgling franchise to full-blown phenomenon, his relationship with Lucas soured soon thereafter. In the wake of *Star Wars*' immense success, Lucas hired additional people to come in and help run the business side of things. A disagreement over the merchandising deal with toymaker Kenner resulted in a rift between Lucas, Lippincott, and 20th Century Fox lawyer Marc Pevers. When push came to shove, Lippincott sided with Pevers, and it was the final nail in the coffin for his relationship with Lucas.[456] Lippincott left the company in June 1978.

However, that was by no means the end of the road for Lippincott as far as marketing genre cinema was concerned; he went on to work on *Alien*, *Flash Gordon* (a major influence on Lucas in making *Star Wars*, coincidentally), and *Judge Dredd* to name a few. Though he is largely retired nowadays, he maintains an active web presence on his blog and on Facebook, where he writes impassioned essays and reveals interesting tidbits of behind-the-scenes trivia that could only come from a man who was as deep in the trenches as he was.

82 Howard Kazanjian, the Producer to the Rescue

With the departure of Gary Kurtz toward the end of *The Empire Strikes Back*, George Lucas found himself in a bit of a pickle—he needed another all-star producer to join the project and placate

the banks. Moreover, he needed someone who could then keep the final film of his trilogy, *Return of the Jedi*, on schedule and under budget. Fortunately, Lucas had to look no further than his former University of Southern California classmate, Howard Kazanjian. A longtime friend and fellow member of the Dirty Dozen—a nickname for an infamous group of on-campus filmmakers that included the likes of Robert Zemeckis, Walter Murch, and John Milius, just to name a few—Kazanjian stepped up to the plate, coming in to work on the tail end of *The Empire Strikes Back* and for the entirety of *Return of the Jedi*.

Kazanjian looks back fondly on their little coterie of creatives. "We learned to work together," he recalled. "We created the feeling of family. The facility was old and funky, but I would have had it no other way."[457] That feeling of family and making do with limited resources was the spirit that drove Kazanjian and Lucas throughout *Return of the Jedi*. Braving sandstorms, desert heat, and a relatively scant budget, Kazanjian was essential to the production, as director Richard Marquand had no experience working on a film of *Jedi*'s scale and Lucas was increasingly concerned with micromanaging Marquand. Without Kazanjian, it's unlikely that the film would have come in on time or for the price that it did.

More than just helping to keep the production on track, Kazanjian proved instrumental in helping to shape the course of the film by bringing a reluctant Harrison Ford back for *Return of the Jedi*. Unlike Carrie Fisher and Mark Hamill, Ford had only signed a two-picture contract, which is part of the reason why Han Solo was frozen in carbonite at the end of *Empire Strikes Back*. Ford was reluctant to return, and Lucas seemed to think that they wouldn't be able to get him back, period. Kazanjian, however, wasn't willing to take no for an answer; he convinced Lucas to simply write Ford into *Jedi*, then made a call to Ford's agent, Phil Gersh, with whom he had negotiated Ford's deal for

Raiders of the Lost Ark. Gersh said he would speak with Ford, but when Kazanjian called back later, the agent had left on vacation and his son David picked up the phone. Rather than wait for Gersh the elder, Kazanjian negotiated Ford's return with David, and the rest is history.

Kazanjian was also part of a small brain trust consisting of Lucas, screenwriter Lawrence Kasdan, and director Richard Marquand, who gathered around a table at Lucas' mansion in San Anselmo for a series of story meetings. During these no-holds-barred sessions, they spent up to 10 hours a day for five days, exploring every possible avenue through which the story could evolve. In particular, Kazanjian is responsible for Darth Vader appearing at the end of the film as a Force ghost alongside Obi-Wan Kenobi and Yoda. "Two days before we shot that scene I suggested that Vader be there as well," he recalled in an interview. "George didn't answer, but just looked at me. The next day George told me to prepare to shoot Vader with Yoda and Ben. Later that the day I had second thoughts about what I had suggested. After all, two good guys were standing next to a very bad guy. But in the end, there was redemption on Vader's part, and forgiveness on Luke's."[458]

With *Star Wars* popularity at an all-time high, the production found itself facing dangers on both ends of the production cycle. Secrecy was of utmost importance; not only would production houses unfairly overcharge if they knew if was for a *Star Wars* project, but they had to keep nosy fans and scoop-hunting journalists off their tail. To combat this, they decided to book location shoots under the guise of making a horror film called *Blue Harvest*, a B-movie with the tagline "Horror Beyond Imagination." Though the press eventually saw through the ruse, it was successful for a time, a gambit that certain sources attribute to Kazanjian (others, to co-producer Jim Bloom).[459]

Likewise, the film found itself in a title crisis when it was finally ready to head to theaters. According to noted *Star Wars* film historian J.W. Rinzler, "George [Lucas] originally was going to call it *Return of the Jedi* and Howard Kazanjian thought it was a weak title, so he changed it to *Revenge*." However, others theorize that it was a conspiracy, a covert measure by Kazanjian to stick it to black market merchandisers who would counterfeit *Star Wars* goods in order to turn a profit. By putting out fake *Revenge* material, they hoped to stymie potential profiteers from bootlegging official merchandise. However, by creating a limited amount of posters labeled *Revenge of the Jedi*, they actually wound up creating unintentional collector's items.

Lucas wasn't the only great creative mind with whom Kazanjian collaborated; he also had a close relationship with the master of suspense himself, Alfred Hitchcock. Every morning, he would meet Hitchcock (or "Hitch" as he was called by his friends) for coffee while working as first assistant director on 1976's *Family Plot*, and the venerable director would discuss his craft with his young ward. Together, they would screen Hitchcock's works in his office complex, where Hitchcock had his own projection room. "Very often he would say in his harsh and slow voice, 'Howard, do you know why I did such a thing in this scene?'" Kazanjian remembered. "Even if I knew the answer, I would always say 'tell me' or 'please explain' and he would start sharing the precise details of his vision."[460] That attention to detail is something that would characterize Kazanjian's career as a producer and a filmmaker.

Over the course of his storied career, Kazanjian directed and produced many important works of genre film. From *The Wild Bunch* to *Return of the Jedi*, from *Raiders of the Lost Ark* to *Demolition Man*, Kazanjian has had a keen eye for compelling visual storytelling and the financial wherewithal to get it done. Though nothing could have prevented *Return of the Jedi* from

making its way into theaters in 1983, it is nearly impossible to imagine the film without Kazanjian's guiding hand pushing it gently in the right direction.

John Dykstra, the Special Effects Jedi

George Lucas may have been the wide-eyed young filmmaker with the vast imagination from which Star Wars sprouted, but he would not have been able to realize his vision of the galaxy far, far away without the help of a group of exceedingly capable, very skilled, and tenacious creative collaborators who stood by him through thick and thin. One of the most important young men Lucas met along the way of *Star Wars'* journey from concept to completion is special effects supervisor John Dykstra. Dykstra's technical wizardry resulted in the epic space battles between Imperial TIE Fighters and Rebel X-wings, the jaw-dropping powers of the Force, and most importantly, the visual aesthetic of lightsabers as we know them today.

Fox had previously shuttered its entire special effects department, an alarming cost-cutting trend that seemed to be sweeping the Hollywood studio system at the time. Lucas and producer Gary Kurtz had to assemble their own special effects department, and so they turned to a young upstart named John Dykstra. In truth, their first choice had been Doug Trumbull, the special effects wizard who had wowed with his work on *2001: A Space Odyssey*. However, Trumbull put forth his young protégé Dykstra instead. The newly minted Dykstra began assembling a team of young, hungry artists and craftsmen who were willing to work long hours for short money (approximately $20,000 per year).[461]

Though the pay was lousy, Dykstra and his team leaped at the chance to shape the sprawling spaceship battles that *Star Wars* promised.

Lucas dubbed his new team "Industrial Light & Magic," a slick title that would go on to become one of the biggest film companies in the world. Dykstra and his crew set up in a warehouse in Van Nuys, in Los Angeles' San Fernando Valley, where they set to work bringing *Star Wars* to life. They set to work creating elaborate model spaceships, the props that would become lightsabers, and developing advanced camera technologies, all in the service of Lucas' vision. Yet, even in spite of Dykstra's team working for cheap, Lucas was said to have been forking over $25,000 per week of his own money in order to fund the operation.

Dykstra and the ILM crew worked in a small, poorly ventilated stage that lacked air conditioning under lights that could get to be up to 120 degrees. Even worse, they were falling behind schedule, which immediately put Dykstra and Lucas at odds. Rumors abounded that the place had become "a hippy commune" under Dykstra's leadership, with the staff often working under the influence of marijuana. They even had a hot tub that they filled with cold water where they would gather in the afternoon and converted an escape slide from a 727 into a makeshift slip 'n' slide. All in all, it seemed like an ideal working environment for a group of young creatives with imagination to spare. "We did blow up a lot of stuff," Dykstra later admitted. [462]

Dykstra's biggest and brightest achievement was the development of the Dykstraflex, a motion-controlled camera that enabled many highly complex special effects. The camera itself was a hodgepodge of older VistaVision cameras and integrated computer circuits that allowed it to be programmed to move through seven separate axes of motion. As a result, Dykstra and his team were able to replicate the sensation of spaceflight as the

camera seamlessly soared past the model ships.[463] Though its creation effectively cut the cost of the films in half, the damage to Dykstra and Lucas' relationship had been done.

Tensions rose between Dykstra and Lucas, particularly as the special effects budget continued ballooning during the Dykstraflex's development. Half of Dykstra's development budget had been spent on the camera, and of the seven shots they had created, only one was deemed usable by Lucas. After a heated exchange, Lucas fired Dykstra, only to hire him back later as a production supervisor to keep ILM in line. Yet, all of Dykstra's hard work was vindicated with the first special effects shot of the film in which we see the small ship *Tantive IV* on the run from the gargantuan Imperial Star Destroyer. Lasers fly as the camera swoops down underneath the Destroyer's hull, continuing on for what feels like forever before finally arriving at its engines. It's a 13 second shot, but it immediately sets the stage for the film, demonstrating the tremendous disparity in power between the Empire and the Rebel Alliance.

This was not only one of the most important shots of the film, but proved to be a crucial test for the Dykstraflex camera. "We had seven or eight hypotheses that had to prove right in order for all that stuff to work," Dykstra said of the camera.[464] However, Dykstra's work was vindicated when he won an Academy Award for Best Visual Effects for his work on *Star Wars*. He would not return for any of the subsequent films, but his contribution to the special effects industry was inarguable.

Along with many of his original ILM colleagues, Dykstra went on to work on *Battlestar Galactica*, forming a new effects company under his direction called Apogee. Lucas and 20th Century Fox were furious, viewing Dykstra's work and use of what was once ILM equipment as plagiarism, particularly because they had nascent ambitions of making a *Star Wars* television series.[465] The lawsuit was eventually thrown out of court, and

Dykstra went on to have a fruitful career including working on *Star Trek: The Motion Picture*, *Batman Forever*, *Batman and Robin*, as well as the first two *Spider-Man* films (the latter of which earned him a Best Visual Effects Oscar). *Star Wars* may not have made Dykstra a rich man, but it made him a lightning rod in the special effects industry. Without his creations, it's difficult to envision how the galaxy far, far away would ever have made it to theater screens near us.

84 Drew Struzan, George Lucas' Poster Boy

Think back to the last time you walked through the halls of your local movie theater. Can you remember what the movie posters looked like? Chances are that they were heavily Photoshopped collages of a thirty-something white guys with just the right amount of stubble in a blown-out blue-and-orange palette. Or, if it's a rom-com, it was probably two people standing back-to-back on a white background with some jaunty text. The point is that the art of creating compelling movie posters feels like it's long dead, but there was one man who made sure that fate never befell the *Star Wars* franchise: Drew Struzan.

Born in Oregon City, Oregon, in 1947, Drew Struzan is an American artist and illustrator who is responsible for creating some of the most iconic posters in cinema history. Over the years, Struzan has become one of the most beloved and sought-after artists in the world. His style can best be described as one of "story montage." Many times, Struzan would weave together different elements of the film to create multiple vignettes that he would then compose together into a single, beautiful image.

With his painterly style, cinematic eye, penchant for realism, and jaw-dropping composition, Struzan's silver screen renderings have become some of the most collectible posters ever made. His involvement doesn't stop at *Star Wars* though; Struzan also created posters for films like *Back to the Future*, *Hook*, *Indiana Jones and the Temple of Doom*, *The Goonies*, and many more.

The first ever poster Struzan made was a one-sheet for a 1975 George Segal film called *The Black Bird*. "It wasn't like I ever had an intention of working in the movie industry," Struzan once confessed. "For a couple of years, I did album covers. I was so poor and ignorant; I lay on the floor and drew the pictures for album covers because I didn't have a table to do it on."[466] One of those album covers was Alice in Chains' *Welcome to My Nightmare*, which *Rolling Stone* named one of the Top 10 Album Covers of All Time. For Struzan, painting pictures wasn't just a job; it was a form of communication. "I don't communicate with people through verbal means; I'm not very good at that," he once said. "The painting always reached out and touched people's hearts, and that's what I wanted to do." It also helps that illustrating movie posters was far more lucrative for Struzan than fine art painting.

For each poster project, Struzan begins by sketching his drawing on gessoed illustration board, then darkening the draft with airbrushed acrylic paint, filling in highlights and detail work with colored pencils and airbrush as needed. Often working from reference photographs, production stills, and models, Struzan works quickly and efficiently, typically turning around a poster project within one to two weeks. However, when it came time to create the poster for John Carpenter's 1982 remake of *The Thing*, Struzan was given less than 24 hours and no concept art to go on. He snapped a photograph of himself wearing a ski parka, got to work, and managed to create the painting overnight in time for his 9:00 AM deadline.[467]

Ralph McQuarrie may have helped to invent the world of *Star Wars* from whole cloth, but it was Struzan's work that truly brought it to life for many fans. Struzan made his first foray into the galaxy far, far away with the legendary "Circus" style poster he created for the 1978 theatrical re-release of *Star Wars*. Technically, Struzan wasn't even hired to do that first poster; rather, his friend Charlie White III had been commissioned to create it. "Charlie's a pretty well-known air-brush artist, but he doesn't do portraiture," Struzan explained in an interview. "So once he got the job, he knew he needed to have portraits done so he called me and asked if I wanted to share doing a painting with him. He'd do all the robots and the spaceships and stuff, and I'd do the people, because he couldn't do people. I said, 'Sure, that'd be fun.' At the time I didn't know. I thought it was a pretty cool job, but I really didn't know what would come of it. So, I did all the people in the painting and he did the airbrushing and the robots and stuff."[468]

Struzan would go on to create posters for each of the *Star Wars* films, many covers for *Star Wars* Expanded Universe books, as well as other Lucasfilm properties like *Indiana Jones*. When *The Phantom Menace* first debuted, George Lucas stipulated contractually that, apart from the text, Struzan's poster was to remain unaltered and had to be used worldwide, effectively making it the official image of the film. As for whether or not we can expect the same legendary Drew Struzan artwork for *Star Wars: The Force Awakens* is another matter entirely. Struzan was tapped by Lucasfilm to create a limited edition variant poster for the much-anticipated sequel as a special gift for D23 attendees. Nothing is set in stone, however, so we'll have to settle for drooling over vintage posters instead. Now, if you'll excuse me, I need a mop to wipe up all said drool.

85

John Williams, *Star Wars'* Very Own Music Man

George Lucas' imagination provided the iconic imagery, Ben Burtt's ingenuity provided the indelible sound effects, John Dykstra's technical wizardry brought lightsabers to life, but without John Williams, all of their work would feel hollow and empty. John Williams is the brilliant composer behind each and every single *Star Wars* film. After the blue text reading "A long time ago in a galaxy far, far away" appears on screen, it is his thundering score that sets the stage for the epic space fantasy to come. At age 83, Williams is not only one of the greatest film composers of all time, but remains just as vibrant and essential as ever as he continues to produce award-winning works time and time again. His next effort, thankfully, is providing the score for the highly anticipated *Star Wars: The Force Awakens*.

Born in New York in 1932, John Williams and his family moved to Los Angeles in 1948, where he finished high school and went on to study composition under the Italian composer Mario Castelnuovo-Tedesco at UCLA. In 1952, Williams was drafted into the U.S. Air Force, where among other duties he conducted and arranged music for the U.S. Air Force band until his service ended in 1955. Upon discharge, Williams relocated to New York City and studied piano at the Julliard School under the famed teacher Rosina Lhévinne.

While in New York, Williams worked as a jazz pianist, going by "Little Johnny Love" Williams, and played both at the city's many nightclubs and as a session musician for composers like Henry Mancini. After returning to Los Angeles, Williams began what would be a decades-long career in the film industry, working with composers like Bernard Herrmann, Alfred Newman, and

Franz Waxman. In 1956, Williams became a staff arranger for Columbia Pictures and, later at 20th Century Fox, where he worked composing music for films. His first film composition was for the 1958 B-movie *Daddy-O,* a campy movie that would one day be gleefully savaged on an episode of *Mystery Science Theater 3000.* During the 1960s, Williams composed the music for a number of television programs, including *Gilligan's Island, Bachelor Father,* and *Lost in Space.* Little did Williams know that space would become a major part of his life just a decade later.

In 1967, Williams earned his first Academy Award nomination for his work on *Valley of the Dolls,* and in 1971 his work on *Fiddler on the Roof* earned him his first Oscar. Williams' rise to success seemed nothing short of meteoric; in just five years time, Williams had earned six Oscar nominations. Then, in 1974, a legendary partnership was born when then-novice director Steven Spielberg approached Williams and asked him to write the music for his debut film, *The Sugarland Express*, a request to which Williams assented. One year later, the duo made history with their 1975 collaboration, the shark attack thriller *Jaws.* The film's ominous, suspenseful two-note theme kept a generation of viewers out of the water and earned Williams his second Academy Award (and his first one for an original composition).

Hoping to capture lightning in a bottle for a third time, Williams began working with Spielberg on the 1977 sci-fi film *Close Encounters of the Third Kind.* That wasn't the only piece of science fiction that had captured Williams' attention during the late '70s though. During that same time, Spielberg recommended Williams to his friend George Lucas, a struggling filmmaker who needed a composer to provide the score for his epic space fantasy, a little film called *Star Wars.*

When creating the iconic sounds that would define a generation of films, Williams looked to the past to make *Star Wars* ring true. "In the case of *Star Wars,* I made a conscious decision to

try to model and shape the score on late 19th century, romantic orchestral scores," Williams said in a 1979 interview. "The idea was that the music should have a familiar emotional ring so that as you looked at all those strange robots and other unearthly creatures, at sights hitherto unseen, the music would be rooted in familiar traditions."[469]

With its nods to composers like Igor Stravinsky and Gustav Holst, Williams' work on *Star Wars* is often credited with beginning a revival of heavily symphonic movie scores in the late '70s. Williams' *Star Wars* score famously employed a musical device known as a leitmotif, a recurring musical theme, often associated with a particular person, idea, or situation. Developed and popularized by German operatic composer Richard Wagner, leitmotifs serve as musical calling cards of sorts, convenient auditory cues to elicit certain emotions and feelings from the audience. In the case of *Star Wars*, this manifested itself in now-iconic tracks like "Luke's Theme," "The Imperial March (Darth Vader's Theme)," and "Leia's Theme." In 1980, Williams returned to score *The Empire Strikes Back*, and again in 1983 for *Return of the Jedi*. Both film scores would earn him Academy Award nominations.

Although the next *Star Wars* film wouldn't come until 1999's *The Phantom Menace*, 16 years after *Return of the Jedi*, Williams said, "Working on this movie was like writing for an old friend."[470] With the prequel films, he continued his tradition of using character-specific themes to be used as leitmotifs throughout the trilogy. For example, in "Anakin's Theme," one can hear the shades of "The Imperial March," foreshadowing the descent of our young, innocent hero into the dark side. With the knowledge of what's to come, chronologically speaking, Williams was able to lace his score with an added sense of direction and purpose that was frankly impossible in previous films.

In case there was any doubt as to the quality of Williams' work, in 1978 he won the Academy Award for *Star Wars*, beating

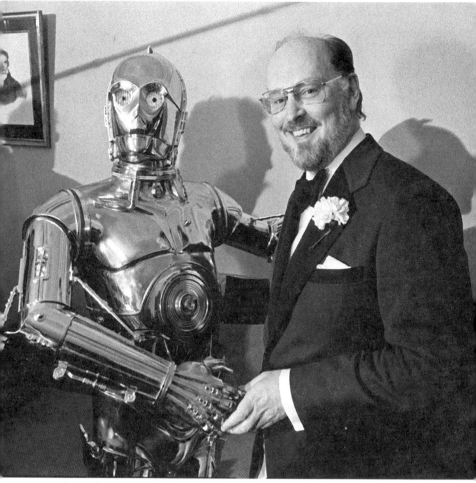

John Williams shakes hands with C-3PO at a news conference in 1980.

out his own score for *Close Encounters of the Third Kind*. Nothing screams "baller status" quite like being so talented that you have to defeat yourself in order to win an Academy Award. With 49 Oscar nominations and five Oscar wins, Williams is the single most nominated artist of all time. To put it in context, since he won the Academy Award for *Star Wars*, there have only been 13 years in which he was not nominated for another Oscar.

As for what the future holds for Williams, he is lending his singular talents to *The Force Awakens*. This time, however, his longtime friend and creative collaborator George Lucas is not involved; rather, J.J. Abrams is sitting at the helm of *Episode VII*. Nevertheless, Williams remains undaunted. "I have to say that J.J. is a much younger man than I," said Williams, "but I will try to keep up with him as much as I can!"[471] Something tells me that Williams won't have any trouble keeping up, but as always, his enthusiasm is music to my ears.

86 Moff Mors, the First LGBT Character in the Galaxy

With countless alien worlds, all manner of extraterrestrial life, and a seemingly endless well of stories contributing to a larger canon, *Star Wars* has always positioned itself as an expansive, inclusive fandom. Even so, it has taken until 2015 for the franchise to get its first-ever LGBT character added to the official canon, the Imperial officer Moff Mors. The character made her debut on April 28, 2015, in Paul S. Kemp's novel *Lords of the Sith*, one of the new official entries into *Star Wars* canon since the powers that be hit the reset button on the Expanded Universe, effectively undoing years of ancillary storytelling.

The character of Moff Mors is described as "an Imperial who has made some very serious mistakes," yet she is also "an incredibly capable leader and spends much of the book working hard to prevent absolute failure."[472] Of course, she also happens to be a lesbian. According to *Lords of the Sith* editor Shelly Shapiro, Mors is "certainly the first [LGBT] character in canon."[473] The keywords here being "in canon." Statistically, there are hundreds

if not thousands of LGBT characters in the *Star Wars* universe whom we have not met, and there are probably reams of fan fiction featuring LGBT characters, but this is important precisely because these characters haven't been represented in the same way others have.

That being said, same-sex relationships have been tackled in other, earlier *Star Wars* titles. For instance, BioWare's video game *Knights of the Old Republic* included a lesbian party member named Juhani. Shapiro also notes that "there was a gay Mandalorian couple, so it's not brand new," referring to a pair of married Mandalorian men, Goran Beviin and Medrit Vasur, from Karen Traviss' *Legacy of the Force* novels. It was a subtle reference, which some readers may not have picked up on. On her website, Traviss addressed the characters rather matter-of-factly, saying, "Mandalorians don't give a toss what you do in your private life as long as you follow the basic rules about clan and looking after your kids." Different though they may be in sexual orientation, they are still people and ones worthy of representation, canonically or otherwise.

Now, it seems that writers like Kemp will carry on in Traviss' footsteps, making the galaxy far, far away feel closer to reality than ever before.[474] Moff Mors' inclusion is an important step forward for the *Star Wars* franchise, which is regularly the target for more inclusivity in various online circles. "That these approvals came through the story group and are being brought to the forefront of the *Star Wars* universe gives me a lot of hope for an ever-increasing diversity of representation in *Star Wars*," said Kemp. "We've had plenty of stories and characters, both major and supporting, that have been straight, white males. We've seen what the world of *Star Wars* looks like through their eyes plenty," he continued. "I would love to see what it looks like through the eyes of people who don't look or think exactly as I do. That's

when I learn most about the world around me, when I get outside of my own point of view."[475]

Pour us two frosty glasses of blue milk, Mr. Kemp, because I'll most certainly drink to that.

87 The Special Editions: What's the Big Deal Anyway?

One of the hallmarks of being a nerd is a deep-seated, almost pathological aversion to change. Hell, it took me years and years to finally come to terms with the fact that Batgirl was Alfred Pennyworth's niece in *Batman & Robin*. That movie is hot garbage, but I *still* managed to get all worked up about it. As the years wore on, though, I came to grips with the fact that things change with time—even the pop culture franchises I know and love. Yet, despite this universal truth, *Star Wars* fans remain steadfast in their exceedingly vocal displeasure over the "Special Editions." What makes these versions of *Star Wars* so "special" anyway? They have been tweaked, torqued, twisted, and transformed by George Lucas, who sought to refine his vision using the latest and greatest technology available. Though most of the changes are relatively minor, they have added up over the years.

To many diehard fans, the true version of *Star Wars* is considered the one that first played in 1977. In this version, Han Solo shoots first when he sits down with Greedo at the Mos Eisley Cantina. It may seem like a minor detail, but it is the subject of one of the most heated fan debates of all time—so much so that it warrants an entire separate chapter in this very book. Since Lucas largely controlled which version made it to home video,

this is widely considered to be one of the hardest versions of the film to track down.

The changes began seeping in as early as 1980 with the release of *The Empire Strikes Back*. The legendary sequel was mostly distributed on 35mm film, but an alternate, slightly different 70mm version exists as well. In this alternate version, there are several instances of alternate dialogue, scene transitions, and sound effects. For instance, when R2-D2 is suddenly ejected from a swamp on the marshy planet of Dagobah, Luke originally says "You're lucky you don't taste very good." In the 70mm version, however, it becomes "You're lucky to get out of there."[476] It was one of the few changes that became a mainstay in future editions.

Later that year, Lucas began messing around with the original *Star Wars* for the first time. Though most changes were minor—a few sound effects and bits of dialogue added in the background—there was one major difference. During the opening crawl, the subtitle "Episode IV: A New Hope" first appeared.[477] Considering the lengthy subtitles that accompany every episode of the *Star Wars* saga, it shouldn't come as any surprise. In fact, Lucas' love affair with lengthy, arcane titles is well documented. Case in point, the original working title of *Star Wars* was *Adventures of Luke Starkiller, As Taken From the Journal of the Whills, Saga 1: The Star Wars*. Try saying that five times fast. (If you managed it, you might just be a Jedi after all.)

In 1983, *Return of the Jedi* hit theaters, although it initially had a different name—*Revenge of the Jedi*. Some say that Lawrence Kasdan suggested that Lucas change the original title of *Return of the Jedi* to something more dramatic, as "Return" felt "too weak," hence the shift to "Revenge." Others argue that the second *Star Trek* movie was then filming under the title *The Vengeance of Khan* (interestingly enough, *Vengeance of Khan* was changed to *Wrath of Khan* to avoid confusion with *Revenge of the Jedi*).[478] Ultimately, Lucas had second thoughts about associating

the act of revenge with his Zen space warriors, and switched it back. However, posters featuring the original name had already been made, making them instant collector's items. (Certain conspiracy theorists out there think that naming it *Revenge* was a ploy by Lucas all along to toy with people making counterfeit merchandise.)

The next big change came with the advent of home video releases on VHS and laserdisc. If you don't know what VHS and laserdisc are, then congratulations on making me feel old. Imagine a brick and a large Frisbee, respectively; now imagine that they were primitive data storage devices capable of storing films within them. What sets these versions apart from most is that sound designer Ben Burtt went back and digitally remastered some of the audio for *A New Hope*, allowing audiences to better hear the likes of C-3PO. He may be fluent in more than 6 million types of communication, but clearly he didn't know how to speak up without a little help in post-production. If it felt like Threepio and the gang were rushing a little bit in these versions, you're not wrong. The film was sped up by approximately three percent, which isn't nearly fast enough to make the Kessel Run, but is a good way to make sure that the films fit on to a single disc.[479]

When 1993 rolled around, the original trilogy was released once again on laserdisc with the billing "*Star Wars* Trilogy: The Definitive Collection." Four years later, in 1997, Lucas made his biggest changes yet with *Star Wars*: Special Editions. Reportedly spending $10 million to remaster *A New Hope*, and a cool $5 million apiece for *Empire* and *Jedi*, Lucas extensively modified his original films in an effort to make them feel more modern in anticipation of the then-forthcoming prequel trilogy.[480] (Full disclosure: This was the version I watched endlessly in the summers on Cape Cod when I avoided going outside in favor of visiting a galaxy far, far away.)





The most sprawling changes occurred within *A New Hope*, in which Lucas replaced matter paintings in the background with digital versions, and made Mos Eisley appear more populous by adding in additional stormtroopers and CG animated dewbacks during the hunt for R2-D2 and C-3PO. That was just the tip of the iceberg, it seems, as the Special Edition also included a new scene between Luke Skywalker and Biggs Darklighter, digitally enhanced versions of the X-wings and the *Millennium Falcon*, all manner of CG aliens in the Mos Eisley Cantina and, most controversially, a recut version of the showdown between Han and Greedo.[481] This time, Greedo shoots first—missing Han at point blank range—allowing the scruffy-looking nerf herder to return fire in "self defense." Little did Lucas know, but this little change would blossom into a debate that would rage for years.

Though *Empire Strikes Back* incurred fewer changes, they are still noticeable: adjusted audio, digital clouds inserted in the Cloud City exterior shots, and a massive, agonized scream from Luke when he's suddenly separated from his hand. Technically, *Empire* actually has the most changes of any of the films, but they were much more subtle. Lucas and company scrubbed out compositing lines around speeders during the Battle of Hoth, which was painstakingly cleaned up for greater clarity.[482]

Return of the Jedi, however, had much more obvious changes in the form of Sy Snootles and the Rebo Band, the jazzy ensemble that keeps the party jumpin' at Jabba's palace. In this version, the original puppets were replaced by the computer-generated stuff of nightmares and the song was changed from "Lapti Nek" to the significantly more grating "Jedi Rocks." Speaking of musical changes, the classic Ewok jam "Yub Nub" was replaced by another John Williams composition. In addition, we get a first glimpse of Coruscant, a modified Sarlacc monster, and many other CGI-enhanced sequences.[483] If you want to get really technical about it, there are plenty of exhaustive frame-by-frame

breakdowns available on the Internet, but that would require more paper than my publisher was willing to give me here.

In 2004, the original *Star Wars* trilogy finally made its way on to DVD, something that fans had been requesting for years. In a classic case of "be careful what you wish for," these versions were further modified with odd color corrections and a few interesting alterations like recasting the Emperor's hologram in *Empire* with Ian McDiarmid; the role was originally played by Clive Revill. Likewise, Boba Fett—originally played by Jason Wingreen—is overdubbed by Temuera Morrison, who plays Jango Fett in *Attack of the Clones*. Last, but not least, there is a third, somewhat baffling recasting in *Return of the Jedi*. At the film's end, when Anakin, Obi-Wan, and Yoda appear as Force ghosts before Luke, Sebastian Shaw no longer plays Anakin; rather, it is Hayden Christensen. Oddly enough, Obi-Wan is still played by Alec Guinness rather than Ewan McGregor. When asked about the questions, Lucas told MSNBC, "It's too bad you need to get kind of half a job done and never get to finish it. So this was my chance to finish it."[484]

In 2006, faced with mounting public backlash, Lucasfilm released the "Limited Edition" DVDs, which were essentially identical to the 2004 release save for the fact that they came with bonus discs loaded with the theatrical version. Or so they claimed—the so-called "theatrical version" was a poorly transferred print identical to the version found on the Definitive Collection on Laserdisc. The films, presented in non-anamorphic 4:3 letterbox format, look terrible, with black bars appearing on all sides of the screen. "Now we'll find out whether they really wanted the original or whether they wanted the improved versions," Lucas remarked to MTV. "It'll all come out in the end."[485]

The most recent version to come out is the 2011 Blu-ray box set release, marking the final opportunity that Lucas would have to tweak his space fantasy saga. No film escaped Lucas' tinkering;

How Oola Got Her Groove Back

For the 1997 Special Edition release, countless digital enhancements were made to the original trilogy, but only one actor was called back to shoot additional material: Femi Taylor. If you don't know Taylor's character immediately, you can hardly be blamed; she doesn't feature very heavily into the film, after all. Taylor played Oola, the slave girl in Jabba's palace who gets fed to the Rancor in the pit below. As the rumor goes, when it came time to create the Special Editions, Taylor was recommended for reshoots because she was in much better shape than she had been 15 years prior during filming. The end result is a mixture of both new and original footage. However, that still doesn't change the fact that Sy Snootles digital makeover is the stuff of waking nightmares.

the original trilogy was now treated to new close-ups in *Jedi*, CG eyelids added to Ewoks, and color corrections. In terms of the prequels, Yoda's puppet from *The Phantom Menace* was digitally replaced, Anakin's dead mother appears to him during a dream sequence in *Attack of the Clones*, and extra dialogue is worked in *Revenge of the Sith*. Worst of all, though, is the scene in *Return of the Jedi* when Darth Vader lifts the Emperor over his head to save his son Luke. Remember how goofy it sounded when Vader yelled, "Noooooooooooooo!" at the end of *Revenge of the Sith*? Well, for some godforsaken reason, Lucas decided to insert that same "Noooooooooooooo!" scream during the climactic showdown between Vader and the Emperor.[486] Still, it's a small price to pay for the visual fidelity afforded by the Blu-ray release.

So, what is a discerning *Star Wars* fan to do? What version is worth watching? If you're a purist—meaning that you want to see something as close to the original theatrical releases as possible—then you should avail yourself of something called "Harmy's Despecialized Edition." The fan-made cut of the film is a Frankenstein's monster of footage cobbled together from various video sources to create the most visually faithful version

possible. Since it is technically not a Lucasfilm production, I won't tell you how to find it here, but search your feelings—and your web browser—and you'll find what you seek.

88 Fight Like a Jedi with Lightsaber Lessons

Are you an aspiring Jedi Knight or Sith Lord? Do you own a lightsaber, but aren't quite sure how to use it? Do you want to wield the most iconic weapon in cinema history without coming off like the gentleman in the now-famous "*Star Wars* Kid" video? Well, you're in luck because not only do lightsaber lessons exist, but they are becoming more and more prevalent across the country.

It is difficult to pinpoint the origin of professional light-saber training academies, but one of the most prevalent is the San Francisco–based school, the Golden Gate Knights. At $10 per lesson, it's a far sight more affordable and convenient than building a spacecraft capable of interstellar travel to take you to a galaxy far, far away. Founded by software engineer Alain Bloch and fencing instructor Matthew Carauddo, the Knights' class blends elements of fencing and yoga to create the closest curriculum to a Jedi Academy that one can find in this quadrant. (Note: as their website will readily tell you, they have no affiliation with Lucasfilm.)

A lifelong fan of *Star Wars*, Bloch found that the lack of legitimate lightsaber training was a gaping hole in the world of fandom, particularly in his home base of San Francisco. "There are a lot of really awesome costuming groups in the Bay Area, but there was no one that was doing reenactments of the lightsaber

battles that you find in movies, which I find to be some of the most exciting parts of them," Bloch said in a 2013 interview. "So I went around and was actually looking for somebody who could possibly teach me how to do this sort of choreography."[487]

In Matthew Carauddo, Bloch found a kindred spirit, albeit one who was professionally trained in the art of fencing and stage choreography. Together, they launched the Golden Gate Knights in 2011 at the Coastside Fencing Academy, and have since moved to Studio Gracia. Each week, adults and children aged 13 or older are able to participate in the three-hour classes; children are referred to Carauddo, who has since parted ways with the GGK and teaches classes of his own at a separate studio. Their students run the gamut from people who are massive *Star Wars* fans to couples on dates to aspiring filmmakers looking to learn some choreography for their projects. In short, harboring a secret desire to be a lightsaber-wielding warrior of light is much more common than you might have thought.

If you don't have your own saber, that's not a problem; the Golden Gate Knights offer a variety of sabers for use. The custom-built sabers emit the trademark lightsaber sound, something that is immensely satisfying to even the most casual of *Star Wars* fans. Many of the sabers, which are essentially translucent tubes filled with a powerful LED light, contain special modifications like accelerometers and impact sensors to make the signature sounds of lightsabers clashing when they make contact.[488] Others, however, prefer to bring their own saber, ones that they either constructed themselves or purchased from online resources like Savatron, Genesis Custom Sabers, FX-Sabers, or a number of other online retailers. The point is that, at long last, you can wield a powerful laser-based sword without the risk of accidentally slicing off a limb or turning your classmate into an empty pile of robes.

During a typical class, the instructor teaches the students a numbered system of fight choreography designed by Carauddo and Bloch. The idea behind it is that using a standardized system like this allows students from different studios to speak a common parlance, so that if they were to meet on the Comic-Con show floor, they could yell a string of numbers at one another and know exactly which moves corresponded to each number.[489] After spinning, slicing, and parrying, the class ends with meditation—a fitting way to finish off a day of Jedi training. After all, the lightsaber is an elegant weapon for a more civilized age. For Bloch, the lightsaber "sort of represents this force of change," he explained. "There's a virtuous element to the lightsaber; it's made of light, and only those who are keen to the Force can wield it effectively."[490] By meditating and reflecting on what was just learned, one can better attune oneself with the Force and the world around us.

For those of you who can't make it to the Bay Area to train with the Golden Gate Knights, fear not—and not just because it's the path to the dark side. There are plenty of other lightsaber training academies popping up all over the place. For example, the fan organization known as the Saber Guild offers classes across the country, the LudoSport Lightsaber Training Academy boasts seven locations in Italy, New York Jedi offers classes in the Empire State, and there are even instructional DVDs (created by Carauddo and martial artist Mark Preader) available for sale at www.sabercombat.com. This is just a small sampling of the offerings out there, but the point is that you have options. Now if I could just find someone to help me shoot lightning out of my fingertips, we'll *really* be in business.

89 Must-Try Mos Eisley Cantina-Ready Cocktails

"To alcohol! The cause of…and solution to…all of life's problems!"
—Homer Simpson

A Jedi craves not these things, but if you're not a member of an ancient monastic order of warrior-monks who dedicates themselves to a pure, ascetic lifestyle, then some of these *Star Wars*-y libations will be right up your alley. Saving the universe is thirsty work, after all. Now that you mention it, so is reading. Honestly, you've had a long day. Don't you deserve a drink? Not just any drink either—these are beverages worthy of any *Star Wars* fan worth their salt. (Especially their margarita salt.)

After scouring the galaxy for recipes, I harnessed my mixology midi-chlorians to put my own unique twist on some classic cocktails. Whether you like something spicy, something sweet, something sour, or something that you can't quite put your finger on, there's a little something for everyone. Search your feelings—and your tastebuds—you know it to be true.

Just promise me that you'll be careful because drinking too much won't just lead you to the dark side; it'll take you straight to the porcelain Sarlacc pit in your bathroom. Be sure to skip out on making the Kessel Run in your own *Millennium Falcon* after imbibing one of these recipes. The operation of motor vehicles is reserved for qualified, sober, scruffy-looking nerf herders, because when you drink and drive, no one wins—not even the Wookiee.

The Thermal Exhaust Port

It's a one in a million shot.

1 oz. blood orange juice

½ oz. fresh squeezed lime juice

½ oz. simple syrup

1 ½ oz. tequila

3 thin slices of jalapeno

seltzer water

salt for rim (or substitute sriracha salt for an additional kick)

Salt the rim of a Collins glass. Fill cocktail shaker with ice, then combine the lime juice, blood orange juice, tequila, simple syrup, and jalapeno. Shake vigorously, pour into the salt-rimmed glass, and fill the rest with seltzer. Then close your eyes and drink.

The Cold Day in Hoth

Like carbonite, but tastier.

1 pint softened vanilla ice cream

2 oz. vodka

2 oz. Kahlua

crumbled pretzel or finely grated bittersweet chocolate for garnish.

Combine ice cream, vodka, and Kahlua in a blender, and pulse until mixture is mostly smooth, but still a little bit thick. Pour into a chilled glass and see what freezes first—your brain or your tauntaun.

The Protocol Punch

Get ready to slur in over 6 million forms of communication.

2 oz. bourbon

¾ oz. lemon juice

¾ oz. honey syrup (made by combining 3 tbsp. honey and 2 tbsp. boiling water, then whisking vigorously)

Combine ingredients in a cocktail shaker, shake what your mama gave you for 15 seconds, then pour into a rocks glass over ice.

The Dagobah Draught

Drink or drink not, there is no try.

2 oz. sour apple schnapps

2 oz. vodka

1 oz. sweet and sour mix

Combine vodka, schnapps, and sweet and sour mix in a cocktail shaker filled with ice. Shake vigorously, then strain into a chilled martini glass. Garnish with a sliver of green apple.

The Kessel Rum

Can you drink it in under 12 par-sips?

2 oz. rum (preferably Jamaican)

1 oz. freshly squeezed lime juice

¼ oz. orgeat almond syrup

½ oz. orange curacao

¼ oz. simple syrup (or substitute rock candy syrup)

Fill a cocktail shaker with crushed ice, add all the ingredients, then shake until chilled. Pour into a rocks glass, garnish with a lime wedge, and/or a tiny umbrella.

90 Rebel Against Your Diet

Ah, blue milk. Is there anything better after spending a day slaving away under the hot Tatooine suns, hauling power converters back and forth between Tosche Station and your Uncle Owen's place until it feels like your back is going to break? Probably not. Wait, you don't know blue milk? Well, it's a good thing you picked up this book. Blue milk is the frothy blue beverage Luke Skywalker orders at that wretched hive of scum and villainy, the Mos Eisley

Cantina in *Star Wars Episode IV: A New Hope*. What's a bantha? Geez, you're full of questions today. Banthas are those massive, hirsute, horned yak-like creatures which you see Tusken Raiders and Imperial stormtroopers riding on occasion. Anyway, since it's unlikely that you'll be making a trip to a galaxy far, far away anytime soon, there is a much easier way to snack like a Skywalker.

Enter the gastronomic Jedi master Jenn Fujikawa. Better known as the mastermind behind Just Jenn Recipes, Fujikawa blends together pop culture and an expansive knowledge of food to create delicious dishes themed after your favorite movies, TV shows, and characters. She has created numerous *Star Wars*–themed dishes in her day, but my personal favorite is her recipe for *Star Wars Rebels* cookies and blue milk, a brilliant twist on a classic snack that will leave your mouth happier than Jabba the Hutt at an all-you-can-eat buffet.

This recipe originally appeared on Nerdist.com and was reprinted with permission from the author.

Star Wars Rebels Cookies
Serves 24
Note: Although you can likely cut the dough yourself, you can pick up a *Star Wars* Rebel Alliance symbol cookie cutter from the CookiePrints store on Etsy for cheap.

Ingredients
3 cups all-purpose flour
½ teaspoon baking powder
pinch of salt
1 cup (2 sticks) unsalted butter, softened
1 cup sugar
1 egg
red food gel dye
red sanding sugar

Steps

1. In a medium bowl, whisk together the flour, baking powder and salt.
2. In the bowl of an electric mixer, cream the butter and sugar until combined.
3. Add the egg and the red food gel dye.
4. Slowly add in the dry ingredients until the dough comes together. The dough will form quickly and when it starts to pull away from the bowl, it's ready.
5. Split the dough in two and wrap in plastic wrap. Chill until you are ready to use.
6. Preheat the oven to 350 degrees. Prep baking sheets with Silpat non-stick baking mats.
7. Roll out the dough to about 1/4 inch thick. Spread the red sanding sugar all over the rolled out dough, then use the cutter cut out the cookies. Transfer onto the prepped baking sheet.
8. Bake for 10 minutes, let cool on a wire rack.

Blue Milk

Serves 2

Ingredients

blue food gel dye
16 ounces milk

Steps

1. Stir the blue dye into the milk until dissolved.
2. Serve cold.

For more incredible recipes like Princess Leia Cupcakes, Chewbacca donuts, Admiral Ackbar cupcakes, and many more non-*Star Wars*–themed delights, be sure to check out www.justjennrecipes.com.

In the meantime, good luck convincing your friends and family that the last cookie is *not* the snack they're looking for.

91 Live the Movies—Enlist in the 501ˢᵗ Legion

Short of being a rebel billionaire with cash to spare or landing a walk-on role in the background of a future *Star Wars* film, there aren't a lot of options for diehard fans to let their fandom flag fly while wearing high quality costumes and raising money for a series of great causes. Or is there? Thanks to groups like the 501ˢᵗ Legion, not only can you find a group of awesome, like-minded *Star Wars* fans, but you can hang out with them in full stormtrooper regalia—all while raising money for charity. Normally, one should let the Wookiee win, but when it comes to groups like the 501ˢᵗ, it's a win-win all around.

Founded in 1997 by Albin Johnson (a.k.a. TK-210), the 501ˢᵗ Legion is a costuming organization that dedicates itself to creating authentic, movie-quality costumes. As they grew in size and scope, the men and women of the 501ˢᵗ Legion, nicknamed "Vader's Fist," turned their attention not toward eradicating Rebel scum, but rather toward taking up the charge in spearheading numerous fan-fueled charity events.

The group's mission is three-fold: 1) to promote interest in *Star Wars* by giving fans a creative outlet through which to express their love of the *Star Wars* saga; 2) to facilitate the use of costumes in the *Star Wars* fandom by fostering a culture of creativity and craftsmanship that results in authentic, handmade costumes; and 3) to contribute, which is to say that the group

wants to put its considerable resources to good use by giving back to both the *Star Wars* community and the community at large.

With more than 6,500 members in more than 50 countries all over the world, the 501ˢᵗ and its members can regularly be seen making live appearances at conventions, children's hospitals, and other events in support of charitable organizations like the American Cancer Society, Cystic Fibrosis Foundation, the Make-a-Wish Foundation, National Association for Autism Research, and many, many more. Not a bad list of credits considering many of them spend their time dressed up as foot soldiers for an intergalactic fascist empire.

Although the 501ˢᵗ is unofficially affiliated with Lucasfilm, author Timothy Zahn integrated them into the Expanded Universe in 2004 in his novel *Survivor's Quest* and the e-book *Fool's Bargain.* They were also immortalized as the legion of blue clone troopers that Darth Vader led into the Jedi Temple in *Star Wars Episode III: Revenge of the Sith.* Though the name was not mentioned explicitly in the film, it appeared in both merchandising and support materials, and in auxiliary materials like the classic game *Star Wars: Battlefront II.*

But that's not all—in the 2008 *Star Wars: The Clone Wars* animated feature film and television series, the 501ˢᵗ appeared once more, led by the popular character Captain Rex. Though much of the Expanded Universe may no longer be canon, there is no doubt that the 501ˢᵗ Legion is going to live on in future entries in the *Star Wars* franchise and beyond.

If you'd like to consider joining the 501ˢᵗ Legion, you can find a chapter near you on their website: www.501st.com. Just be forewarned: if you're prone to overheating or if you have the sweat glands of a Wookiee, those costumes can be, according to their FAQ page, "like the planet Tatooine in summertime." But,

if the price you pay for doing some good while rocking a totally radical *Star Wars* costume is losing some electrolytes, then that might just be the bargain of a lifetime. Now, ten-hut, soldier! Fall in!

92 Ho Ho Oh No! the *Star Wars Holiday Special*

"The worst two hours of television ever."

—David Hofstede[491]

"That was the worst piece of crap I've ever done."

—legendary TV producer Dwight Hemion[492]

"If I had the time and a sledgehammer, I would track down every copy of that show and smash it."

—George Lucas

What could inspire such visceral reactions? What could have made all of these people so angry? Could such a thing also include Bea Arthur, Wookiees, and dancing stormtroopers galore? Yes, yes it could. The TV show in question is the legendarily awful *Star Wars Holiday Special,* and even 36 years later it remains a laughingstock in fandom—*Star Wars* and otherwise—the world over.

In a nutshell, the *Star Wars Holiday Special* tells the story of Chewbacca and Han Solo making a beeline for the Wookiee homeworld of Kashyyyk so that Chewie can celebrate Life Day with his family. (Life Day, for the uninitiated, is essentially Christmas, but for Wookiees.) However, our heroes aren't alone;

two Imperial Star Destroyers are in hot pursuit. What follows is a weird hodgepodge of familiar faces like Luke Skywalker, Han Solo, and Princess Leia interacting with newly introduced members of Chewie's family—his wife, Malla; his father, Itchy; and his son, Lumpy, as they try to evade Imperial forces. (Their full names are Mallatobuck, Attichitcuk, and Lumpawaroo, respectively). Oh, and did I mention that there's plenty of musical interludes, Harvey Korman as a bumbling robot, Bea Arthur as the bartender who runs the Mos Eisley Cantina, a Jefferson Starship music video, and an animated sequence involving the search for the cure to a sleeping virus that infects the core cast? Because all of that and more happens during the course of this baffling two-hour-long special.

So, how did it happen? How did the first feature film-length *Star Wars* story post-*A New Hope* turn out to be such an unmitigated disaster? Well, for starters, it was a simpler time in the world of television broadcasting, and it seemed like a sure-fire bet. CBS approached George Lucas and his organization (then known as the Star Wars Corporation) with a list of *Star Wars*–related ideas—chief among them was a television special. A special seemed like a smart way for Lucas and company to keep both *Star Wars* and its characters in the public's eye until *The Empire Strikes Back* hit theaters, and the network had seen success with inserting segments with the Cantina characters on variety shows hosted by the likes of Donny and Marie Osmond and Richard Pryor. Furthermore, the film was already a global phenomenon, but goosing merchandising revenue was always a high priority. What seemed like a sure bet, though, soon turned into a nightmare for the network, the filmmakers, and nearly everyone involved.

Immediately, there was trouble behind the scenes. Though Lucas was intent on working with the team of talented TV writers, his insistence on centering the story around Wookiees

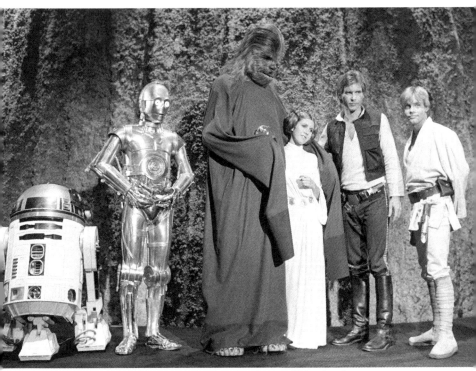

Happy Life Day! The whole gang in a publicity still for the abomination known as the Star Wars Holiday Special. (George Brich)

was met with resistance. "You've chosen to build a story around these characters who don't speak," writer Bruce Vilanch told Lucas. "The only sound they make is like fat people having an orgasm."[493] Lucas was unamused and would not budge. Vilanch would leave the production midway through, and attempt to take his name off it—never a good sign.

Fellow USC film school alumnus David Acomba was tapped to direct in Lucas' absence. Interestingly, Acomba proposed using a then-unknown comedian he had seen perform at an L.A. comedy club, but the producers wanted more name recognition. That comedian was none other than Robin Williams, who had just begun his run on *Mork and Mindy,* the series that would

make him a household name, a few months prior. It was the first of many battles he would face on the strained production.

Shooting proved to be a torturous affair too—during Bea Arthur's Cantina shoot at Burbank Studios, many of the actors in alien costumes would pass out due to lack of oxygen. Acomba's son happened to be on set that day watching the shoot, horrified as the chaos unfolded. "Some of them were passing out," Acomba recalled in an interview. "And there's my son watching these creatures he loves die in front of him."[494] Unsurprisingly, Acomba left the project after filming a sequence with Jefferson Starship lip-synching "Light the Sky on Fire," sending his notice of departure via telegram.

Television and variety show veteran Steve Binder was brought in as a replacement director. Binder's track record was unimpeachable; he famously convinced Elvis Presley to croon his heart out for a 1968 "Comeback Special." If anyone could have salvaged the sinking ship that was the *Star Wars Holiday Special*, it was Binder. Alas, the damage had already been done and Binder's work was already cut out for him. To wit, his only contact with Lucas and his people came in the form of a story bible about Wookiees. Things got so bad that the main actors— Hamill, Ford, and Fisher—came up to producer Gary Kurtz and one of them asked, "How did we get into this mess?" It's a question that I'm sure many of the production staff asked themselves too.[495]

The end result was an overwrought monstrosity that not even Dr. Moreau would have created in good conscience. In spite of his desire to be involved, Lucas' attention was drawn elsewhere by a deluge of projects coming about as a result of *Star Wars'* success. In his absence, things began going off the rails as the show transformed from Lucas' original, sweet, irony-free vision into a weird hybrid of *Star Wars* and an ultra-campy variety show that producers forcibly layered over it.

When the *Star Wars Holiday Special* finally aired on November 17, 1978, nearly 13 million viewers tuned in to watch. Harvey Korman played an extraterrestrial, four-armed version of Julia Child who whipped up a questionable holiday treat called "Bantha Surprise"; Art Carney plied Chewbacca's family with groan-worthy bits like "Why all the long, hairy faces?"; Diahann Carroll appears on a virtual reality console for a truly weird psychosexual acrobatics routine; Bea Arthur convinces the alien clientele of her Cantina bar that it's closing time by singing them a little ditty called "Goodnight But Not Goodbye"; and even Carrie Fisher got in on the action by having Princess Leia make her debut as the most unexpected chanteuse in the galaxy.[496] Oh, and there was also an animated sequence with Boba Fett that is considered to be the sole redeeming quality of the entire affair. Not even the bounty hunter could save the show though; Nielsen data indicates that ratings dropped precipitously after it appeared.

Though Jar Jar Binks would become the new poster child for fanboy backlash, the *Star Wars Holiday Special* remains a pinnacle of poor decision-making. Finding a legitimate copy of the *Star Wars Holiday Special* is nearly impossible nowadays, but a few enterprising individuals have uploaded it to YouTube and other less savory filesharing websites, so you can definitely track it down. Though the damage it did to the *Star Wars* brand was hardly irreparable, it remains a blemish on the franchise's record.

Still, there is an upside to all of this, it seems. Speaking with the late David Carr, Carrie Fisher revealed that in exchange for recording DVD commentary for the *Star Wars* films, she demanded that George Lucas give her a copy of the special. Why, you ask? "So I could, you know, have something for parties," Fisher explained. "When I wanted everyone to leave."[497] No need to press play, Carrie—we're reading you loud and clear.

The Opening Crawl

The most thrilling moment of any *Star Wars* movie isn't the epic lightsaber duels or the interstellar spaceship combat or even seeing our heroes narrowly escape a gruesome end at the hands of the Galactic Empire. Rather, it's the excitement of hearing John Williams' thundering score strike up as the iconic opening crawl sets the stage for the events to come. It may not seem like the most adrenaline-fueled moment to the untrained eye, but the moment that blue text reading "A long time ago in a galaxy far, far away…." gives way to the film's title and the scrolling yellow prologue (in News Gothic, for the font nerds out there) heralds the beginning of a tremendous cinematic adventure. Consider it the equivalent of looking out your window and seeing freshly fallen, unspoiled snow, just waiting for you to enjoy it.

Inspired by the opening crawls used at the beginning of old serials like *Flash Gordon*, the *Star Wars* opening crawl has become one of the most recognizable aspects of the franchise. Writing it was no cakewalk either. In a 2005 interview with the *Chicago Sun-Times*, Lucas said, "The crawl is such a hard thing because you have to be careful that you're not using too many words that people don't understand. It's like a poem."[498] In fact, his early drafts differed from what audiences wound up seeing in 1977. "I showed the very first crawl to a bunch of friends of mine in the 1970s," Lucas said. "It went on for six paragraphs with four sentences each. Brian De Palma was there, and he threw his hands up in the air and said, 'George, you're out of your mind! Let me sit down and write this for you.' He helped me chop it down into the form that exists today."[499] It's a good thing that Lucas said hello to his little friend.

While the opening crawl may seem like a simple scene—a three-paragraph prologue scrolling up from the bottom of the screen toward a vanishing point at the top—it is a much more complex operation than meets the eye. In fact, before the advent of computer-generated graphics, the *Star Wars* opening crawl was one of the hardest shots of the entire production. Rather than using complex camera trickery, Lucasfilm constructed large physical models, measuring two feet wide and six feet long. In order to simulate the text moving, the camera slowly and meticulously panned over it in a process that sometimes took days to achieve the desired effect.

"Everything has to be lined up just perfectly and you spend days running through tests," said *Return of the Jedi* visual effects supervisor Ken Ralston. "Every little blemish shows up. Any little

The Original Opening Crawl

The opening crawl, with its yellow text against a black background, has become synonymous with *Star Wars* films, but George Lucas still needed a little help from his friends to make it iconic. Before he consulted his good friend and fellow filmmaker Brian De Palma, the opening crawl to *Star Wars Episode IV: A New Hope* read as follows:

"It is a period of civil wars in the galaxy. A brave alliance of underground freedom fighters has challenged the tyranny and oppression of the awesome GALACTIC EMPIRE.

Striking from a fortress hidden among the billion stars of the galaxy, rebel spaceships have won their first victory in a battle with the powerful Imperial Starfleet. The EMPIRE fears that another defeat could bring a thousand more solar systems into the rebellion, and Imperial control over the galaxy would be lost forever.

To crush the rebellion once and for all, the EMPIRE is constructing a sinister new battle station. Powerful enough to destroy an entire planet, its completion spells certain doom for the champions of freedom."

Granted, it isn't markedly different from the final version, but it just goes to show what a difference a little bit of finessing and fine-tuning can make.

bump, any little movement of the camera is going to screw up this big 2,000-frame-long take."[500]

Essentially, Lucas and company had created the world's most frustrating teleprompter. Of course, what Ralston described as "pure torture" would be far less aggravating by the time *Star Wars Episode I: The Phantom Menace* rolled around, thanks to significant advances in computer graphics technology. Then again, depending on who you ask, *The Phantom Menace* was its own kind of torture. But I digress.

94 How *Star Wars* Saved Marvel Comics

If you asked anyone on January 1, 2015 what their two most anticipated films of the year were, they would have likely told you *Star Wars: The Force Awakens* and *Avengers: Age of Ultron*. There's a statistically implausible chance that they might have told you *Paul Blart: Mall Cop 2*, but that doesn't sound like anyone you would want to know anyway. The point of this is that in 2015, the two largest franchises in the world are *Star Wars* and the Marvel Cinematic Universe (*Avengers, Guardians of the Galaxy*, etc.). However, what few people realize is that without *Star Wars*, there's a decent chance that Marvel Comics would have collapsed in on itself in the late '70s and early '80s. Just as Luke Skywalker and the Rebel Alliance saved the galaxy, *Star Wars* saved Marvel from utter annihilation.

The year was 1976 and Marvel Comics was in dire financial straits. How bad was it? One of their best-selling titles, *Amazing Spider-Man*, only sold 282,000 copies of the 555,000 printed.[501] That means that nearly 50 percent of those titles went

unsold, and the relative non-existence of a direct comics market meant that newsstands could return unsold product for credit. Essentially, every unsold comic was another nail in the coffin. Making matters worse was the fact that Marvel consistently shipped titles late, issues were missed entirely, and storylines were steadily decreasing in quality. To make matters worse, according to former editor-in-chief Jim Shooter, "the cheesy non-comics magazine department was losing millions."[502] Morale was plummeting and, as Shooter put it, "it seemed like the company as a whole was in a death spiral."

Marvel was in need of a miracle, and that came in the form of longtime Marvel writer and former editor-in-chief Roy Thomas. Though they had previously tried—and failed—to pitch the idea to Stan Lee, George Lucas' representatives Charlie Lippincott and Ed Summer pitched *Star Wars* to Roy Thomas. After seeing Ralph McQuarrie's concept art, Thomas was a believer, but what really sold him on the idea was the price: free.

"The *Star Wars* people didn't ask for any money for the adaptation," Thomas explained in an interview. "They might have asked for money for the rights when they first approached Marvel and were turned down. By the time they came to me, money wasn't a big factor—they either wanted the book done [on our terms] or they were not going to get the book done."[503] It was an offer that Thomas couldn't refuse, but like most offers one can't refuse there was one condition: the first two issues had to be released prior to the film's theatrical release. This was, in large part, because *Star Wars* had a major PR problem before it hit theaters and needed all the help it could get to stand out from the herd.

In a 2011 article, Shooter explained how "George Lucas himself came to Marvel's offices to meet with Stan and help convince him that we should license *Star Wars*." Popular rumor holds that Lee kept Lucas waiting in the reception room for 45 minutes.[504] Whether or not that's true is lost to the sands of time,

but Shooter says that it "reflects the mood at the time," which was one of profound risk aversion, especially for genres that were not proven commodities. And few commodities were more unproven than an unknown space western that was currently in production in the Tunisian desert.

However, this wasn't a proposition without basis or merit. It was an era in which Stan Lee and then–Marvel Comics president Jim Galton were on a licensing kick, snatching up copyrights and brand names in an effort to shore up their holdings and give them deeper roots in Hollywood. From terms and names like "Spider-Woman" and "Ms. Marvel" to existing sci-fi films like *Logan's Run* and *Godzilla* to Edgar Rice Burroughs characters like Tarzan and John Carter, it seemed as though nothing was outside Marvel's editorial purview. It also bolstered Thomas' argument that he had been right on the money previously about licensing Robert E. Howard's *Conan the Barbarian,* and the comics based on it consistently ranked among Marvel's highest sellers.[505]

It wasn't easy, though. Neither writer Roy Thomas nor artist Howard Chaykin saw a cut of the film until the first two issues were being printed. They pieced together what became *Star Wars* #1–6 by using a combination of concept art, production stills, and multiple versions of the *Star Wars* script.[506] This meant that the final product included scenes and moments that didn't make it into the final version of the movie, such as a green-skinned anthropomorphic alien rabbit in a red jumpsuit named Jaxxon, and Jabba the Hutt being a jaundiced walrus-man, but that's part of the comic's charm. Alongside Lucasfilm marketing director Charles Lippincott, Thomas and Chaykin made their way to San Diego Comic-Con in the summer of '76 to discuss the story, preview some artwork, and show some production slides.[507] Though it was a meager presentation by today's standards, it planted the seeds of interest in the audience, who began singing the property's praises in the weeks and months to come.

Like Luke Skywalker firing a torpedo into a thermal exhaust port, Thomas' instincts proved to be right on target. The film generated a fair amount of advance interest, which lead to decent sales before it hit theaters. However, once *Star Wars* made its theatrical debut, it captured the hearts and minds of people all over the world—no Jedi mind tricks required. Issues were flying off of store shelves faster than they could be printed. After its initial print run, *Star Wars* #1 went on to sell more than 1 million copies in reprints, a tremendous return on Marvel's investment. For Marvel it was as though R2-D2 had disabled the trash compactor moments before they were to be crushed into dianoga feed. "In the most conservative terms," Shooter wrote, "it is inarguable that the success of the *Star Wars* comics was a significant factor in Marvel's survival through a couple of very difficult years, 1977 and 1978."[508]

I mentioned this anecdote briefly in *100 Things Avengers Fans Should Know & Do Before They Die*, but its importance cannot be understated. Essentially, without *Star Wars*, it's likely that we wouldn't have the Marvel Cinematic Universe or Marvel Comics as we know it today. So the next time you sit down to watch Tony Stark and the Avengers save the universe from Thanos and the Infinity Gauntlet, just make sure to tip your cap to the galaxy far, far away.

Who Shot First? Han Solo vs. Greedo

There was a second shooter on the grassy knoll that fateful day in November 1963. The moon landing was faked by Stanley Kubrick on a soundstage in New Mexico. President Barack Obama is the king of a race of secret lizard people that control

the world media. These are but a few of the most pervasive conspiracy theories in the world, but few are as divisive and far-reaching as the debate over who shot first—Greedo or Han Solo? That's right—the fateful encounter between our favorite scruffy-looking nerf herder and the bug-eyed, green-skinned Rodian bounty hunter in the Mos Eisley Cantina in *Episode IV: A New Hope* is one of the most hotly contested bits of lore in all of *Star Wars* fandom.

Both Han Solo and Greedo work for local crime lord Jabba the Hutt, who had placed a bounty on Han's head prior to the events of the first film. While laying low in the Mos Eisley Cantina, Greedo pulls his blaster on Han, forcing him to sit down at a booth. At the table, Han tells Greedo that he has Jabba's money, but Greedo—living up to his name—flips the script by demanding Han pay him directly. Cool as a cucumber, Han buys time by explaining that he doesn't have the money while he slyly draws his own blaster from underneath the table. Having finally had enough, Greedo tells Han that Jabba is done waiting for his money, and that he has been eagerly awaiting the chance to take the legendary Han Solo out once and for all. Han replies, "Yes, I'll bet you have," and suddenly there is an explosive flash of light! Greedo slumps over the table, dead as a doornail.

Now this is good news for our hero, right? He escapes a murderous alien bounty hunter by getting the drop on him? Wrong, according to George Lucas. Apparently, Lucas was not happy with how the scene played in the film, believing that it portrayed Han, one of film's primary protagonists, as a cold-blooded killer. In the 1977 version of the film, after Han says, "Yes, I'll bet you have," there is a shot of Greedo's face, followed by a plume of smoke and the sound of a blaster firing. However, when Lucas remastered the film for the 1997 special edition, a shot was inserted after Han's line of Greedo shooting at Han first and missing before Han returns fire in kind, killing the bounty hunter.

It may seem like a small change, but it provoked outrage amongst fans who felt it cheapened and altered Han's heroic journey by making his transition from anti-hero to full-fledged hero less dramatic. That moral grayness that allowed Han Solo to preemptively strike against Greedo is precisely what drew so many fans to the charismatic character in the first place. In 2004, the sequence was actually shortened for the DVD release, which made Han and Greedo appear to shoot nearly simultaneously, but many were still unsatisfied.

In spite of Lucas' assertions, the original script seems to indicate that Han did indeed shoot first after all:

"Suddenly the slimy alien disappears in a blinding flash of light. Han pulls his smoking gun from beneath the table as the other patrons look on in bemused amazement. Han gets up and starts out of the cantina, flipping the bartender some coins as he leaves."[509]

Speaking with *The Hollywood Reporter* in 2012, George Lucas tried to explain things once and for all, saying, "The controversy over who shot first, Greedo or Han Solo, in *Episode IV*, what I did was try to clean up the confusion, but obviously it upset people because they wanted Solo to be a cold-blooded killer, but he actually isn't."[510] The confusion, evidently, arose from the way in which it was filmed, which was almost entirely in close-ups. In the 1997 special editions, which are often maligned by fans, Lucas inserted "a little wider shot in there that made it clear that Greedo is the one who shot first." Even so, fans were unsatisfied, rallying behind the cry of "Han shot first," in direct opposition to Lucas' claim. "Everyone wanted to think that Han shot first, because they wanted to think that he actually just gunned him down," said Lucas.[511]

At the end of the day, the question of who is right and who is wrong is obfuscated by the multiple versions of *Star Wars* and conflicting reports. The definitive answer may have actually come

from Harrison Ford himself, who was asked about the iconic encounter during a Reddit AMA (Ask Me Anything) interview. His response was quite simple: "I don't know and I don't care."[512] I would say that neither do we, Mr. Ford, but we both know that would be a lie. The truth is out there, and we will uncover it.

The Scream Heard 'Round the Galaxy

The electric hum of an unsheathed lightsaber. The barbaric, guttural yawp of a Wookiee. The sing-song bleeping and blooping of R2-D2. These are but a few of the most iconic sounds in the *Star Wars* universe, but they pale in comparison to the legacy of one sound effect in particular: the Wilhelm Scream. The blood-curdling shriek isn't just one of the most enduring sound effects in the *Star Wars* canon; it is one of the most frequently used sounds in cinema history, with appearances in some 152 separate scenes.[513] And it's all thanks to *Star Wars* sound designer Ben Burtt.

Back in 1977, George Lucas asked Ben Burtt to handle the sound design for *Star Wars*, a daunting job that would encompass recording, editing, and mixing—three categories that usually comprised three separate jobs. Difficult thought it may have been, Burtt was more than up to the task, rising to the occasion to create sounds like the lightsaber hum, R2-D2's droid sounds, and the languages for alien races like the Ewoks. Burtt didn't limit himself to a galaxy far, far away either; he went on to create soundscapes for *Invasion of the Body Snatchers* (1978), *E.T.* (1982), and *Lincoln* (2012).

With *Star Wars*, though, Burtt's job was particularly daunting, as they were trying to create a sprawling, sci-fi universe

using natural-sounding, organic sounds. "Since we were going to design a visual world that had rust and dents and dirt, we wanted a sound world that had squeaks and motors that may not be smooth-sounding or quiet," said Burtt in an interview with *BlueStage Magazine*. "Putting in sounds from the real world creates the illusion that these fantasies are credible."[514] Case in point: the infamous labored breathing of Darth Vader's life-supporting suit was created by Burtt recording himself breathing through various diving masks and scuba gear at a local dive shop.

Yet, not even Burtt could manage to create every single sound effect from scratch; after all, the film was on a time table. For several battle sequences, he used stock sounds that existed within expansive sound libraries. One that immediately came to Burtt's mind was a sound effect from the 1953 western film *The Charge at Feather River*, a bone-chilling shriek let loose by a character named Wilhelm after he is struck by an arrow. But that wasn't where the sound came from originally. It first appeared in the 1952 Gary Cooper western *Distant Drums*, when a soldier wading through a swamp lets out an ear-splitting scream while an alligator viciously drags him underwater.

The sound effect was recorded after the fact in a sound booth during a process known as ADR—additional dialogue recording. Six screams were recorded in a single take, and the fifth one was the one that would become the infamous Wilhelm scream.[515] No one knows for certain, but Burtt believes the scream was the product of actor and singer Sheb Woolley. Regardless, the sound effect became a part of Warner Bros. sound library and was used time and time again by the studio in its various films. In the early 1970s, the sound effect became something of an in-joke amongst a group of up-and-coming sound designers at the University of Southern California's film school, including Burtt. To make each other laugh, they managed to slip it into each of their student projects.[516]

Although it was labeled "man getting bit by an alligator, and he screamed," Burtt instead dubbed it the "Wilhelm scream" in homage to Private Wilhelm. As a nod to his friends, Burtt inserted the Wilhelm into *Star Wars*, most noticeably when Luke shoots a stormtrooper who then falls into an abyss aboard the Death Star in *A New Hope*. With that scene, his one-man quest to make the sound effect ubiquitous had begun in earnest. That being said, no one could have predicted the heights the joke would reach.

Over the years, Burtt included the sound in every *Star Wars* and *Indiana Jones* movie, something that caused filmmakers and fans alike to take notice. It became something of an Easter egg among cinephiles, attracting the attention of directors like Quentin Tarantino and Peter Jackson, in addition to scores of sound designers. As a result, the silly scream has earwormed its way into in films including *Reservoir Dogs*, *Toy Story*, *The Fifth Element*, *The Lord of the Rings: The Two Towers*, *Transformers*, and many, many more.

During a cameo appearance in *Return of the Jedi* as an Imperial Army colonel, Burtt is knocked off a balcony by Han Solo. As he fell to his doom, Burtt let loose a Wilhelm-style "Aaaaaahhhhhhhhhh" of his very own. It was a fitting end for the man who is responsible for turning a simple sound effect into a fixture of the modern pop culture landscape. For better or for worse, the sound effect has earned its place in cinematic history. Let's just be grateful that it wasn't something more insidious that proliferated instead, like Salacious Crumb's creepy laugh.

97 Rancho Obi-Wan

Remember when you were younger and you would walk down the aisles of your local department store's toy section ogling all of the incredible Kenner *Star Wars* action figures? Chances are you likely had a couple, maybe even the Death Star playset if you were lucky, but the idea of having them all in one place in your house was the stuff of pure fantasy. While many of us suffered the indignity of our mothers throwing our *Star Wars* figures away when we went off to college or running out of storage space on our bookshelves, one man kept the dream alive. That man is Steve Sansweet and he has made it his mission in life to catalog, preserve, and share his *Star Wars* collection with the world. This isn't just any collection, mind you; it's the largest private collection of *Star Wars* memorabilia in the world.

Housed at the sprawling Sonoma County compound, affectionately dubbed Rancho Obi-Wan, Steve Sansweet's collection of more than 91,000 *Star Wars*–related items stretches out across a 9,000-square-foot museum building.[517] According to Sansweet, "That is only one-third of the total collection. There's a whole warehouse behind [the main building] with boxes we haven't even opened yet."[518] By some estimates, there are more than 300,000 pieces in the collection, which is more than enough to turn any fan greener than Greedo with envy.

Located in northern California, roughly an hour outside of San Francisco, Rancho Obi-Wan is nestled on a quiet country road. Yet unlike the many wineries, farms, and bed & breakfasts that dominate the region, Rancho Obi-Wan is immediately recognizable thanks to the stippled portrait of Obi-Wan Kenobi himself on the complex's wrought iron gate. Once they swing

DAN CASEY

384

open, a veritable treasure trove of *Star Wars* history lies at the end of the driveway. (Oh, and chances are pretty high that you'll be greeted by a couple of seriously adorable dogs too.)

Sansweet didn't originally set out to assemble the world's largest collection of *Star Wars* merchandise though; it began back when he was working at the *Wall Street Journal.* A colleague of his had received a promotional book advertising an upcoming science fiction film called *Star Wars.* Much like the rest of the world, the colleague had no idea the pop culture juggernaut that the film would become, and threw the book into the garbage can. At the end of the day, Sansweet fished it out of the circular file, and the rest was history.

While living in Los Angeles, Sansweet's collection continued to grow in size, forcing him to build two additional stories on his home to accommodate it. Later, he relocated to northern California in order to accept a position working for Lucasfilm in specialty marketing and fan relations, which led him to Rancho Obi-Wan's current home. When he was moving, the moving company informed him that the relocation was the company's second largest residential move in its history.[519] (Sansweet didn't know what the largest one was, but something tells me that it wasn't a *Stark Trek* fan's collection of vintage tricorders.)

Before it became Rancho Obi-Wan, the Sonoma County estate was a chicken ranch that housed more than 20,000 chickens.[520] While there are still a few chickens clucking around the grounds—a nod to the land's roots—it is decidedly more modern nowadays. The one-time chicken coop has been completely transformed into a state-of-the-art archive containing a labyrinthine network of rooms filled with original Drew Struzan posters, a life-size animatronic version of Figrin D'an and the Modal Nodes (a.k.a. the Cantina Band), and even German *Star Wars*–branded toilet paper (complete with the tagline "Wipe Out the Dark Side"). There is also an expansive library with Extended

Universe novels in nearly every language imaginable as well as the 16 books on *Star Wars* that Sansweet has authored. When the familiar thunder of John Williams' score begins pumping through the loudspeakers, you know you've found your people.

Like a smuggler's hoard, Sansweet's collection encompasses both official merchandise and bootleg contraband. This "hive of fun and thriller" contains untold oddities and treasures like shoddily spelled and reproduced action figures from Turkey, a Bantha piñata, a tape dispenser shaped like C-3PO lying like one of Jack Dawson's French girls, an 18-and-over section of sundries so scandalous that Jabba the Hutt himself would blush, and much more. Then, just when you think you've seen everything, Sansweet leads you down a corridor modeled after an Imperial Star Destroyer, which opens up to reveal a room filled with *Star Wars* arcade machines, pinball cabinets, and even a Dejarik table (the holographic chess that they play on the *Millennium Falcon*).

Want to experience the galactic goodness of Rancho Obi-Wan yourself? You don't need to use any Jedi mind tricks to get in; as a result of Rancho Obi-Wan's transition to non-profit museum status, anyone can take a private tour lead by Sansweet. For $60 per head, you and a guest can take a tour that will last between one and three hours (depending on the how thoroughly you interrogate Sansweet about each and every item you come across). If you need more information, no Bothans need die—you can find out everything you need on their website: www.ranchoobiwan. org. So start scrimping together your Republican credits and fuel up the landspeeder because Rancho Obi-Wan is a must-see on any Padawan's pilgrimage.

98 Build Your Own R2-D2

One might assume that the heart and soul of the *Star Wars* franchise is Luke Skywalker, the unassuming moisture farmer who embarks on an intergalactic adventure to save the galaxy from the forces of evil. One might assume that it is Princess Leia, the damsel-in-distress who rises to become a formidable strategist and commander. One might even assume that it's Han Solo, the self-interested smuggler who learns the importance of teamwork in order to become a true hero. All of these assumptions are patently wrong, however. The true heart and soul of *Star Wars* has neither a heart nor a soul; rather, he has highly advanced programming routines. He is none other than R2-D2, the bleeping, blooping, steadfast companion of both Luke and Anakin Skywalker, and one of the few characters to appear in every *Star Wars* film.

Apart from the comic relief R2-D2 injects—and sometimes electrocutes—into the proceedings, he is endlessly useful, with everything from holographic video playback to advanced hacking techniques at his disposal. At one point or another, every *Star Wars* fan has thought to him or herself, "By the twin sons of Tatooine, I sure would love to have an R2-D2 astromech droid of my very own!" (Okay, maybe you worded it slightly better.) Well, you're in luck because we live in a world where you actually *can* have your own astromech droid. Granted, it may not be nearly as sassy as the original, but that's because there's only one Kenny Baker.

Groups like the R2-D2 Builders Club allow likeminded hobbyists and those with an interest in robotics to bring a piece of the galaxy far, far way to life through making their own functional Star Wars droids. Established in 1999, the organization was started by Dave Everett, who created a Yahoo! Group to share

Artoo Whatnow?

Like many *Star Wars* fans, I've found myself wondering just where in the hell the name "R2-D2" came from anyway. After *A New Hope* debuted, an official *Star Wars* encyclopedia explained that it was shorthand for "Second Generation Robotic Droid Series-2," but that wasn't always the plan. According to popular lore, during the production of one of Lucas' earlier films, *American Graffiti*, sound designer Walter Murch asked for "Reel 2, Dialog Track 2" in the abbreviated form of "R-2-D-2". Lucas, who had dozed off in the room while working on the script for *Star Wars*, momentarily woke from his slumber after hearing the request. He mumbled that it was a "great name," then immediately fell back asleep.

Chambers, Bill. "Film Freak Central Interviews Editor Walter Murch (page 4)." Film Freak Central Interviews Editor Walter Murch. Film Freak Central, 2000. Web. 07 Mar. 2015. <https://web.archive.org/web/20110810072318/http://filmfreakcentral.net/notes/wminterview4.htm>.

his blueprints with other aspiring astromechanics. Now with thousands of members across the globe, the Builders Club creates fully operational replica droids out of aluminum, plastic, and other assorted materials. These aren't just fancy doorstops either; many of them can move via remote control, light up, and even play back some of Artoo's famous sound effects. I haven't seen one yet with a holographic video player, but just give it a couple of months and I'm sure they'll prove me wrong.

Building a functional R2-D2 lookalike isn't exactly a simple undertaking—or a cheap one, for that matter. It takes hundreds of hours, but how much does it cost? "It's the one question you don't want your spouse to know the answer to," said droid builder Victor Franco. "The average cost is a little over $5,000," he continued. "A single small aluminum part can cost $100. It's not for the faint of heart."[521] That being said, depending on the materials used and the level of authenticity you're striving to achieve, making your own Artoo can cost as little as $500 (approximately 33 copies of this book, give or take), so start saving your Republican credits.

With servo motors, plywood, resin, proficiency in soldering, and a great deal of patience required, building your very own little R2-D2 can be a daunting task. Not everyone has access to a laser cutter or a CNC (computer numerical control) machine, after all. However, seeing fans' faces oscillate between shock and delight upon seeing a fully functional unit in person makes it more than worth the investment. So, if you're interested in putting your engineering aspirations to good use, you can find a number of tutorials and blueprints online. However, I recommend that you make a beeline for Astromech.net, the official website of the R2 Builders Club, which is the preeminent resource for aspiring bot-builders. Of course, you should also know that once you build an R2-D2, you're going to want to build an X-wing for him to sit in. It's a slippery slope, but with your welding skills, I think you'll be just fine. Just remember to always wear your safety goggles!

Star Wars Celebration

While heading to a convention or an event like Comic-Con can be loads of fun and a great place to meet other like-minded *Star Wars* fans, it can also be a wretched hive of scum and villainy. No, you're not going to have to deal with unsavory bounty hunters, but you will have to deal with throngs of people that aren't necessarily there to spread the *Star Wars* gospel. They may recognize your Lobot costume, but will they *appreciate* it? Not necessarily. Surely there has to be a better option, right? Enter: *Star Wars* Celebration, the official convention for *Star Wars* fans, by *Star Wars* fans.

DAN CASEY

Started in 1999, *Star Wars* Celebration is one of the largest
fan gatherings of Star Wars fans in the entire world. Lucasfilm
held the original event in 1999 to celebrate the upcoming release
of *Star Wars Episode I: The Phantom Menace*. Held at the Wings
Over the Rockies Air and Space Museum in Denver, Colorado,
the first *Star Wars* Celebration was a comparatively small affair.
The first *Star Wars* convention since 1987, Celebration I (as it
is known) attracted an estimated 20,000 attendees, who took in
sights like Anakin's podracer and a life-size X-wing fighter (which
remains at the Wings Over the Rockies Air and Space Museum
today). Fans were also treated to behind-the-scenes footage from
The Phantom Menace, and the premiere of the music video
for "Duel of the Fates," a symphonic tune composed by John
Williams and performed by the London Symphony Orchestra
and the London Voices. (Fun fact: the song lasted 11 days on
MTV's *Total Request Live*, and the LSO remains the only classical
group ever to have a video debut on the show.)[522]

Yet, Celebration I was only the beginning. Since its auspicious
start in 1999, there have been eight more Celebration-branded
events across the world in cities like Indianapolis, Los Angeles,
Orlando, London, Tokyo, and Essen, Germany. In 2015, a 10th
Celebration was planned to bring all manner of *Star Wars*-y
goodness—and hopefully some advance footage from *The
Force Awakens*—to Anaheim, California. (Interestingly, only the
events taking place in the United States are officially numbered
Celebration events; the international Celebrations were dubbed
"Celebration Europe" and "Celebration Japan.") In the past,
Celebration has allowed diehard fans to get a first look at shows
like *Star Wars Rebels*. With a history of high-profile guests like
Mark Hamill, Carrie Fisher, and George Lucas, Celebration is
definitely the con you're looking for, and there's a considerable
chance you'll find the droids you're looking for there too.

100

May the Fourth Be With You

Each year, *Star Wars* fans across the world come together to celebrate their passion for the galaxy far, far away for a single day. That isn't to say that most of us don't spend a staggering amount of time thinking about *Star Wars* during the rest of the year, but May 4th, better known as May the Fourth or *Star Wars* Day, is special in its own way.

While May the Fourth may seem like an obvious pun to make, its origins are anything but. In 1979, Margaret Thatcher was elected the first ever Prime Minister of Britain. To congratulate the newly minted PM on her victory, the *London Evening News* ran a half-page ad that read, "May the Fourth Be With You, Maggie. Congratulations."[523] Though *Star Wars* had only been released two years prior, its cultural impact was undeniable—so much so that wordplay based on its catchphrase permeated UK politics.

The phrase was used time and time again over the years, particularly after the advent of the Internet, which allowed fans spread across the world to find one another. It was like a secret handshake of sorts, but with a global pop culture juggernaut behind it. However, it wasn't until 2011 that the day itself was transformed into a celebration of all things *Star Wars*. At the Toronto Underground Cinema in Canada, people commemorated the day with a film festival and a costume contest.[524] It didn't take long for others to catch on and follow suit.

When Disney purchased the *Star Wars* brand from George Lucas and Lucasfilm in 2012, the celebration grew even larger as the House of Mouse held official "*Star Wars* Day" celebrations at its theme parks, offering discounts on *Star Wars* merchandise

as well as exclusive collectibles. Many fans have tried to make it a two-day celebration by referring to the next day as "Revenge of the Fifth," a play on *Star Wars Episode III: Revenge of the Sith*.[525] Considering that it coincides with Cinco de Mayo, it's often difficult to tell who is embracing their inner Sith and who has had one too many margaritas.

Of course, if you want to be a true *Star Wars* purist, you can celebrate your undying love for the franchise on May 25. Why wait 21 days, you ask? Well, that's because *Star Wars* first exploded onto theater screens on May 25, 1977. It wasn't just opening day for an ambitious science fiction film; it was the start of a certifiable phenomenon. Regardless of when you celebrate, just make sure you do so with likeminded scruffy-looking nerf herders because, more than anything, *Star Wars* has become about community.

Indeed, May has long been an important month to *Star Wars* fans. Each of the six live-action films so far have debuted in May, and George Lucas was born on May 14, to boot. *The Force Awakens* is the first *Star Wars* film not to make its theatrical bow in May, but that doesn't mean *Star Wars* fans across the galaxy will be any less likely to party like Admiral Ackbar at SeaWorld (which I assume is quite heartily).

Acknowledgments

After many late nights, early mornings, and a steady IV drip of concentrated espresso, I completed the book you now hold in your hand. However, this was anything but a solo effort. Much like Luke Skywalker needed the love and guidance of his friends and mentors, I too had people in my corner pulling for me every step of the way. Firstly, thank you to my editor Jesse Jordan for once again helping me transform this manuscript from a Sarlacc pit of random ideas, factoids, and histories into a cohesive work; to Triumph for giving me another incredible opportunity to turn one of my great passions into a written work; to my aunt, Mary Casey, for being the Obi-Wan Kenobi to my Luke Skywalker; to my parents for their tireless support, infinite patience, and endless wisdom; to my dog Maisie for being generally adorable and probably a Sith Lord in disguise; and to my colleagues at Nerdist for giving me a reason to look forward to going into the office each day after pulling my umpteenth late night in a row.

If I forgot to list you by name, please don't take it personally. By this point, my brain is more warped than Emperor Palpatine's complexion, and I would probably accidentally call you by some nonsensical Jedi name anyhow. Last, but not least, thanks to you, the reader, for going on this journey with me. Were it not for you, there would be no reason to write about the galaxy far, far away in the first place. May the Force be with you. Always.

Endnotes

1. "1977: Dutch Children Held Hostage." BBC News. BBC, 23 May 1977. Web. 01 May 2015.
2. Jedick, Rocky. "KLM-Panam Tenerife Disaster." Go Flight Medicine. N.p., 11 Oct. 2014. Web. 01 May 2015.
3. Korkis, Jim. "In His Own Words: Chuck Jones on Duck Dodgers." Cartoon Research. Jerry Beck, 2 Oct. 2013. Web. 01 May 2015.
4. Taylor, Chris. *How Star Wars Conquered the Universe: The Past, Present, and Future of a Multibillion Dollar Franchise*. New York: Basic, 2014. p. 165 Print.
5. Ibid, p. 169.
6. Ibid, p. 182-187
7. Clark, Noelene. "'Star Wars': A Look Back on Opening Day in May 1977." Hero Complex. Los Angeles Times., 25 May 2011. Web.
8. Taylor, Chris. *How Star Wars Conquered the Universe: The Past, Present, and Future of a Multibillion Dollar Franchise*. New York: Basic, 2014. p. 183 Print.
9. "Star Wars (1977)." Box Office Mojo. Amazon, n.d. Web. 01 May 2015.
10. "Star Wars (Franchises)." Box Office Mojo. Amazon, n.d. Web. 01 May 2015.
11. "Star Wars Total Franchise Revenue." Statistic Brain. Statistic Brain Research Institute, 15 Apr. 2015. Web. 01 May 2015.
12. "Disney to Acquire Lucasfilm Ltd." The Walt Disney Company. N.p., 30 Oct. 2012. Web. 01 May 2015.
13. Taylor, Chris. *How Star Wars Conquered the Universe: The Past, Present, and Future of a Multibillion Dollar Franchise*. New York: Basic, 2014. p. 43. Print.
14. Ibid. p. 44-45.
15. Silberman, Steve. "Life After Darth." Wired.com. Conde Nast Digital, May 2005. Web. 16 May 2015.
16. Kaminski, Michael. *The Secret History of Star Wars: The Art of Storytelling and the Making of a Modern Epic*. Kingston, Ont.: Legacy, 2008. p. 29. Print.
17. Taylor, Chris. *How Star Wars Conquered the Universe: The Past, Present, and Future of a Multibillion Dollar Franchise*. New York: Basic, 2014. p. 50-51. Print.
18. Kaminski, Michael. *The Secret History of Star Wars: The Art of Storytelling and the Making of a Modern Epic*. Kingston, Ont.: Legacy, 2008. p. 38. Print.
19. Silberman, Steve. "Life After Darth." Wired.com. Conde Nast Digital, May 2005. Web. 16 May 2015.
20. "Star Wars (Franchises)." Box Office Mojo. Amazon, n.d. Web. 01 May 2015.
21. Curtis, Bryan. "George Lucas Is Ready to Roll the Credits." The New York Times. The New York Times, 21 Jan. 2012. Web. 16 May 2015.
22. "Disney to Acquire Lucasfilm Ltd." The Walt Disney Company. N.p., 30 Oct. 2012. Web. 01 May 2015.
23. Silberman, Steve. "Life After Darth." Wired.com. Conde Nast Digital, May 2005. Web. 16 May 2015.
24. Kaminski, Michael. *The Secret History of Star Wars: The Art of Storytelling and the Making of a Modern Epic*. Kingston, Ont.: Legacy, 2008. p. 71. Print.
25. Rinzler, J. W. *The Making of Star Wars: The Definitive Story behind the Original Film*. New York: Ballantine, 2007. p. 626. Print.
26. "Star Wars Episode IV: A New Hope." Wookieepedia. Wikia. 17 May 2015. Web.
27. Ibid.
28. "Star Wars (1977)." Box Office Mojo. IMDb.com, n.d. Web. 17 May 2015.
29. Kaminski, Michael. *The Secret History of Star Wars: The Art of Storytelling and the Making of a Modern Epic*. Kingston, Ont.: Legacy, 2008. p. 78. Print.
30. Rinzler, J. W. *The Making of Star Wars: The Empire Strikes Back*. New York: Ballantine, 2010. p. 43. Print.
31. Ibid, p. 42.
32. Ibid.
33. Barr, Patricia, Adam Bray, Daniel Wallace, and Ryder Windham. "Rescue on Hoth". *Ultimate Star Wars*. New York, NY: DK, 2015. p. 116 Print.
34. "*Star Wars Episode III: Revenge of the Sith*." Wookieepedia. Wikia. 17 May 15..
35. Rinzler, J. W. *The Making of Star Wars: The Empire Strikes Back*. New York: Ballantine, 2010. p. 362-366. Print.
36. Barr, Patricia, Adam Bray, Daniel Wallace, and Ryder Windham. "Vader's Revelation". *Ultimate Star Wars*. New York, NY: DK, 2015. p. 129 Print.
37. Kaminski, Michael. *The Secret History of Star Wars: The Art of Storytelling and the Making of a Modern Epic*. Kingston, Ont.: Legacy, 2008. p. 220. Print.
38. Ibid. 219.
39. Rinzler, J. W. *The Making of Star Wars: The Empire Strikes Back*. New York: Ballantine, 2010. p. 279. Print.
40. Rinzler, J. W. *The Making of Star Wars: The Empire Strikes Back*. New York: Ballantine, 2010. p. 322. Print.
41. Rinzler, J. W. The Making of Star Wars Return of the Jedi: The Definitive Story. New York, NY: Ballantine, 2013. p. 33. Print.
42. Rinzler, J. W. The Making of Star Wars Return of the Jedi: The Definitive Story. New York, NY: Ballantine, 2013. p. 1710. Print.
43. Kaminski, Michael. *The Secret History of Star Wars: The Art of Storytelling and the Making of a Modern Epic*. Kingston, Ont.: Legacy, 2008. p. 300. Print.
44. Arnold, William. "Director George Lucas Takes a Look Back -- and Ahead." SeattlePI.com. Seattle Post-Intelligencer, 11 May 2005. Web. 16 May 2015.
45. "Star Wars: Episode I The Phantom Menace." Wookieepedia. Wikia, n.d. Web. 16 May 2015.
46. Ibid.
47. Ibid.

48. Taylor, Chris. *How Star Wars Conquered the Universe: The Past, Present, and Future of a Multibillion Dollar Franchise*. New York: Basic, 2014. p. 331. Print.
49. Kaminski, Michael. *The Secret History of Star Wars: The Art of Storytelling and the Making of a Modern Epic*. Kingston, Ont.: Legacy, 2008. p. 307. Print.
50. Taylor, Chris. *How Star Wars Conquered the Universe: The Past, Present, and Future of a Multibillion Dollar Franchise*. New York: Basic, 2014. p. 331. Print.
51. "Scalpers a 'menace' on Eve of Opening." Deseret News. N.p., 18 May 1999. Web. 16 May 2015.
52. Kaminski, Michael. *The Secret History of Star Wars: The Art of Storytelling and the Making of a Modern Epic*. Kingston, Ont.: Legacy, 2008. p. 374. Print.
53. "Prequel Update with Rick McCallum." *Star Wars Insider* #45. Titan Magazines. Aug/Sep 1999. p. 63.
54. Kaminski, Michael. *The Secret History of Star Wars: The Art of Storytelling and the Making of a Modern Epic*. Kingston, Ont.: Legacy, 2008. p. 357-358. Print.
55. Duncan, Jody. *Mythmaking: Behind the Scenes of Attack of the Clones*. New York: Ballantine, 2002. p. 89. Print.
56. "Prequel Update with Rick McCallum." *Star Wars Insider* #45. Titan Magazines. Aug/Sep 1999. p. 63.
57. Taylor, Chris. *How Star Wars Conquered the Universe: The Past, Present, and Future of a Multibillion Dollar Franchise*. New York: Basic, 2014. p. 334. Print.
58. "Star Wars Episode II: Attack of the Clones." Wookieepedia. Wikia. N.d. Web.
59. Taylor, Chris. *How Star Wars Conquered the Universe: The Past, Present, and Future of a Multibillion Dollar Franchise*. New York: Basic, 2014. p. 334. Print.
60. Kaminski, Michael. *The Secret History of Star Wars: The Art of Storytelling and the Making of a Modern Epic*. Kingston, Ont.: Legacy, 2008. p. 345. Print.
61. "Jedi, Klingons invade new dictionary." CNN.com. CNN. 25 Sep 2002. Web.
62. Dretzka, Gary. "Lucas Strikes Back / 'Star Wars' Creator Defends Jar Jar and Says Plot Rules His Universe." SFGate. San Francisco Chronicle, 13 May 2002. Web. 17 May 2015.
63. Perenson, Melissa J. "As the *Star Wars: Episode III—Revenge of the Sith* DVD is Released, Producer Rick McCallum Turns to TV." *Science Fiction Weekly*. November 2005. Web.
64. "Star Wars Episode III: Revenge of the Sith." Wookieepedia. Wikia. Web.
65. Ibid.
66. Kaminski, Michael. *The Secret History of Star Wars: The Art of Storytelling and the Making of a Modern Epic*. Kingston, Ont.: Legacy, 2008. p. 412-413. Print.
67. Crean, Ellen. "'Sith' Invites Bush Comparisons." CBSNews. CBS Interactive, 16 May 2005. Web. 17 May 2015.
68. Rinzler, J. W. *Star Wars Episode III: The Making of Revenge of the Sith*. New York, NY: Del Rey, 2005. p. 17. Print.
69. Rinzler, J. W. *The Making of Star Wars: The Definitive Story behind the Original Film*. New York: Ballantine, 2007. p. 1045. Print.
70. Barr, Patricia, Adam Bray, Daniel Wallace, and Ryder Windham. "Luke Skywalker". *Ultimate Star Wars*. New York, NY: DK, 2015. p. 118 Print.
71. "Luke Skywalker." StarWars.com. Lucasfilm, n.d. Web. 12 May 2015.
72. Asher-Perrin, Emily. "Carrie Fisher's Sound Thoughts on Princess Leia in 1983." Tor. Macmillan, 25 Oct. 2013. Web. 29 Mar. 2015. <http://www.tor.com/blogs/2013/10/carrie-fishers-sound-thoughts-on-princess-leia-in-1983>.
73. Asselin, Janelle. "Waid & Dodson Talk 'Star Wars: Princess Leia' [Interview]." Comics Alliance. Screencrush Network, 27 July 2014. Web. 29 Mar. 2015. <http://comicsalliance.com/star-wars-comics-marvel-princess-leia-mark-waid-terry-dodson-interview-comic-con-san-diego/>.
74. "AFI's 100 Greatest Heroes & Villains." American Film Institute. American Film Institute, 4 June 2003. Web. 22 Mar. 2015. <http://www.afi.com/100Years/handv.aspx>.
75. Lang, Susan S. "Slime-mold Beetles Named for Bush, Cheney, Rumsfeld -- but Strictly in Homage." Cornell Chronicle. Cornell University, 13 Apr. 2005. Web. 22 Mar. 2015. <http://www.news.cornell.edu/stories/2005/04/slime-mold-beetles-named-bush-cheney-rumsfeld>.
76. Edwards, Gavin. "George Lucas and the Cult of Darth Vader." Rolling Stone. Wenner Media LLC, 2 June 2005. Web. 22 Mar. 2015. <http://www.rollingstone.com/movies/news/george-lucas-and-the-cult-of-darth-vader-20050602>.
77. "Darth Vader." StarWars.com. Lucasfilm, n.d. Web. 22 Mar. 2015. <http://www.starwars.com/databank/darth-vader>.
78. Ibid
79. Bouzereau, Laurent, George Lucas, Lawrence Kasdan, and Leigh Brackett. Star Wars: The Annotated Screenplays. London: Titan, 1998. p. 8. Print.
80. Anders, Charlie Jane. "10 Things You Probably Didn't Know About Star Wars." Io9. Gawker Media, 21 June 2011. Web. 28 Mar. 2015. <http://io9.com/5813935/10-things-you-probably-didnt-know-about-star-wars>.
81. "Solo, Han." StarWars.com. Archive.org, n.d. Web. 28 Mar. 2015. <http://web.archive.org/web/20110903234809/http://www.starwars.com/databank/character/hansolo/index.html>.
82. Breznican, Anthony. "'Star Wars' Spin-offs: A Young Han Solo Movie, and a Boba Fett Film." EW.com. Entertainment Weekly, 18 Jan. 2015. Web. 28 Mar. 2015. <http://www.ew.com/article/2013/02/06/star-wars-spin-offs-young-han-solo-movie-boba-fett>.
83. Hutchinson, Sean. "15 Chewbacca Facts in Honor of Peter Mayhew's Birthday." Mental Floss. N.p., 19 May 2014. Web. 26 Feb. 2015. <http://mentalfloss.com/article/56801/15-chewbacca-facts-honor-peter-mayhews-birthday>.
84. Lucas, George and Murch, Walter. Audio commentary. *THX-1138: The George Lucas Director's Cut*. Dir. Lucas. Warner Bros. 1971.
85. Hutchinson, Sean. "15 Chewbacca Facts in Honor of Peter Mayhew's Birthday." Mental Floss. N.p., 19 May 2014. Web. 26 Feb. 2015. <http://mentalfloss.com/article/56801/15-chewbacca-facts-honor-peter-mayhews-birthday>.
86. Madrigal, Alexis C. "The Remarkable Way Chewbacca Got a Voice." The Atlantic. Atlantic Media Company, 07 Aug. 2014. Web. 26 Feb. 2015. <http://www.theatlantic.com/technology/archive/2014/08/the-remarkable-way-chewbacca-got-a-voice/375697/>.
87. Macan, Darko. Duursema, Jan. Gibbons, Dave. Abell, Dusty. *Star Wars: Chewbacca #2*. Portland, OR: Dark Horse Comics. 16 Feb 200. Print.
88. Salvatore, R. A. Star Wars - The New Jedi Order: Vector Prime. New York: Ballantine, 1999. Print.
89. "R2-D2." StarWars.com. Lucasfilm, n.d. Web. 07 Mar. 2015. <http://www.starwars.com/databank/r2-d2>.
90. Friedman, Brent. "Point of No Return." *Star Wars: The Clone Wars*. 12 Jan. 2013. Television.
91. "R2-D2." StarWars.com. Lucasfilm, n.d. Web. 07 Mar. 2015. <http://www.starwars.com/databank/r2-d2>.

92. Brooks, Dan. "R2-D2 Is in Star Wars: Episode VII, and He's Fan-Made." StarWars.com. Lucasfilm, 19 Nov. 2013. Web. 07 Mar. 2015. <http://www.starwars.com/news/r2-d2-is-in-star-wars-episode-7-and-hes-fan-made>.

93. Hibberd, James. "Anthony Daniels' Deep-dive 'Star Wars' Interview: C-3PO's Past, Present and Future." EW.com. Entertainment Weekly, 16 Sept. 2014. Web. 09 Mar. 2015. <http://www.ew.com/article/2014/09/16/star-wars-anthony-daniels-interview/2>.

94. Scoleri, John. "An Annotated Guide to The Star Wars Portfolio by Ralph McQuarrie | StarWars. com." StarWars.com. Lucasfilm, 14 Jan. 2014. Web. 09 Mar. 2015. <http://www.starwars.com/news/an-annotated-guide-to-the-star-wars-portfolio-by-ralph-mcquarrie>.

95. "C-3PO (See-Threepio)." StarWars.com. Lucasfilm, n.d. Web. 09 Mar. 2015. <http://www.starwars.com/databank/c-3po>.

96. Ibid.

97. Hibberd, James. "Anthony Daniels' Deep-dive 'Star Wars' Interview: C-3PO's Past, Present and Future." EW.com. Entertainment Weekly, 16 Sept. 2014. Web. 09 Mar. 2015. <http://www.ew.com/article/2014/09/16/star-wars-anthony-daniels-s

98. Ibid.

99. Rickey, Carrie. "Animation Adds Little to 'Clone'" Philly.com. The Philadelphia Inquirer, 15 Aug. 2008. Web. 03 May 2015.

100. "The Clone Wars: Season One." Wookieepedia. Wikia, n.d. Web. 03 May 2015.

101. "The Clone Wars: Season Two." Wookieepedia. Wikia, n.d. Web. 03 May 2015.

102. "The Clone Wars: Season Three." Wookieepedia. Wikia, n.d. Web. 03 May 2015.

103. "The Clone Wars: Season Four." Wookieepedia. Wikia, n.d. Web. 03 May 2015.

104. "The Clone Wars: Season Five." Wookieepedia. Wikia, n.d. Web. 03 May 2015.

105. "The Clone Wars: The Lost Missions." Wookieepedia. Wikia, n.d. Web. 03 May 2015.

106. Goldman, Eric. "Star Wars: The Clone Wars - Dave Filoni Looks Back at Season 6 and the Show's Final Episodes." IGN. Ziff Davis Media, 18 Mar. 2014. Web. 03 May 2015.

107. Hibberd, James. "'Star Wars Rebels' Interview: New Series Goes to Dark Places, Embraces 1977 Film's Spirit." EW.com. Entertainment Weekly, 17 Jan. 2015. Web. 11 Apr. 2015.

108. Parisi, Frank, Gary Scheppke, and George Lucas. The Art of Star Wars: The Clone Wars. San Francisco: Chronicle, 2009. 13. Print.

109. "Star Wars Rebels: Meet Chopper, Grumpy Astromech Droid." StarWars.com. Lucasfilm, 28 Jan. 2014. Web. 11 Apr. 2015.

110. Dyer, James. "J.J. Abrams Talks Star Wars Episode" Empire Online. Bauer Consumer Media Ltd., 23 Mar. 2013. Web. 24 Feb. 2015. <http://www.empireonline.com/news/story.asp?NID=36884>.

111. Krebs, Josef. "The /Empire Strikes Back/ Director: Irvin Kershner." Sound and Vision. N.p., 30 Sept. 2004. Web. 30 Mar. 2015. <http://www.soundandvision.com/content/empire-strikes-back-director-irvin-kershner>.

112. Ryan, Mike. "In Hindsight, Empire Strikes Back Director Irvin Kershner Would've Helmed One of the Prequels." Vanity Fair. Conde Nast, 18 Oct. 2010. Web. 30 Mar. 2015. <http://www.vanityfair.com/hollywood/2010/10/irvin-kershner>.

113. Newbold, Mark. "Interviewing Kershner: A Conversation with the Director of The Empire Strikes Back | StarWars.com." StarWars.com. Lucasfilm, 18 Sept. 2014. Web. 30 Mar. 2015. <http://www.starwars.com/news/interviewing-kershner-a-conversation-with-the-director-of-the-empire-strikes-back>.

114. Ryan, Mike. "In Hindsight, Empire Strikes Back Director Irvin Kershner Would've Helmed One of the Prequels." Vanity Fair. Conde Nast, 18 Oct. 2010. Web. 30 Mar. 2015. <http://www.vanityfair.com/hollywood/2010/10/irvin-kershner>.

115. Newbold, Mark. "Interviewing Kershner: A Conversation with the Director of The Empire Strikes Back | StarWars.com." StarWars.com. Lucasfilm, 18 Sept. 2014. Web. 30 Mar. 2015. <http://www.starwars.com/news/interviewing-kershner-a-conversation-with-the-director-of-the-empire-strikes-back>.

116. Ryan, Mike. "In Hindsight, Empire Strikes Back Director Irvin Kershner Would've Helmed One of the Prequels." Vanity Fair. Conde Nast, 18 Oct. 2010. Web. 30 Mar. 2015. <http://www.vanityfair.com/hollywood/2010/10/irvin-kershner>.

117. Krebs, Josef. "The /Empire Strikes Back/ Director: Irvin Kershner." Sound and Vision. N.p., 30 Sept. 2004. Web. 30 Mar. 2015. <http://www.soundandvision.com/content/empire-strikes-back-director-irvin-kershner>.

118. Ryan, Mike. "In Hindsight, Empire Strikes Back Director Irvin Kershner Would've Helmed One of the Prequels." Vanity Fair. Conde Nast, 18 Oct. 2010. Web. 30 Mar. 2015. <http://www.vanityfair.com/hollywood/2010/10/irvin-kershner>.

119. Houston, David. "An Interview with Irvin Kershner, Director of THE EMPIRE STRIKES BACK." Starlog #34 May 1980: 25-28. Web. 29 Mar. 2015. <http://thestarwarstrilogy.com/starwars/post/2013/06/08/An-Interview-with-Irvin-Kershner>.

120. Wainfur, Rob. "Richard Marquand And His Star Wars Contribution." Coffee With Kenobi. N.p., 12 Sept. 2014. Web. 30 Mar. 2015. <http://www.coffeewithkenobi.com/richard-marquand-and-his-star-wars-contribution/>.

121. Malartre, Jules-Pierre. "Richard Marquand Interview: Return Of The Jedi, Star Wars." Den of Geek. Dennis Publishing, 25 June 2013. Web. 30 Mar. 2015. <http://www.denofgeek.com/movies/star-wars/26133/richard-marquand-interview-return-of-the-jedi-star-wars>.

122. Marcus Hearn "Cliffhanging". The Cinema of George Lucas. New York City: Abrams. 2005. pp. 140–1.

123. Patterson, Richard. "Producing and Directing Return of The Jedi - Page 3." American Cinematographer. N.p., 19 Aug. 2007. Web. 30 Mar. 2015. <http://www.theasc.com/magazine/starwars/articles/jedi/pdir/pg3.htm>.

124. Rinzler, J. W. The Making of Star Wars Return of the Jedi: The Definitive Story. New York: Del Rey, 2013. p. 59. Print.

125. Patterson, Richard. "Producing and Directing Return of The Jedi - Page 4." American Cinematographer. N.p., 19 Aug. 2007. Web. 30 Mar. 2015. <http://www.theasc.com/magazine/starwars/articles/jedi/pdir/pg4.htm>.

126. Ibid.

127. Malartre, Jules-Pierre. "Richard Marquand Interview: Return Of The Jedi, Star Wars." Den of Geek. Dennis Publishing, 25 June 2013. Web. 30 Mar. 2015. <http://www.denofgeek.com/movies/star-wars/26133/richard-marquand-interview-return-of-the-jedi-star-wars>.

128. Burns, Kevin, dir. Star Wars: The Legacy Revealed. The History Channel. 28 May 2007. Television.

129. Wallace, Daniel. The Jedi Path: A Manual for Students of the Force. San Francisco: Chronicle, 2011. Print.

130. Ibid.

131. "Great Sith War." Wookieepedia. Wikia, n.d. Web. 06 Apr. 2015.

132. "Jedi Order." Wookieepedia. Wikia, n.d. Web. 06 Apr. 2015.

133. Wallace, Daniel. The Jedi Path: A Manual for Students of the Force. San Francisco: Chronicle, 2011. Print.

134. Wallace, Daniel. Book of Sith: Secrets from the Dark Side. Seattle: 47North, 2012. Print.

135. Gaider, David. "Funniest Thing Ever Was Reading Posts by Fans Who Thought the Sith Philosophy in KotOR1 Made so Much Sense. #cribbeditfromMeinKampf #justFYI." Twitter. 22 Feb. 2013. Web. 03 Apr. 2015.

136. "The Rule of Two." Wookieepedia. Wikia, n.d. Web. 3 Apr. 2015.

137. Anders, Charlie Jane. "10 Things You Probably Didn't Know About Star Wars: Return of the Jedi." Io9. Gawker Media, 25 Sept. 2013. Web. 06 Apr. 2015.

138. Taylor, Christian. "Destiny". *Star Wars: The Clone Wars*. dir. Dunlevy, Kyle. Netflix. 7 Mar. 2014. Television.
139. Taylor, Christian. "Voices". *Star Wars: The Clone Wars*. dir. Keller, Danny. Netflix. 1 Mar. 2014. Television.
140. Taylor, Chris. *How Star Wars Conquered the Universe: The Past, Present, and Future of a Multibillion Dollar Franchise*. New York: Perseus Group, p. 44. Print.
141. Rinzler, J. W. *The Making of Star Wars: The Definitive Story behind the Original Film*. New York: Ballantine, 2007. p. 133. Print.
142. Taylor, Chris. *How Star Wars Conquered the Universe: The Past, Present, and Future of a Multibillion Dollar Franchise*. New York: Perseus Group, p. 59. Print.
143. Ibid, p. xx.
144. Rinzler, J. W. *The Making of Star Wars: The Definitive Story behind the Original Film*. New York: Ballantine, 2007. p. 355. Print.
145. Ibid p. 1081.
146. "Force Power." Wookieepedia. Wikia. n.d. Web. 13 Apr. 2015.
147. Databank. StarWars.com. Lucasfilm. Web. 13 Apr. 2015
148. "Alderaan." StarWars.com. Lucasfilm, n.d. Web. 15 Apr. 2015.
149. "Bespin." StarWars.com. Lucasfilm, n.d. Web. 15 Apr. 2015.
150. "Coruscant." StarWars.com. Lucasfilm, n.d. Web. 15 Apr. 2015
151. "Dagobah." StarWars.com. Lucasfilm, n.d. Web. 15 Apr. 2015
152. "Dantooine." Wookieepedia. Wikia, n.d. Web. 15 Apr. 2015.
153. "Endor." StarWars.com. Lucasfilm, n.d. Web. 15 Apr. 2015
154. "Felucia." StarWars.com. Lucasfilm, n.d. Web. 15 Apr. 2015
155. "Geonosis." StarWars.com. Lucasfilm, n.d. Web. 15 Apr. 2015.
156. "Hoth." StarWars.com. Lucasfilm, n.d. Web. 15 Apr. 2015.
157. "Kamino." StarWars.com. Lucasfilm, n.d. Web. 15 Apr. 2015.
158. "Kashyyyk." StarWars.com. Lucasfilm, n.d. Web. 15 Apr. 2015.
159. "Mustafar." StarWars.com. Lucasfilm, n.d. Web. 15 Apr. 2015.
160. "Mygeeto." Wookieepedia. Wikia. n.d. Web. 15 Apr. 2015.
161. "Naboo." StarWars.com. Lucasfilm, n.d. Web. 15 Apr. 2015.
162. "Saleucami." StarWars.com. Lucasfilm, n.d. Web. 15 Apr. 2015.
163. "Tatooine." StarWars.com. Lucasfilm, n.d. Web. 15 Apr. 2015.
164. "Utapau." StarWars.com. Lucasfilm, n.d. Web. 15 Apr. 2015.
165. "Yavin 4." StarWars.com. Lucasfilm, n.d. Web. 15 Apr. 2015.
166. Faraci, Devin. "The Galactic Empire Becomes The First Order In STAR WARS: THE FORCE AWAKENS." Birth.Movies. Death. N.p., 16 Apr. 2015. Web. 02 May 2015.
167. Ratcliffe, Amy. "STAR WARS: THE FORCE AWAKENS Kicks Off Celebration with New Teaser and Special Guests." Nerdist. Legendary Digital Network, 16 Apr. 2015. Web. 02 May 2015.
168. Gonzalez, Dave. "This Weekend, 'Star Wars' 88 Million Views Made 'Superman' Bleed." Forbes. Forbes Magazine, 20 Apr. 2015. Web. 02 May 2015.
169. Bell, Crystal. "J.J. Abrams Is Just As Terrified About 'Star Wars: The Force Awakens' As You Are." MTV News. Viacom, 7 Jan. 2015. Web. 02 May 2015.
170. "Yoda." StarWars.com. Lucasfilm, n.d. Web. 06 Apr. 2015.
171. Ibid.
172. Barr, Patricia, Adam Bray, Daniel Wallace, and Ryder Windham. "Yoda". *Ultimate Star Wars*. New York, NY: DK, 2015. p. 52 Print.
173. "Yoda." StarWars.com. Lucasfilm, n.d. Web. 06 Apr. 2015.
174. Rinzler, J. W. The Making of Star Wars, the Empire Strikes Back: The Definitive Story. New York: Del Rey, 2010. p. 271 Print.
175. Ibid, p. 272-273
176. Hauptfuhrer, Fred. "Yoda Mania." People.com. People Magazine, 09 June 1980. Web. 03 May 2015.
177. Ibid. p. 1727 Print.
178. "Obi-Wan Kenobi." StarWars.com. Lucasfilm. N.p. 15 May 2015. Web.
179. Ibid.
180. Barr, Patricia, Adam Bray, Daniel Wallace, and Ryder Windham. "The Battle of Geonosis". *Ultimate Star Wars*. New York, NY: DK, 2015. p. 51 Print.
181. Barr, Patricia, Adam Bray, Daniel Wallace, and Ryder Windham. "Obi-Wan Kenobi", *Ultimate Star Wars*. New York, NY: DK, 2015. p. 20. Print.
182. "Obi-Wan Kenobi." StarWars.com. Lucasfilm. N.p. 15 May 2015. Web.
183. Ibid.
184. Rinzler, J. W. *The Making of Star Wars, the Empire Strikes Back: The Definitive Story*. New York: Del Rey, 2010. p. 382 Print.
185. Ricca, Brad. "The Real First Appearance of Boba Fett." StarWars.com. Lucasfilm, 08 July 2014. Web. 04 May 2015.
186. Rinzler, J. W. *The Making of Star Wars, the Empire Strikes Back: The Definitive Story*. New York: Del Rey, 2010. p. 689. Print.
187. "Boba Fett." StarWars.com. Lucasfilme, n.d. Web. 06 Apr. 2015.
188. Barr, Patricia, Adam Bray, Daniel Wallace, and Ryder Windham. "Boba Fett". *Ultimate Star Wars*. New York, NY: DK, 2015. p. 70 Print.
189. Ibid.
190. "Boba Fett." StarWars.com. Lucasfilm, n.d. Web. 06 Apr. 2015.
191. Rinzler, J. W. *The Making of Star Wars: The Definitive Story behind the Original Film*. New York: Ballantine, 2007. p. 420-421. Print.
192. Taylor, Chris. *How Star Wars Conquered the Universe: The Past, Present, and Future of a Multibillion Dollar Franchise*. New York: Perseus Group, p. 232, Print.
193. Breznican, Anthony. "Mark Hamill on His Emotional Return to 'Star Wars' and Luke Skywalker." EW.com. Entertainment Weekly. 18 Jan. 2015. Web. 10 May 2015.
194. Ibid.
195. Rinzler, J. W. *The Making of Star Wars: The Definitive Story behind the Original Film*. New York: Ballantine. 2007. p. 406-407. Print.
196. Ibid. p. 502-503. Print.
197. Rinzler, J. W. *The Making of Star Wars, the Empire Strikes Back: The Definitive Story*. New York: Del Rey, 2010. p. 34 Print.

198. Purdie, Ross. "Princess Leia Actress Carrie Fisher Did Cocaine on Set of The Empire Strikes Back." NewsComAu. Australian Associated Press, 12 Oct. 2010. Web. 11 May 2015.

199. Obias, Rudie. "9 Films Punched up by Famous Screenwriters." Mental Floss. Felix Dennis, 11 Apr. 2013. Web. 11 May 2015.

200. Bray, Catherine. "Carrie Fisher Interview: 'Star Wars Has Been My Whole Life'" Time Out London. N.p., 22 Sept. 2014. Web. 11 May 2015.

201. Zuckerman, Esther. "The Best Part of 'Star Wars: Episode VII' Will Be Carrie Fisher's Press Tour." The Wire. The Atlantic Monthly Group, 27 May 2014. Web. 11 May 2015.

202. Ibid.

203. Rinzler, J. W. The Making of Star Wars: The Definitive Story behind the Original Film. New York: Ballantine, 2007. p. 400-404. Print.

204. Ibid, p. 496.

205. Ryan, Mike. "Harrison Ford's Complicated History With Han Solo." The Huffington Post. 11 Sept. 2012. Web. 11 May 2015.

206. Rinzler, J. W. The Making of Star Wars, the Empire Strikes Back: The Definitive Story. New York: Del Rey, 2010. p. 34 Print.

207. "How Much Did The Original Star Wars Cast Get Paid?" Yahoo! Movies UK. Yahoo!, 1 Apr. 2015. Web. 11 May 2015.

208. Jackson, Matthew. "Little-known Sci-fi Fact: The REAL Reason Han Was Frozen in Carbonite." Blastr. Syfy, 20 July 2013. Web. 11 May 2015.

209. "How Much Did The Original Star Wars Cast Get Paid?" Yahoo! Movies UK. Yahoo!, 1 Apr. 2015. Web. 11 May 2015.

210. Pantozzi, Jill. "Harrison Ford Wants Han Solo To Die. There. We Said It. He'd Still Play Him In Star Wars VII Though." The Mary Sue. N.p., 6 Nov. 2012. Web. 11 May 2015.

211. Ryan, Mike. "Harrison Ford's Complicated History With Han Solo." The Huffington Post. 11 Sept. 2012. Web. 11 May 2015.

212. "Harrison Ford FINALLY Speaks out about Star Wars." Blastr. Syfy, 21 May 2010. Web. 11 May 2015.

213. Rinzler, J. W. The Making of Star Wars: The Definitive Story behind the Original Film. New York: Ballantine, 2007. p. 423. Print.

214. Ibid. p. 424.

215. "How Much Did The Original Star Wars Cast Get Paid?" Yahoo! Movies UK. Yahoo!, 1 Apr. 2015. Web. 15 May 2015.

216. Acuna, Kirsten. "Obi-Wan Kenobi Actor Thought 'Star Wars' Was 'Fairy-Tale Rubbish'" Business Insider. Business Insider, Inc, 08 Jan. 2013. Web. 15 May 2015.

217. Mudie, Keir. "Star Wars' Obi Wan Kenobi Sir Alec Guinness HATED Film Classic Which Made Him a Fortune." Mirror Online. Daily Mirror, 03 May 2014. Web. 15 May 2015.

218. Ibid.

219. Truitt, Brian. "'Star Wars' Emperor Recalls His First Day on the Job." USA Today. Gannett Company, 1 May 2013. Web. 11 May 2015.

220. "Emperor Palpatine/Darth Sidious." StarWars.com. Lucasfilm. N.p. Web. 11 May 2015.

221. Barr, Patricia, Adam Bray, Daniel Wallace, and Ryder Windham. "Sheev Palpatine". Ultimate Star Wars. New York, NY: DK, 2015. p. 24-25 Print.

222. "Emperor Palpatine/Darth Sidious." StarWars.com. Lucasfilm. N.p. Web. 11 May 2015.

223. Barr, Patricia, Adam Bray, Daniel Wallace, and Ryder Windham. "Sheev Palpatine". Ultimate Star Wars. New York, NY: DK, 2015. p. 24-25 Print.

224. "Emperor Palpatine/Darth Sidious." StarWars.com. Lucasfilm. N.p. Web. 11 May 2015.

225. Bouzereau, Laurent. Star Wars: The Annotated Screenplays. London: Titan, 1998. 259. Print.

226. Sansweet, Stephen J. "Hutt." Star Wars Encyclopedia. New York: Ballantine Pub. Group, 1998. Print.

227. Hamill, Mark. From Star Wars to Jedi: The Making of a Saga. TV special. PBS. 3 Dec. 1983.

228. Greenwood, Carl. "Star Wars 7: Rare Documentary Takes a Look inside $500,000 Jabba the Hutt Puppet." The Mirror. N.p., 22 May 2014. Web. 29 Mar. 2015. <http://www.mirror.co.uk/tv/tv-news/star-wars-7-rare-documentary-3587662>.

229. Millionaire, Tony. Star Wars Tales #20. Portland, OR: Dark Horse Comics. 30 June 2004.

230. "Jar Jar Binks." Wookieepedia. Wikia. n.d. Web. 24 Feb. 2015. <http://starwars.wikia.com/wiki/Jar_Jar_Binks>.

231. Rabin, Nathan. "The Phantom Lucas." The Dissolve. Pitchfork Media, 8 Apr. 2014. Web. 24 Feb. 2015. <https://thedissolve.com/features/exposition/501-the-phantom-lucas/>.

232. Morgenstern, Joe. "Our Inner Child Meets Young Darth Vader." WSJ. The Wall Street Journal, 19 May 1999. Web. 24 Feb. 2015. <http://www.wsj.com/articles/SB927082592439077365>.

233. Abramovitch, Seth. "The Three Stages of Jar-Jar Denial, By George Lucas." Movieline. Penske Media Corporation, 06 Jan. 2010. Web. 24 Feb. 2015. <http://movieline.com/2010/01/06/the-three-stages-of-jar-jar-denial-by-george-lucas/>.

234. Michnovetz, Matt. "Citadel Rescue." Star Wars: The Clone Wars. 11 Mar. 2011. Television.

235. Murray, Charles. "The Wrong Jedi." Star Wars: The Clone Wars. 2 Mar. 2013. Television.

236. Wallace, Daniel, Mike Sutfin, and Andy Mangels. "Grand Moff Tarkin." Star Wars: The New Essential Guide to Characters. New York: Ballantine, 2002. Print.

237. Gorden, Greg. Star Wars: Imperial Sourcebook. New York: West End Games. 1989.

238. "Leia's Last Chance" Blue Milk Special. 11 September 2009. Web. <http://www.bluemilkspecial.com/?p=166>

239. "Lando Calrissian." StarWars.com. Lucasfilm, n.d. 23 Mar. 2015. <http://www.starwars.com/databank/lando-calrissian>.

240. Windham, Ryder, Chris Reiff, and Chris Trevas. Imperial Death Star: DS-1 Orbital Battle Station, Owner's Workshop Manual. Bristol, U.K.: Haynes. 2013. Print.

241. Slavicsek, Bill. Death Star Technical Companion. Honesdale, PA: West End Games, 1991. Print.

242. "Death Star." Star Wars Databank. The Internet Archive, n.d. Web. 1 Apr. 2015.

243. "Death Star II." StarWars.com. Lucasfilm, n.d. Web. 1 Apr. 2015. <http://www.starwars.com/databank/death-star-ii>.

244. Shawcross, Paul. "This Isn't the Petition Response You're Looking For." Whitehouse.gov. The White House, 14 Jan. 2013. Web. 01 Apr. 2015. <https://petitions.whitehouse.gov/response/isnt-petition-response-youre-looking>.

245. "How Much Would It Cost To Build The Death Star?" Centives. N.p., 15 Feb. 2012. Web. 01 Apr. 2015. <http://www.centives.net/S/2012/how-much-would-it-cost-to-build-the-death-star/>.

246. Quinn, Karl. "Star Wars Actor Peter Mayhew in Melbourne for Supanova Fan Convention." The Sydney Morning Herald. Fairfax Media, 12 Apr. 2014. Web. 26 Mar. 2015. <http://www.smh.com.au/victoria/star-wars-actor-peter-mayhew-in-melbourne-for-supanova-fan-convention-20140411-36iiy.html>.

247. Jenkins, Garry. Empire Building: The Remarkable Real-Life Story of Star Wars. Secaucus, N.J.: Carol Publishing Group, 1999, p. 88.

248. Hawkins, Bennett. "Did You Know George R.R. Martin Helped Inspire Chewbacca? Here's A Brief Look At The Character's Creation." Uproxx. N.p., 19 May 2014. Web. 28 Mar. 2015. <http://uproxx.com/gammasquad/2014/05/a-look-back-on-chewbacca-creation-for-peter-mayhews-birthday/>.

249. Daneman, Matthew. "An Interview with Peter 'Chewbacca' Mayhew of "Star Wars" Fame." Rochester Democrat and Chronicle. Gannett Company, 29 Apr. 2014. Web. 27 Mar. 2015. <http://www.democratandchronicle.com/story/money/business/blogs/business/2014/04/29/from-the-musty-dc-archives-an-interview-with-peter-chewbacca-mayhew-of-star-wars-fame/8472099/>.

250. Hibberd, James. "Anthony Daniels' Deep-dive 'Star Wars' Interview: C-3PO's Past, Present and Future." EW.com. Entertainment Weekly, 16 Sept. 2014. Web. 09 Mar. 2015. <http://www.ew.com/article/2014/09/16/star-wars-anthony-daniels-interview/2>.

251. Ibid.

252. Stevens, Kevin. "Anthony Daniels Interview." The Official Anthony Daniels Web Site. Star Wars Insider, June 1995. Web. 13 Mar. 2015. <http://www.anthonydaniels.com/journalism/wc/index.html>.

253. Ibid.

254. "Anthony Daniels." Wookieepedia. Wikia, n.d. Web. 13 Mar. 2015. <http://starwars.wikia.com/wiki/Anthony_Daniels>.

255. Ibid.

256. Hibberd, James. "Anthony Daniels' Deep-dive 'Star Wars' Interview: C-3PO's Past, Present and Future." EW.com. Entertainment Weekly, 16 Sept. 2014. Web. 09 Mar. 2015. <http://www.ew.com/article/2014/09/16/star-wars-anthony-daniels-interview/2>.

257. Moore, Kevin, and Kenny Baker. "Kenny Baker R2D2 Star Wars Special Radio Interview." *The Moore Show*. YouTube, 14 Jan. 2012. Web. 11 Mar. 2015. <https://www.youtube.com/watch?v=AHpGT4pz5Ws>.

258. Ibid.

259. Burns, James. "Happy 80th Birthday, Kenny Baker!" StarWars.com. Lucasfilm, 08 Sept. 2014. Web. 11 Mar. 2015. <http://www.starwars.com/news/happy-80th-birthday-kenny-baker>.

260. Pellegrom, Dennis. "Kenny Baker Interview." Star Wars Interviews. May 2006. Web. 11 Mar. 2015. <http://starwarsinterviews1.blogspot.com/2010/01/kenny-baker-interview.html>.

261. Williams, Andrew. "Kenny Baker." Metro. N.p., 27 Oct. 2009. Web. 11 Mar. 2015. <http://www.metro.co.uk/showbiz/interviews/1217-kenny-baker>.

262. Burns, James. "Happy 80th Birthday, Kenny Baker!" StarWars.com. Lucasfilm, 08 Sept. 2014. Web. 11 Mar. 2015. <http://www.starwars.com/news/happy-80th-birthday-kenny-baker>.

263. Ibid.

264. Rinzler, J. W. *The Making of Star Wars: The Definitive Story behind the Original Film*. New York: Ballantine, 2007. p. 1080. Print.

265. Ward, Marshall. "The Man Behind Darth Vader (Interview with Dave Prowse)." Rock Cellar Magazine. N.p., 01 Oct. 2001. Web. 16 Apr. 2015.

266. Ibid. p. 1161.

267. Grobel, Lawrence. "James Earl Jones: The Man Behind The Voice." Movieline. Penske Media Corporation, 01 May 1999. Web. 16 Apr. 2015.

268. Taylor, Chris. *How Star Wars Conquered the Universe: The Past, Present, and Future of a Multibillion Dollar Franchise*. New York: Perseus Group, p. 268. Print.

269. "Darth Vader Actor Talks George Lucas Conflict, And Why He Didn't Want To Play Chewbacca." The Moviefone Blog. AOL-HuffPost Entertainment, 8 Aug. 2012. Web. 16 Apr. 2015.

270. "Ahsoka Tano." StarWars.com. Lucasfilm, Web. 09 Apr. 2015.

271. "Ahsoka Tano Biography Gallery." StarWars.com. Lucasfilm, Web. 09 Apr. 2015.

272. Krstic, George. "Storm Over Ryloth." *Star Wars: The Clone Wars*. Dir. Brian Kalin O'Connell. Cartoon Network. 27 Feb. 2009. Television.

273. Murray, Charles. "To Catch a Jedi." *Star Wars: The Clone Wars*. Dir. Kyle Dunlevy. Cartoon Network. 23 Feb. 2013. Television.

274. Murray, Charles. "The Wrong Jedi." *Star Wars: The Clone Wars*. Dir. Dave Filoni. Cartoon Network. 2 Mar. 2013. Television.

275. Ratcliffe, Amy. "Ashley Eckstein Discusses STAR WARS REBELS and the Return of Ahsoka Tano." Nerdist. Legendary Digital Network, 11 Mar. 2015. Web. 8 Apr. 2015.

276. Barr, Patricia, Adam Bray, Daniel Wallace, and Ryder Windham. "Count Dooku". *Ultimate Star Wars*. New York, NY: DK, 2015. p. 22. Print.

277. "Qui-Gon Jinn." StarWars.com. Lucasfilm, n.d. Web. 25 Apr. 2015.

278. Barr, Patricia, Adam Bray, Daniel Wallace, and Ryder Windham. "Count Dooku". *Ultimate Star Wars*. New York, NY: DK, 2015. p. 22. Print.

279. "Qui-Gon Jinn." StarWars.com. Lucasfilm, n.d. Web. 25 Apr. 2015.

280. Barr, Patricia, Adam Bray, Daniel Wallace, and Ryder Windham. "Count Dooku". *Ultimate Star Wars*. New York, NY: DK, 2015. p. 22. Print.

281. "Qui-Gon Jinn." StarWars.com. Lucasfilm, n.d. Web. 25 Apr. 2015.

282. "Designing a Sith Lord - CINECHEW." Cinechew. N.p., 04 July 2014. Web. 25 Apr. 2015.

283. Athman, Fareed. "Iain McCaig Talks Designing Star Wars' Darth Maul." GamesRadar+. Future Plc, 23 Aug. 2011. Web. 25 Apr. 2015.

284. "Darth Maul." StarWars.com. Lucasfilm, n.d. Web. 26 Apr. 2015.

285. Barr, Patricia, Adam Bray, Daniel Wallace, and Ryder Windham. "Darth Maul". *Ultimate Star Wars*. New York, NY: DK, 2015. p. 36. Print.

286. "Darth Maul." StarWars.com. Lucasfilm, n.d. Web. 26 Apr. 2015.

287. Ibid.

288. Barr, Patricia, Adam Bray, Daniel Wallace, and Ryder Windham. "Darth Maul". *Ultimate Star Wars*. New York, NY: DK, 2015. p. 36. Print

289. Sagers, Aaron. "Wizard World NYC: Ray Park Wants To Be Snake Eyes And Darth Maul Again." MTV Geek. Viacom, 3 July 2013. Web. 25 Apr. 2015.

290. "Jango Fett." StarWars.com. Lucasfilm, n.d. Web. 18 Apr. 2015.

291. "Slave I." Wookieepedia. Wikia. N.d. 4 May 2015. Web.

292. "Jango Fett." StarWars.com. Lucasfilm, n.d. Web. 18 Apr. 2015

293. Ibid.

294. Barr, Patricia, Adam Bray, Daniel Wallace, and Ryder Windham. "Padmé Amidala". *Ultimate Star Wars*. New York, NY: DK, 2015. p. 26. Print.

295. "Padmé Amidala." StarWars.com. Lucasfilm. N.d. 11 May 2015. Web.

296. Ibid.
297. Barr, Patricia, Adam Bray, Daniel Wallace, and Ryder Windham. "Padmé Amidala". *Ultimate Star Wars*. New York, NY: DK, 2015. p. 26. Print.
298. Ibid, p. 95
299. "Padmé Amidala." StarWars.com. Lucasfilm. N.d. 11 May 2015. Web.
300. "Mace Windu." StarWars.com. Lucasfilm. N.d. 11 May 2015. Web.
301. Ibid.
302. Barr, Patricia, Adam Bray, Daniel Wallace, and Ryder Windham. "Mace Windu". *Ultimate Star Wars*. New York, NY: DK, 2015. p. 54. Print.
303. Ibid.
304. "Mace Windu." StarWars.com. Lucasfilm. N.d. 11 May 2015. Web.

305. Barr, Patricia, Adam Bray, Daniel Wallace, and Ryder Windham. "General Grievous". *Ultimate Star Wars*. New York, NY: DK, 2015. p. 86. Print.
306. Ibid.
307. "General Grievous." StarWars.com. Lucasfilm, n.d. Web. 15 May 2015.
308. Ibid.
309. "Wedge Antilles." StarWars.com. Lucasfilm. N.d. 12 May 2015. Web.
310. Schedeen, Jesse. "OCD: Star Wars' Fake Wedge." IGN. Ziff Davis Media, 8 June 2009. Web. 13 May 2015.
311. Hidalgo, Pablo. "Star Wars Mysteries: Hunting for the Fake Wedge." StarWars.com. Lucasfilm, 06 Feb. 2013. Web. 13 May 2015.
312. Ibid.
313. Ibid.
314. Masters, Kim. "Lucasfilm's Kathleen Kennedy on 'Star Wars,' 'Lincoln' and Secret J.J. Abrams Meetings (Exclusive)." The Hollywood Reporter. N.p., 30 Jan. 2013. Web. 09 May 2015.
315. Ibid.
316. Ibid.
317. Della Cava, Marco R. "Lucasfilm's Kathleen Kennedy Has Produced Quite a Career." USA Today. N.p., 6 June 2013. Web. 9 May 2015.
318. Robinson, Joanna. "Lucasfilm Finally Confirms Indiana Jones Sequel Is on the Horizon." Vanity Fair. Conde Nast Digital, 5 May 2015. Web. 09 May 2015.
319. Taylor, Chris. *How Star Wars Conquered the Universe: The Past, Present, and Future of a Multibillion Dollar Franchise*. New York: Perseus Group, p. 392.
320. Faraci, Devin. "Kathleen Kennedy: STAR WARS Is For Women Too." Birth.Movies.Death. Alamo Drafthouse, 16 Apr. 2015. Web. 09 May 2015.
321. Taylor, Chris. *How Star Wars Conquered the Universe: The Past, Present, and Future of a Multibillion Dollar Franchise*. New York: Perseus Group, p. 409-410. Print.
322. Barr, Patricia, Adam Bray, Daniel Wallace, and Ryder Windham. "Count Dooku". *Ultimate Star Wars*. New York, NY: DK, 2015. p. 76. Print.
323. "Count Dooku." StarWars.com. Lucasfilm, n.d. Web. 18 Apr. 2015.
324. Barr, Patricia, Adam Bray, Daniel Wallace, and Ryder Windham. "Count Dooku". *Ultimate Star Wars*. New York, NY: DK, 2015. p. 76. Print.
325. Ibid.
326. "Count Dooku." StarWars.com. Lucasfilm, n.d. Web. 18 Apr. 2015.
327. Ibid.
328. Luceno, James. Star Wars: Darth Plagueis. Los Angeles: Del Rey. 2012. Print.
329. "The Legendary Star Wars Expanded Universe Turns a New Page." StarWars.com. Lucasfilm, 25 Apr. 2014. Web. 12 May 2015.
330. Bradfield, Rob. "SWCA: Reinventing the 'Star Wars' Universe With the Lucasfilm Story Group." Spinoff Online. Comic Book Resources, 22 Apr. 2015. Web. 13 May 2015.
331. Lussier, Germain. "How The Lucasfilm Story Group Does Star Wars Canon." Slashfilm. N.p., 20 Apr. 2015. Web. 13 May 2015.
332. Bradfield, Rob. "SWCA: Reinventing the 'Star Wars' Universe With the Lucasfilm Story Group." Spinoff Online. Comic Book Resources, 22 Apr. 2015. Web. 13 May 2015.
333. Prudom, Laura, and Alex Stedman. "'Star Wars: Rogue One' Plot to Focus on Death Star." Variety. Penske Media Corporation, 19 Apr. 2015. Web. 07 May 2015.
334. Sneider, Jeff. "'Star Wars' 2nd Anthology Film Will Be Boba Fett's Origin Story." TheWrap. The Wrap News Inc., 04 May 2015. Web. 07 May 2015.
335. Ratcliffe, Amy. "Are These the Subjects for the STAR WARS Spin-off Films?." Nerdist. Legendary Digital Network, 15 May 2014. Web. 07 May 2015.
336. Taylor, Chris. *How Star Wars Conquered the Universe: The Past, Present, and Future of a Multibillion Dollar Franchise*. New York: Perseus Group, p. 37-39. Print.
337. Rinzler, J. W. *The Making of Star Wars: The Definitive Story behind the Original Film*. New York: Ballantine, 2007. p. 840. Print.
338. Rinzler, J. W. *The Making of Star Wars: The Definitive Story behind the Original Film*. New York: Ballantine, 2007. p. 895-896. Print.
339. "Clone troopers." StarWars.com. Lucasfilm, n.d. Web. 26 Apr. 2015.
340. "Clone trooper." Wookieepedia. Wikia, n.d. Web. 26 Apr. 2015.
341. "Clone troopers." StarWars.com. Lucasfilm, n.d. Web. 26 Apr. 2015.
342. "Stormtroopers." StarWars.com. Lucasfilm, n.d. Web. 26 Apr. 2015.
343. "Stormtrooper." Wookieepedia. Wikia, n.d. Web. 26 Apr. 2015.
344. Taylor, Chris. *How Star Wars Conquered the Universe: The Past, Present, and Future of a Multibillion Dollar Franchise*. New York: Perseus Group, p. 287. Print.
345. Alter, Ethan. "'Star Wars' Author Alan Dean Foster on 'Splinter of the Mind's Eye,' the Sequel That Might Have Been." Yahoo! Movies. Yahoo!, 16 Mar. 2015. Web. 05 May 2015.
346. Taylor, Chris. *How Star Wars Conquered the Universe: The Past, Present, and Future of a Multibillion Dollar Franchise*. New York: Perseus Group, p. 287. Print.

347. Bricken, Rob. "There's No Debate Necessary — Here's the Person Who Should Make the next Star Wars Cartoon." Io9. Gawker MEdia, 4 Mar. 2013. Web. 13 May 2015.
348. Simon, Alex. "Chillin' Big with Lawrence Kasdan." Venice Magazine. The Hollywood Interview, Sept. 2001. Web. 14 May 2015.
349. Ibid.
350. Rinzler, J. W. *The Making of Star Wars, the Empire Strikes Back: The Definitive Story.* New York: Del Rey, 2010. p. 316. Print.
351. Ibid. p. 343.
352. Rinzler, J. W. *The Making of Star Wars Return of the Jedi: The Definitive Story.* New York: Del Rey, 2013. p. 368. Print.
353. Clark, Noelene. "'Star Wars' Writer Lawrence Kasdan Wants Spinoff Film to 'start fresh'." Hero Complex. Los Angeles Times, 9 Feb. 2013. Web. 14 May 2015.
354. Shapiro, T. Rees. "Ralph McQuarrie, Artist Who Drew Darth Vader, C-3PO, Dies at 82." Washington Post. The Washington Post, 4 Mar. 2012. Web. 08 May 2015.
355. Hibberd, James. "Anthony Daniels Definitive 'Star Wars' Interview." EW.com. Entertainment Weekly, 17 Jan. 2015. Web. 08 May 2015.
356. Magid, Ron. "The Old Master: Ralph McQuarrie on Designing Star Wars." Star Wars Insider #76. RalphMcQuarrie.com, June-July 2004. Web. 08 May 2015.
357. Blauvelt, Christian. "Ralph McQuarrie, 'Star Wars' Concept Artist, Dies at 82." EW.com. Entertainment Weekly, 18 Jan. 2015. Web. 08 May 2015.
358. "Kessel Run." Wookieepedia. Wikia. N.d. Web. 01 May 2015.
359. Meyers, J.D. "Deriving the Parallax Formula." Goddard Space Flight Center. National Aeronautics and Space Administration, n.d. Web. 01 May 2015.
360. Hill, Kyle. "How the Star Wars Kessel Run Turns Han Solo Into a Time-Traveler." Wired.com. Conde Nast Digital, 12 Feb. 2013. Web. 01 May 2015.
361. Ibid.
362. Lucas, Katie. "The Unknown." *Star Wars: The Clone Wars.* Dir. Bosco Ng. 7 Mar. 2014. Television.
363. Lucas, Katie. "Conspiracy." *Star Wars: The Clone Wars.* Dir. Brian Kalin O'Connell. 7 Mar. 2014. Television.
364. Lucas, Katie. "Fugitive." *Star Wars: The Clone Wars.* Dir. Danny Keller. 7 Mar. 2014. Television.
365. Lucas, Katie. "Orders." *Star Wars: The Clone Wars.* Dir. Kyle Dunlevy. 7 Mar. 2014. Television.
366. Rinzler, J. W. *The Making of Star Wars Return of the Jedi: The Definitive Story.* New York: Del Rey, 2013. p. 444. Print.
367. Ibid.
368. Ibid, p. 444-445.
369. Ibid, p. 1029, 1038, 1670
370. Barr, Patricia, Adam Bray, Daniel Wallace, and Ryder Windham. "Admiral Ackbar". *Ultimate Star Wars.* New York, NY: DK, 2015. p. 104. Print.
371. "Admiral Ackbar." StarWars.com. Lucasfilm. Web. 20 Apr. 2015.
372. Sansweet, Stephen J. *Star Wars Encyclopedia.* New York: Ballantine. 1998. Print.
373. Ibid.
374. Russell, Dawn. "Colonel Rebel Gets the Boot." MSNewsNow.com. WorldNow, 18 June 2003. Web. 20 Apr. 2015.
375. Castillo, Michelle. "The Saga of Admiral Ackbar's Bid to Be Leader of the Ole Miss Rebels." Time. Time, 8 Sept. 2010. Web. 20 Apr. 2015.
376. Ibid.
377. "Blaster Pistol." StarWars.com. Lucasfilm, n.d. Web. 25 Apr. 2015.
378. DeBord, Jason. "Star Wars Episode IV: A New Hope." The Original Prop Blog. N.p., 09 Jan. 2009. Web. 26 Apr. 2015.
379. Rinzler, J. W. *The Sounds of Star Wars.* San Francisco: Chronicle Books. p. 54. 2010. Print.
380. Allain, Rhett. "An Analysis of Blaster Fire in Star Wars." Wired.com. Conde Nast Digital, 24 May 20120. Web. 26 Apr. 2015.
381. Kaminski, Michael. "Under the Influence of Akira Kurosawa: The Visual Style of George Lucas". *Myth, Media, and Culture in Star Wars: An Anthology.* Lanham, MD: Scarecrow Press., 2012. p. 97. Print.
382. "Lightsaber." StarWars.com. Lucasfilm, n.d. Web. 23 Mar. 2015. <http://www.starwars.com/databank/lightsaber>.
383. Taylor, Chris. *How Star Wars Conquered the Universe: The Past, Present, and Future of a Multibillion Dollar Franchise.* New York: Perseus Group, p. 6. Print.
384. "Laser Blades." TV Tropes. N.p., n.d. Web. 23 Mar. 2015. <http://tvtropes.org/pmwiki/pmwiki/php/Main/LaserBlade>.
385. *Empire of Dreams: The Story of the Star Wars Trilogy.* Dir. Kevin Burns. Fox, 2004. DVD.
386. "Lightsaber." Wookieepedia. Wikia, n.d. Web. 23 Mar. 2015. <http://starwars.wikia.com/wiki/Lightsaber>.
387. "Interview with Nelson Shin." CNN. Cable News Network, 9 Nov. 2007. Web. 23 Mar. 2015. <http://edition.cnn.com/2007/WORLD/asiapcf/10/18/talkasia.nelsonshin/index.html>.
388. "Ben Burtt - Sound Designer of Star Wars." FilmSound.org. N.p., n.d. Web. 23 Mar. 2015. <http://filmsound.org/starwars/burtt-interview.htm>.
389. Ibid.
390. Ibid.
391. Bricken, Rob. "13 Things You Probably Don't Know About Lightsabers." Io9. Gawker Media, 25 Apr. 2014. Web. 23 Mar. 2015. <http://io9.com/13-things-you-probably-dont-know-about-lightsabers-1567641737>.
392. Stamp, Jimmy. "Otto Wagner and the *Millennium Falcon.*" Life Without Buildings. N.p., 14 Apr. 2008. Web. 24 Mar. 2015. <http://lifewithoutbuildings.net/2008/04/otto-wagner-and-millennium-falcon.html>.
393. Horton, Cole. "How the War Built the *Millennium Falcon.*" StarWars.com. Lucasfilm, 18 Feb. 2014. Web. 23 Mar. 2015. <http://www.starwars.com/news/from-world-war-to-star-wars-the-millennium-falcon>.
394. Ibid.
395. Rinzler, J. W. *The Sounds of Star Wars.* San Francisco: Chronicle, 2010. 82. Print.
396. Peterson, Lorne. *Sculpting A Galaxy - Inside the Star Wars Model Shop.* San Rafael, CA: Insight Editions. p. 2–3
397. "*Millennium Falcon.*" Wookieepedia. Wikia, n.d. Web. 24 Mar. 2015. <http://starwars.wikia.com/wiki/Millennium_Falcon>.
398. Lucerno, James. *Star Wars: Millennium Falcon.* New York: Del Rey/Ballantine, 2008. Print.
399. Parry, Nick. "Town's Secret Star Wars History." BBC News. BBC, 18 May 2005. Web. 24 Mar. 2015. <http://news.bbc.co.uk/2/hi/uk_news/wales/south_west/4555455.stm>
400. "X-wing Starfighter." StarWars.com. Lucasfilm, n.d. Web. 02 Apr. 2015.
401. Rinzler, J. W. *The Making of Star Wars: The Definitive Story behind the Original Film.* New York: Ballantine, 2007. p. 496. Print.
402. Ibid, p. 376

403. Wappler, Margaret. "'Star Wars: Episode VII': J.J. Abrams Reveals X-wing Fighter in New Video." Hero Complex. Los Angeles Times, 21 July 2014. Web. 2 Apr. 2015.
404. *Star Wars: The Power of Myth*. New York, NY: DK Publishing, 1999. p. 27. Print.
405. *Empire of Dreams: The Story of the Star Wars Trilogy*. Dir. Kevin Burns and Edith Becker. 20th Century Fox, 2004. DVD.
406. Rinzler, J. W. *The Making of Star Wars: The Definitive Story behind the Original Film*. New York: Ballantine, 2007. p. 262. Print.
407. "TIE Fighter." StarWars.com. Lucasfilm, n.d. Web. 2 Apr. 2015.
408. "Asajj Ventress." StarWars.com. Lucasfilm, n.d. Web. 18 Apr. 2015.
409. Barr, Patricia, Adam Bray, Daniel Wallace, and Ryder Windham. "Asajj Ventress". *Ultimate Star Wars*. New York, NY: DK, 2015. Print.
410. "Asajj Ventress." StarWars.com. Lucasfilm, n.d. Web. 18 Apr. 2015.
411. Barr, Patricia, Adam Bray, Daniel Wallace, and Ryder Windham. "Asajj Ventress". *Ultimate Star Wars*. New York, NY: DK, 2015. Print.
412. Rinzler, J. W. *The Making of Star Wars: The Empire Strikes Back*. New York: Del Rey, 2010. p. 499. Print.
413. Sciretta, Peter. "Did Oakland's Cranes Inspire the AT-AT Walkers? The Answer Finally Revealed!" Slashfilm. Slashfilm, 26 June 2008. Web. 24 Apr. 2015.
414. Lucas, George. *Star Wars Episode V: The Empire Strikes Back*. DVD commentary.
415. Barr, Patricia, Adam Bray, Daniel Wallace, and Ryder Windham. "All Terrain Armored Transport (AT-AT)". *Ultimate Star Wars*. New York, NY: DK, 2015. p. 305 Print.
416. "AT-ST Walker." StarWars.com. Lucasfilm, n.d. Web. 25 Apr. 2015.
417. Rinzler, J. W. *The Making of Star Wars: Return of the Jedi*. New York: Del Rey, 2013. p. 1819-1820. Print.
418. Ibid, 1821.
419. "AT-TE Walker." StarWars.com. Lucasfilm, n.d. Web. 25 Apr. 2015.
420. "AT-TE Walker." Wookieepedia. Wikia, n.d. Web. 25 Apr. 2015.
421. "Red Squadron." Wookieepedia. Wikia, n.d. Web. 20 Apr. 2015.bl
422. Waid, Mark. Dodson, Terry. *Star Wars: Princess Leia* #1. New York: Marvel Comics. 4 Mar. 2015. Print.
423. "Wedge Antilles" StarWars.com. Lucasfilm. Web. 20 Apr. 2015.
424. Ibid.
425. "Red Squadron." Wookieepedia. Wikia, n.d. Web. 20 Apr. 2015.
426. "History of Star Tours." Studios Central. N.p., n.d. Web. 17 Apr. 2015.
427. Surrell, Jason. "Now the Adventure Is Real: Imagineering Star Tours" StarWars.com. Lucasfilm, 03 Mar. 2014. Web. 17 Apr. 2015.
428. Ibid.
429. Surrell, Jason. "Imagineering Star Tours, Part 2: Lightspeed to Endor." StarWars.com. Lucasfilm, 27 Mar. 2014. Web. 17 Apr. 2015.
430. Ibid.
431. Ibid.
432. "History of Star Tours." Studios Central. N.p., n.d. Web. 17 Apr. 2015.
433. Surrell, Jason. "Imagineering Star Tours, Part 3: Visual Effects & Opening." StarWars.com. Lucasfilm, 11 Apr. 2014. Web. 17 Apr. 2015.
434. "Little-known Sci-fi Facts: 3 Ways George Lucas' Wife Saved Star Wars." Blastr. Syfy, 08 Mar. 2011. Web. 18 Apr. 2015.
435. Scanlon, Paul. "George Lucas: The Wizard of Star Wars." Rolling Stone. N.p., 25 Aug. 1977. Web. 18 Apr. 2015.
436. Chaw, Walter. "A Funny Thing Happened on the Way to Toshi's Station: FFC Interviews Mark Hamill." Film Freak Central, 20 Mar. 2005. Web. 18 Apr. 2015.
437. Ibid.
438. Ibid.
439. Kaminski, Michael. *The Secret History of Star Wars: The Art of Storytelling and the Making of a Modern Epic*. Kingston, Ont.: Legacy, 2008. p. 277-79. Print.
440. Lippincott, Charles. "Marcia Lucas." Charles Lippincott | Facebook. 14 Apr. 2015. Web. 18 Apr. 2015.
441. De Lange, Sander. "Galactic Backpacking, Part 4: Visiting Real-World Tatooine." StarWars.com. Lucasfilm, 17 Oct. 2014. Web. 7 Apr. 2015.
442. "Star Wars Location Spotting in Tunisia." Los Apos. N.p., n.d. Web. 07 Apr. 2015.
443. De Lange, Sander. "Galactic Backpacking, Part 2: Visiting Real-World Naboo." StarWars.com. Lucasfilm, 15 Aug. 2014. Web. 08 Apr. 2015.
444. Ibid.
445. De Lange, Sander. "Galactic Backpacking: Visiting Real-World Hoth." StarWars.com. Lucasfilm, 20 June 2014. Web. 08 Apr. 2015.
446. Ibid.
447. Arnold, William. "Inside the Secure World of Skywalker Ranch." Seattle Post-Intelligencer. Seattle Hearst Media, 11 May 2005. Web. 02 Mar. 2015. <http://www.seattlepi.com/ae/movies/article/Inside-the-secure-world-of-Skywalker-Ranch-1173112.php>.
448. Strickler, Jeff. "Skywalker Ranch: George Lucas Creates a Magic World in Real Life." StarTribune. Limelight Networks, 18 May 2002. Web. 02 Mar. 2015. <http://www.startribune.com/lifestyle/11466216.html>.
449. Arnold, William. "Inside the Secure World of Skywalker Ranch." Seattle Post-Intelligencer. Seattle Hearst Media, 11 May 2005. Web. 02 Mar. 2015. <http://www.seattlepi.com/ae/movies/article/Inside-the-secure-world-of-Skywalker-Ranch-1173112.php>.
450. Chanel, Sunny. "Take a Tour of George Lucas' Skywalker Ranch." Fandango. N.p., 16 Jan. 2015. Web. 02 Mar. 2015. <http://www.fandango.com/movie-news/take-a-tour-of-george-lucas-skywalker-ranch-748799>.
451. Rinzler, J. W. *The Making of Star Wars: The Definitive Story behind the Original Film*. New York: Ballantine, 2007. p. 575. Print.
452. Rinzler, J. W. *The Making of Star Wars: The Definitive Story behind the Original Film*. New York: Ballantine, 2007. p. 1878. Print.
453. Lippincott, Charles. " Marvel Star Wars Comics Part 1." From the Desk of Charles Lippincott.. N.p., 10 Mar. 2015. Web. 18 Apr. 2015.
454. "Lucas Controls a Marketing Force." CNNMoney. Cable News Network, 19 May 1999. Web. 18 Apr. 2015.
455. "Star Wars (1977) - Box Office Mojo." Star Wars (1977). Box Office Mojo, n.d. Web. 17 Apr. 2015.
456. Lippincott, Charles. " Writing MARVEL STAR WARS PART 2." From the Desk of Charles Lippincott.. N.p., 31 Mar. 2015. Web. 18 Apr. 2015.

457. Taylor, Chris. *How Star Wars Conquered the Universe: The Past, Present, and Future of a Multibillion Dollar Franchise*. New York: Perseus Group, p. 46. Print.

458. Pellegrom, Dennis. "Howard Kazanjian Interview." Star Wars Interviews. N.p., Jan. 2010. Web 31 Mar 2015. <http:// starwarsinterviews1.blogspot.com/2010/01/howard-kazanjian-interview.html>.

459. Taylor, Chris. *How Star Wars Conquered the Universe: The Past, Present, and Future of a Multibillion Dollar Franchise*. New York: Perseus Group, p. 267. Print.

460. Nazaretyan, Ani. "The Dealmaker & The Filmmaker." Occidental Entertainment (2011): 90-91. Mar.-Apr. 2011. Web. 31 Mar. 2015.

461. Taylor, Chris. *How Star Wars Conquered the Universe: The Past, Present, and Future of a Multibillion Dollar Franchise*. New York: Perseus Group, n.d. 122. Print.

462. Dykstra, John, and Chloe Dykstra. "We Are John Dykstra (VFX for Original Star Wars) and Daughter Chloe Dykstra (host/ game Reviewer). AUA". Reddit. Reddit, 22 Oct. 2014. Web. 07 Mar. 2015. <http://www.reddit.com/r/IAmA/comments/2k0u0e/ we_are_john_dykstra_vfx_for_original_star_wars/>.

463. Venkatasawmy, Rama. *The Digitization of Cinematic Visual Effects: Hollywood's Coming of Age*. Lanham: Lexington, 2013. 133-35. Print.

464. Taylor, Chris. *How Star Wars Conquered the Universe: The Past, Present, and Future of a Multibillion Dollar Franchise*. New York: Perseus Group, p. 172. Print.

465. Ibid. p. 221.

466. Lefferts, Daniel. "Meet Drew Struzan, the Man Behind Hollywood's Most Famous Movie Posters | Clios." Clios. N.p., 22 Oct. 2014. Web. 26 Mar. 2015. <http://clios.com/meet-drew-struzan-the-man-behind-hollywoods-most-famous-movie-posters/1028>.

467. Ibid.

468. Carter, Jeff. "Drew Struzan Interview." Echo Station. N.p., n.d. Web. 24 Mar. 2015. <http://www.echostation.com/interview/ drew3.htm>.

469. Arnold, Alan. "'The Making of The Empire Strikes Back' (1979)." *Once Upon a Galaxy: A Journal of the Making of The Empire Strikes Back*. John Williams Fan Network, 17 Nov. 1979. Web. 02 Mar. 2015. <http://www.jwfan.com/?page_id=4585>.

470. John Williams Interview. Bouzereau, Laurent, and Jody Duncan. *Star Wars: The Making of Episode I*, the Phantom Menace. New York: Ballantine, 1999. Web. <http://www.jwfan.com/?page_id=4565>

471. Bobbin, Jay. "'Man of Steel' Will Be 'hard for Me' to See, Says 'Superman' Composer John Williams - Zap2it | News & Features." Zap2it. N.p., 24 May 2013. Web. 04 Mar. 2015. <http://www.zap2it.com/blogs/ man_of_steel_will_be_hard_for_me_to_see_says_superman_composer_john_williams-2013-05>.

472. Gera, Emily. "Star Wars Gets Its First Official LGBT Character Added to Canon." Polygon. Vox Media, 09 Mar. 2015. Web. 09 Mar. 2015. <http://www.polygon.com/2015/3/9/8174063/star-wars-lgbt-moff-mors-lords-sith>.

473. Young, Bryan. "Episode CIV: Nimoy, Rebels, and Shelly Shapiro." Interview. Full of Sith Podcast. 1 Mar. 2015. Web. 9 Mar. 2015. <http://fullofsith.com/archives/1328>.

474. Traviss, Karen. "Frequently Asked Questions." KarenTraviss.com. 2008. Web. 09 Mar. 2015. <http://www.karentraviss.com/ page22/files/Is_it_true_that_some_of_the_Man.html>.

475. Young, Bryan. "'Star Wars' Introduces an LGBT Character Into Canon." Big Shiny Robot. N.p., 6 Mar. 2015. Web. 09 Mar. 2015. <http://www.bigshinyrobot.com/58601/star-wars-introduces-lgbt-character-canon/>.

476. Kirby, Ben. "Who Shot First? The Complete List Of Star Wars Changes". Empire Online. Bauer Consumer Media Ltd., 20 Aug. 2014. Web. 26 Mar. 2015. <http://www.empireonline.com/features/star-wars-changes>.

477. "Star Wars: Episode IV A New Hope." StarWars.com. Lucasfilm, n.d. Web. 26 Mar. 2015. <http://www.starwars.com/films/ star-wars-episode-iv-a-new-hope>.

478. McMillan, Graeme. "30 Things You Didn't Know About Return of The Jedi." Wired.com. Conde Nast Digital, 24 May 2013. Web. 26 Mar. 2015. <http://www.wired.com/2013/05/return-of-the-jedi-anniversary/>.

479. Kirby, Ben. "Who Shot First? The Complete List Of Star Wars Changes". Empire Online. Bauer Consumer Media Ltd., 20 Aug. 2014. Web. 26 Mar. 2015. <http://www.empireonline.com/features/star-wars-changes>.

480. Ibid.

481. Ibid.

482. Ibid.

483. Ibid.

484. "Lucas Talks as 'Star Wars' Trilogy Returns." TODAY.com. The Associated Press, 15 Sept. 2004. Web. 26 Mar. 2015. <http:// www.today.com/id/6011380/ns/today-today_entertainment/t/lucas-talks-star-wars-trilogy-returns/#.VROzx5PF_YM>.

485. Vineyard, Jennifer. "George Lucas Says Indiana's Next Crack Of The Whip Will Be Tamer." MTV News. Viacom, 10 May 2006. Web. 26 Mar. 2015. <http://www.mtv.com/news/1531527/george-lucas-says-indianas-next-crack-of-the-whip-will-be-tamer/>.

486. Kirby, Ben. "Who Shot First? The Complete List Of Star Wars Changes". Empire Online. Bauer Consumer Media Ltd., 20 Aug. 2014. Web. 26 Mar. 2015. <http://www.empireonline.com/features/star-wars-changes>.

487. Clark, Noelene. "'Star Wars' Fans Become Jedi Padawans at Lightsaber school." Hero Complex. Los Angeles Times, 21 Feb. 2013. Web. 06 Apr. 2015.

488. Taylor, Chris. *How Star Wars Conquered the Universe: The Past, Present, and Future of a Multibillion Dollar Franchise*. New York, NY: Basic, 2014. p. 65. Print.

489. Ibid.

490. Clark, Noelene. "'Star Wars' Fans Become Jedi Padawans at Lightsaber school." Hero Complex. Los Angeles Times, 21 Feb. 2013. Web. 06 Apr. 2015.

491. Hofstede, David. What Were They Thinking: The 100 Dumbest Events in Television History. New York: Back Stage, 2004. Print.

492. Hicks, L. Wayne. "When The Force was a Farce." TVParty. N.p., n.d. Web. 15 Feb. 2015. <http://www.tvparty.com/70starwars. html>.

493. DiGiacomo, Frank. "The Star Wars Holiday Special." Vanity Fair. Conde Nast, Dec. 2008. Web. 16 Feb. 2015. <http://www. vanityfair.com/magazine/2008/12/star_wars_special200812/>.

494. Ibid.

495. Ibid.

496. Pasternack, Alex. "Happy Wookie Life Day: The Star Wars Holiday Special Was the Worst Thing on Television." Motherboard. Vice Media, 23 Dec. 2012. Web. 17 Feb. 2015. <http://motherboard.vice.com/blog/ the-star-studded-star-wars-holiday-special-was-the-worst-thing-on-television-ever--2>.

497. Tozzi, Lisa. "Her Most Desperate Hour: Carrie Fisher Discusses 'The Star Wars Holiday Special'" The New York Times. The New York Times, 12 Jan. 2010. Web. 16 Feb. 2015. <http://artsbeat.blogs.nytimes.com/2010/01/12/her-most-desperate-hour-carrie-fisher-discusses-the-star-wars-holiday-special/?_r=0>.

498. Pearlman, Cindy. "The Force behind 'The Force'" The Chicago Sun-Times. 15 May 2005. Print.

499. Ibid.

500. Hill, Kyle. "Unnecessary Information: A NEW HOPE's Opening Crawl Is 18,000 Miles Overhead « Nerdist." Nerdist. Nerdist Industries, 12 Feb. 2015. Web. 21 Feb. 2015. <http://www.nerdist.com/2015/02/unnecessary-information-a-new-hopes-opening-crawl-is-18000-miles-overhead/>.

501. Miller, John Jackson. "Amazing Spider-Man Annual Sales Figures." Comichron. N.p., n.d. Web. 19 Feb. 2015. <http://www.comichron.com/titlespotlights/amazingspiderman.html>.

502. Shooter, Jim. "Roy Thomas Saved Marvel." JimShooter.com N.p. 5 July 2011. Web. <http://www.jimshooter.com/2011/07/roy-thomas-saved-marvel.html>

503. Veronese, Keith. "How Star Wars Saved Marvel and the Comic Book Industry." io9. Gawker Media, 15 Sept. 2011. Web. 19 Feb. 2015. <http://io9.com/5840578/how-star-wars-saved-the-comic-book-industry>.

504. Shooter, Jim. "Roy Thomas Saved Marvel." JimShooter.com N.p. 5 July 2011. Web. <http://www.jimshooter.com/2011/07/roy-thomas-saved-marvel.html>

505. Howe, Sean. Marvel Comics: The Untold Story. New York: Harper. 2012. p. 193.

506. Veronese, Keith. "How Star Wars Saved Marvel and the Comic Book Industry." io9. Gawker Media, 15 Sept. 2011. Web. 19 Feb. 2015. <http://io9.com/5840578/how-star-wars-saved-the-comic-book-industry>. Shooter, Jim. "Roy Thomas Saved Marvel." JimShooter.com N.p. 5 July 2011. Web. <http://www.jimshooter.com/2011/07/roy-thomas-saved-marvel.html>

507. Sansweet, Steve. "The Ties That Bind: Why Comic-Con and Lucasfilm Are Soul Mates | StarWars.com." StarWars.com. Lucasfilm, 16 July 2012. Web. 19 Feb. 2015. <http://www.starwars.com/news/the-ties-that-bind-why-comic-con-and-lucasfilm-are-soul-mates>.

508. Shooter, Jim. "Roy Thomas Saved Marvel." JimShooter.com N.p. 5 July 2011. Web. <http://www.jimshooter.com/2011/07/roy-thomas-saved-marvel.html>

509. Peterson, Andrea. "Reddit Asked Harrison Ford Who Shot First. Here's What He Said." Washington Post. The Washington Post, 14 Apr. 2014. Web. 18 Feb. 2015. <http://www.washingtonpost.com/blogs/the-switch/wp/2014/04/14/reddit-asked-harrison-ford-who-shot-first-heres-what-he-said/>.

510. Block, Alex Ben. "5 Questions With George Lucas: Controversial 'Star Wars' Changes, SOPA and 'Indiana Jones 5'" The Hollywood Reporter. N.p., 9 Feb. 2012. Web. 18 Feb. 2015. <http://www.hollywoodreporter.com/heat-vision/george-lucas-star-wars-interview-288523>.

511. Ibid.

512. Ford, Harrison. "I Am Harrison Ford. AMA." Reddit. N.p., 13 Apr. 2014. Web. 18 Feb. 2015. <http://www.reddit.com/r/IAmA/comments/22xh4j/i_am_harrison_harrison_ford_ama/cgrbxl4>.

513. "BlueStage Story: The Scream of the Jedi Knight." Sennheiser.com. BlueStage Magazine. Web. 31 Jan. 2015.

514. Ibid.

515. Hutchinson, Sean. "Where Did the Wilhelm Scream Come From and Why Do So Many Filmmakers Use It?" Mental Floss. N.p., 25 Nov. 2014. Web. 31 Jan. 2015.

516. Ibid.

517. The collection numbered 91,000-plus as of June 2013 when I visited the massive museum.

518. Casey, Dan. "Inside Rancho Obi-Wan, America's Largest Private Star Wars Collection « Nerdist." Nerdist. 9 July 2013. Web. 07 Feb. 2015. < http://www.nerdist.com/2013/07/inside-rancho-obi-wan-americas-largest-private-star-wars-collection/>

519. Ibid.

520. "History." Rancho Obi-Wan. N.p., n.d. Web. 08 Feb. 2015. < http://www.ranchoobiwan.org/about/history/>

521. Pfeiffer, Eric. "How to Build Your Own R2D2." Yahoo! News. Yahoo!, 30 Mar. 2013. Web. 17 Feb. 2015. <http://news.yahoo.com/blogs/sideshow/build-own-r2d2-062419995.html>.

522. "The TRL Archive`." ATRL. N.p., n.d. Web. 14 Feb. 2015. <http://atrl.net/trlarchive/?s=debuts>.

523. "Why Is May the 4th Called Star Wars Day?" StarWars.com. Lucasfilm, n.d. Web. 14 Feb. 2015. <http://www.starwars.com/may-the-4th>.

524. Zalben, Alex. "A Brief History of 'Star Wars' Celebration May The Fourth." MTV News. MTV, 3 May 2014. Web. 15 Feb. 2015. <http://www.mtv.com/news/1819357/a-brief-history-of-star-wars-celebration-may-the-fourth/>.

525. "Why Is May the 4th Called Star Wars Day?" StarWars.com. Lucasfilm, n.d. Web. 14 Feb. 2015. <http://www.starwars.com/may-the-4th>.